POLAR
THE FUTURE OF ICE, LIFE, AND THE ARCTIC
TALES

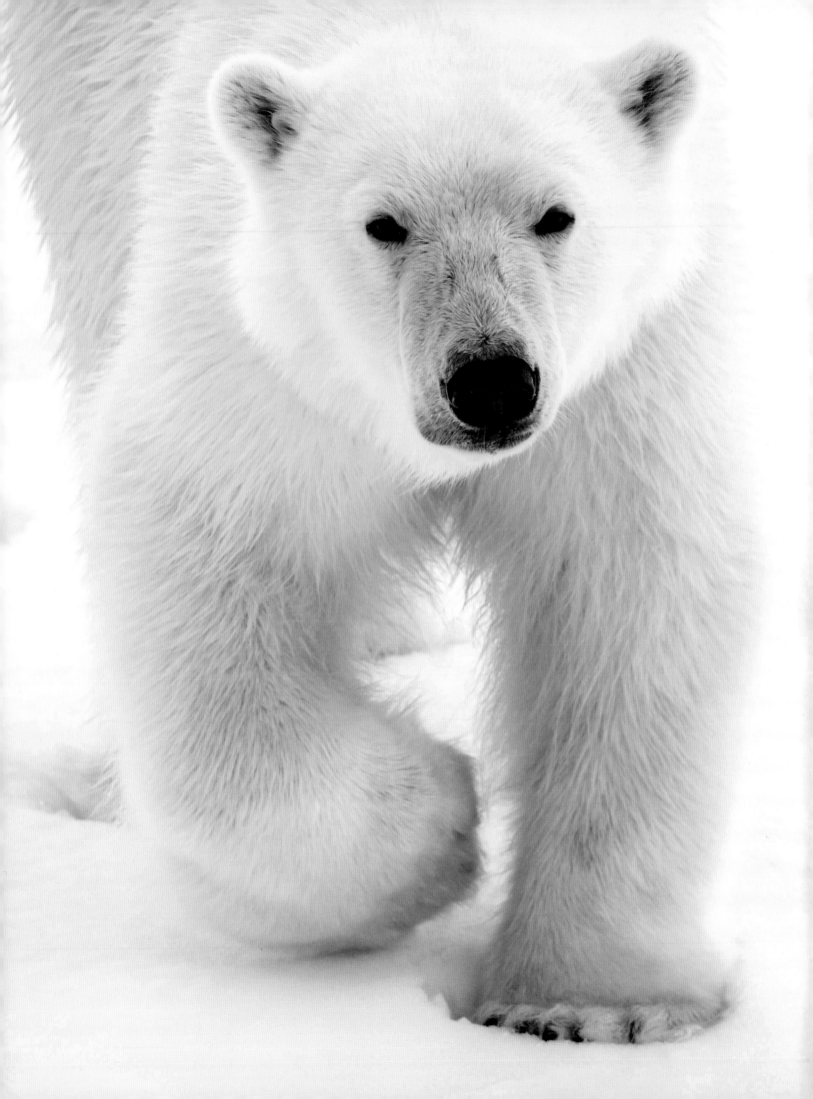

An iceberg the size of a small country breaks loose to become part of the ocean. Glaciers, thousands of years old, melt. Sea levels rise and land disappears. The North Pole pack ice, a seemingly solid island of ice, dissolves into water. Maps are redrawn.

Things that felt eternal are changing.

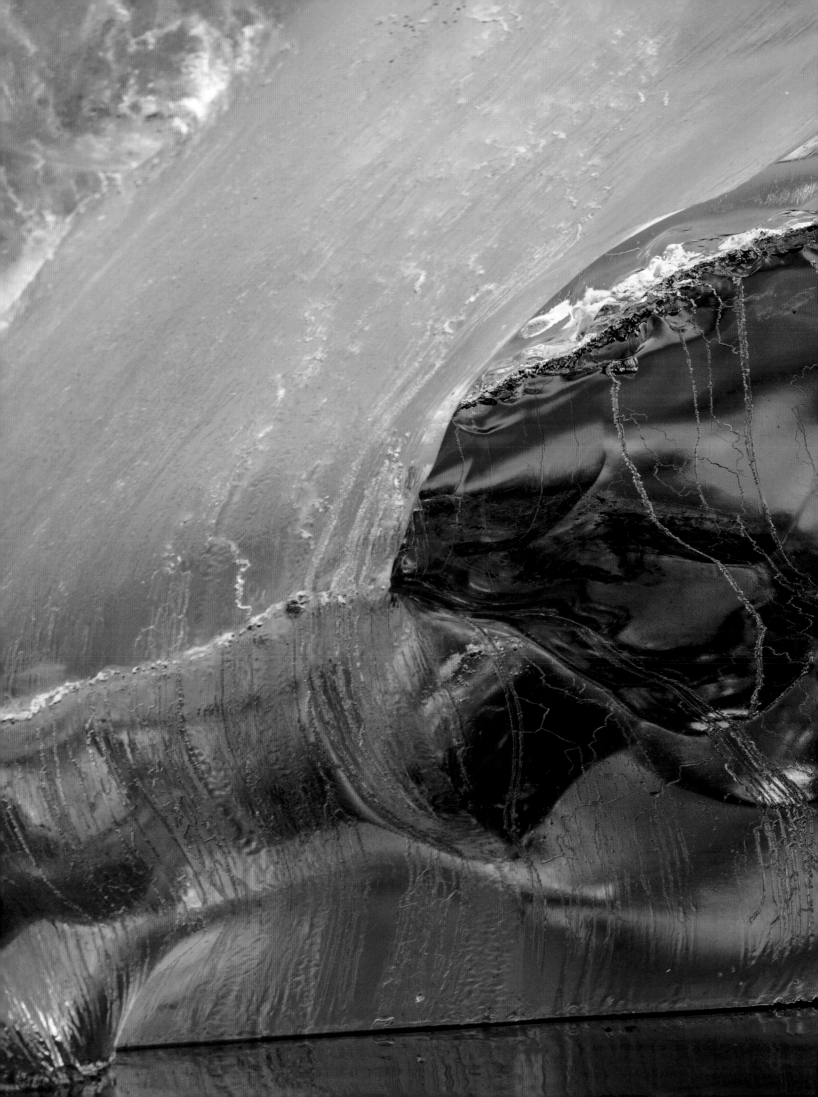

POLAR TALES

THE FUTURE OF ICE, LIFE, AND THE ARCTIC

MELISSA SCHÄFER AND FREDRIK GRANATH

RIZZOLI
NEW YORK

New York · Paris · London · Milan

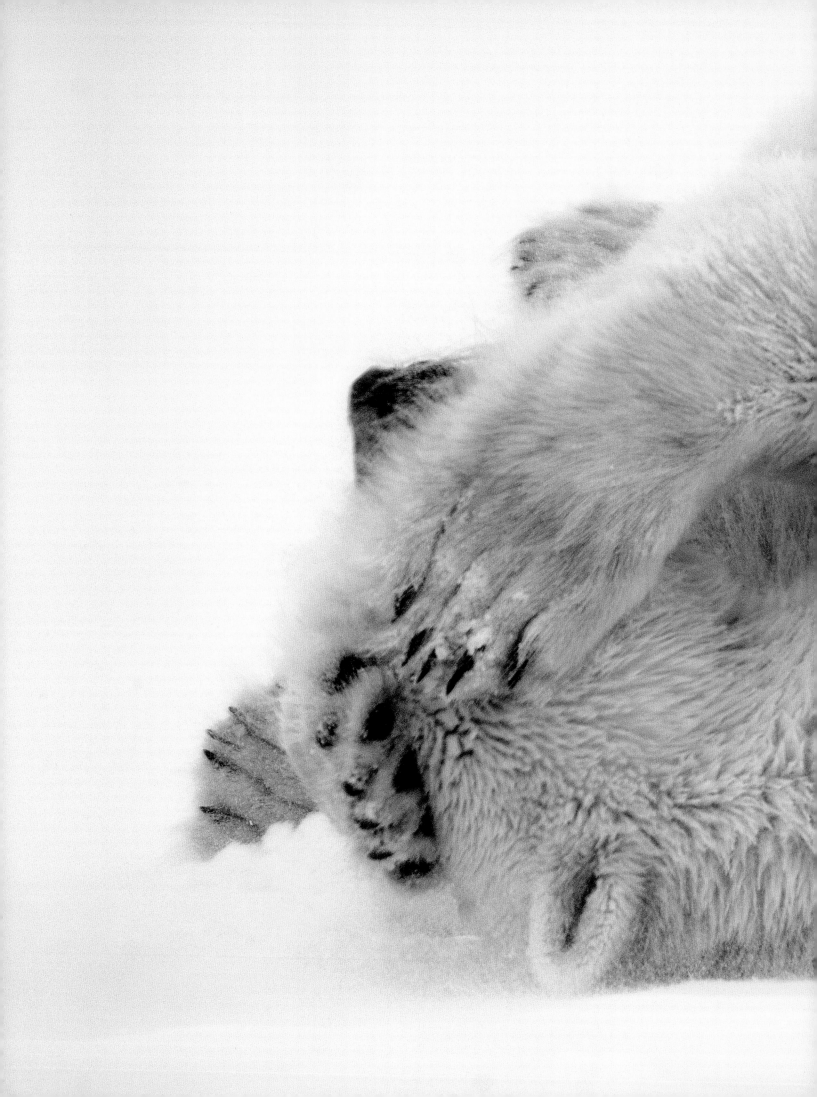

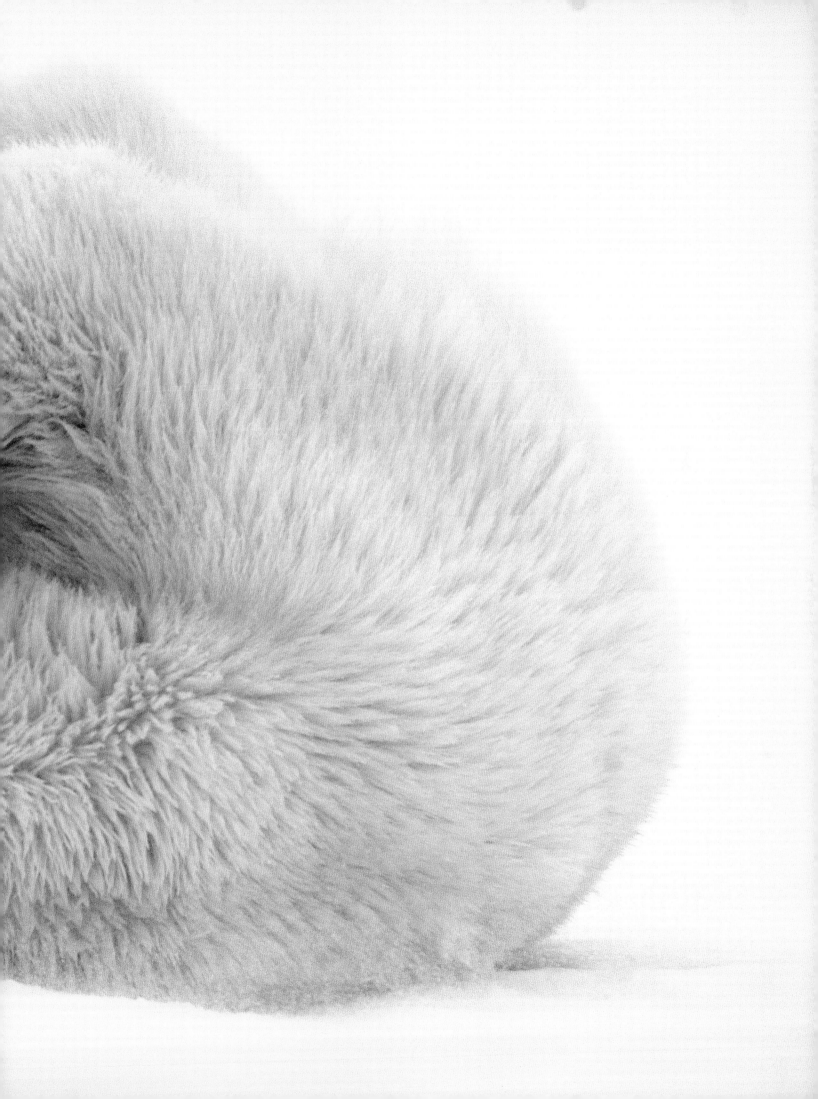

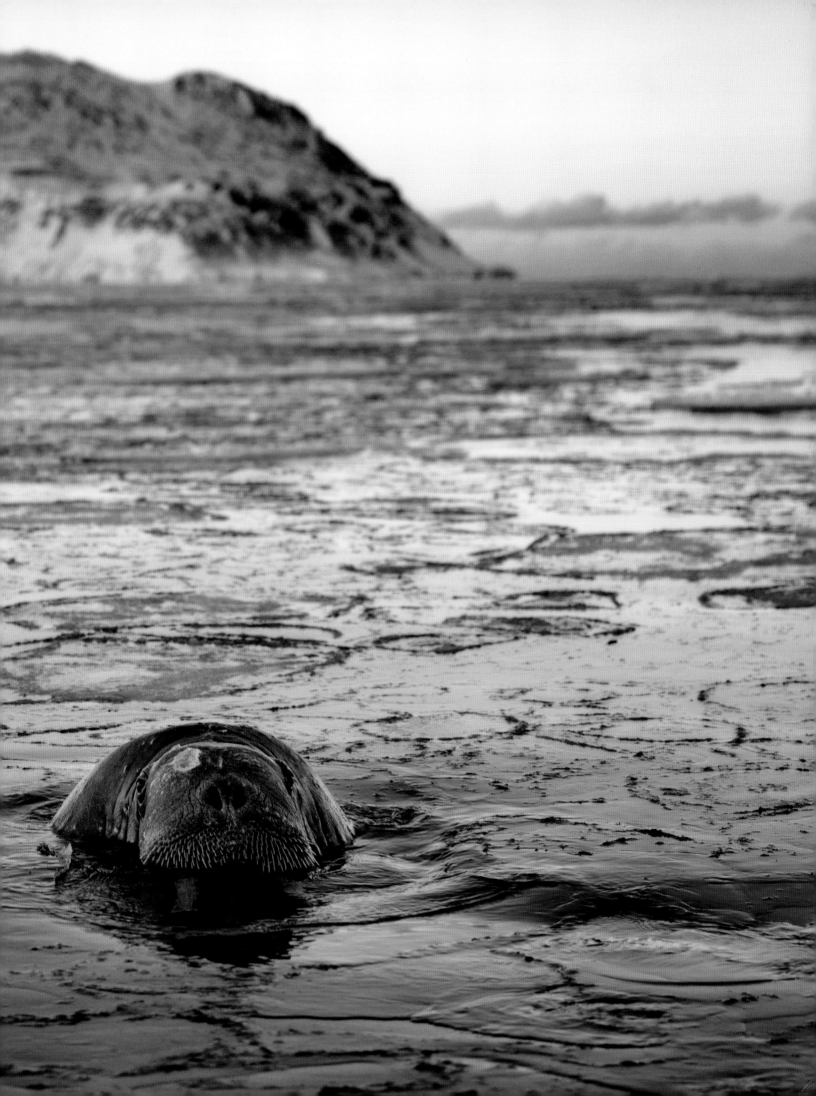

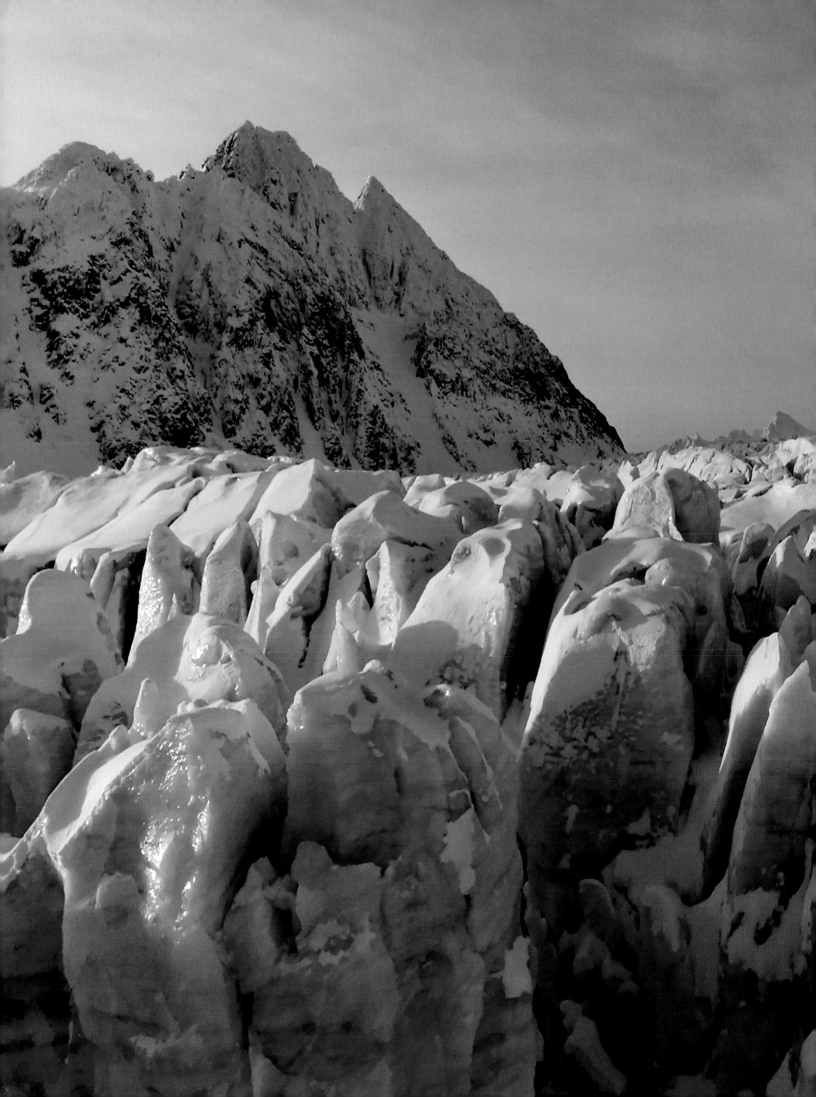

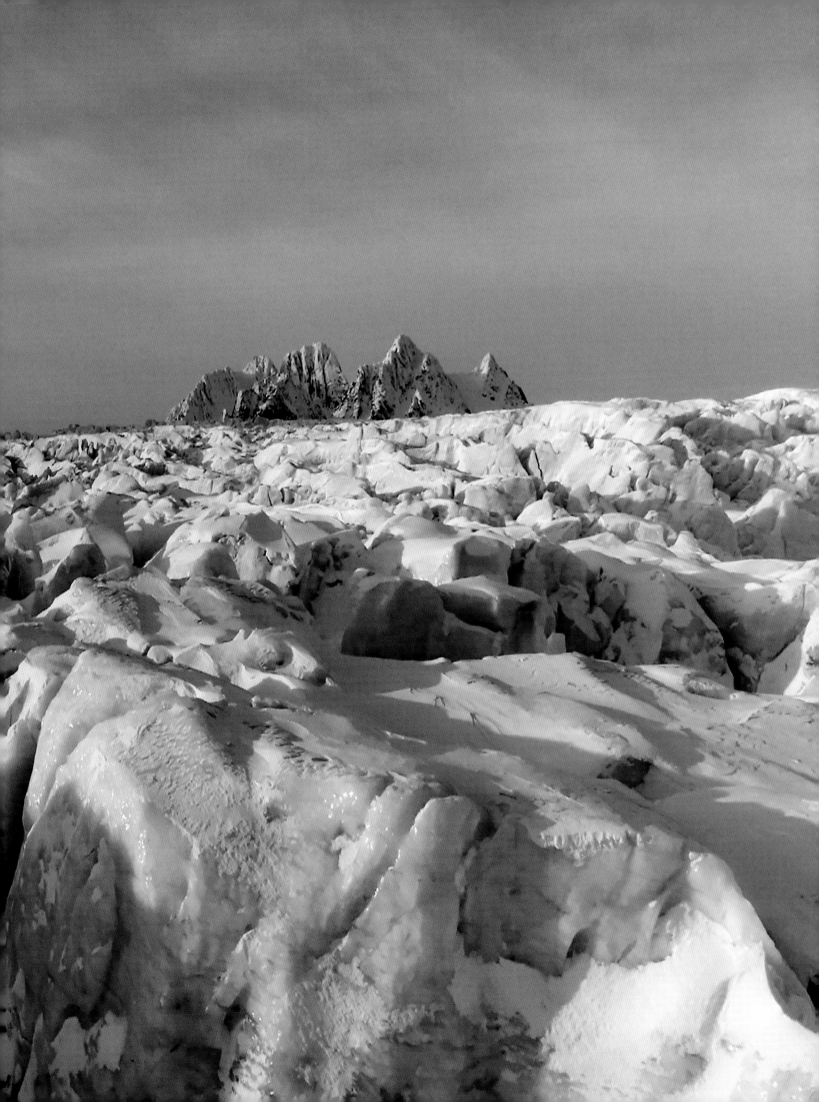

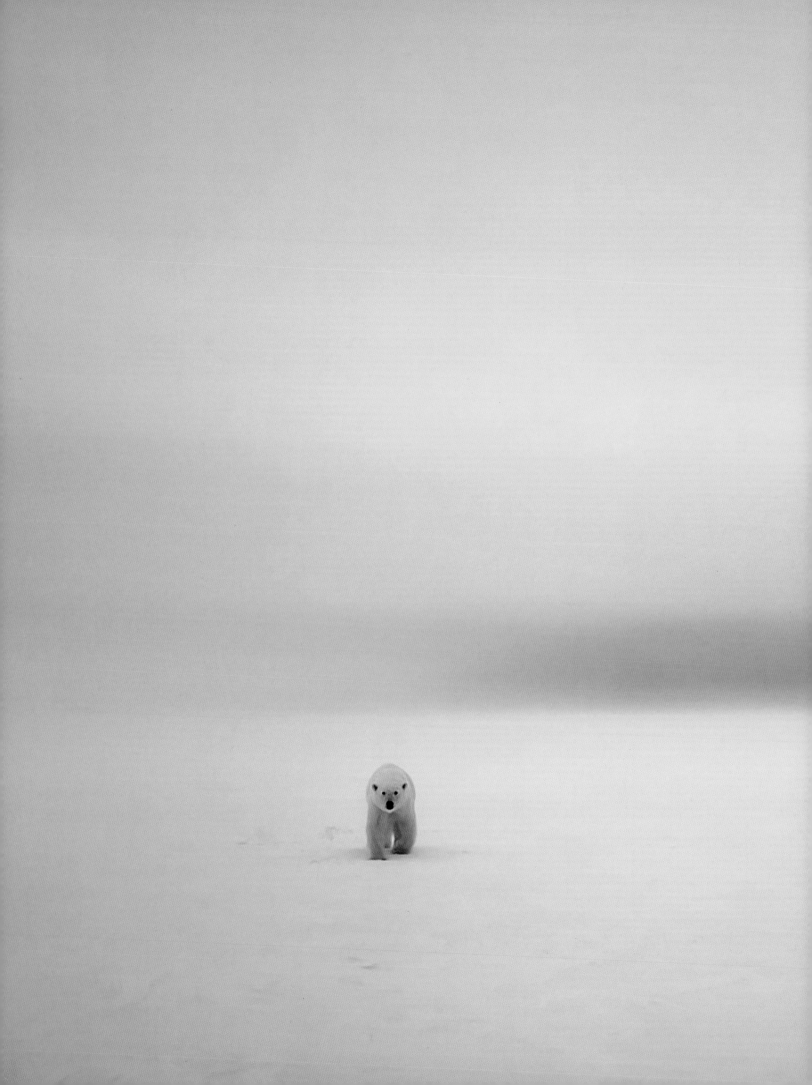

CONTENTS

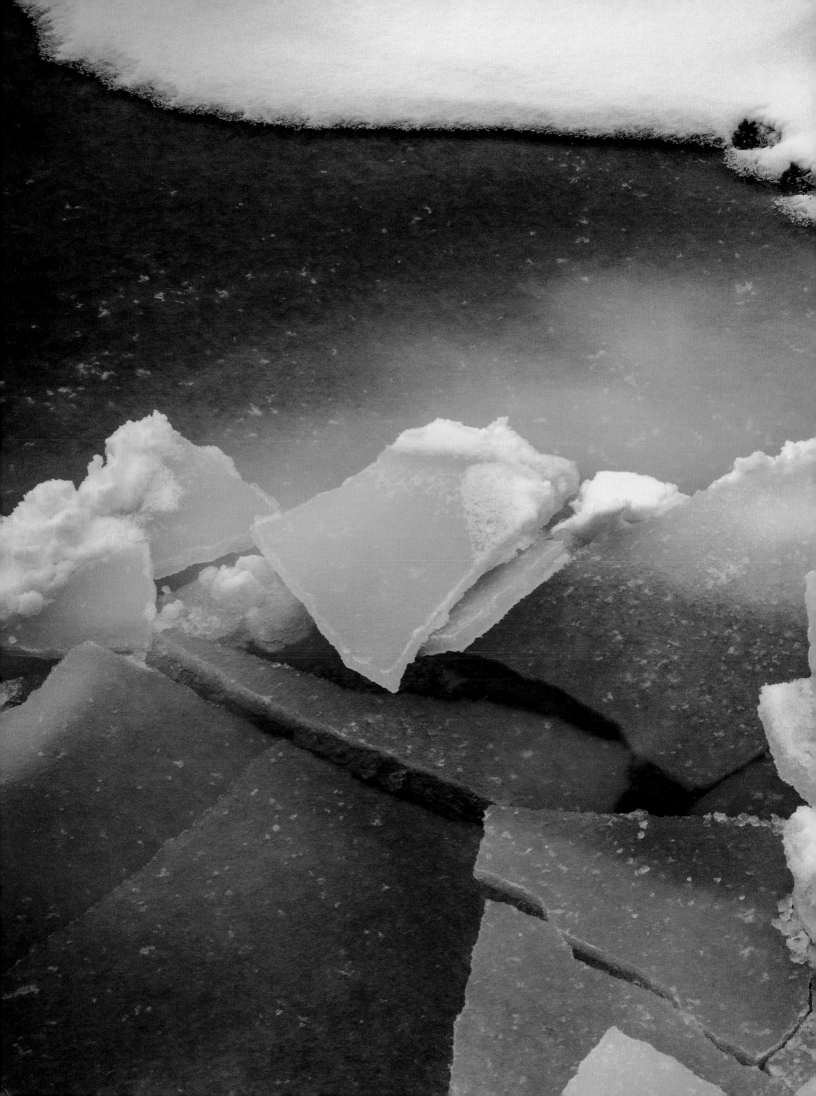

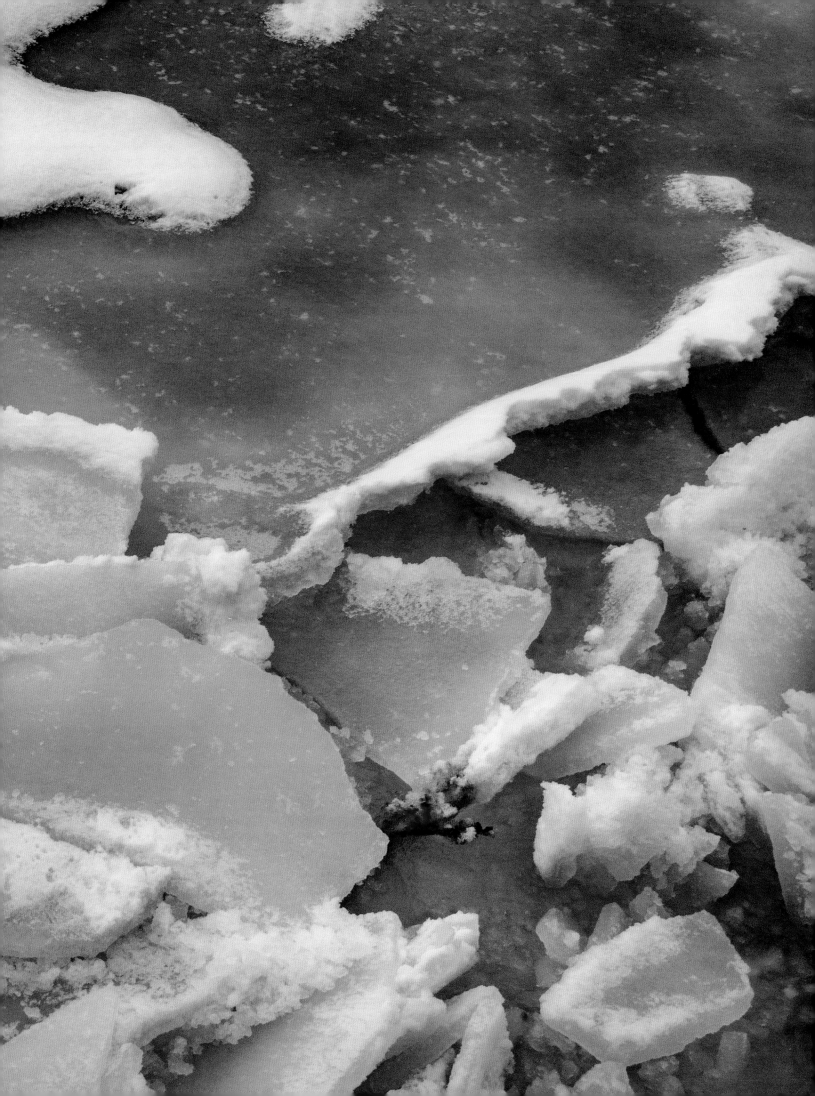

PROLOGUE

IT IS ABOUT ICE. It is about life. It is about all of us. The High Arctic is perhaps the roughest and toughest place on Earth. It is home to some of the strongest wildlife and is a place where man has to fight to survive. At the same time, it is the most fragile place you could imagine.

The sea is crucial to the ecosystems of the Far North. Compare it to the soil of ecosystems on land. If you take away the soil in a forest, the trees will die. It is the same for the Arctic. Algae, bacteria, and microscopic organisms live in the ice and feed the life underneath. When the ice gets weaker, these organisms and fish are affected, which then affects the most important thing for polar bears—the seals. If you remove the ice, the ecosystem collapses from its very base.

Anyone who doubts the power of human beings to change our planet's climate should take a look at the home of the polar bear, the Arctic Ocean. It has literally begun to melt away. No place on Earth has more detectable proof of climate change. It is where it is easiest to see and most dramatic. Ice becomes water.

We have witnessed the accelerating warming with our own eyes over the years. Areas and routes we once traveled by snowmobile or on foot are now only accessible by boat.

Earth's climate has changed throughout history. Most of these climate changes are attributed to very small variations in Earth's orbit that change the amount of solar energy our planet receives. But the current warming trend is of particular significance because most of it is human induced and proceeding at a rate that is unprecedented in the past 1,300 years. Eight of the 10 warmest years on record globally have occurred during the last decade. The main reason for our climate changing and temperatures rising is our level of greenhouse gas emissions.

The reality behind all the headlines, science reports, and numbers is quite brutal. There is a truth behind all the words. Global warming is very real. It is a fact—not an opinion or a political issue.

A couple hundred years ago, we were all part of nature. Now we've moved to cities and have the entire world on our smartphones. At some point, we lost sight of the fact that to harm nature is

to harm ourselves. We disconnected from nature and, over time, it became something we watch on television or plan a vacation to visit. It is time to reconnect. If not for the sake of nature, then for the sake of ourselves. But we think that's the same thing. If nature isn't kept healthy, humans will not survive. It is as simple as that.

This book is not only about the polar bear. It is about all of us. What happens in the Arctic affects all life on our planet. We share Earth with so much life and beauty that want nothing but to live and be part of the natural world, part of ecosystems that are in perfect balance, until we step in and mess it up.

It is about the world we want to leave for the next generation. We are all a part of this world, and we all have a role to play. Everything we do matters and affects more than just ourselves. Everything is connected, and all our actions have consequences.

The greatest threat to future life on Earth is the belief that someone else will save it.

As we write these words, we are on our way back north to our bears. Our journey continues. When all the noise is gone, and the only sound is that of the cold Arctic wind, we feel life pumping through our veins.

And gratitude.

STOCKHOLM, SWEDEN

JANUARY 1

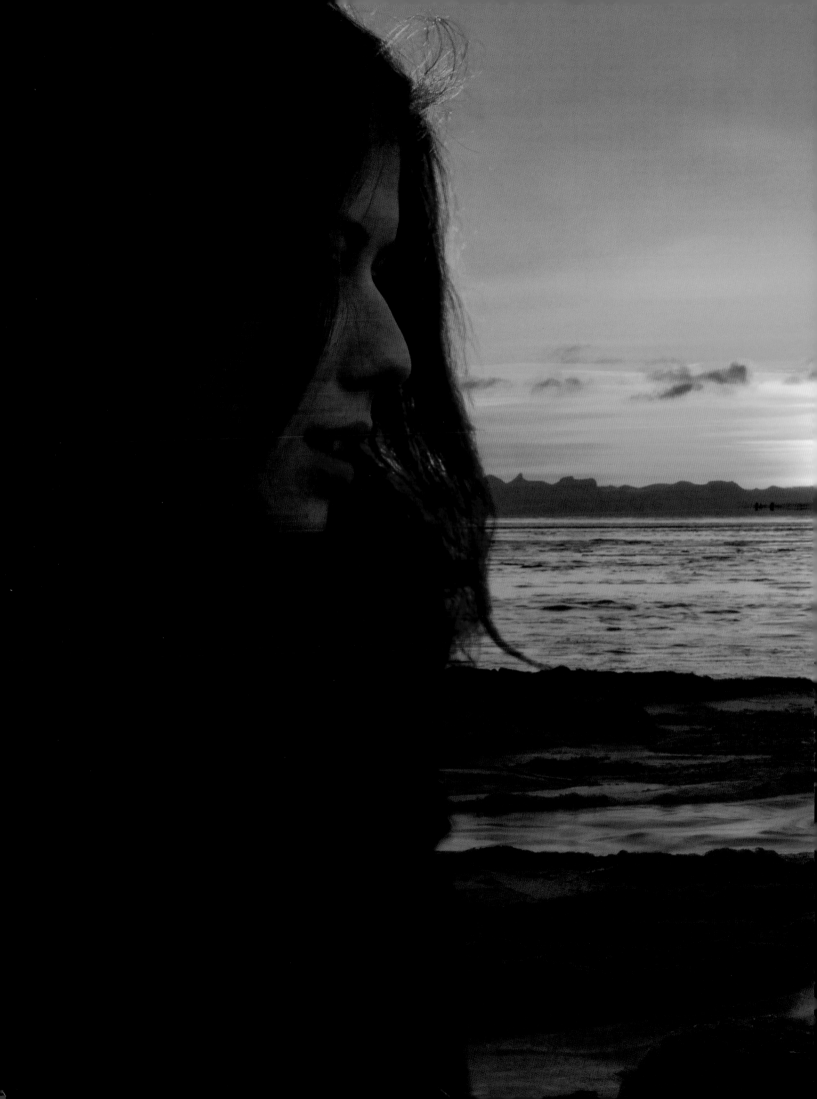

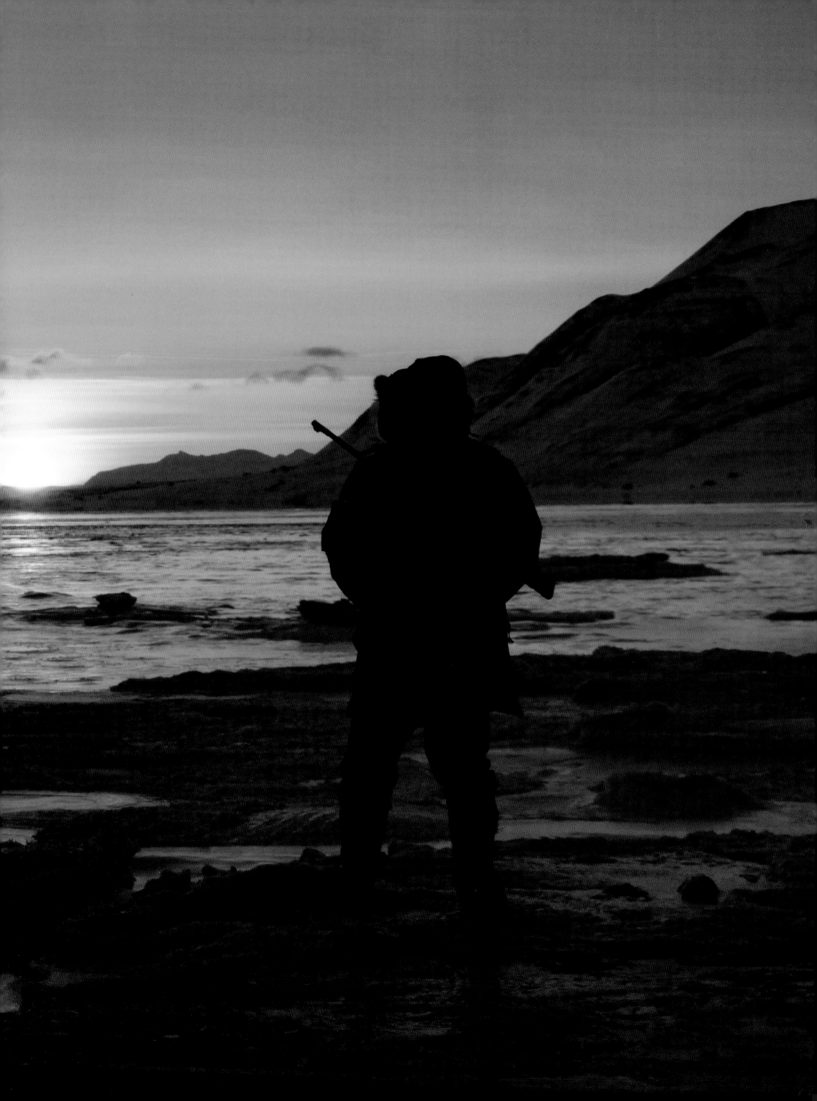

ON NEW YEAR'S DAY, we landed on Svalbard together for the first time. We came from Stockholm, Sweden, which was covered in winter snow. As we stepped out of the plane, into the deepest and darkest Arctic polar night, we were met by a mild breeze—and pouring rain. It was bizarre. Strange. Even scary. All our expectations for midwinter Arctic, all our preparations for the cold, crashed. Although the rain would set the tone for the winter and spring that were ahead of us, things would change for the better.

We had met only months earlier, and in many ways that year became year zero for both of us. With the one big love, time is reset. Melissa's first winter up north was life-changing in many ways. Her dad gave her a teddy polar bear when she was a few years old, and she spent her childhood watching all the documentaries she could get her hands on. Now she was finally in the Far North herself. And the polar bears were waiting, somewhere out there in the dark.

I had experienced many things around the Arctic over the years, from beauty and wonder to death and horror. But that winter everything seemed to happen with new eyes and heart. From the darkness of polar night and the first aurora to the polar bear named Helen on the east coast of Spitsbergen later that spring, everything felt like the first time.

This is our story. But it is also about how every ounce of ice, every drop of water, and every single life on this planet is connected.

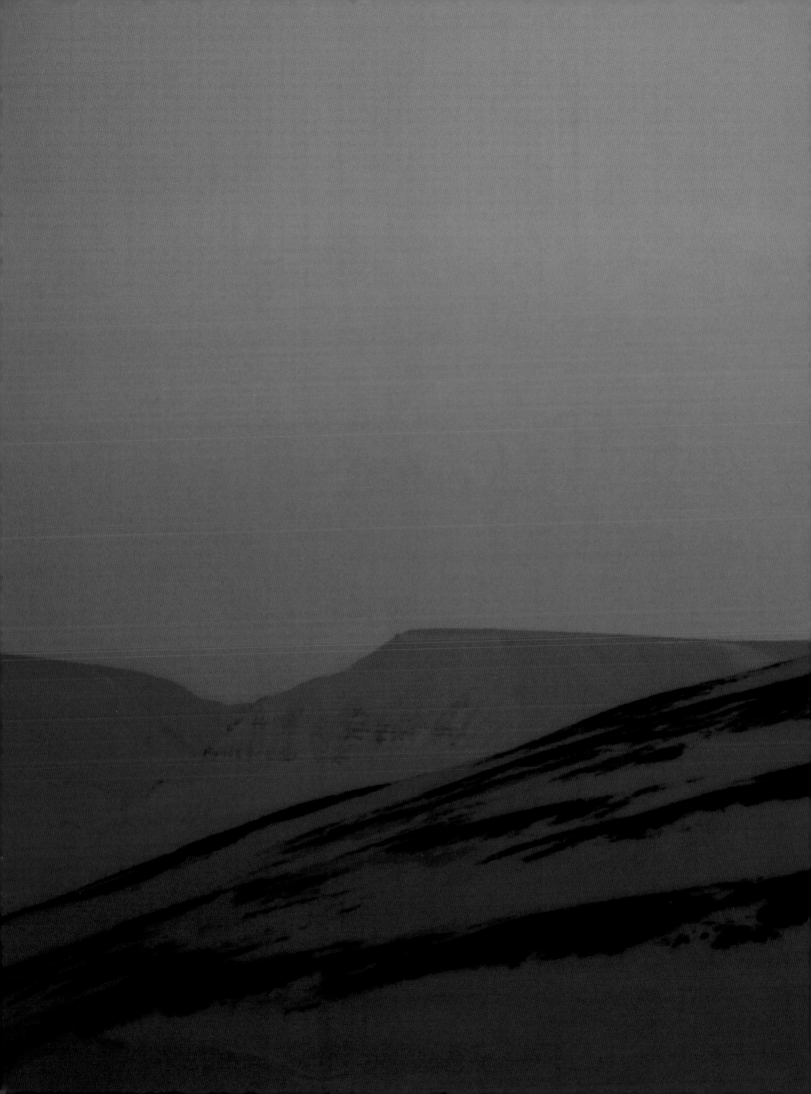

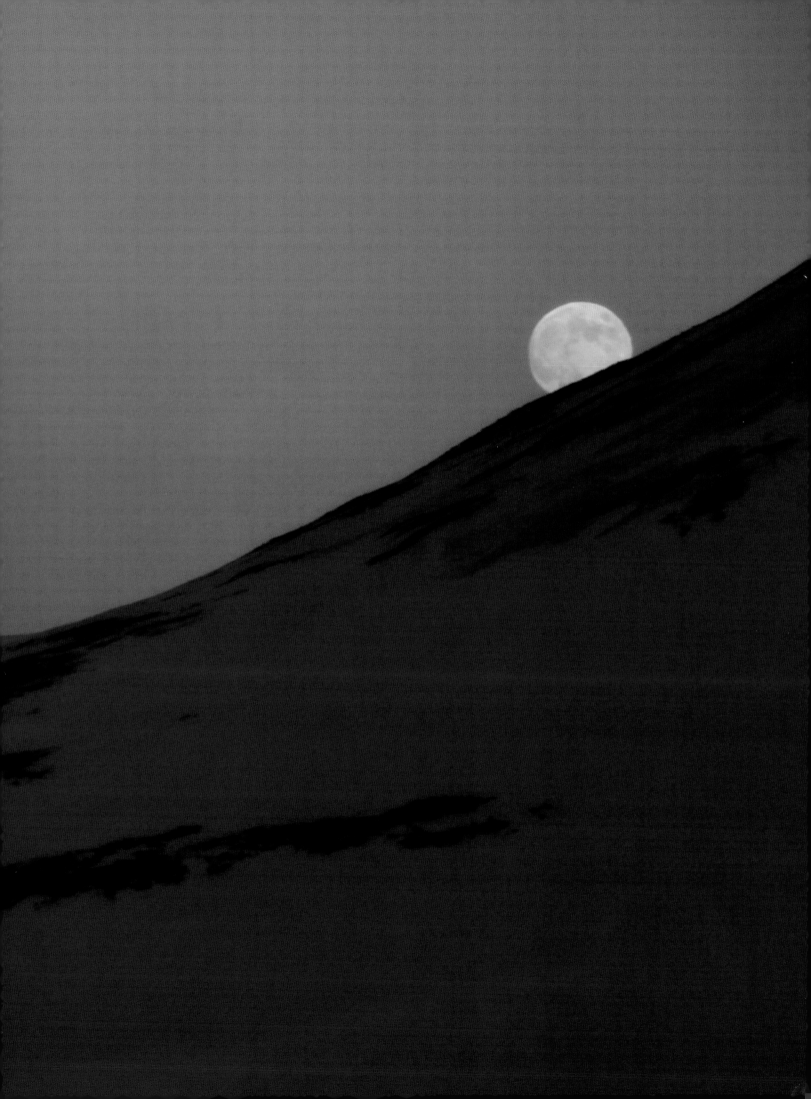

CLOSE TO 80° NORTH, Svalbard rises out of the Arctic Ocean. It is our home, and also the home of 2,000 to 3,000 polar bears. Svalbard consists of hundreds of islands, of which Spitsbergen is the biggest. Here, only 700 miles south of the North Pole, there are rugged mountains, glaciers, and magnificent landscapes making up one of the most unique and harsh regions on the planet. Sixty percent of the land area is covered by glaciers.

This was uncharted territory up until June 17, 1596, when Dutch navigator and explorer Willem Barentsz discovered Spitsbergen. It is one of the latest additions to the world map, and the archipelago now belongs to Norway.

These northerly latitudes are a world of contrasts in constant transformation. The seasons, the ever-changing light, the weather, the sea ice, the air—everything is in transition. Even the landscapes change as the glaciers move and sculpt the land beneath.

In the High Arctic, winters and summers are literally like night and day. On Svalbard, polar night reigns from November to February, when the sun remains under the horizon and the only sources of light are the moon, the stars, and the colorful auroras. Although far from visible, the sun still colors the sky dark blue, and some days it can make the sky red and purple for moments of magic by shining its light on ice crystals in the atmosphere.

From April to August on the other hand, the sun never sets. In the midst of midnight sun, the sun remains high in the sky even at midnight.

But the period between polar night and midnight sun is what we love the most. As the days become longer and the winter night slowly turns to permanent day, the rising sun brings forward color reflections in the sky, snow, and ice, shifting from blue, pink, and violet to red and orange. If time offers a home, that is ours.

THE AURORA, on the next spread, is a natural light display in the sky caused by the collision of solar wind and magnetospheric-charged particles in the high-altitude atmosphere. In northern latitudes, the effect is known as the aurora borealis, or the northern lights. It was named for the Roman goddess of dawn, Aurora, and the Greek name for the north wind, Boreas, by Galileo in 1619. In the past, the auroras were believed to be a sign from God.

Perhaps the loveliest of beliefs comes from the Algonquin people, who believed that Nanabozho the Creator, after he finished creating Earth, traveled to the Far North, where he built great fires that still reflect southward to remind those he created of his lasting love.

Sometimes the aurora appears only for a few brief seconds, and you wonder if you really saw it. Sometimes it can dance in the sky for hours.

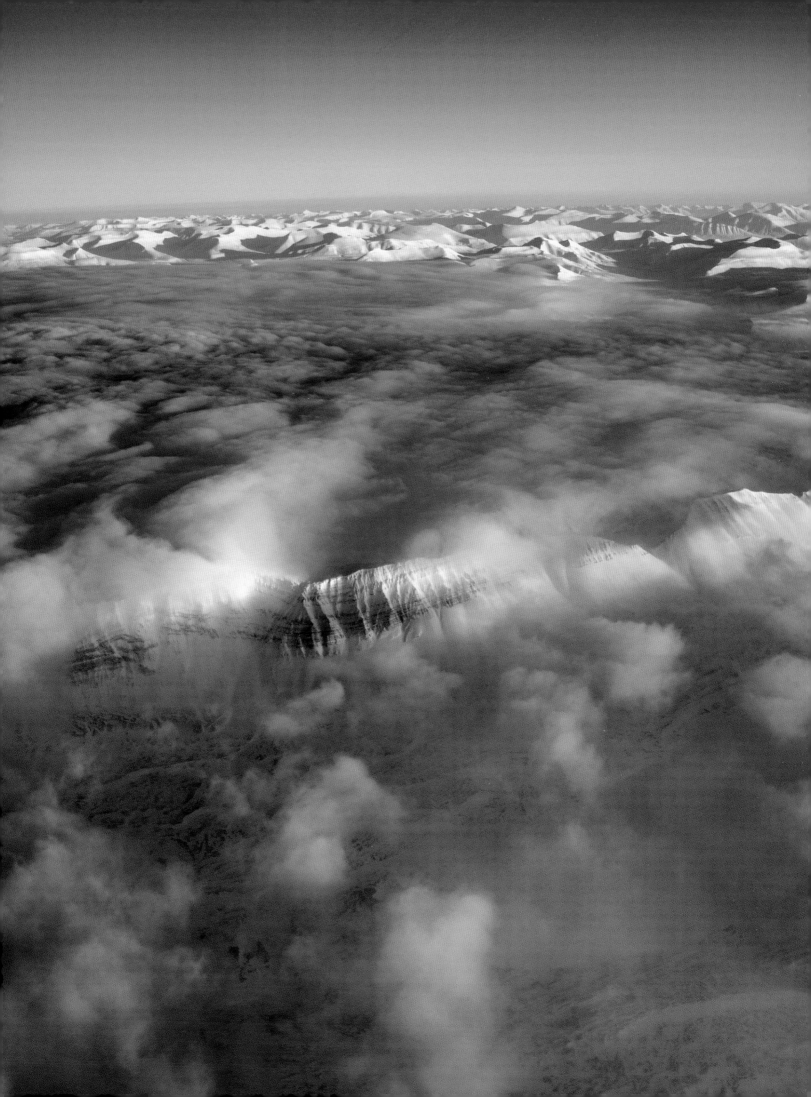

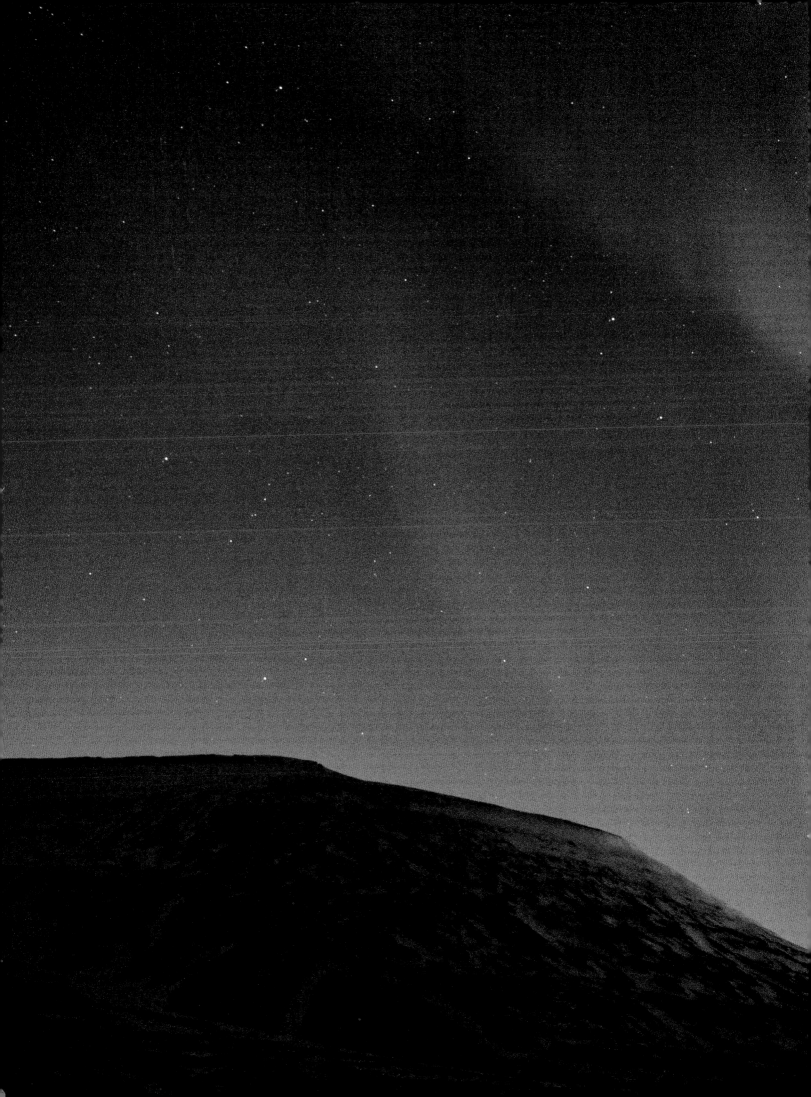

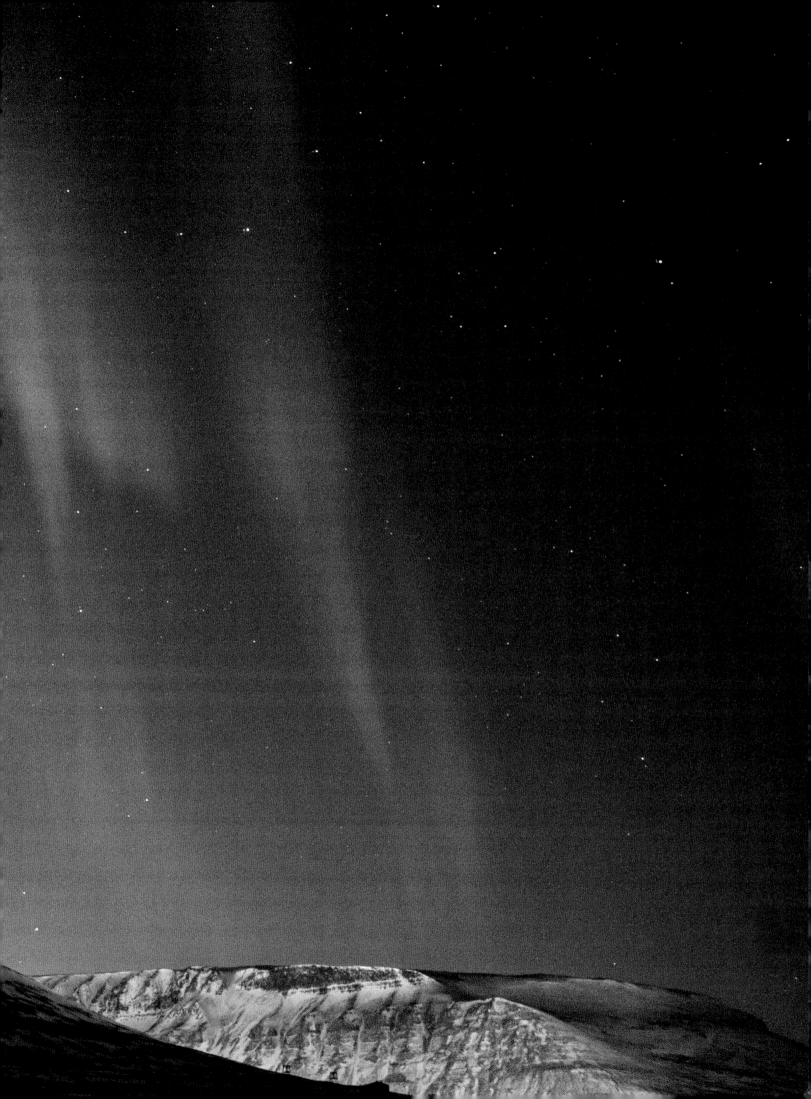

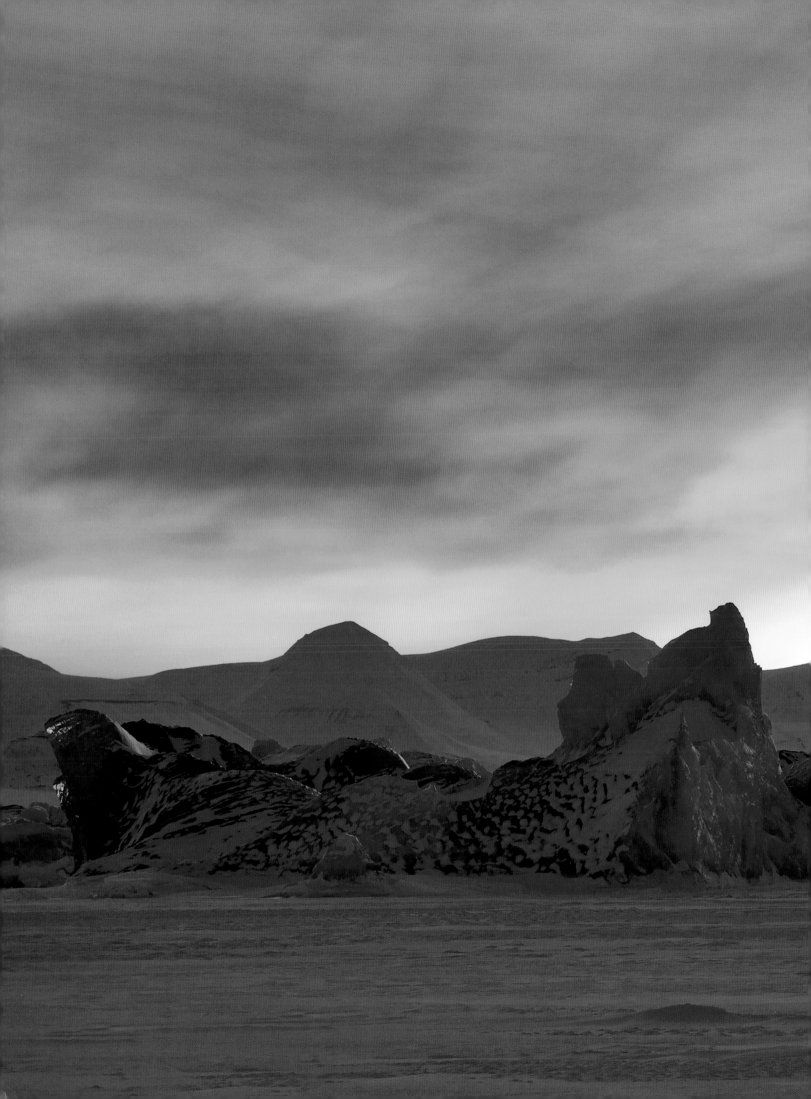

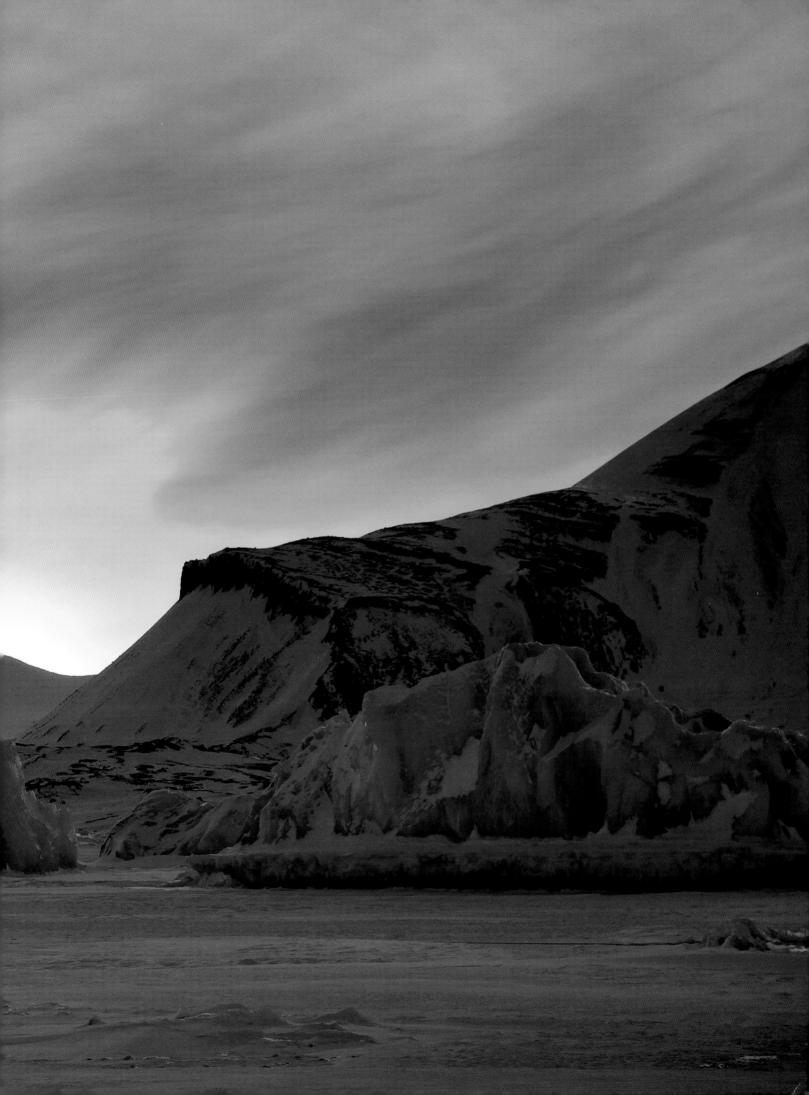

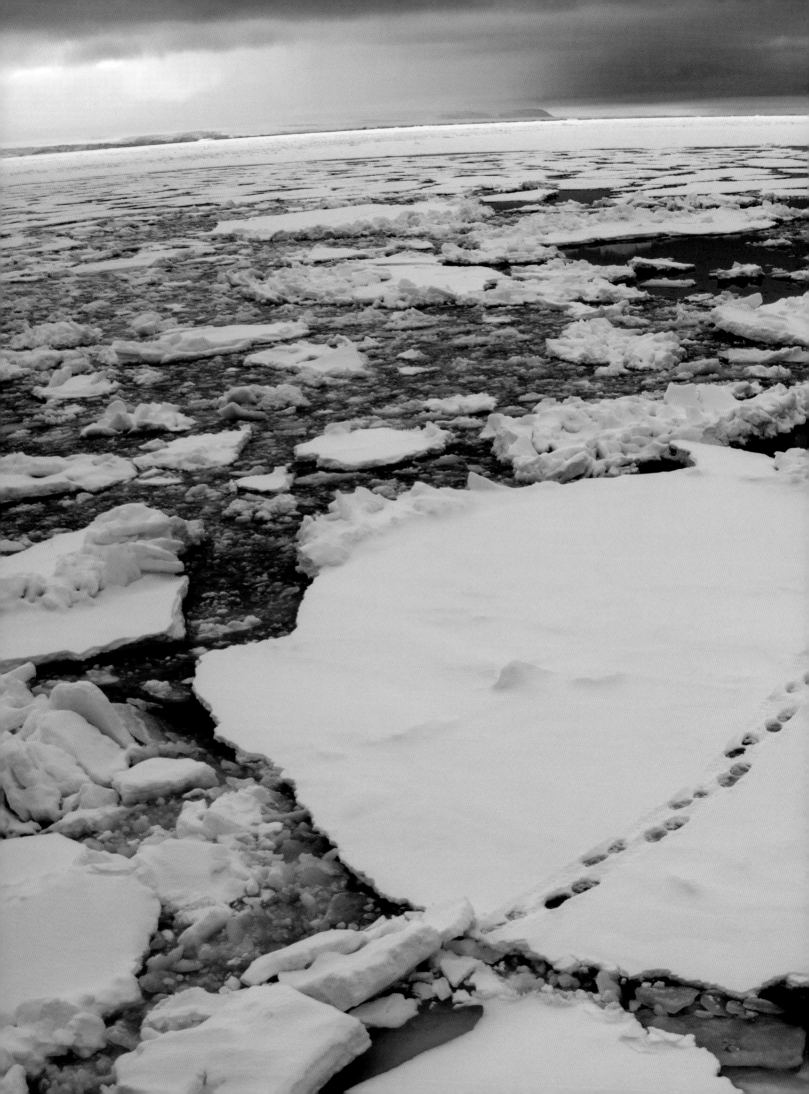

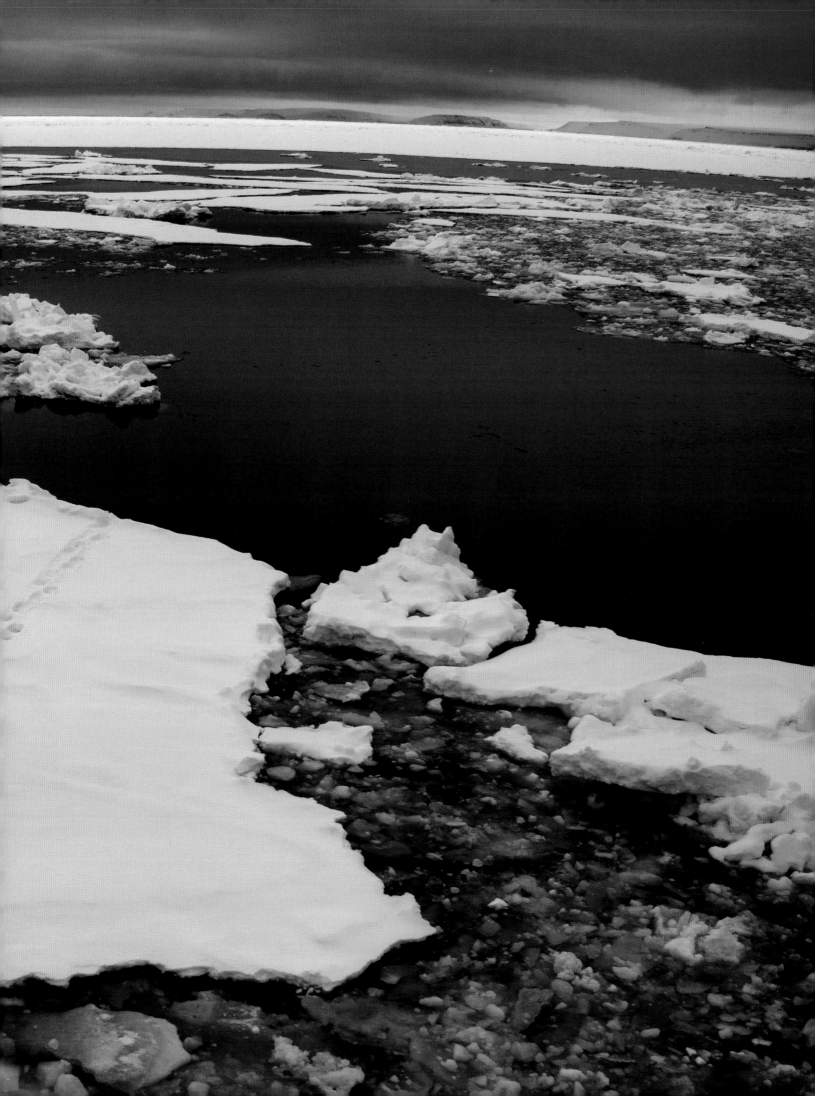

THE EVER-WANDERING ONE

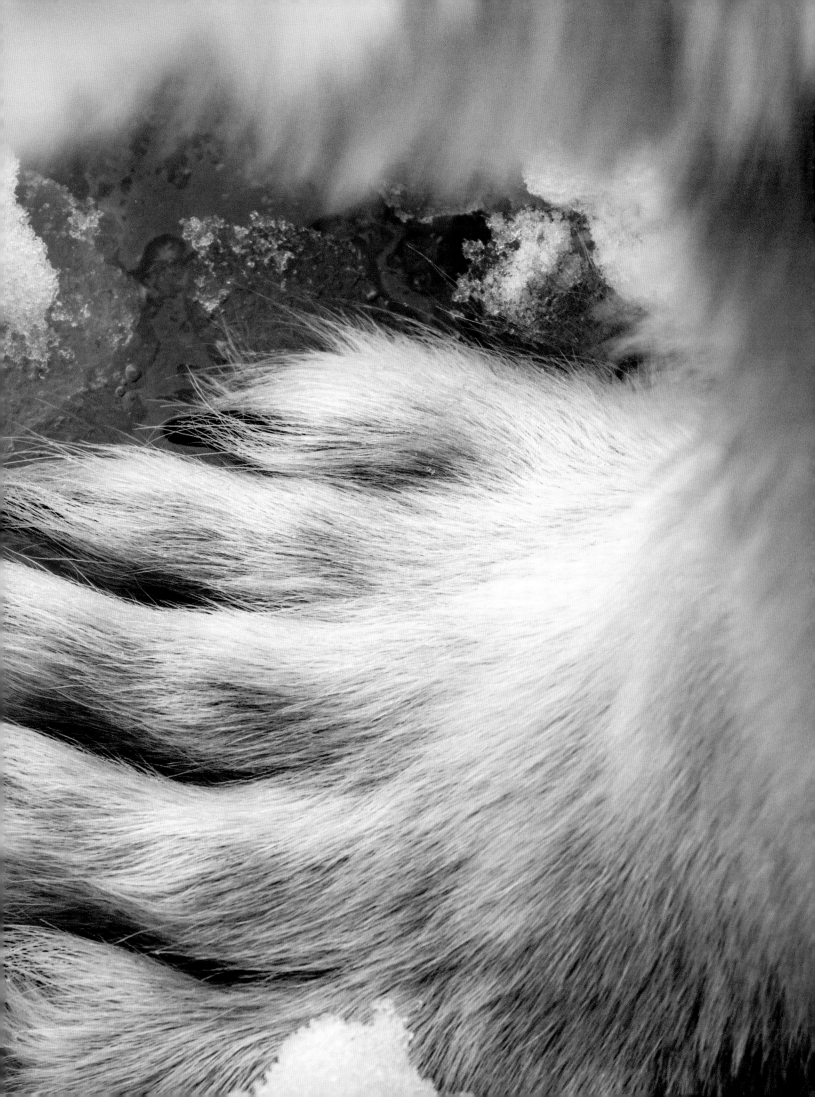

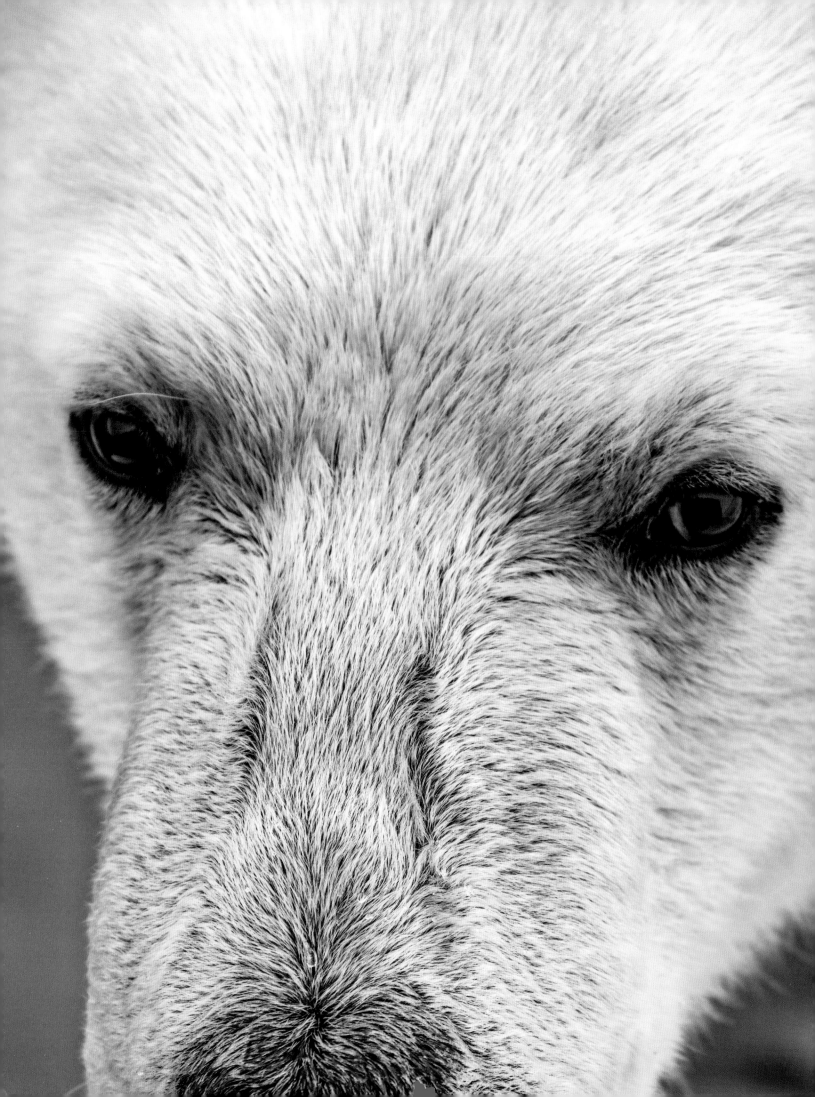

THE KING OF THE ARCTIC, the one who walks on ice, the ever-wandering one, he who makes one frightened, the great white one—the polar bear has many names. The greatest predator on Earth is so powerful and beautiful yet so vulnerable. The bear is completely dependent on a stable and cold climate and a frozen ocean for life.

The polar bear is believed to have evolved from a group of brown bears that became isolated by glaciers in the eastern part of Siberia some 150,000 years ago. Conditions changed, it became colder, and the bears had to adapt.

In 1774, after he had sailed to Svalbard and the Seven Islands (Sjuøyane), English explorer and officer Constantine John Phipps was the first to describe the polar bear as a distinct species. He chose the scientific name *Ursus maritimus*, Latin for "bear of the sea," because of the bear's habitat. The Inuit refer to the bear as nanook, nanuk, or nanuq.

The polar bear is regarded as a marine mammal because it spends many months of the year at sea. However, it is the only living marine mammal that also lives on land. Its preferred habitat is the sea ice covering the waters over the continental shelf and the Arctic archipelagos. These areas are often called the "Arctic Ring of Life." It is where the North Pole pack ice meets the open water and the regions surrounding the farthest-north land—seas full of life and with higher levels of biological productivity than the deeper waters closer to the North Pole.

The region around the North Pole consists of a big, cold ocean surrounded by land. The Arctic Ocean is like no other ocean on this planet, and because of its location and climate, the lands that surround it are also unique.

The pack ice is an island of ice covering most of the Arctic Ocean. This ice cap is what defines the High Arctic. It is not only a source of cold, but also life. It is in constant trans-formation; it grows, shrinks, and moves through the seasons. In fall and winter it thickens, expands, and embraces the northernmost land areas on our planet, and in summer it thins and recedes to higher latitudes.

This ice is the home of the polar bear. It is here the bear finds its main prey, the ringed seal. The seals rest and breed on the ice where the polar bear hunts.

There are 19 different populations of polar bears in the northern parts of Canada, Alaska, Russia, Greenland, and, our home ground, Svalbard. There is no "typical" polar bear. Even within those populations, all bears behave differently. And this is perhaps what is most rewarding about our work—getting to know the personalities of these bears. How similar yet how completely different they are. Like us humans. Individuals.

The world's 20,000 to 30,000 polar bears do have one thing in common: They need the sea ice. They need the cold to thrive and survive.

We work with polar bears because we love them, and we work in the Arctic because a big part of us belongs there. But behind these photos is a story about our future. Between the moments we live for is something bigger, something that connects and affects us all.

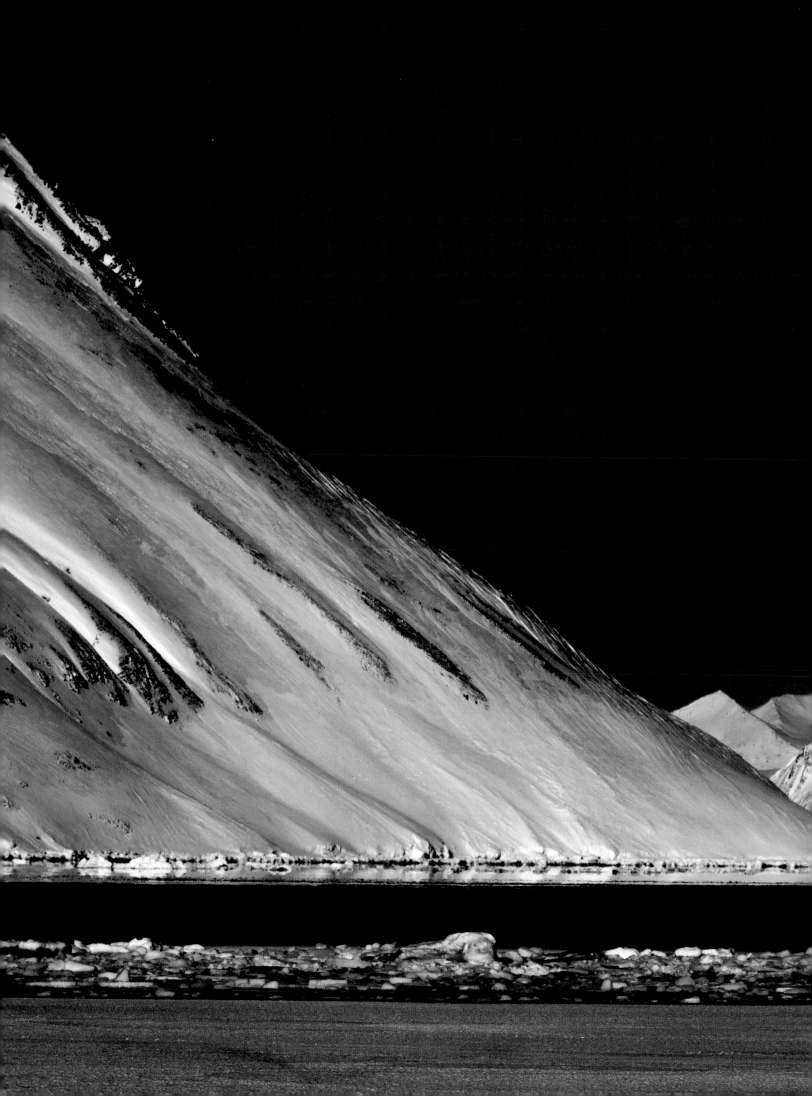

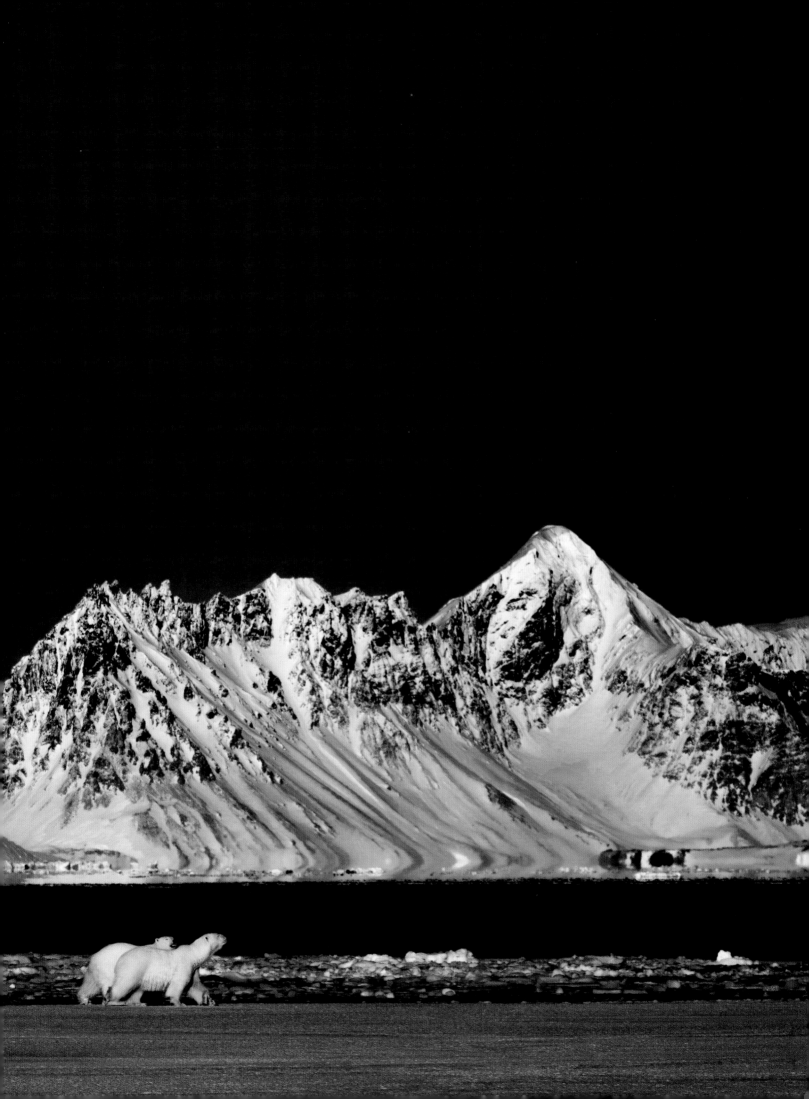

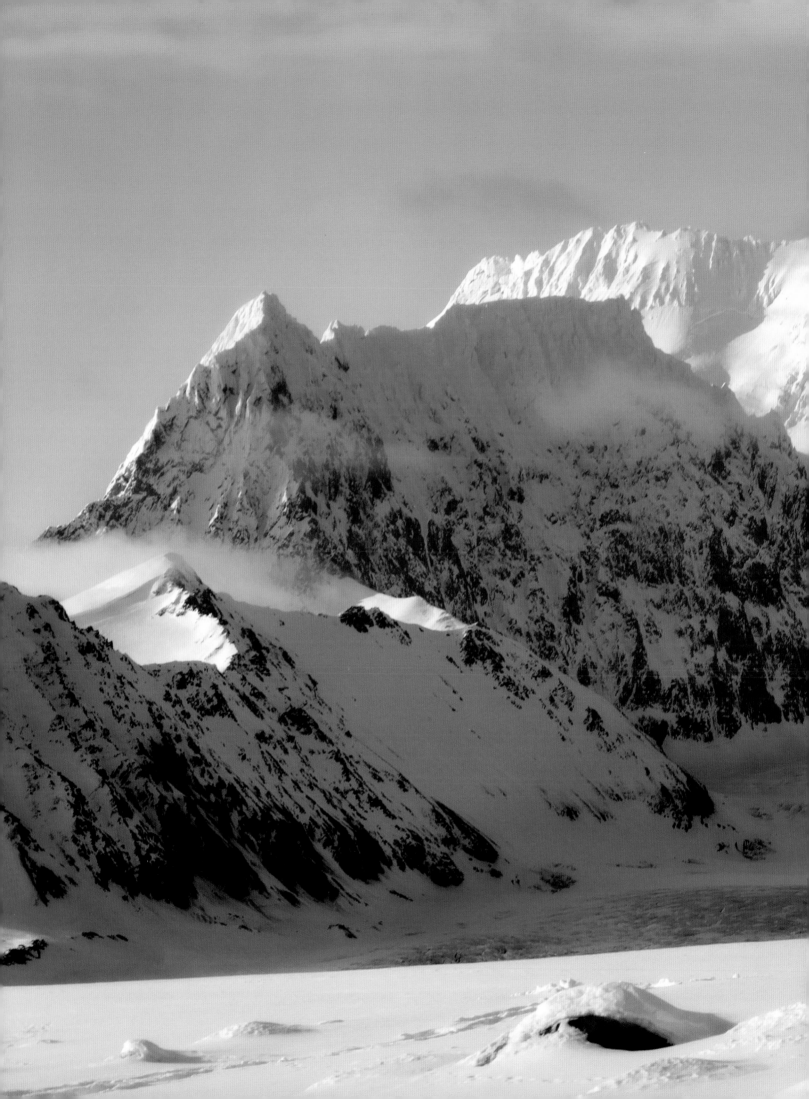

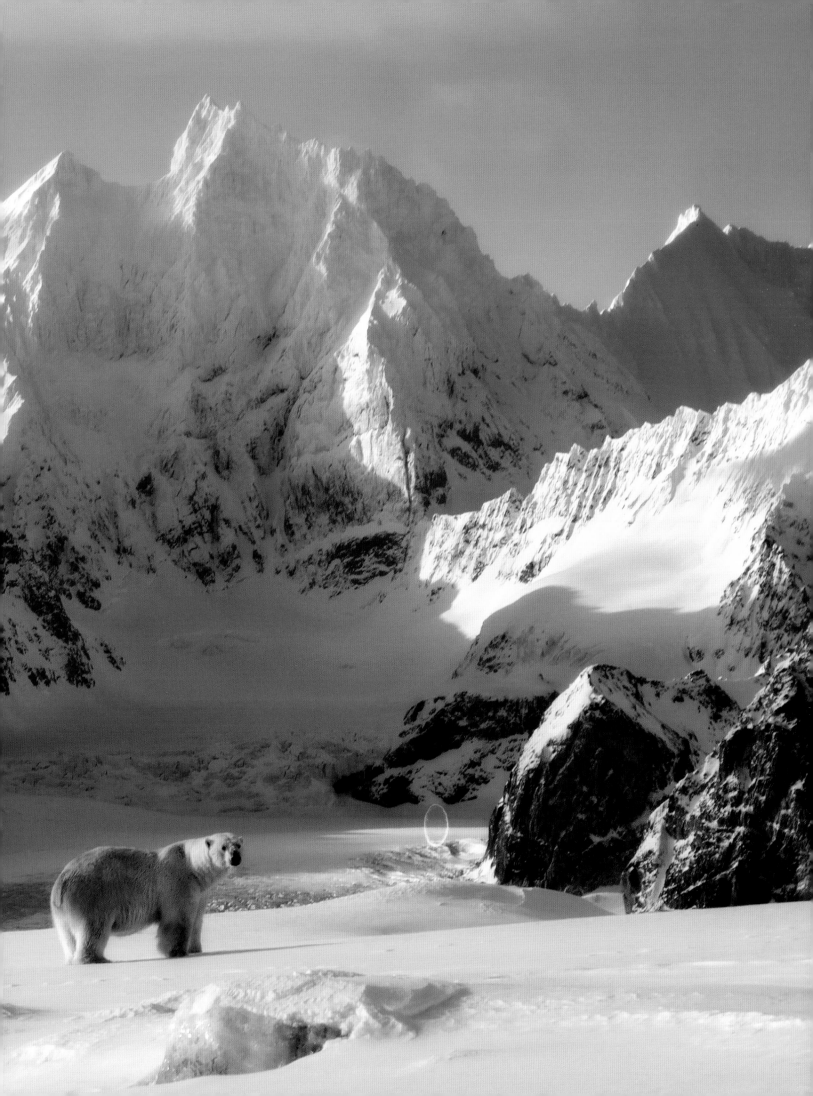

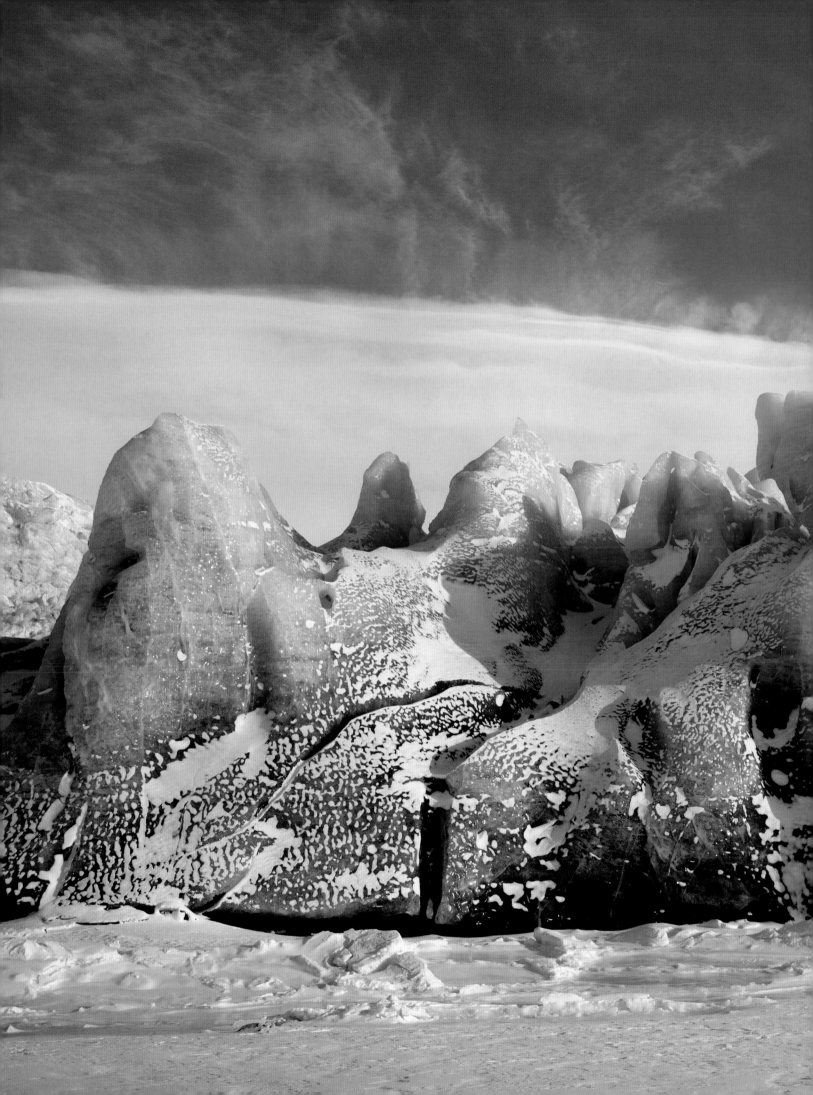

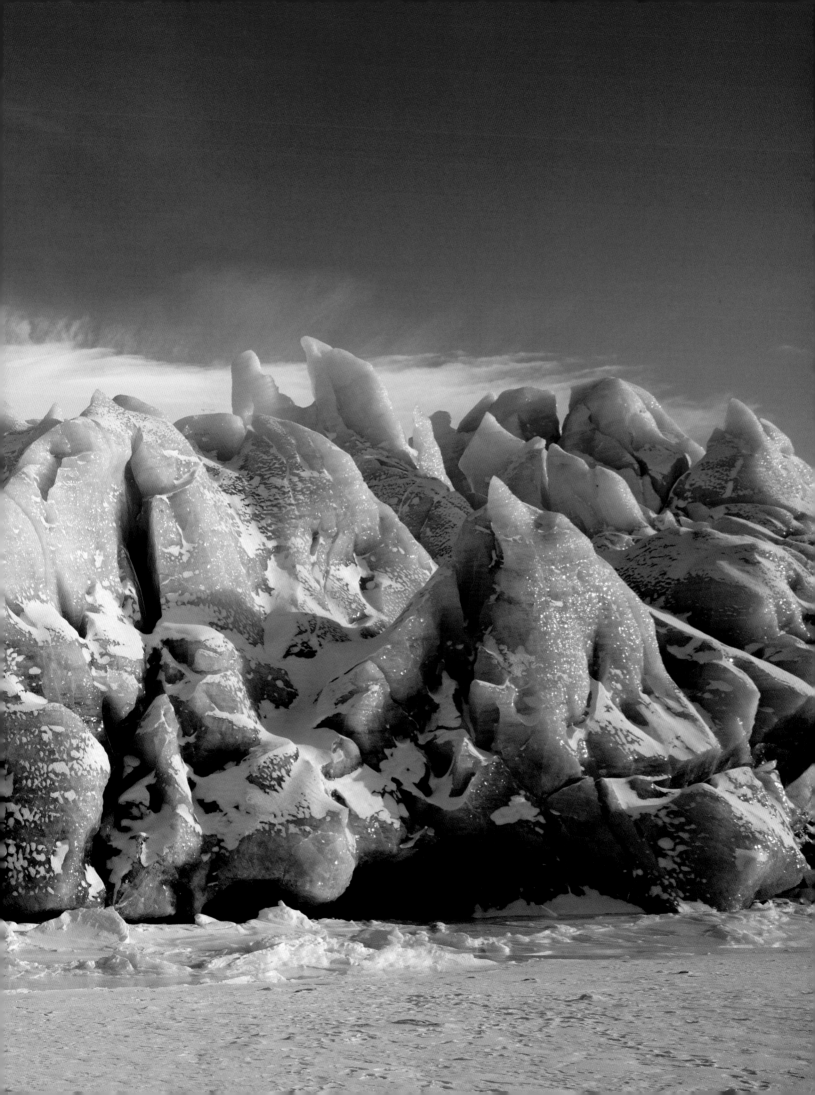

THE POLAR BEAR IS A WANDERER. In its constant search for food and life, it is endlessly on the move. Some bears are more local, but others cover great distances and follow the edge of the Arctic pack ice through the seasons.

We often see the local bears staying in smaller regions throughout the year. During the cold winter and spring, they have access to sea ice, where they can hunt for seals. In the summer, the ice melts and breaks up, often a slow process over weeks or even months. But sometimes it is faster—solid, thick ice can break up and disappear in the blink of an eye with strong winds and warm ocean currents.

In summer, many of these bears become stranded on land, left with nothing to eat except what they may find, perhaps some bird eggs and seaweed, or, if they get lucky, a dead whale on the beach. But none of this is enough to sustain them for long. The wait for new ice to walk out on can be extensive; in recent years, it has often been more than six months in some regions. When an adult bear cannot hunt for its main prey, the seal, it loses more than two pounds per day in weight.

Other bears follow the sea ice as it moves through the seasons. Take Kara, a 13-year-old female. She was captured by scientists in Spitsbergen in April a few years ago and fitted with a GPS collar. After she was released, she headed east. She swam for days and walked mile after mile on the ice. She passed Franz Josef Land and continued her journey. By December, Kara had passed six time zones and covered 2,000 miles. After that, her GPS stopped sending signals; scientists believe it was because she entered a den to give birth.

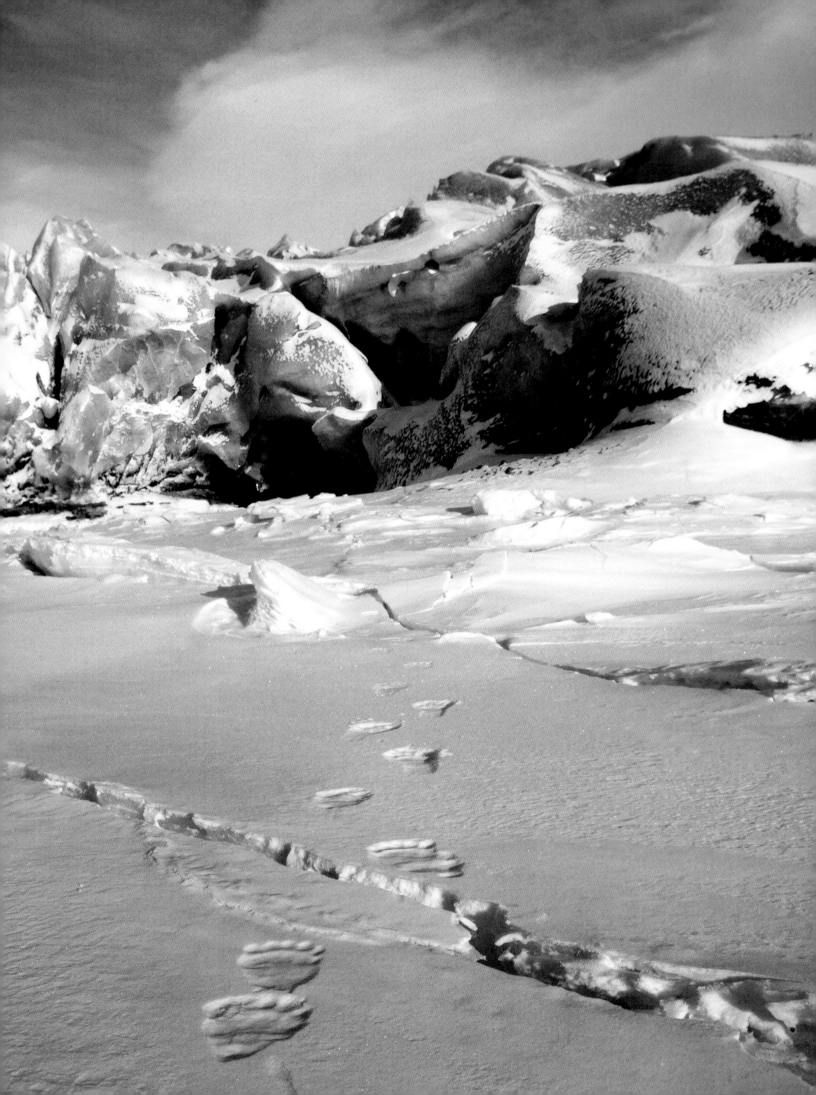

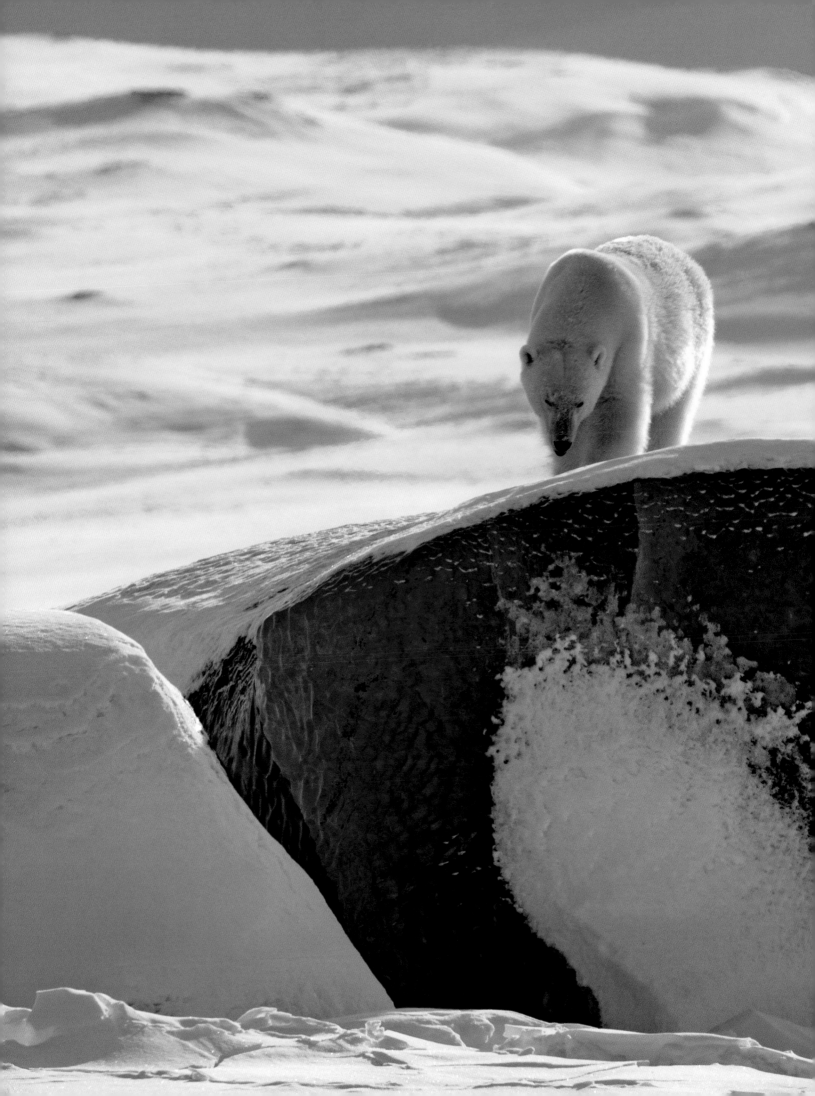

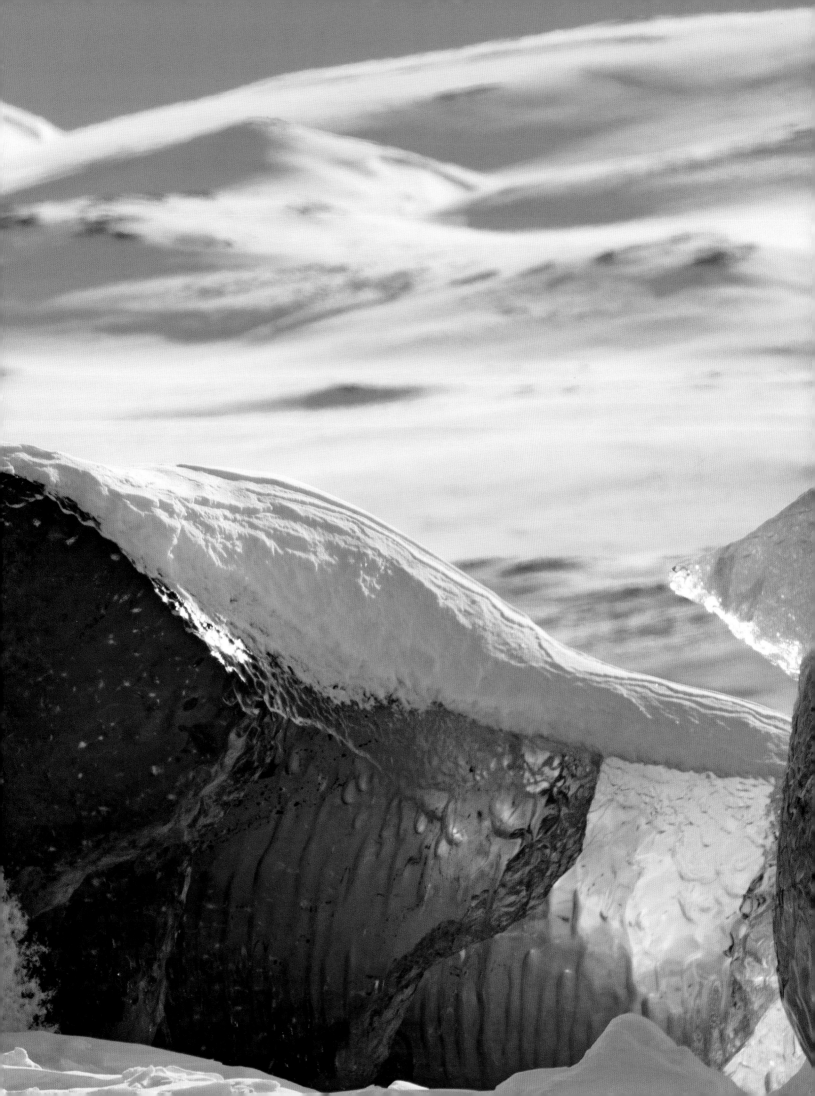

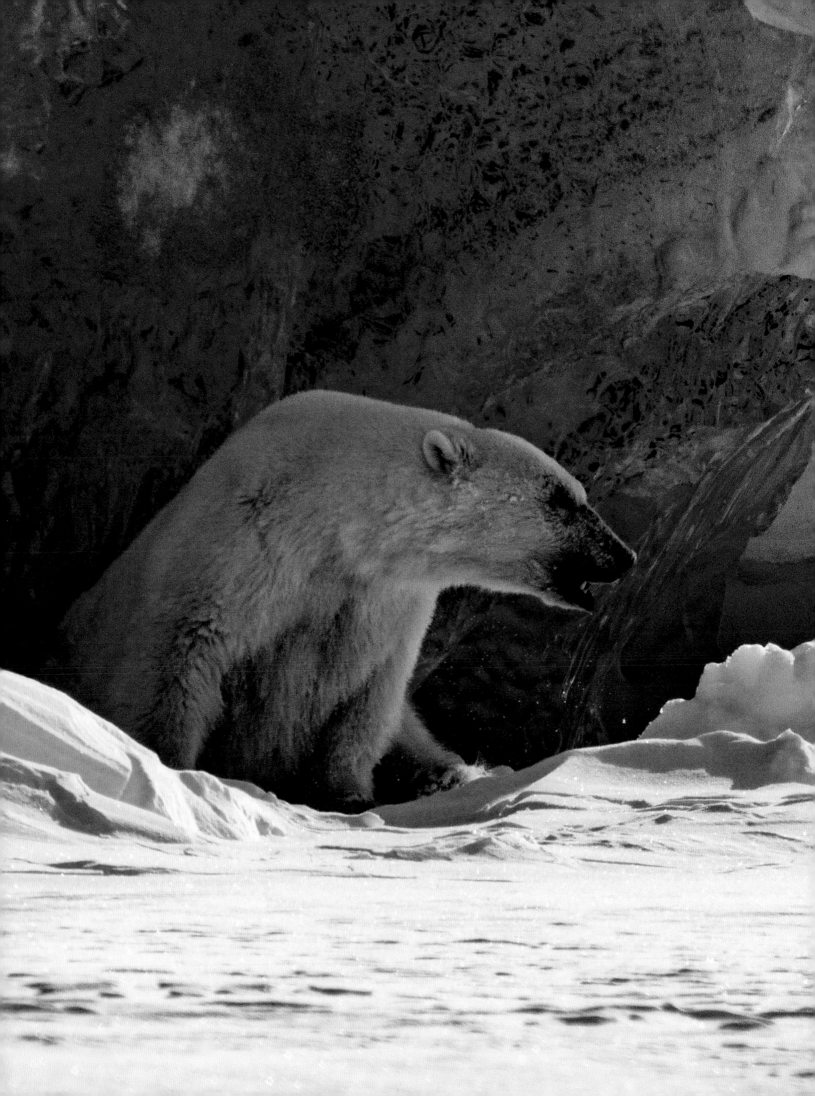

ALL POLAR BEARS ARE UNIQUE INDIVIDUALS. And every face tells a story. Like Helen's.

She came to us from far away. First, like it usually is when we meet a new polar bear on the ice, we saw her as a little dot on the horizon a mile or two away. Then she came closer and closer. After a while she started walking zigzag, like a polar bear often does when it approaches someone or something it wants to investigate—or eat.

It looks like it's walking sideways past you. First to the left, then to the right. But it gets closer quickly, and before you know it, it's only a hundred yards away. That's when a bear, if it attacks, makes a run toward you. But we knew she wouldn't do that. Many years and thousands of close encounters with bears have given us the knowledge of how to read their signals.

After a while, she arrived at the stunning iceberg right in front of us. She climbed up on top, and it was like she was posing for us. She was so beautiful. A three- or four-year-old female who had not had her first cubs yet. Melissa named her Helen.

Then she jumped back down, walked around the iceberg, and started to play in the snow, rolling around on her back and belly. Completely relaxed and cooler than ice. Of course, she was sniffing us out, trying to figure out who and what we were. But it was all just out of curiosity, as she had probably never seen a human being before.

The moment she looked at us, we stopped breathing.

We don't know for sure how long, but it felt like hours that she played around right in front of us. It was an evening we will never, ever forget. And Melissa could not have received a more perfect welcome to the Arctic. Helen was Melissa's first polar bear. Of course, she had to be a beautiful one.

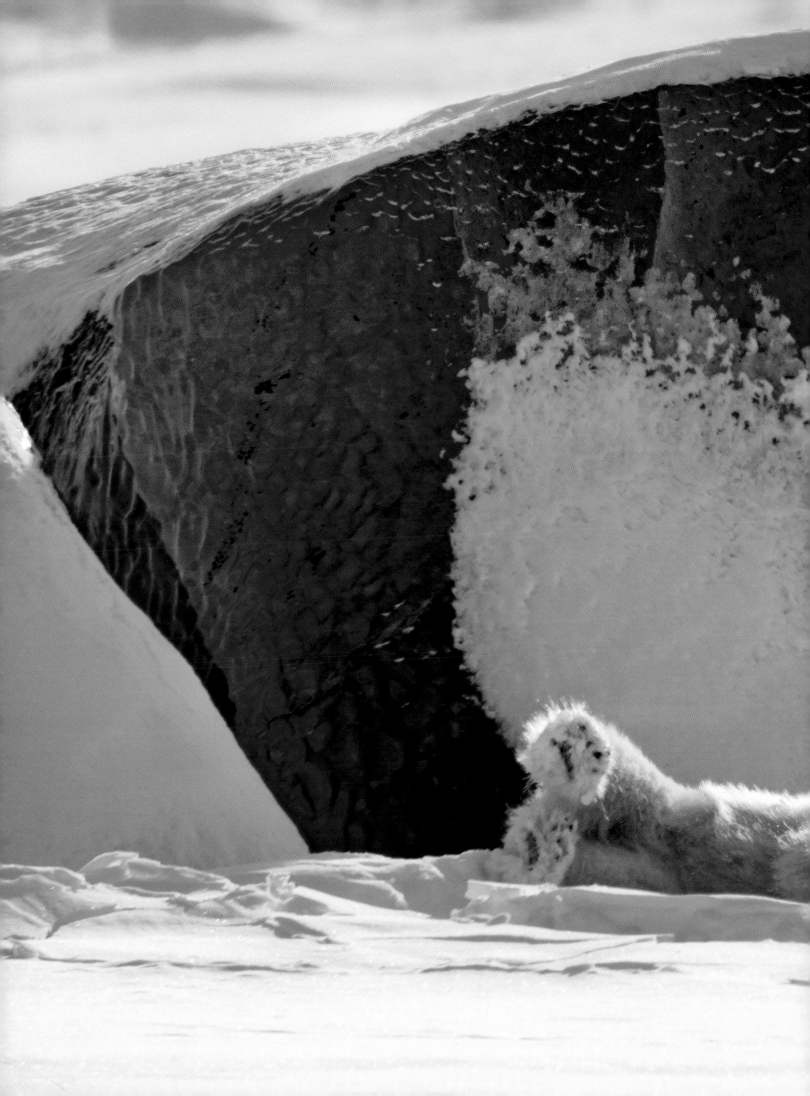

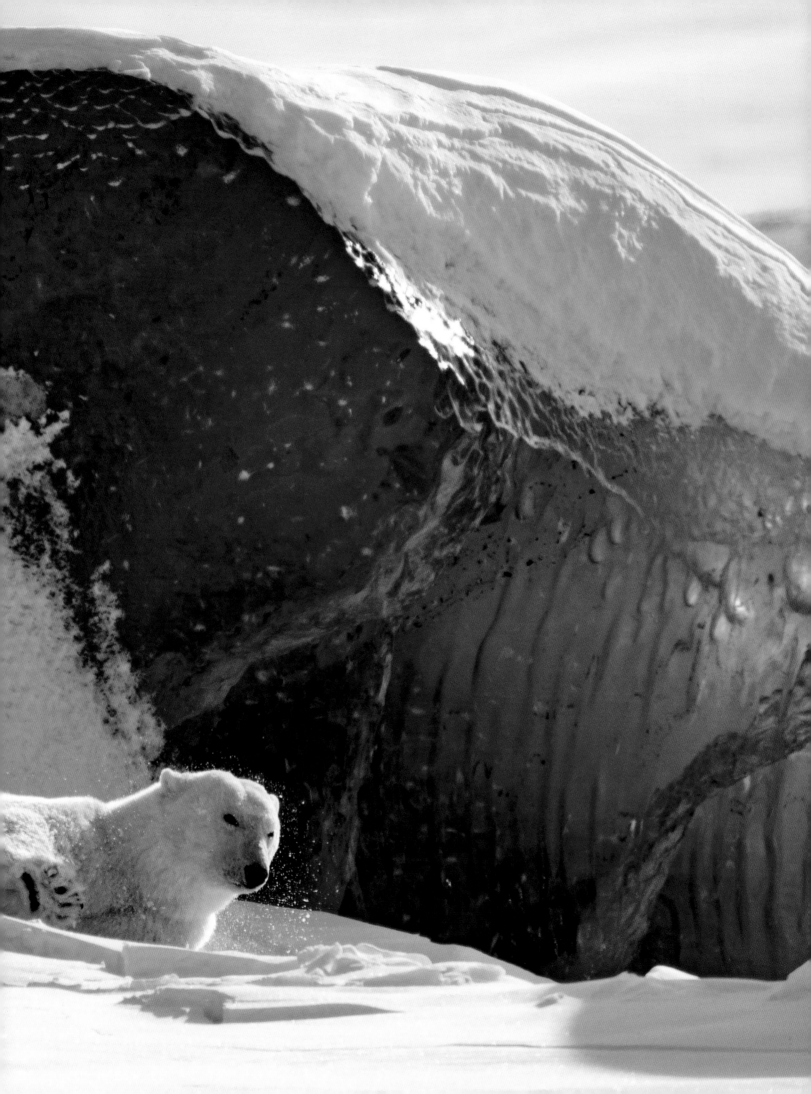

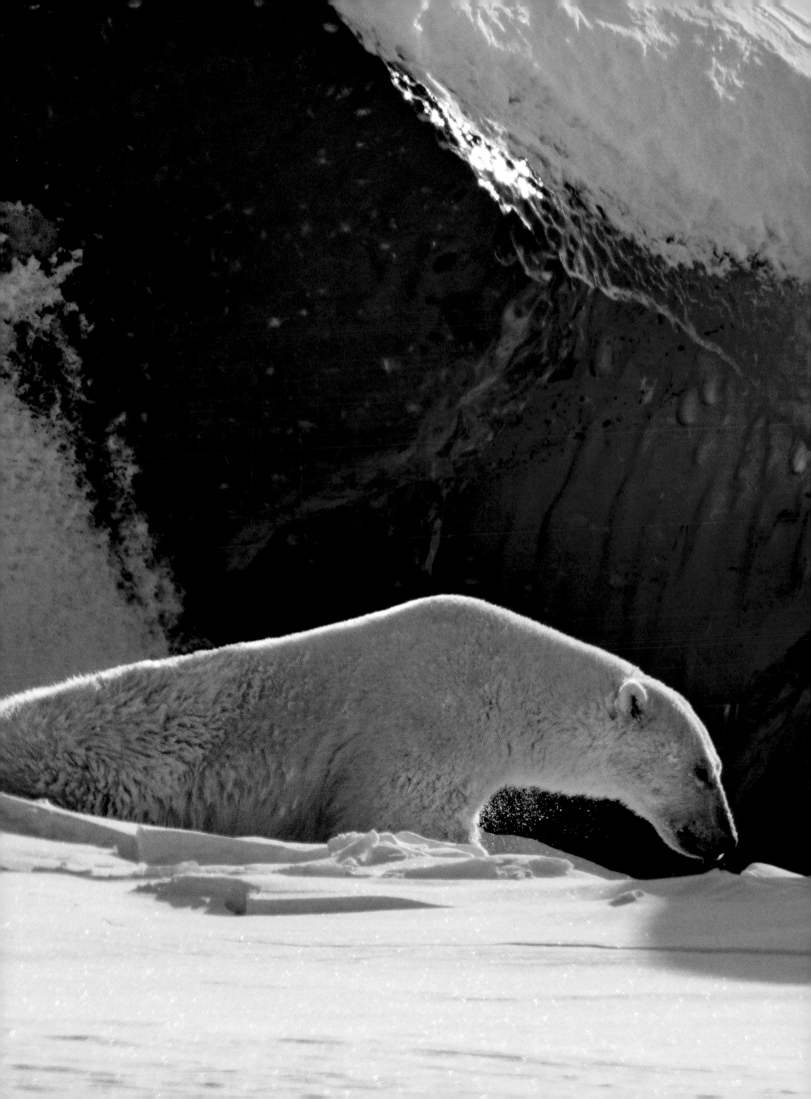

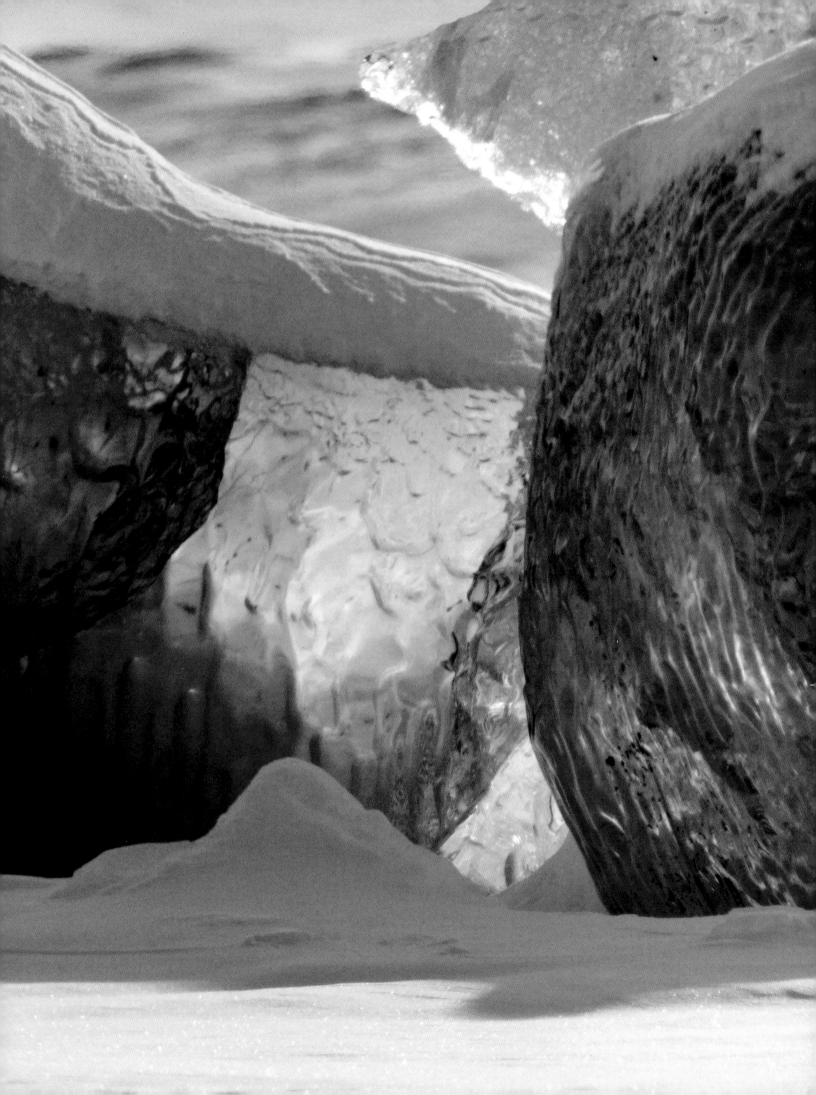

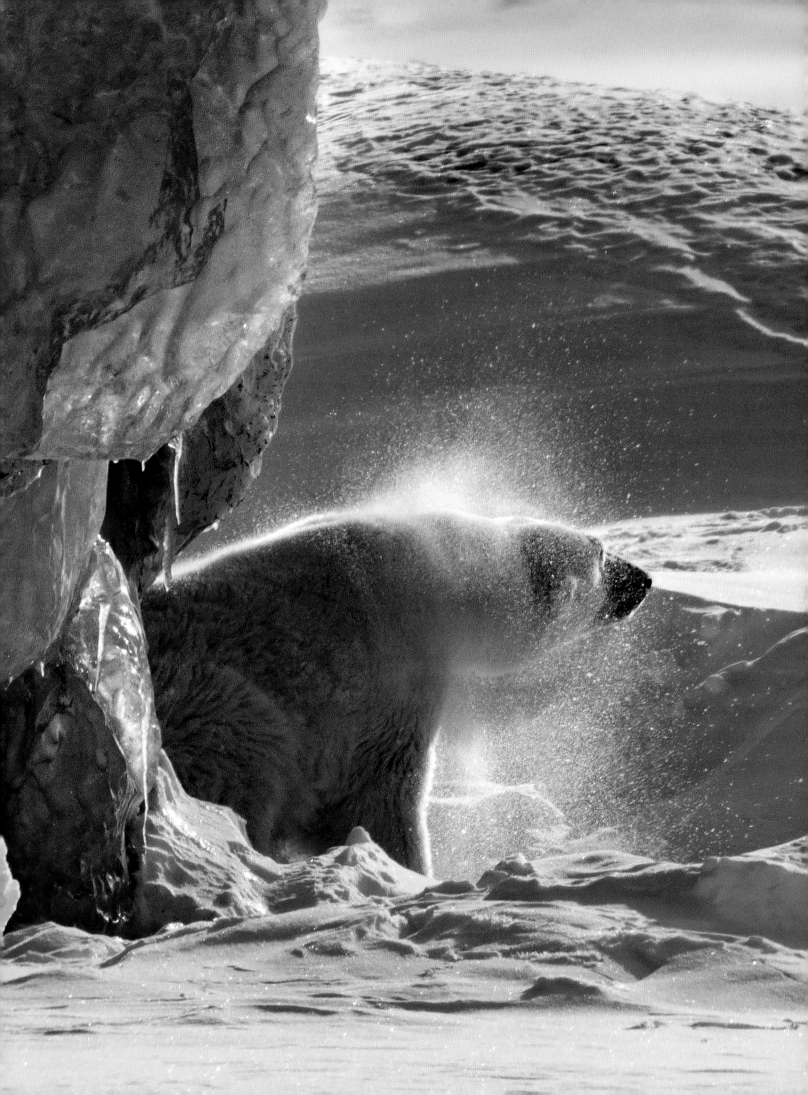

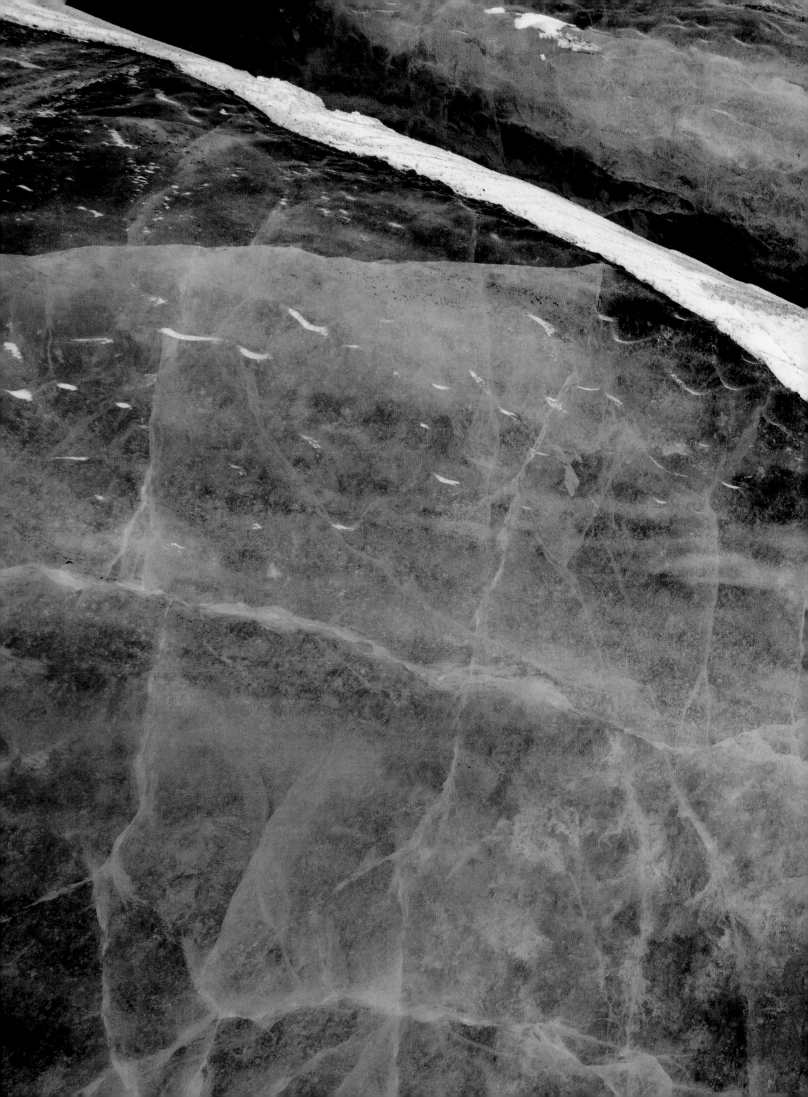

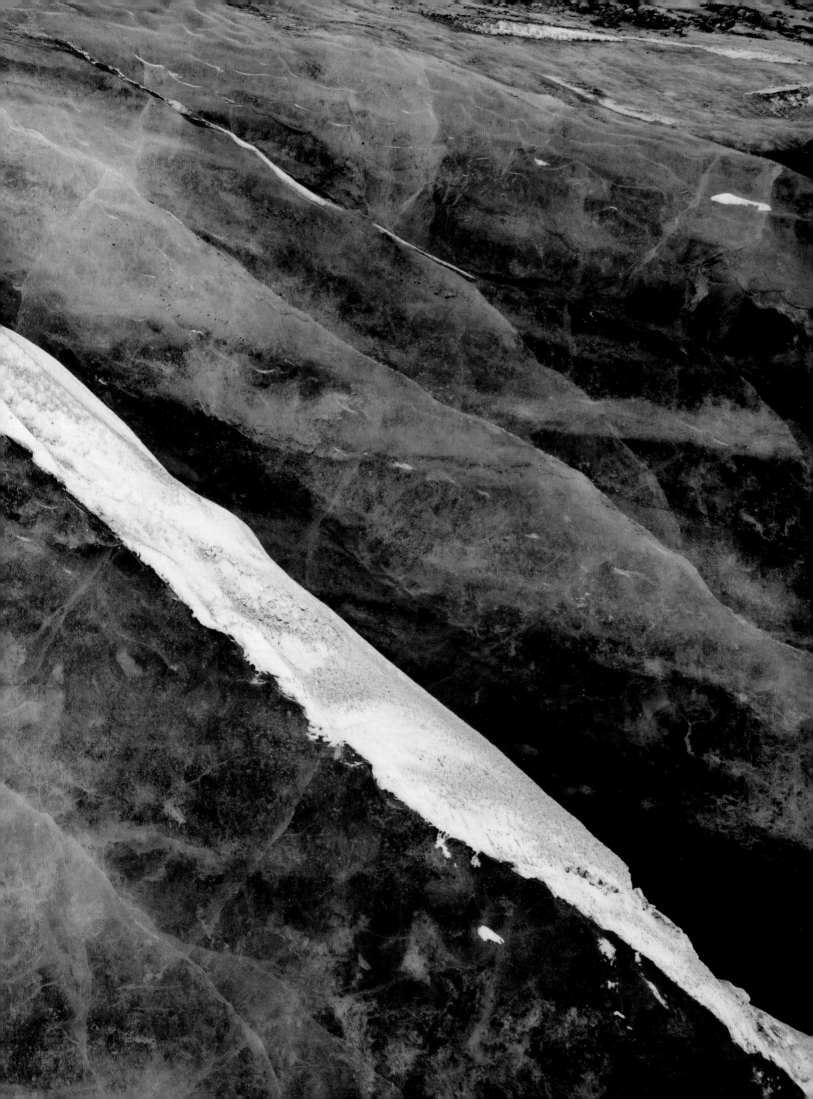

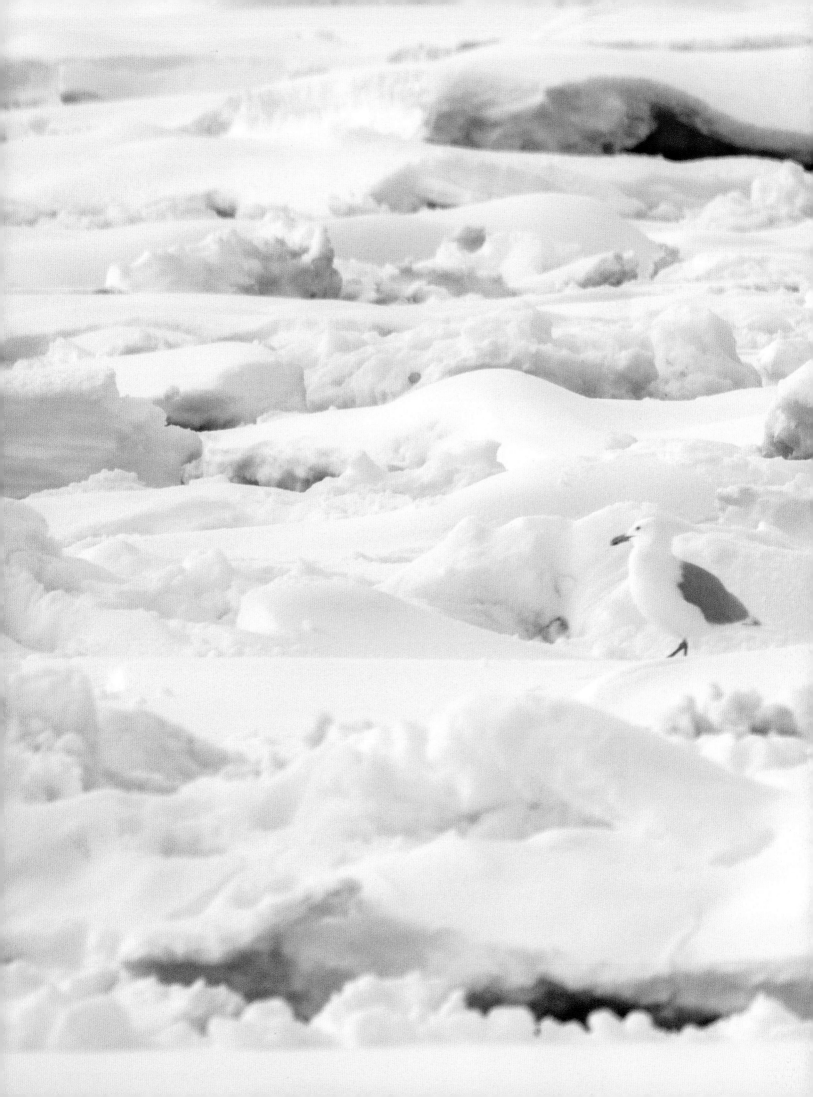

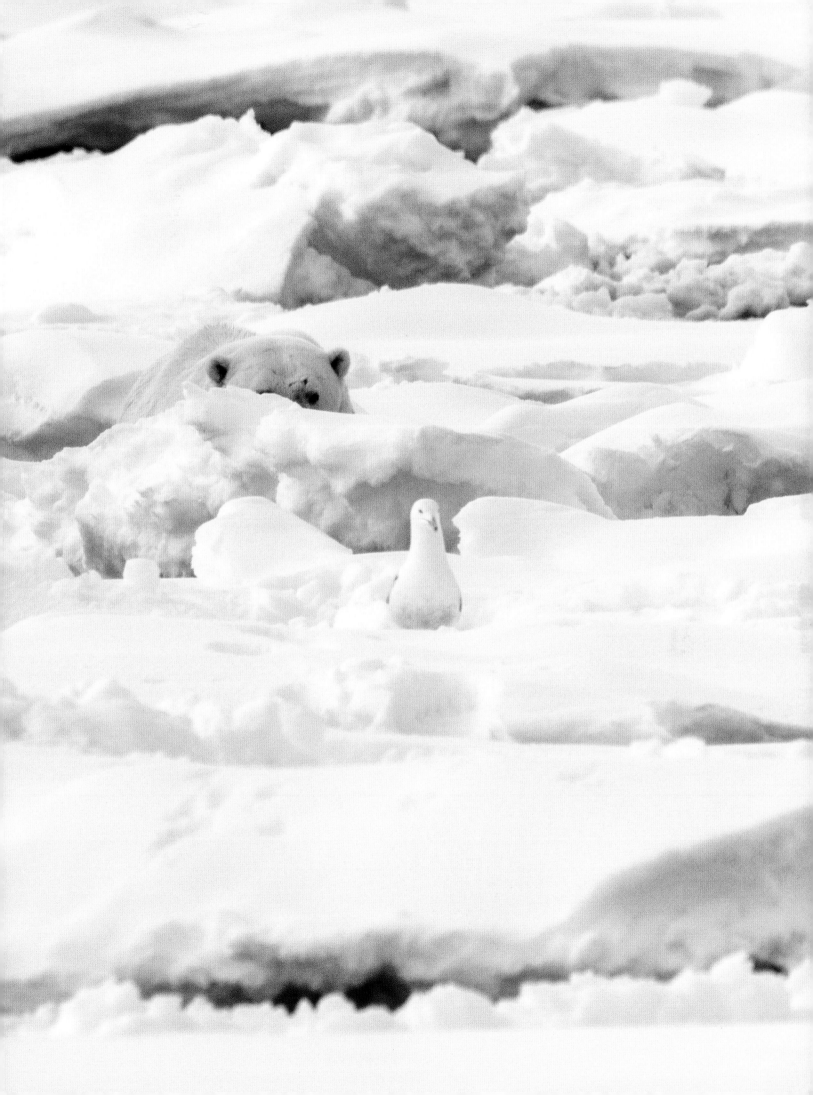

OUR FIRST WINTER TOGETHER was a normal one in terms of weather and ice conditions and how they have developed over the last few years.

The sea ice around Svalbard has melted drastically over the past couple of decades. Many of the fjords that used to be frozen for many months every winter are now free of ice all year. There are still variations from year to year, but the long-term trend is crystal clear.

Record-breaking temperatures are robbing parts of the Arctic of its winters. We can't overestimate how big the changes we see up north are. The Arctic is warming several times faster than the rest of the world. In the past 30 years, the region has been warming twice as fast as anywhere else in the world; the minimum coverage of summer sea ice has fallen by half, and its volume has fallen by three-quarters. New records are set almost every year, and the warming is accelerating.

Most bears we encountered that first winter were on the east coast of Spitsbergen, an area that, until only a decade ago, used to be packed with a huge area of solid ice almost all year. Now the sea ice was limited to a few small, frozen bays. These areas became common ground for many bears who had to compete over the seals that dared to pop up on the ice. This was good for photographs because finding what we were looking for was easy, but not for the polar bears—the reason we were taking photographs in the first place.

The bears usually try to avoid one another. A mother with newborn cubs especially does everything she can to stay away from other bears. An aggressive male would not hesitate to kill her cubs in order to mate with her. But a polar bear mother is very protective of her little ones, and she will risk her own life protecting them. The mothers with cubs we came across in this small area of ice were always on the run, trying to get away from other bears and keep their cubs safe. This made it even more difficult to find food for the ones who needed it the most.

We encountered the beautiful young female we named Helen there in early April, and when we returned to the same bay two months later, we were hoping to meet her again.

The solid ice of the bay had broken up into floes. Helen was nowhere to be found. Instead, this guy was waiting for us in the middle of a blood-spattered carnage. He was smiling. "Come play with me. I mean you no harm," he seemed to be saying. Scary, inviting, creepy, and beautiful—all at the same time. We named him Optimus, and he was the prime example of a big, healthy, powerful, and confident male polar bear.

A few weeks later, all the ice in the bay was gone. Hopefully, both Helen and Optimus followed the drift ice to the north. The waters around Svalbard remained open water for more than seven months, until the following winter.

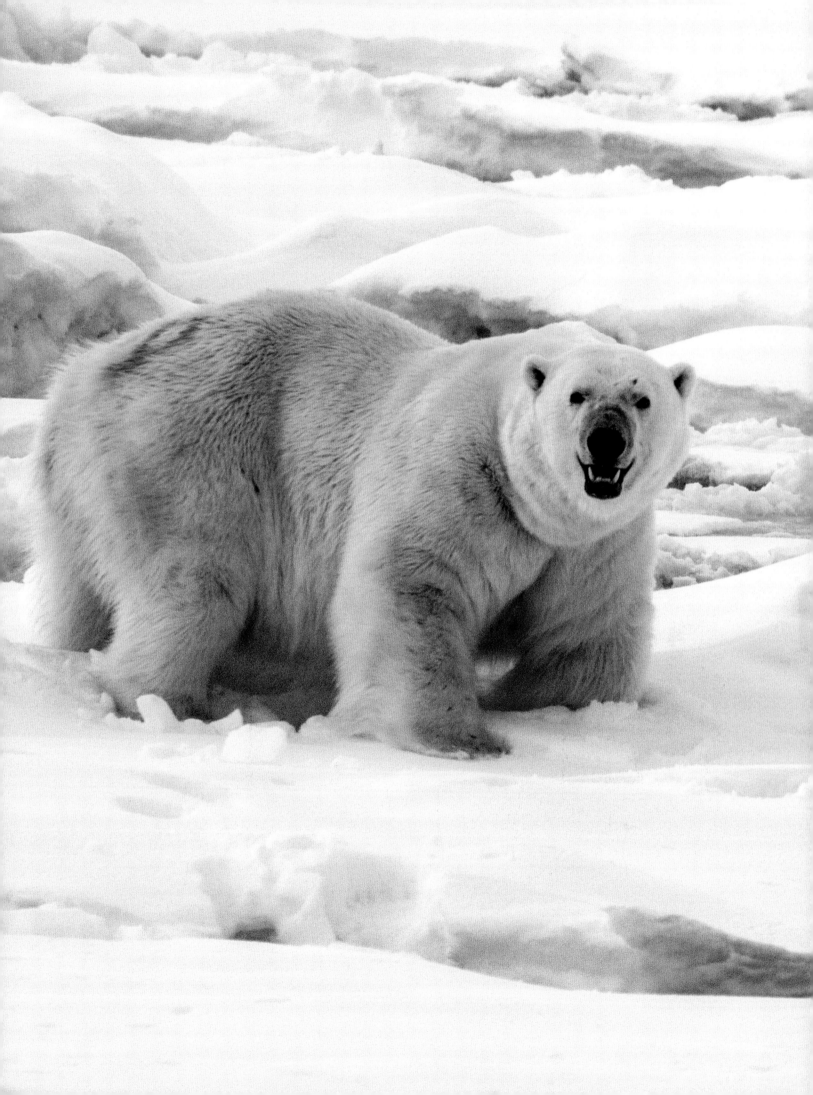

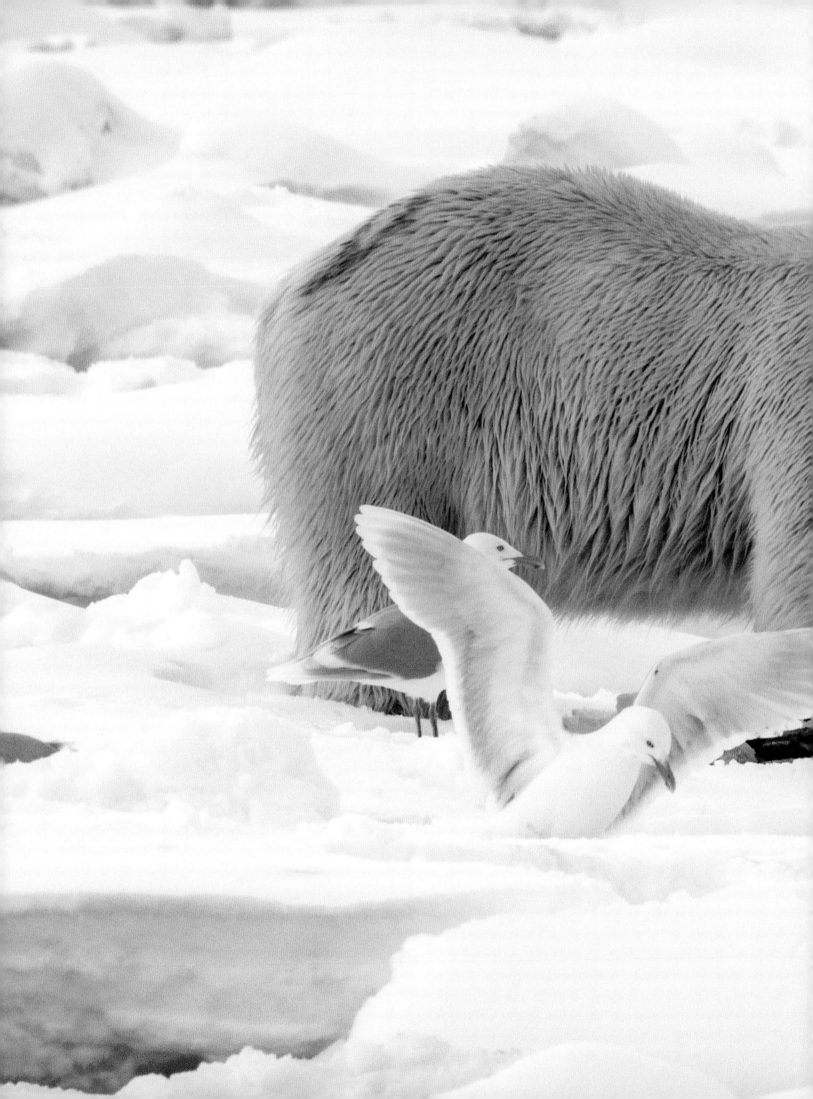

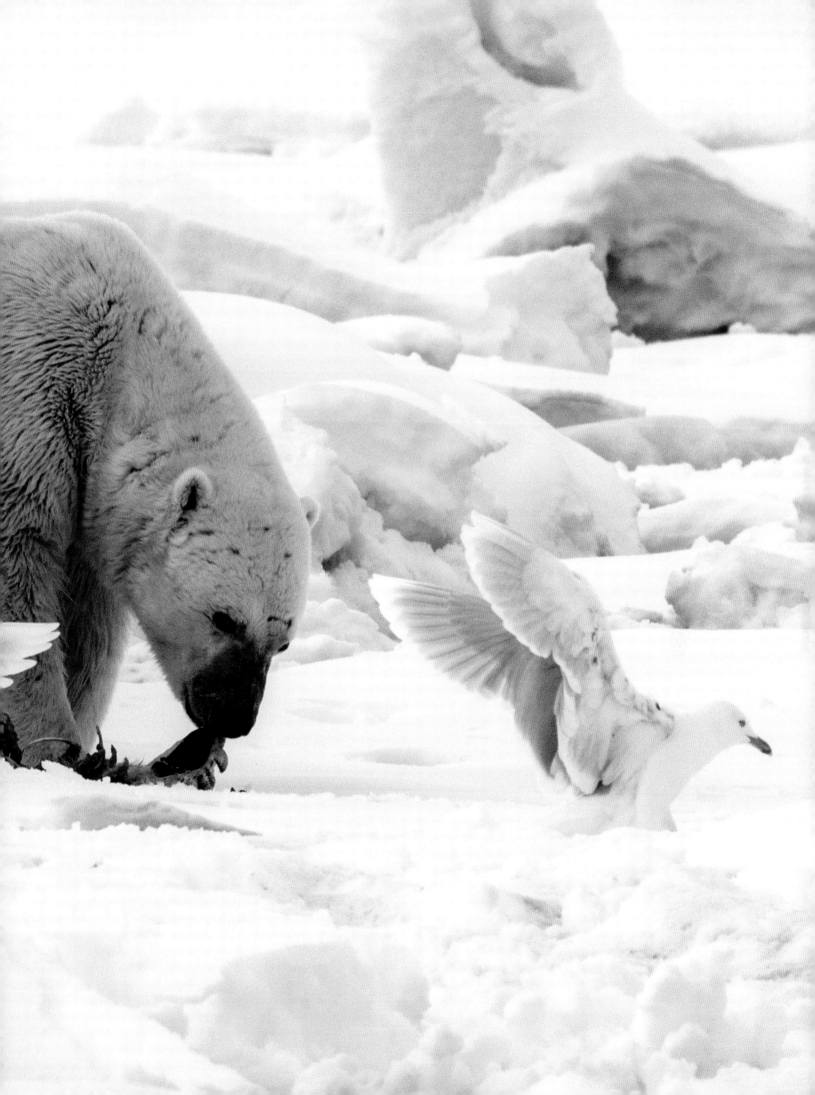

FOOD IS SPARSE IN THE ARCTIC, and the polar bear has to be the perfect hunter. In a world of ice and snow, there are very few places to hide, and anything that sticks out can usually be seen from far away. But what gets a polar bear on the right track is its sense of smell. It can detect a seal resting on the ice from several miles away.

The polar bear has different methods of hunting and catching its food. One is to attack the seal when it rests on the ice. Often the bear approaches its prey from a far distance in a zig-zag line, seeming like it's going to walk past or away, but still getting closer quite quickly. It is very clever. It acts uninterested until the final seconds of an attack. The polar bear looks its prey straight in the eye once it has decided to kill, and then reaches a speed of 25 to 30 miles per hour in a couple of seconds. It strikes its prey with enormous power, killing it instantly.

Another hunting method is using patience. A seal keeps dozens of breathing holes open through a big area of sea ice to avoid the bears. When a bear finds one of these, it stands still, like a statue, patiently waiting over the hole for the seal to appear, sometimes for hours. When the seal looks up through the hole, the polar bear jumps into it with all its weight, often crushing the ice around the hole and killing the seal with one single strike.

The polar bear also hunts seals that are resting on ice floes. A recent study shows that polar bears, who are amazing in water, can dive down to almost 50 feet and stay underwater for as long as three minutes. The bear often stalks the seal by swimming slowly and silently, hiding behind ice floes, only to dive down and approach from underwater the last distance. When it reaches the edge of the ice floe, it uses all its power to emerge from the water quickly and grab the seal. This is the most difficult way of hunting, but, with fewer areas of solid ice, it is likely to become more common.

IT IS A POWERFUL CREATURE, the polar bear. It has evolved unique features for living in one of the most extreme environments on Earth. Its paws can be 12 inches across, and it has thick claws—curved, sharp, strong, and deeply scooped on the underside. Each claw can measure more than two inches long. The bear uses them to catch and hold prey and to provide traction on the ice.

Research of polar bear injury patterns found injuries to the right forelimb to be more frequent than those to the left, suggesting, perhaps, that most polar bears, like most humans, are right-handed.

The bear's skin, under its fur, is black in order to better soak in and absorb the warming rays of the sun. And the fur is actually not white; it is transparent. Each hair is hollow and colorless. It often looks white because the air spaces inside the hair scatter light of all colors. The color white becomes visible to us when an object reflects back all visible wavelengths of light rather than absorbing some of them.

A male polar bear can weigh more than 1,500 pounds and measure more than 10 feet in length, females about half that. But those are just numbers. It wasn't until we stood in front of one ourselves that we truly understood how powerful a polar bear is. Facing it on the ice, you can feel its strength—not only in its size, but also in its spirit-like presence. It feels like it can smell your thoughts.

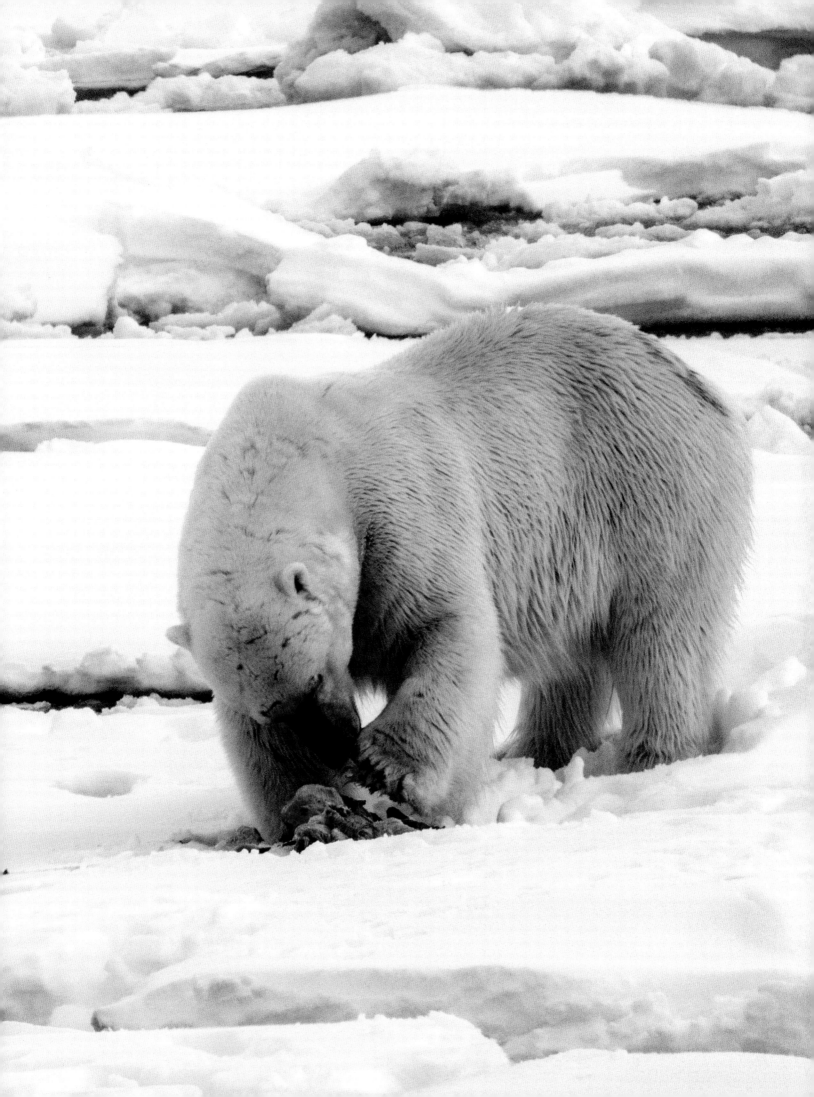

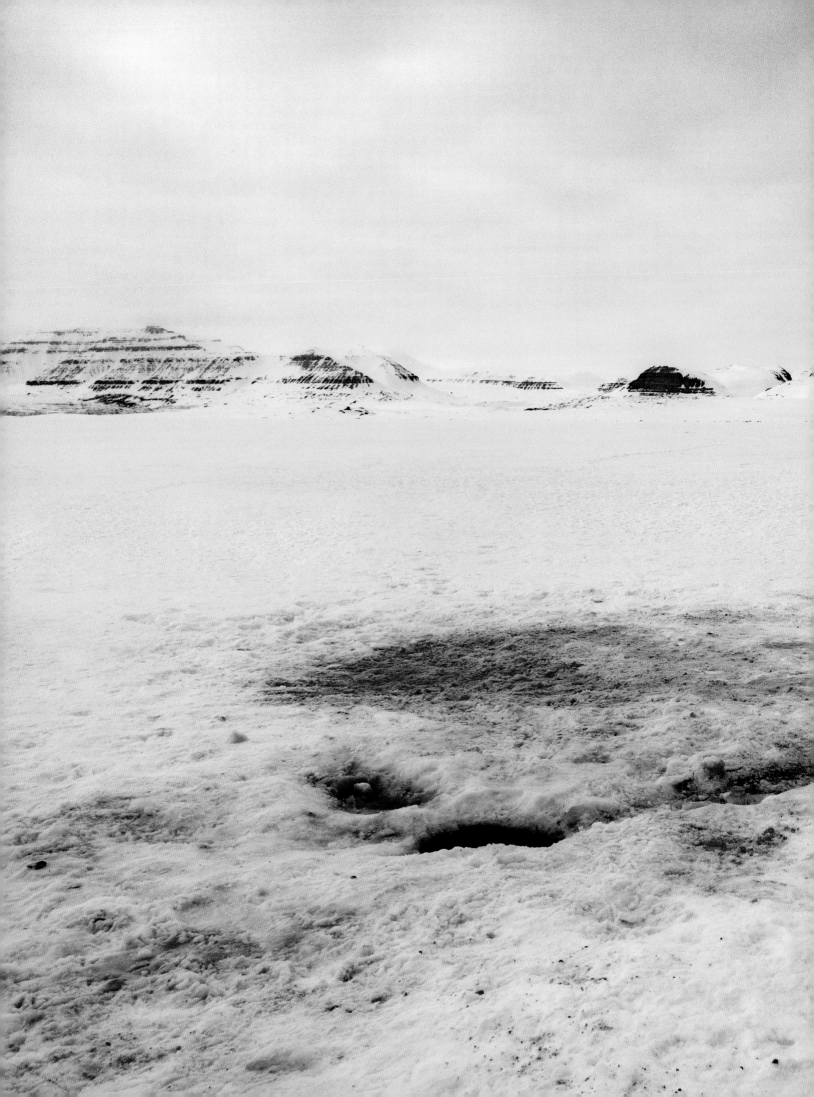

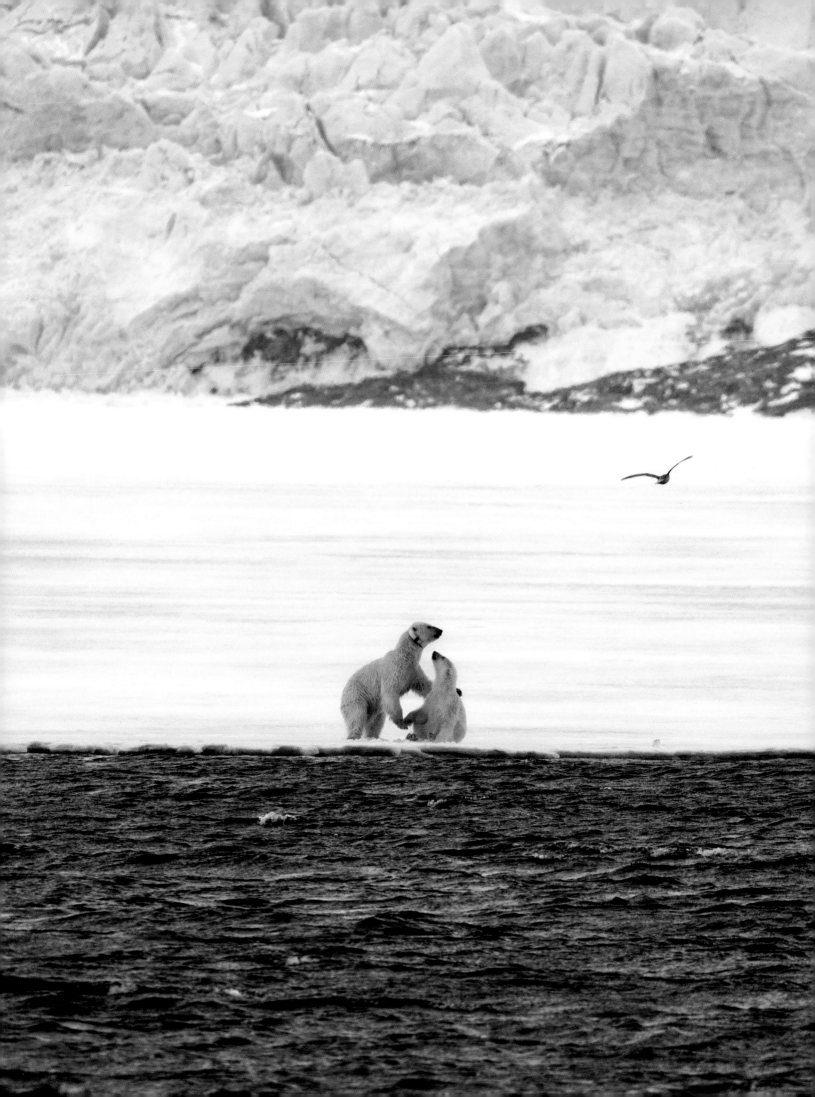

OPTIMUS HAD THE NUMBER 59 sprayed on his back. He had been tagged by scientists a few weeks earlier, and from his number we later learned that he was a 14-year-old male.

A tremendous amount of research is being done on polar bears by some of the world's best and most dedicated scientists. The polar bear plays an important role in the changing global climate. By learning about the life of the polar bear, we learn about what is happening in the rest of the world.

Every winter the Norwegian Polar Institute spends a few weeks capturing and releasing bears around Svalbard. Each bear is shot with a tranquilizer at close range from a helicopter. It falls asleep within a few minutes. Once the scientists are on the ground or the ice with the sleeping bear, their work begins.

Measurements of head, body, and weight and samples of blood, blubber, and fur are taken, as well as DNA samples for genetic studies. The bear is also tagged with an earpiece roughly the size of a pea. It contains a small disc that measures light and temperature. If the bear is caught again in later years, the disc can tell roughly where the bear has been and if it has been in a den giving birth to cubs. One of the main reasons for using this device is to learn about females' reproductive history. For example, if a bear has entered a den two years in a row, she lost her first litter.

If a bear is caught for the first time, it also gets a tattoo for later identification, and a tooth far back in the mouth is removed. The tooth tells the age of the bear and is one it doesn't need. Finally, a number is painted on the bear's back with normal hair dye, which disappears in a month or two. This is to prevent capturing the same bear twice during the same winter; hence Optimus's number 59.

Capturing a bear several times over its lifetime gives valuable information about its development in health and travel over the years. With the data from many individuals, much can be learned about the population and the species.

Every winter a number of female polar bears are also given GPS collars. The reason only females get these collars is that the shape of a female's head is rounder and its neck is thinner, whereas a male has a wider, more muscular, and more horselike neck, so the collar risks sliding off.

These collars make it possible to see how the bears move, especially in relation to sea ice. Comparing the GPS data with satellite images of ice conditions offers a lot of knowledge about how polar bears are affected by climate change. The data shows how they walk on ice, swim, enter and exit their dens, and much more. All this work gives the scientists tools to follow polar bears through the rapidly accelerating climate changes we are experiencing.

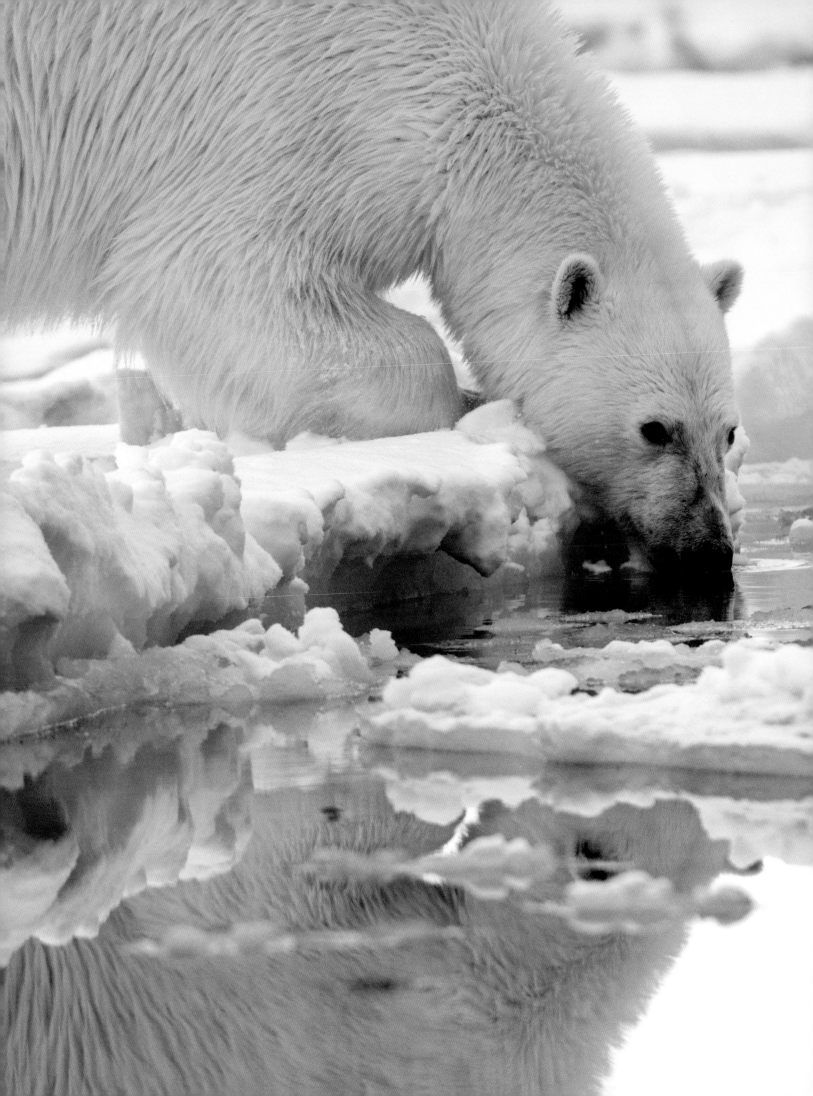

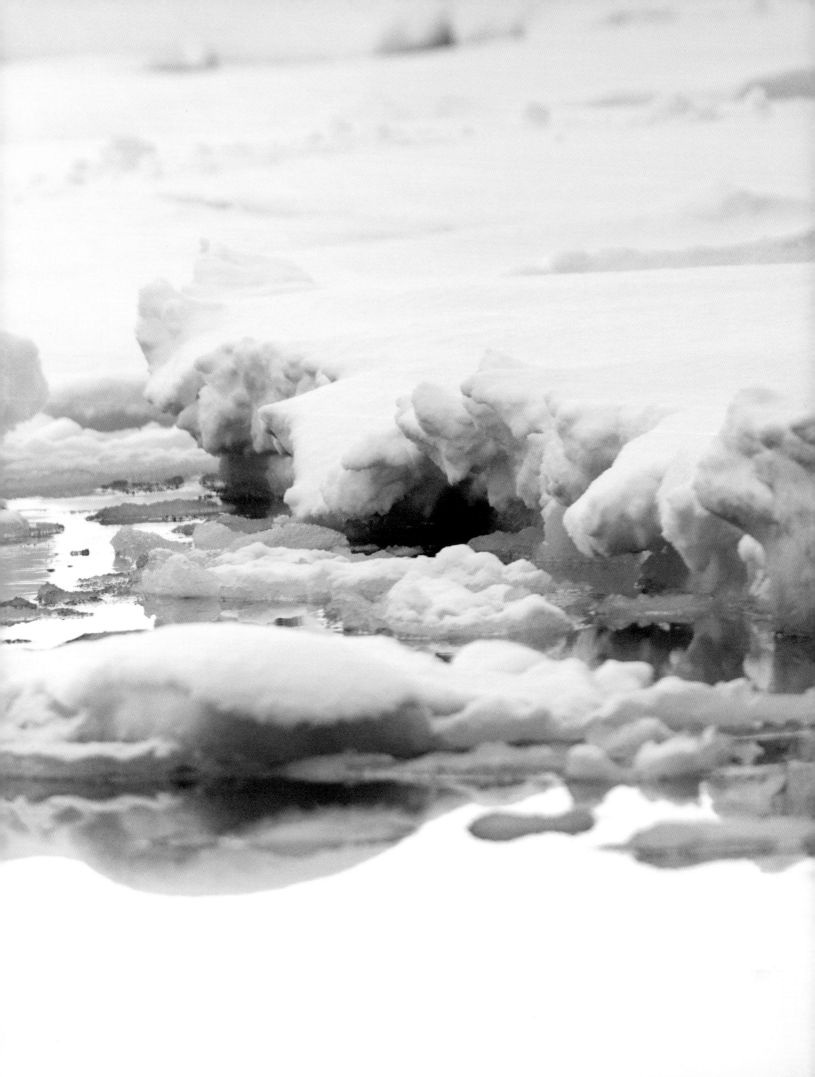

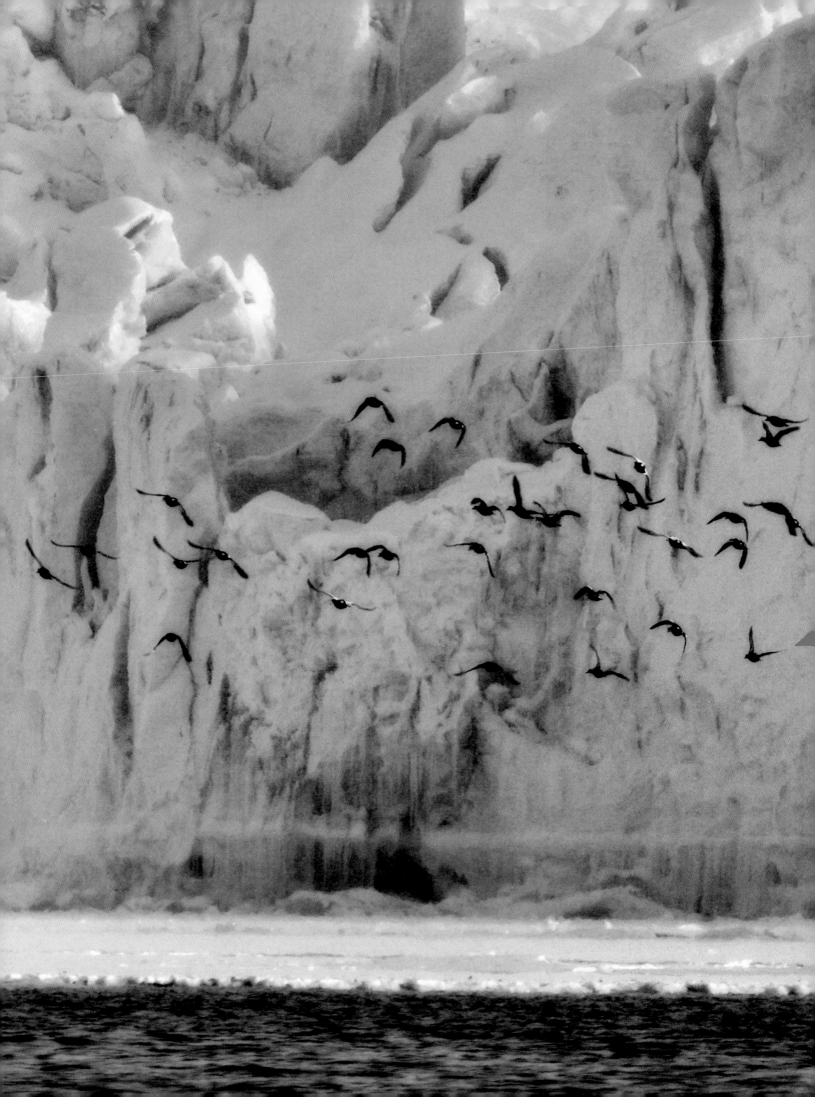

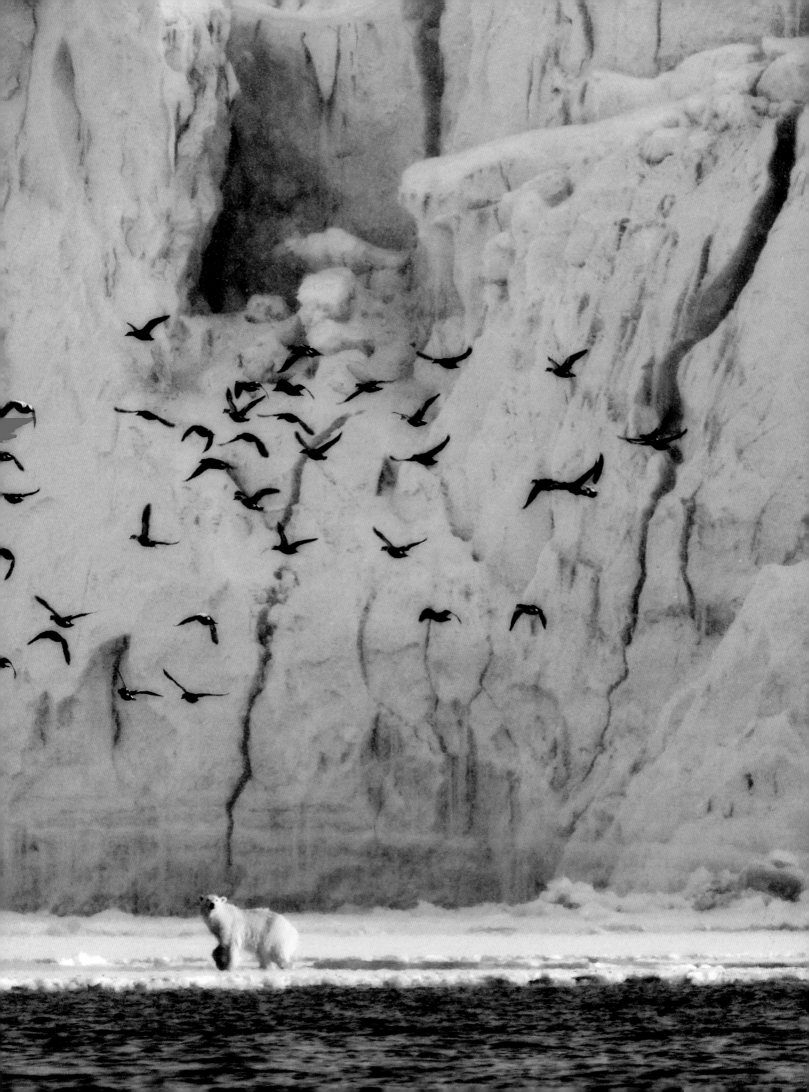

THE POLAR BEAR IS A MASTER at napping. It can do it any time and anywhere. In winter it usually takes its rest during daytime, since seals are more active at night. When a blizzard comes, it often takes shelter behind an iceberg or digs a shallow pit in the snow and takes a nap with its back against the wind, using a paw as a pillow. The snow piles up on top of it, and the nap can last a few hours, or, during a long-lasting blizzard, a few days.

The Arctic offers some extreme conditions, and the king of the Arctic doesn't like bad weather. Conserving energy is just as crucial as hunting for a polar bear. Sometimes it can almost appear lazy. But with so little access to food, conserving energy is necessary for survival. The bear can go weeks—or, over a long summer without sea ice, even months—without eating, living only off its own fat reserves. Being smart and not wasting energy trying to find food that's not around is very important.

The polar bear always takes the shortest route, often also the easiest—like this guy, who slides down the slope on his belly. When he eventually finds his prey and gets the chance to hunt, all his energy will explode with enormous power and speed.

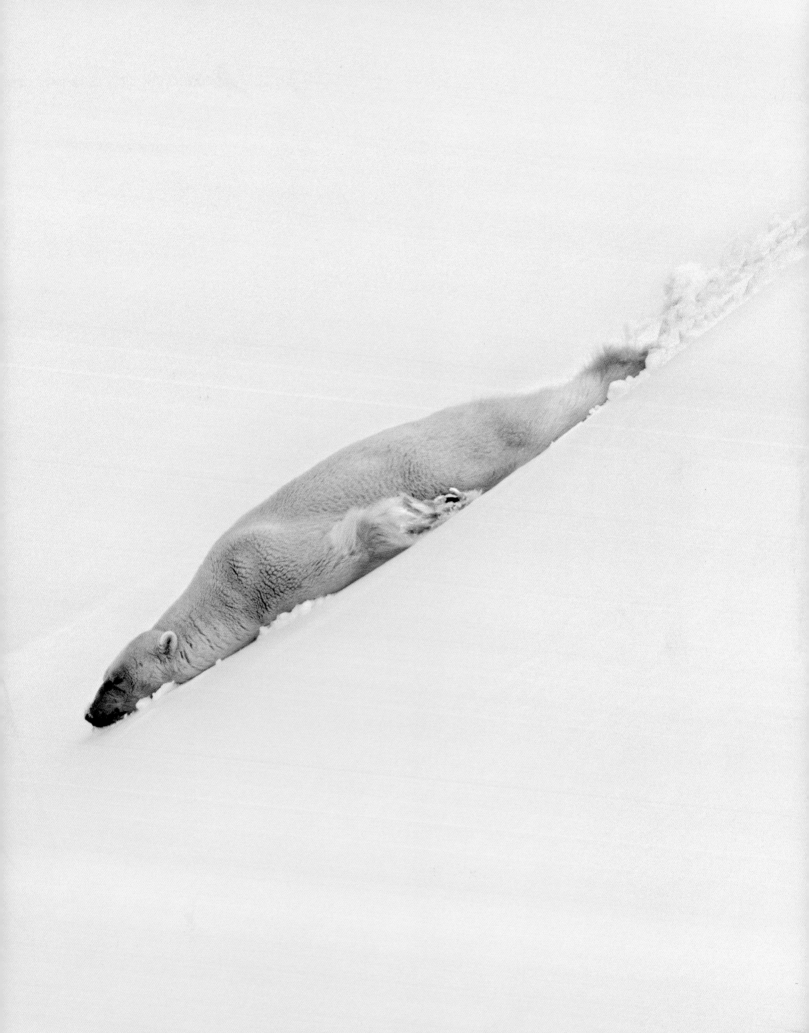

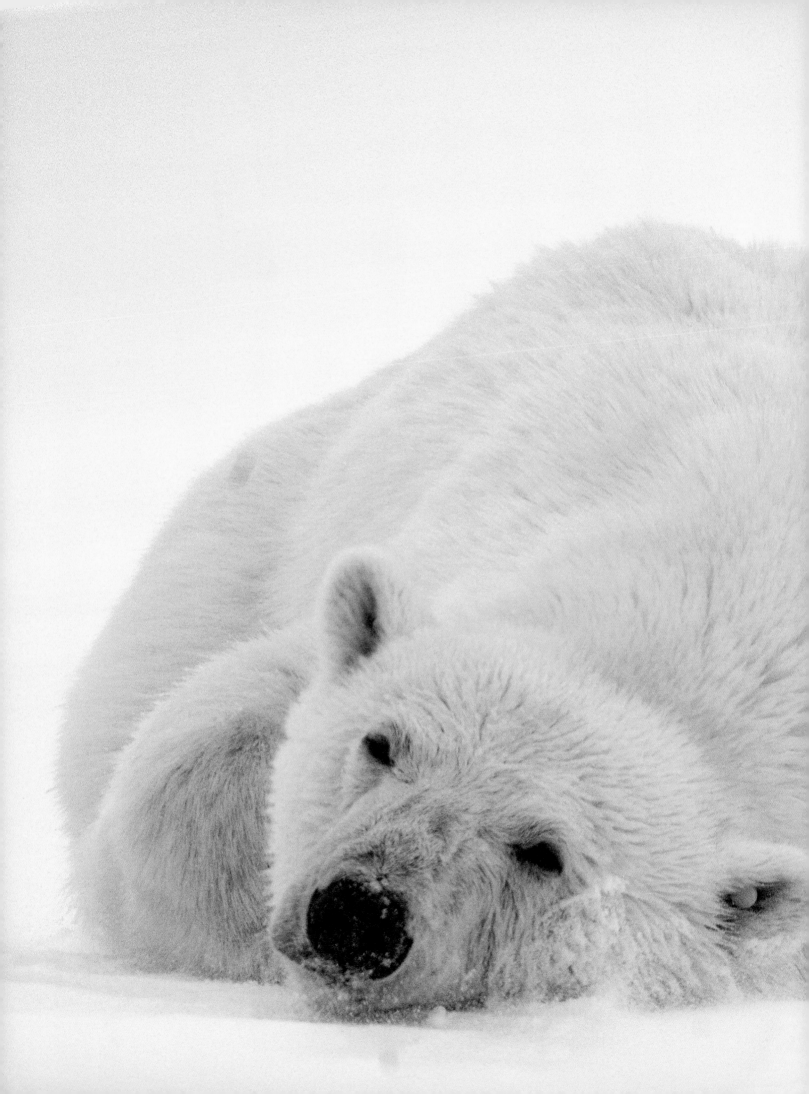

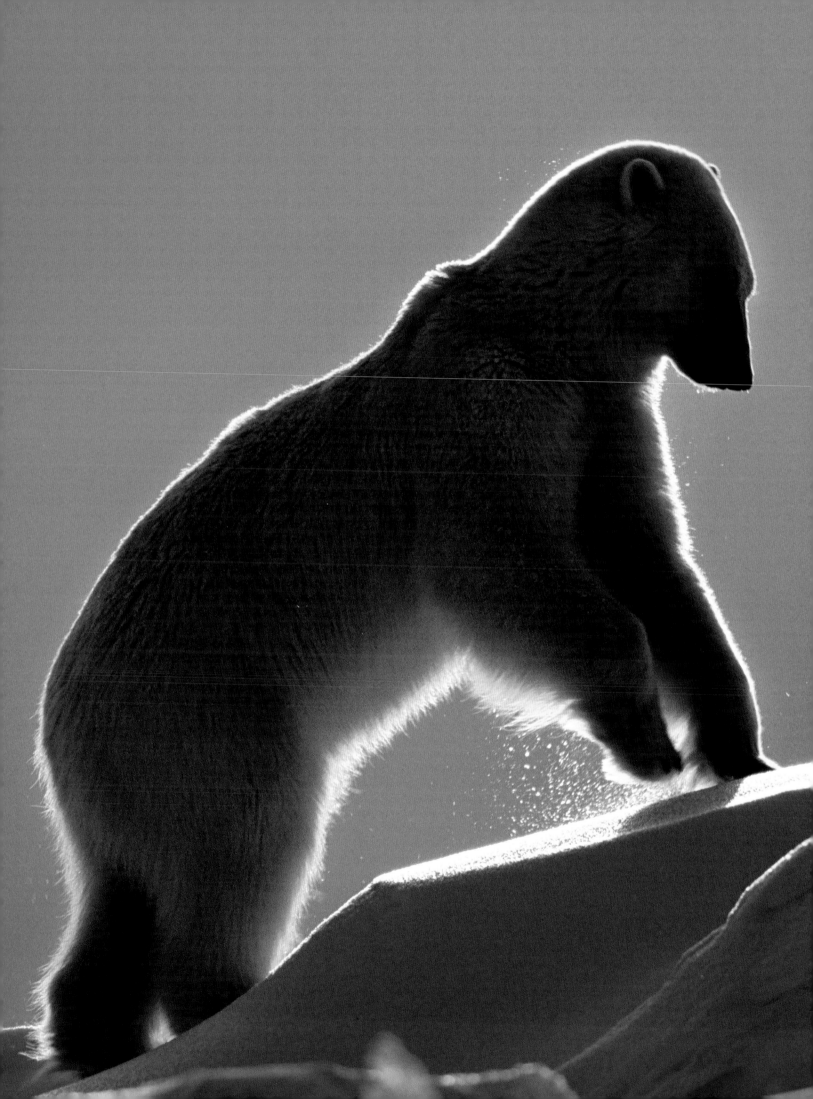

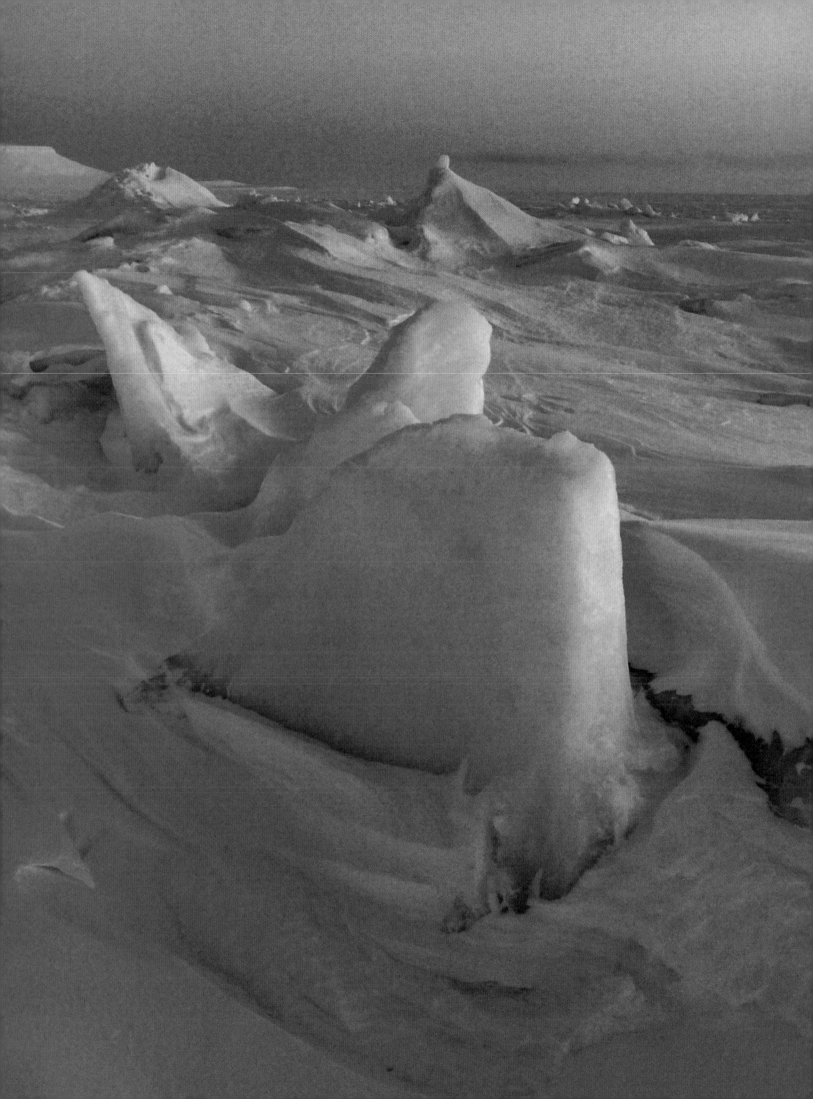

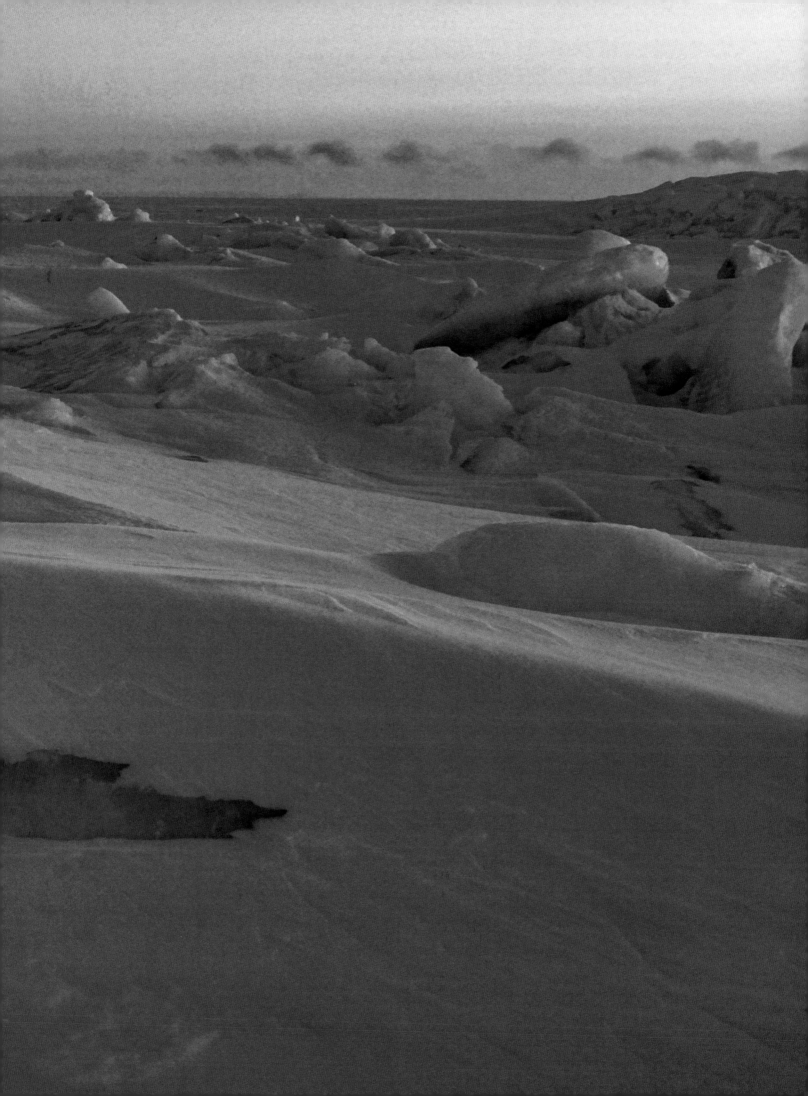

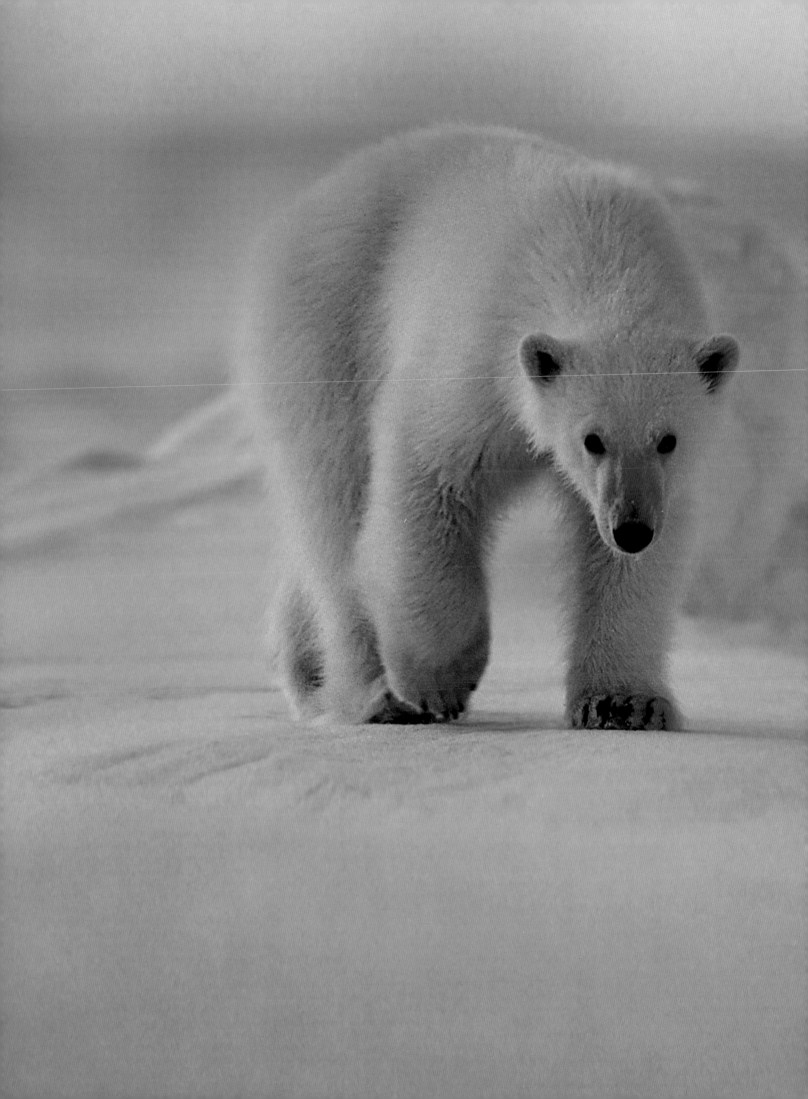

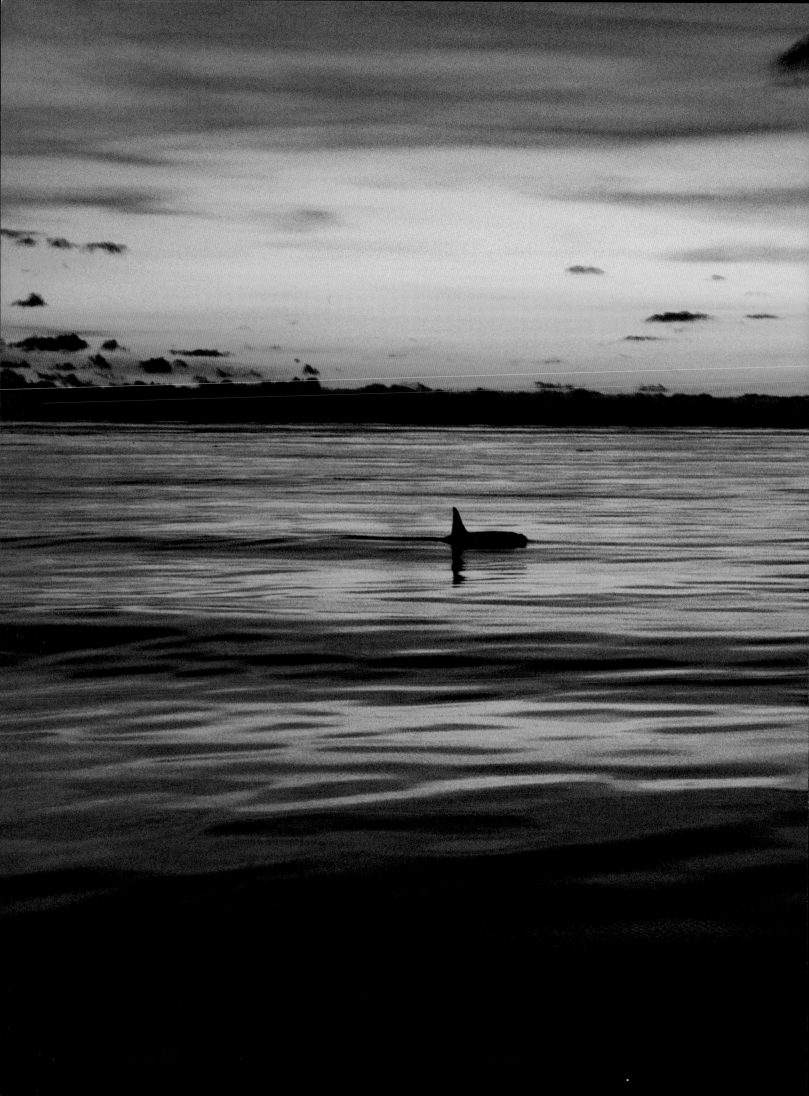

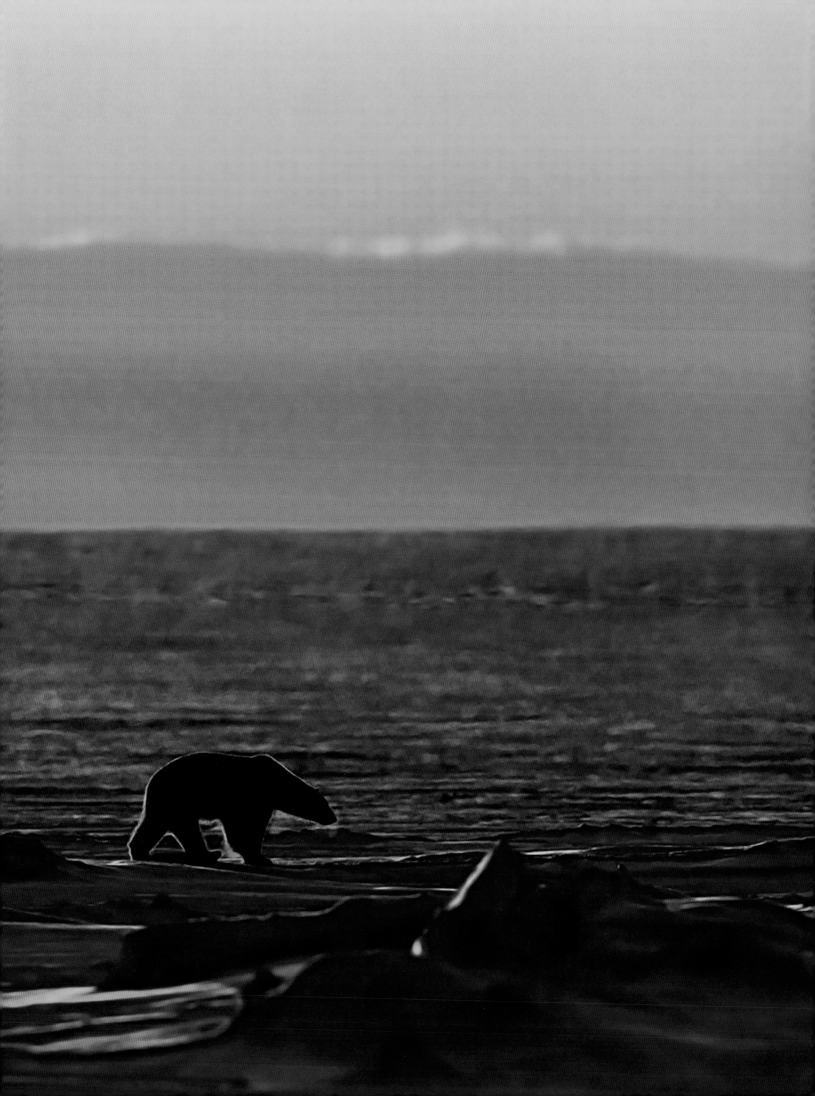

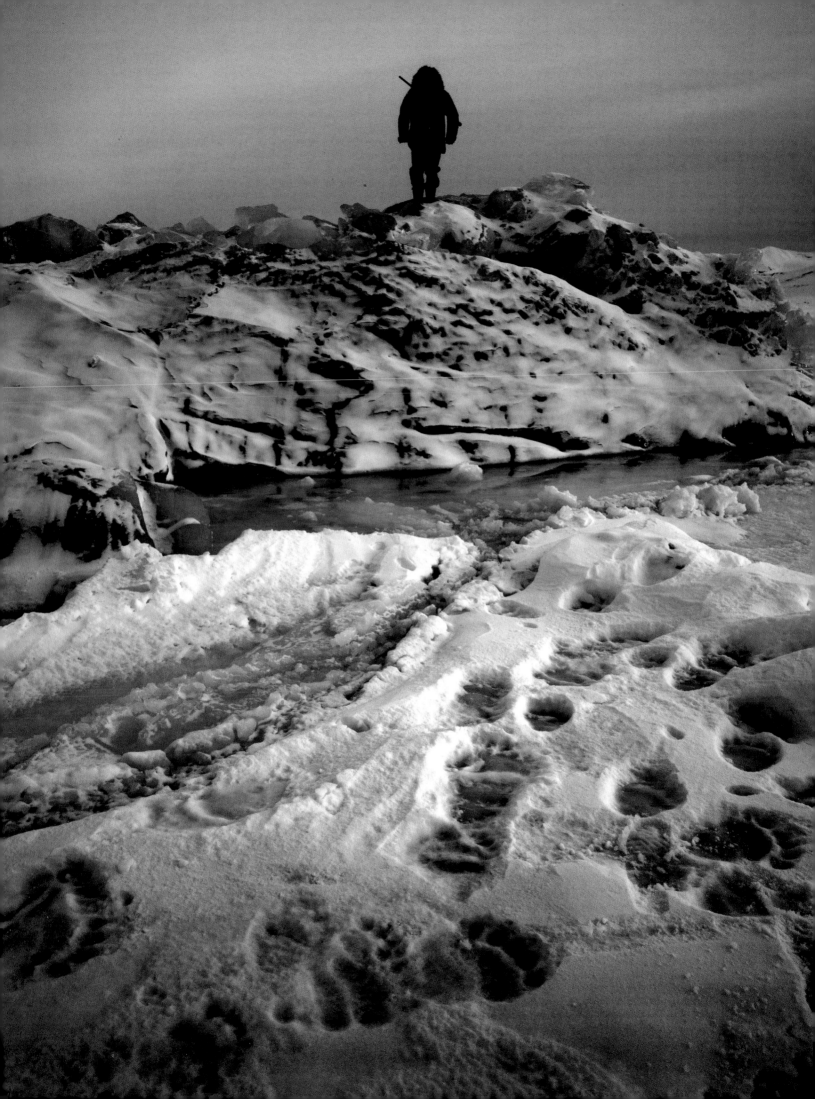

BEING CLOSE TO OUR BEARS is what is most important to us in our work. And by close we don't necessarily mean distance in feet or yards, but close in the sense that we actually learn something about them, that we connect. Getting close takes time. Not hours or days, but years. After all this time among these bears, after all the encounters and moments, we finally begin to feel close to them.

Every encounter is special. Every encounter is a lesson.

One expedition I remember was to a small island in the eastern Svalbard archipelago. It was a few years ago, before Melissa and I met. As I was returning to base camp, an old trapper's cabin, I saw the most beautiful sunset over the frozen ocean. In midwinter, after months of polar night, the days quickly become longer. During the first evenings of the midnight sun, the hours when the sun goes down and almost hits the horizon are probably the most beautiful. The sea ice and sky turn the most insane colors. Red, yellow, orange—sometimes I had to pinch myself to check if it was real or not.

I got closer to the cabin and heard roaring, panting, and growling. The silhouettes of two large male polar bears appeared against the setting sun. They were standing on their back feet, fighting like it was the Rumble in the Jungle with Muhammad Ali and George Foreman. One bear would punch the other, then back off, and then they would sit staring at each other, only to get right back at it again. On the sideline, perhaps 50 yards away, was their audience. A beautiful young female was sitting still, watching them and the sunset. The two males were fighting over her—the grand prize.

The fight continued. As the sun began to rise, it became clear that we had a winner. One of the bears became more and more defensive, and after a final roaring attack, he just stayed down. The female polar bear left her spectator's seat and walked away with the winning male, following close behind him.

When I came out of my cabin the next morning, the defeated bear was still lying there, a few hundred yards away. Still in the same position. Was he dead? I had to walk closer to check. He raised his head. His spirit, masculinity, and manhood had been crushed. But physically he was fine.

It's not uncommon for male bears to fight over females, but it rarely gets too bloody. Polar bears are too smart for that. Even though they would be able to kill each other in seconds, they instead fight like dogs. It's about showing who is the biggest, baddest, and most masculine. It's about dominance.

DURING THE NEXT COUPLE OF WEEKS, I bumped into the loving couple—the bear who won that fight and his female—a number of times. They played like puppies, chasing each other across the small island and sea ice surrounding it. She would play hard to get, and he would run after her. But as soon as he got too far behind, she would stop and let him catch up. It was fun to watch. They were completely focused on each other and barely noticed me even when we were close.

Except for one time. I was at the bottom of a valley in the middle of the island, and I suddenly heard the two bears coming, running over the top of a high hill above me. The female bear appeared first. She looked down, immediately spotted me, and stopped. But the male bear who came after her didn't see me and continued over the peak in high speed, running like there was no tomorrow. He rushed down the steep hill, straight toward me.

I fired a warning shot in the air to get his attention. He finally spotted me, but his speed was too high, and the slope seemed too steep to be able to stop in time. He sat on his butt and tried stopping with his front paws deep in the snow. But he was sliding so fast. I was sure he would crash straight into me. He looked just as terrified as me as he glided closer and closer. Only a few yards away, he finally managed to stop.

He sat down and looked me in the eye. He was closer than I'd ever allow a bear, but I took the deepest breath I have ever taken and lowered my gun. We were both thinking the same thing. Then he stood up and slowly climbed back up the hill to his girl.

The following week, I had the privilege of witnessing the two bears mating in the sunshine on a hillside next to the ocean. Six months later, in the darkest fall, the female would hopefully return to that same hillside to build a den and give birth to her cubs.

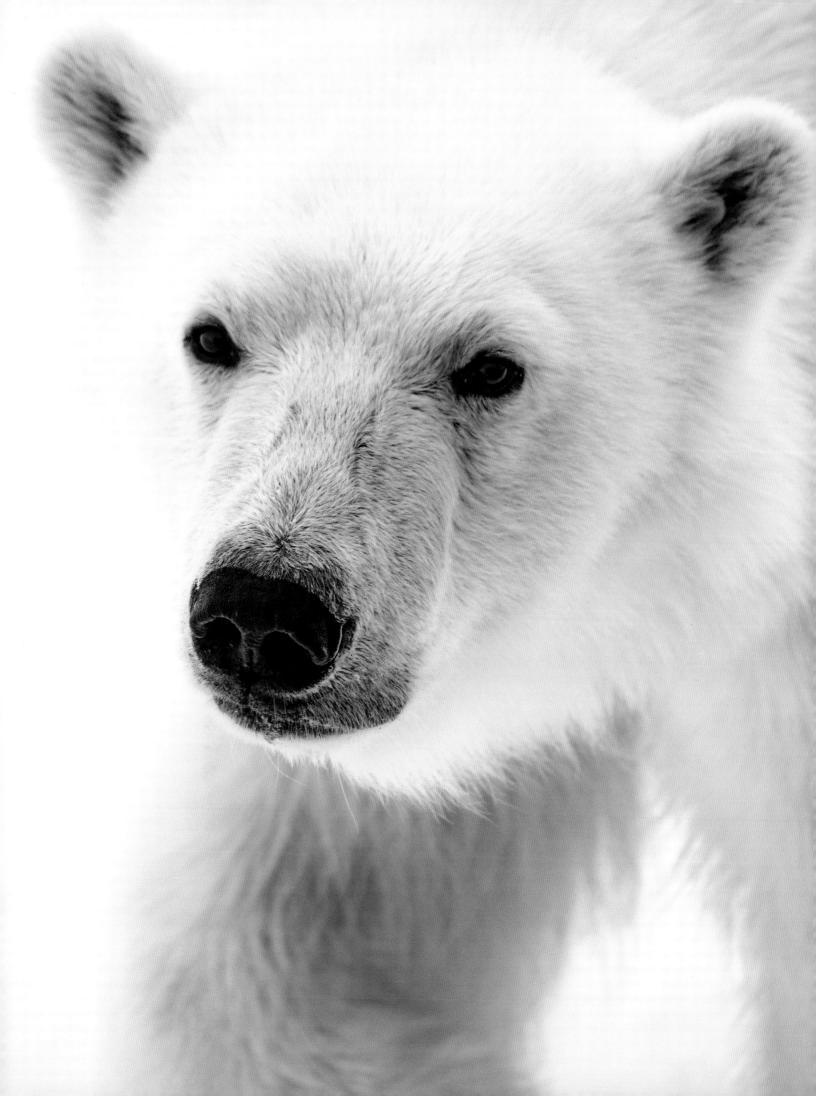

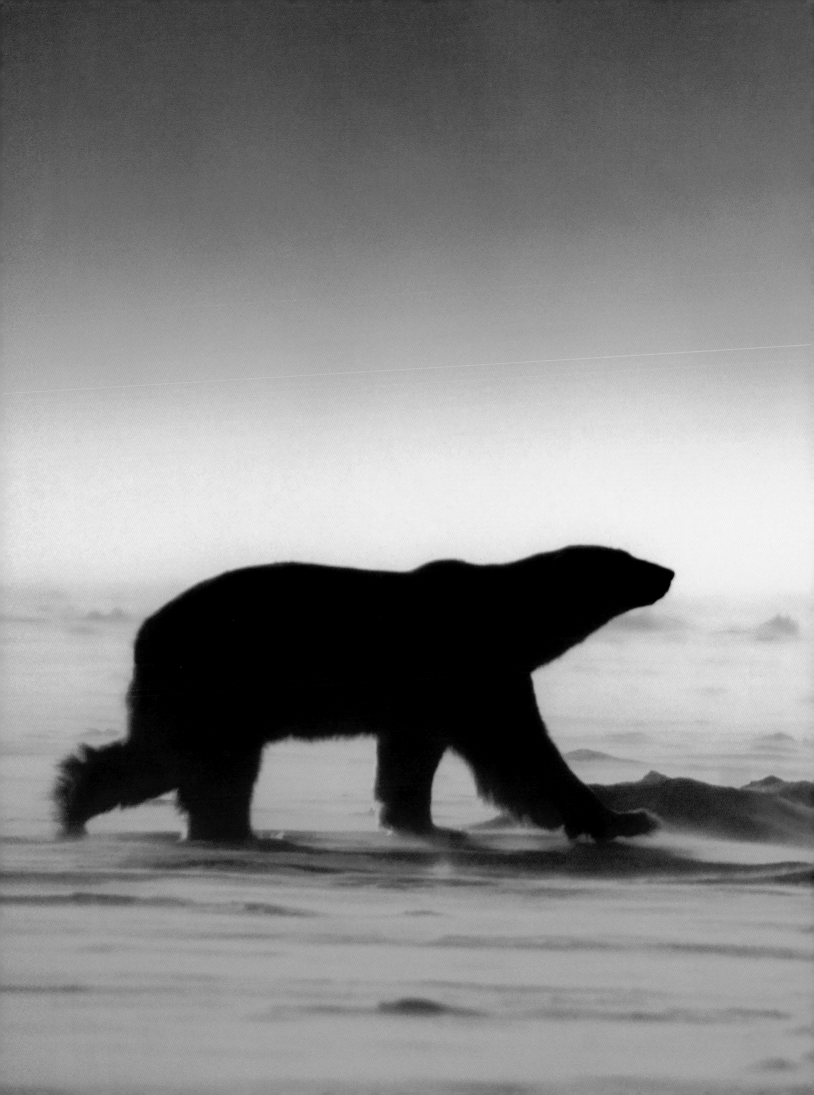

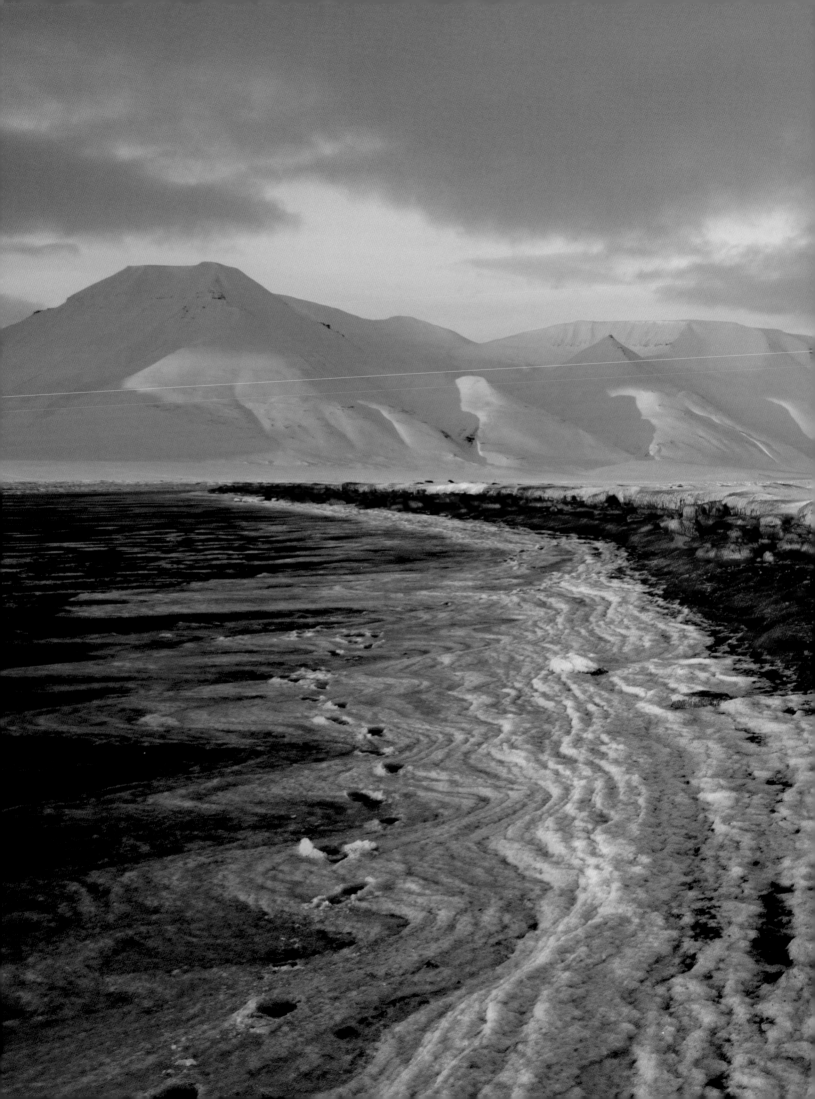

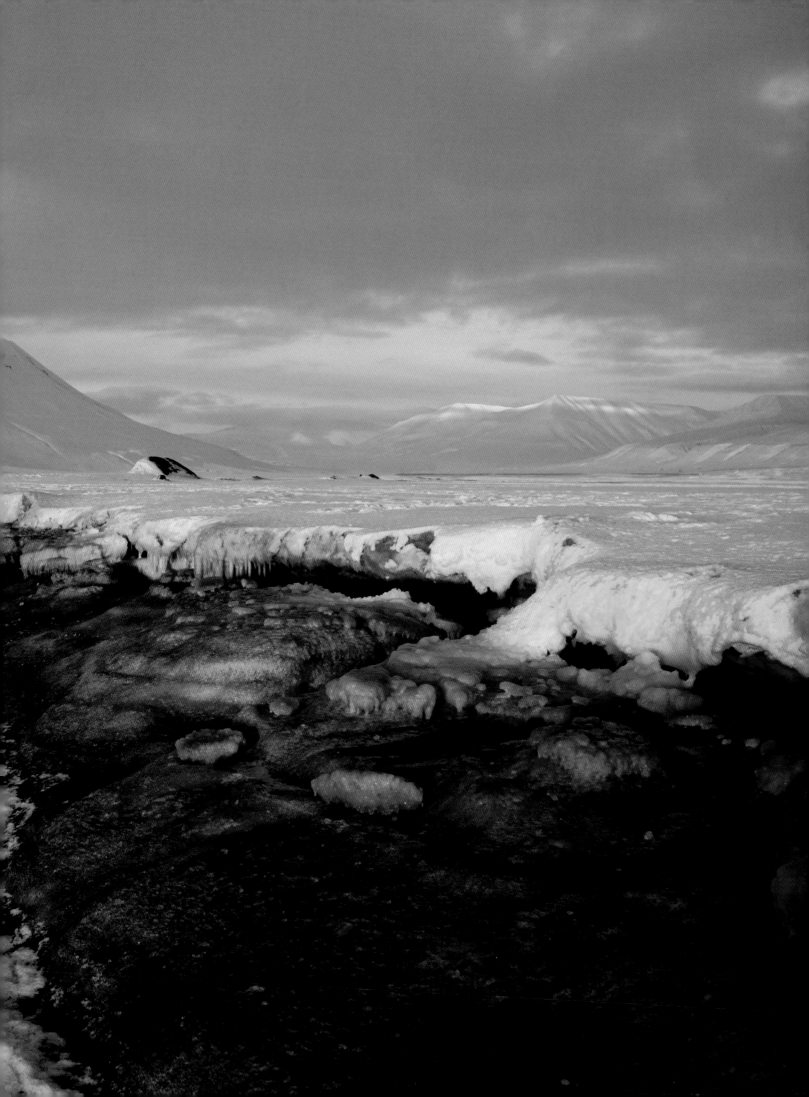

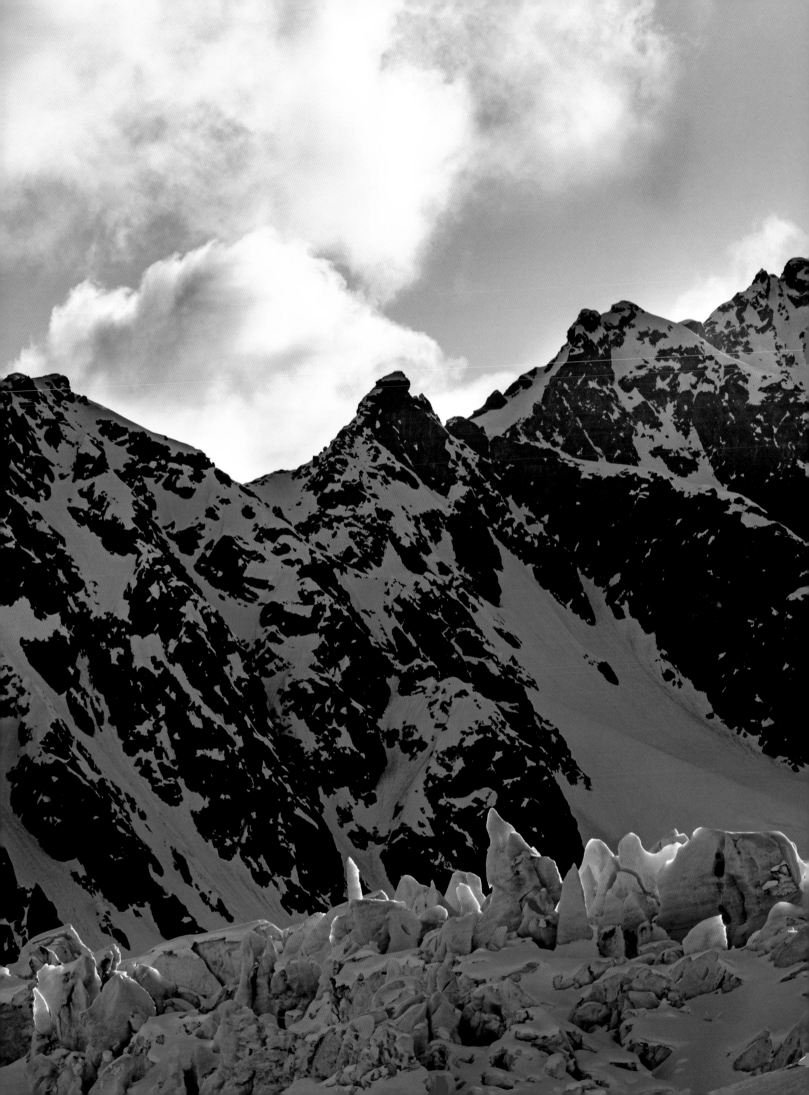

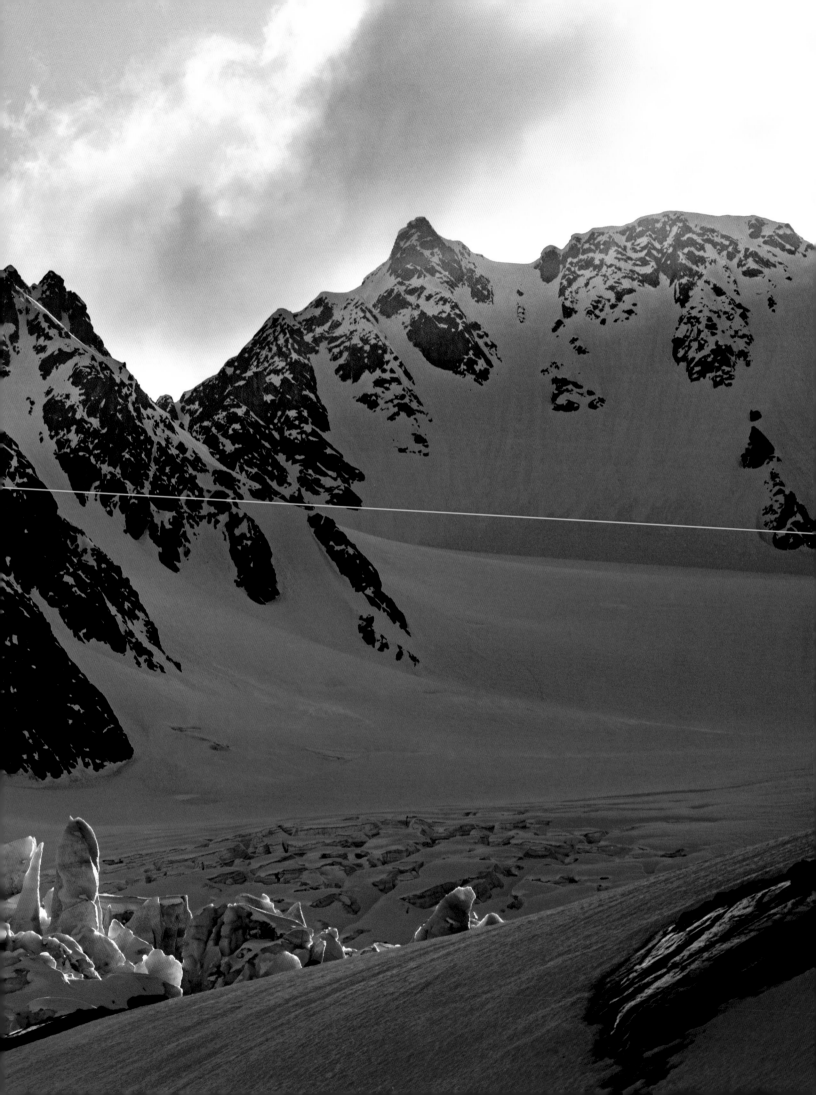

A MOTHER'S LOVE

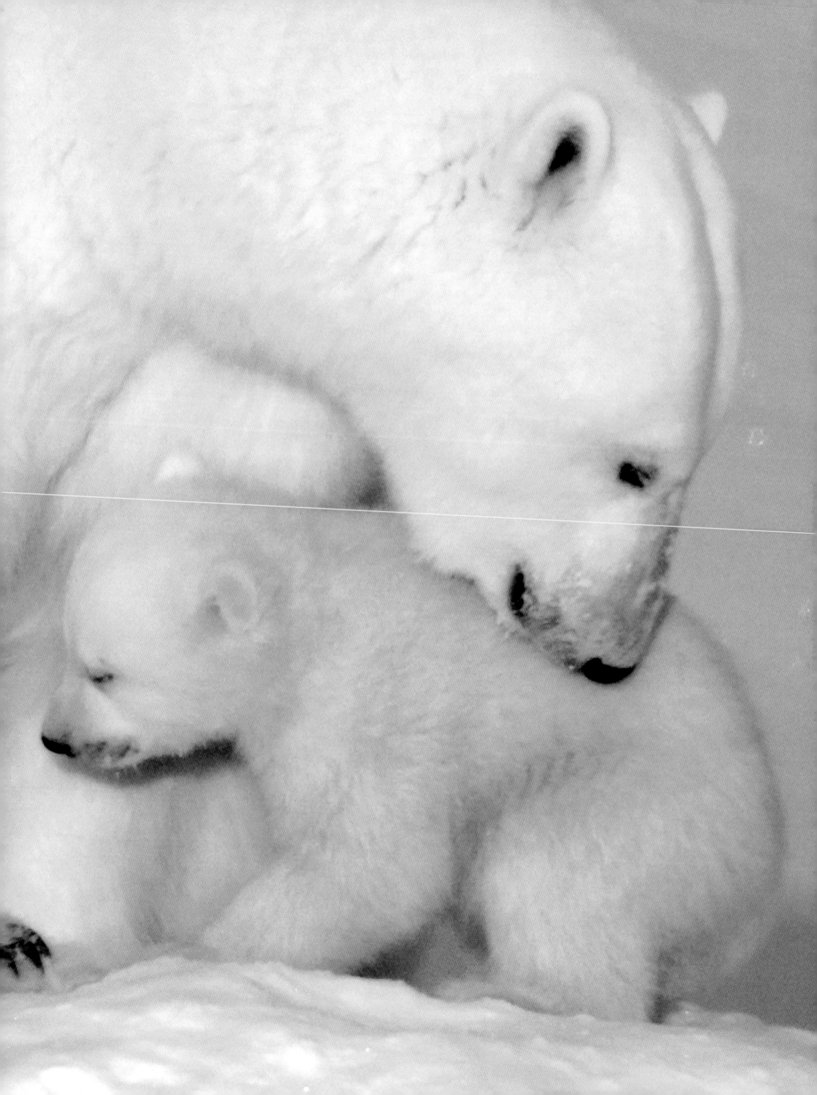

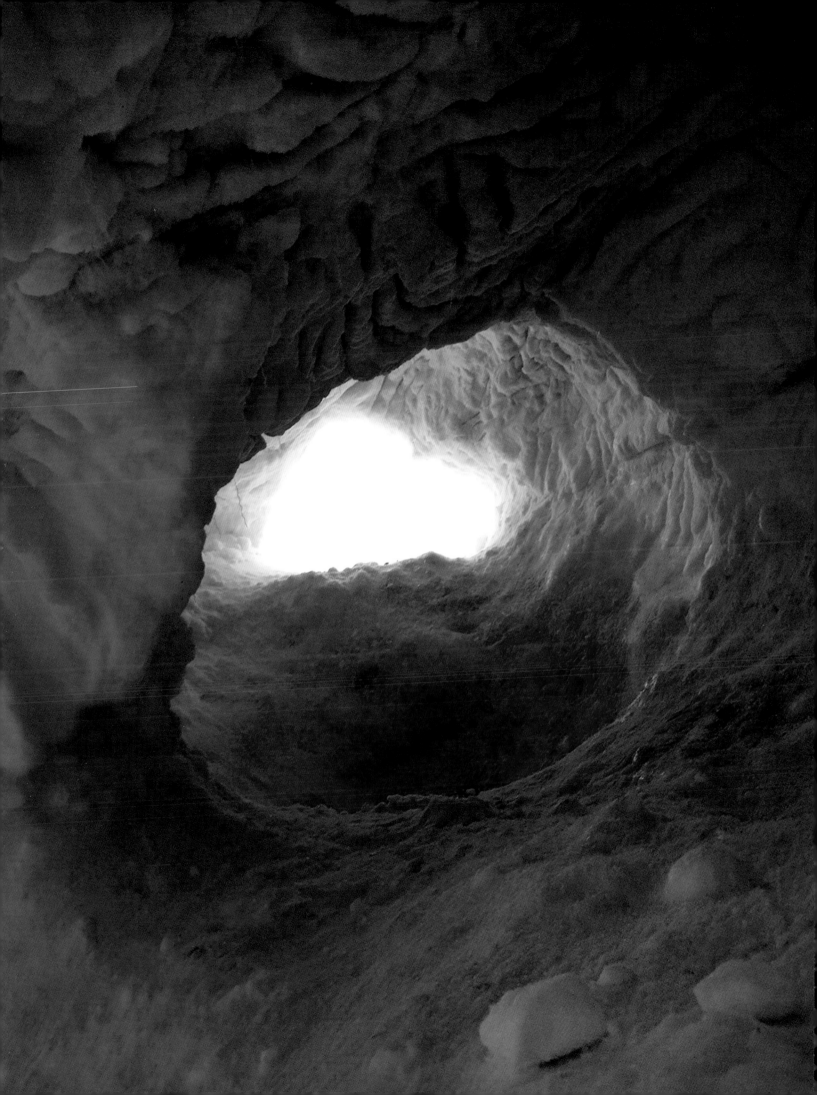

POLAR BEARS ARE COMPLETELY DEPENDENT ON SEA ICE to find food. But they also need access to land, which is where they give birth to new life. As our climate becomes warmer and the ice edge recedes north, the distance between land and ice increases every year. Important denning areas are becoming more difficult—or even impossible—to reach because of little or no sea ice when females enter their dens to give birth.

Around November, in the darkest part of fall, a pregnant polar bear seeks out a snowy hill, often bordering the ocean, to build her den. She digs herself down and lets new snow cover her, creating a room under the snow. There she takes shelter for several months. Around January she gives birth to her cubs, usually two of them, and stays in the den nurturing them until March or April, when she comes out. After staying in the area around the den for a week or two, the family leaves and never comes back. A lifelong journey on the ice begins.

This photo is from the inside of a den only hours after it was abandoned by a mother and her two cubs. When the bears leave the safety of their den, a desperate hunt for food begins. The mother hasn't eaten for many months and now has a family to take care of.

Earlier, polar bears around Svalbard could easily walk back on land to build their dens. But during the last couple of decades, the ice has receded farther and farther away from the islands during the fall. Now the bears that want to give birth on Svalbard have to swim far to reach land. Norwegian scientists recently witnessed a female that swam for five days to reach Svalbard.

But, of course, there are limits to a bear's stamina and strength. Such a long swim is extremely costly for a female that is about to stay in her den, give birth, and eat nothing for five months. Even if she makes it, her condition when she comes out in the spring will most likely be quite bad, and the chances for her cubs to survive will not be good. And if there is no sea ice close when she comes out, finding food becomes even more difficult.

The polar bear is an amazing swimmer—it can swim hundreds of miles and stay in the water for days—but it is impossible for young cubs to manage this feat. It is the bear's fat layer that keeps it warm in the water, and this is why mother bears are so reluctant to swim with young cubs in their first spring and summer. The cubs don't have enough fat. When they are forced to swim longer distances, many of them die.

THE LOSS OF IMPORTANT DENNING AREAS is potentially devastating for the polar bear. Quoting our friend, polar bear scientist Andrew Derocher, "There are three jewels in the polar bear crown: Kong Karls Land in Svalbard, Wrangel Island in Russia, and western Hudson Bay in Canada." These are the areas that historically have had the highest density of dens in the entire Arctic. Kong Karls Land may already be lost for the bears due to no ice. Up until the year 2000, there were dozens of dens there every winter. In recent years, there were only a handful. In 2019, there were none. Both Wrangel Island and Hudson Bay are also in peril from warming.

Between 2004 and 2009, researchers in Canada collected data from 68 GPS collars deployed on adult female polar bears, in combination with satellite imagery of sea ice, to identify incidences of bears swimming more than 30 miles at a time. During the six-year period, they identified 50 long-distance swimming events involving 20 polar bears.

Eleven of the polar bears that swam long distances had young cubs at the time of collar deployment; five of those bears lost their cubs while swimming—a 45 percent mortality rate. In contrast, only 18 percent of the cubs that were not forced to swim long distances died.

The longest recorded swim was a female who swam for nine straight days, traversing 426 miles in the Beaufort Sea north of Alaska—waters so rough that many ships face problems. The water temperature is close to freezing. During the swim, she not only lost 22 percent of her body weight, but also her only cub.

Another bear the scientists were following on Svalbard a couple of years ago swam an average of seven-and-a-half hours every day of July.

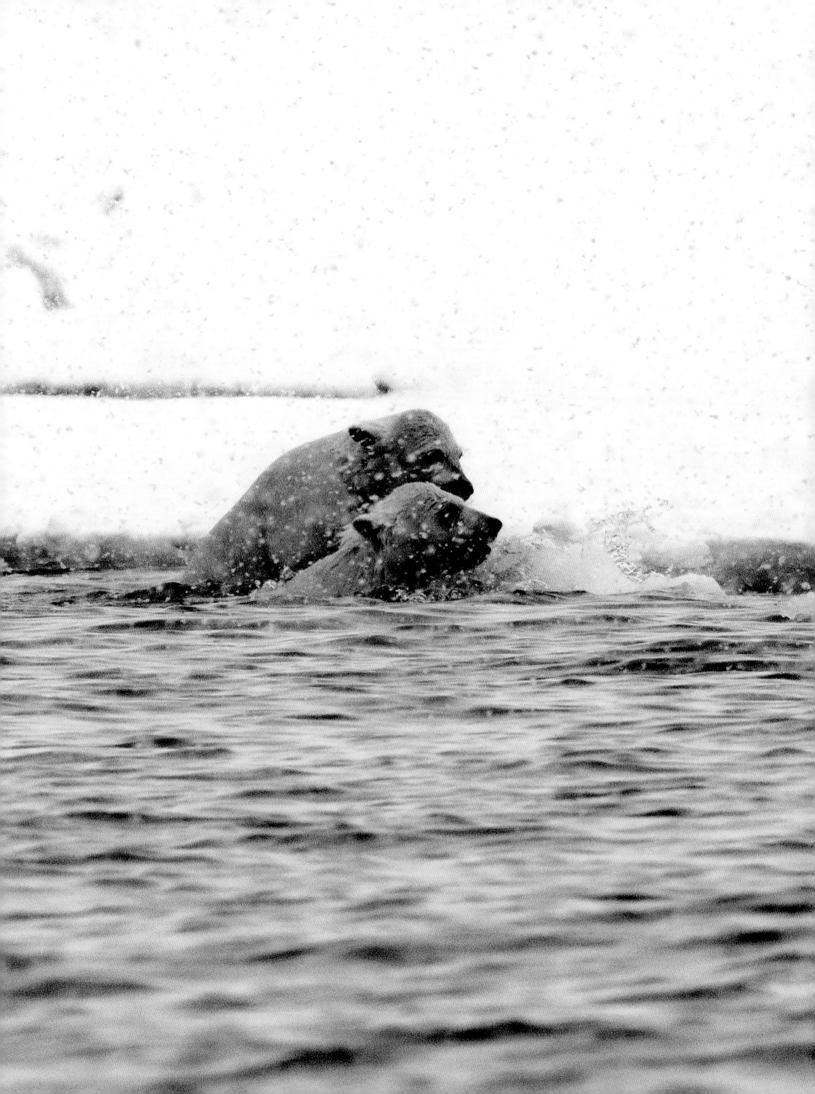

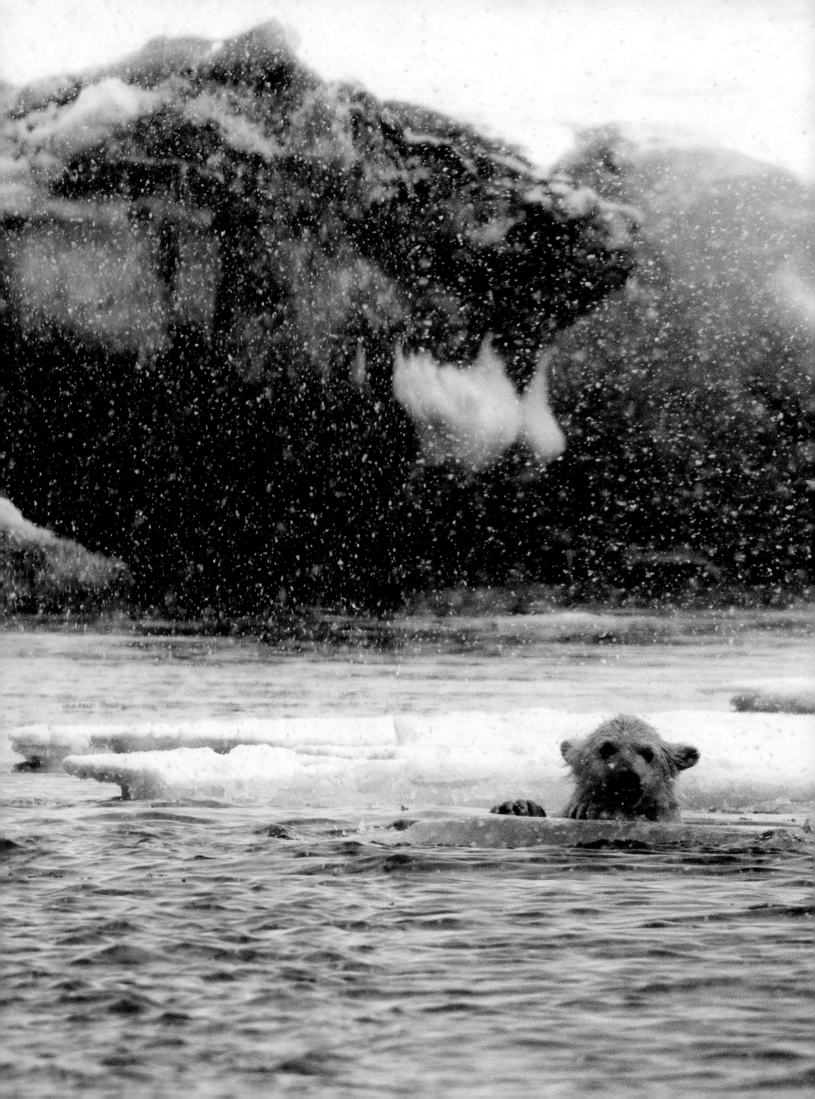

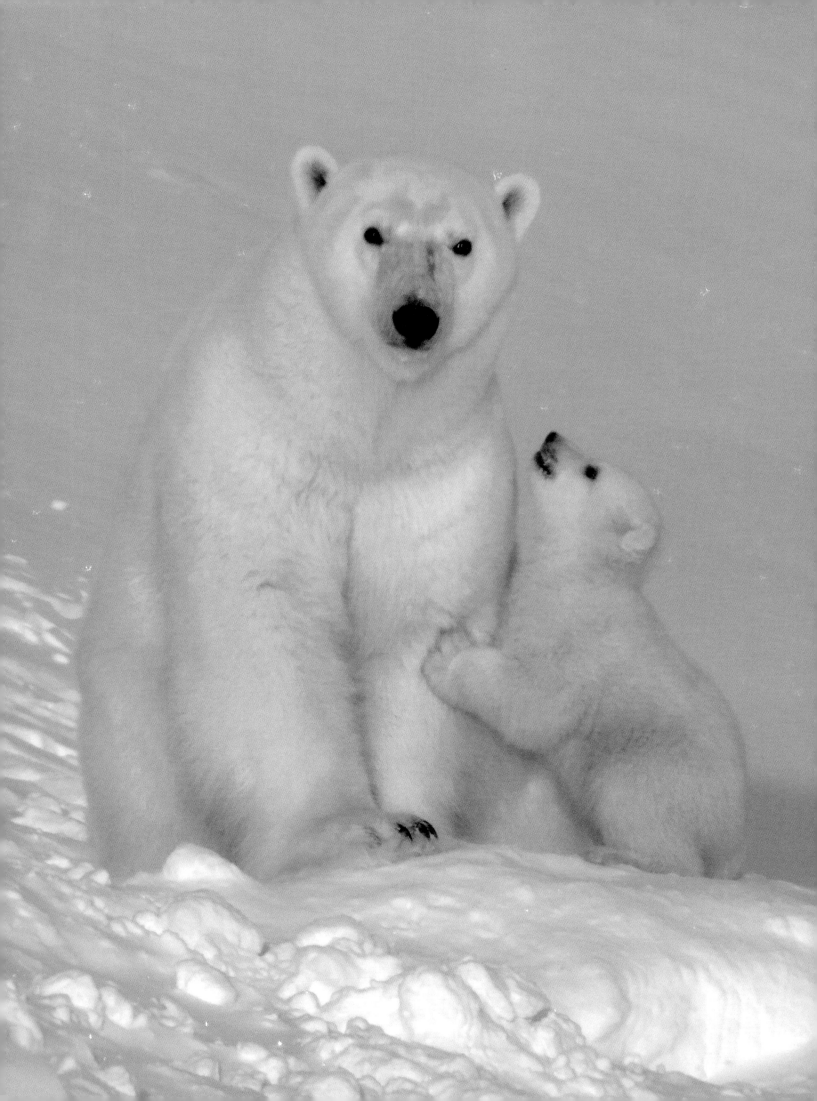

SOME POLAR BEARS ROAM ENDLESSLY; some are more local. Kara was a wandering bear, while Bouba le Blanc was a more local one. Bouba was captured by scientists in her home territory on northwestern Spitsbergen in the beautiful Raudfjord. They fitted her with a GPS collar to follow her movements. From this data—as well as satellite images of ice conditions at the time—we can make a series of assumptions.

Bouba was a beautiful young female in very good shape that had not had her first cubs yet. She spent all spring and early summer around Raudfjord, where there was plenty of ice, and she caught several seals. But in early summer, the ice melted. Bouba was stranded on land, and didn't eat anything for several months. As autumn arrived, she was starving. Bouba had mated earlier in the spring and was going to have cubs around the turn of the new year. If she didn't get anything to eat, she and her cubs would not make it.

In October, she jumped into the freezing water and swam north. And she kept on swimming. She swam for three days, almost 100 miles, until she finally reached the solid ground of the North Pole pack ice. There she spent a month on the ice, walking back and forth, catching seals and eating plenty.

But in November, winter was approaching. Within a few weeks, she would have to build a den and enter it. It is impossible to accomplish this feat on moving and unstable sea ice. So Bouba jumped back into the ocean and swam straight south, the same distance once again, back to the place she had come from. Once back in Raudfjord, she climbed a hillside to dig her den and later that winter gave birth to two cubs.

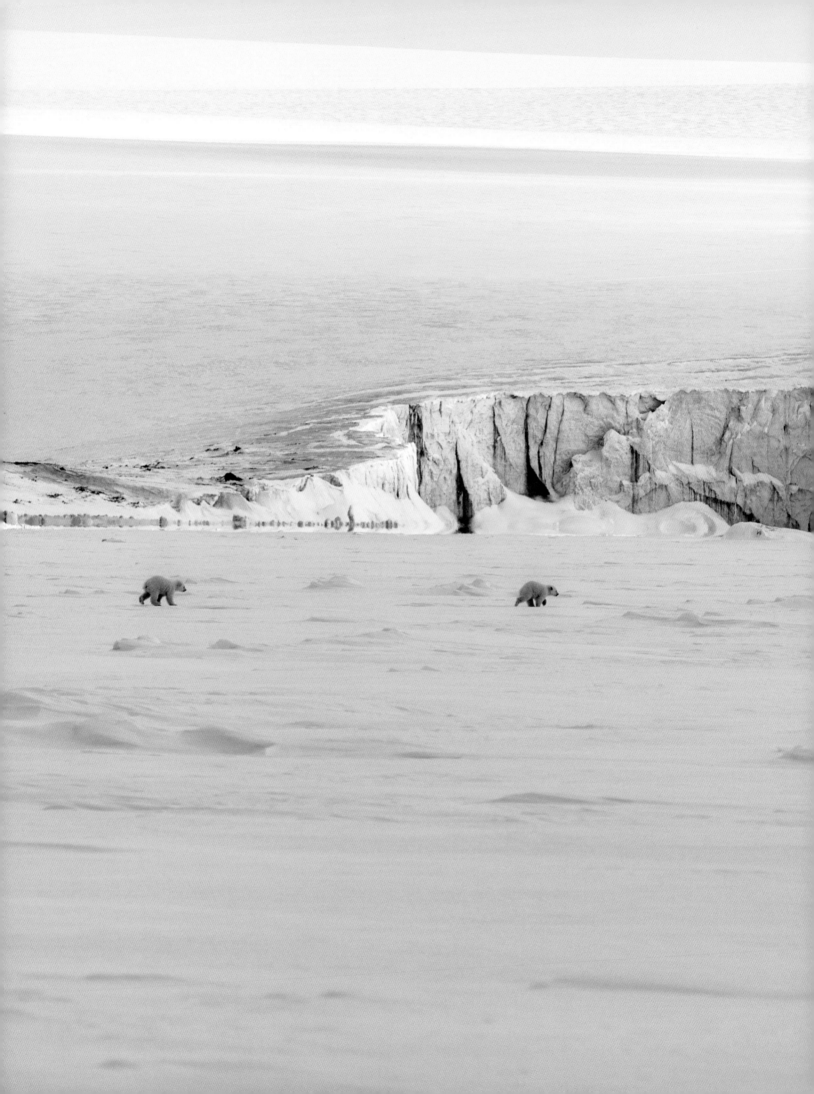

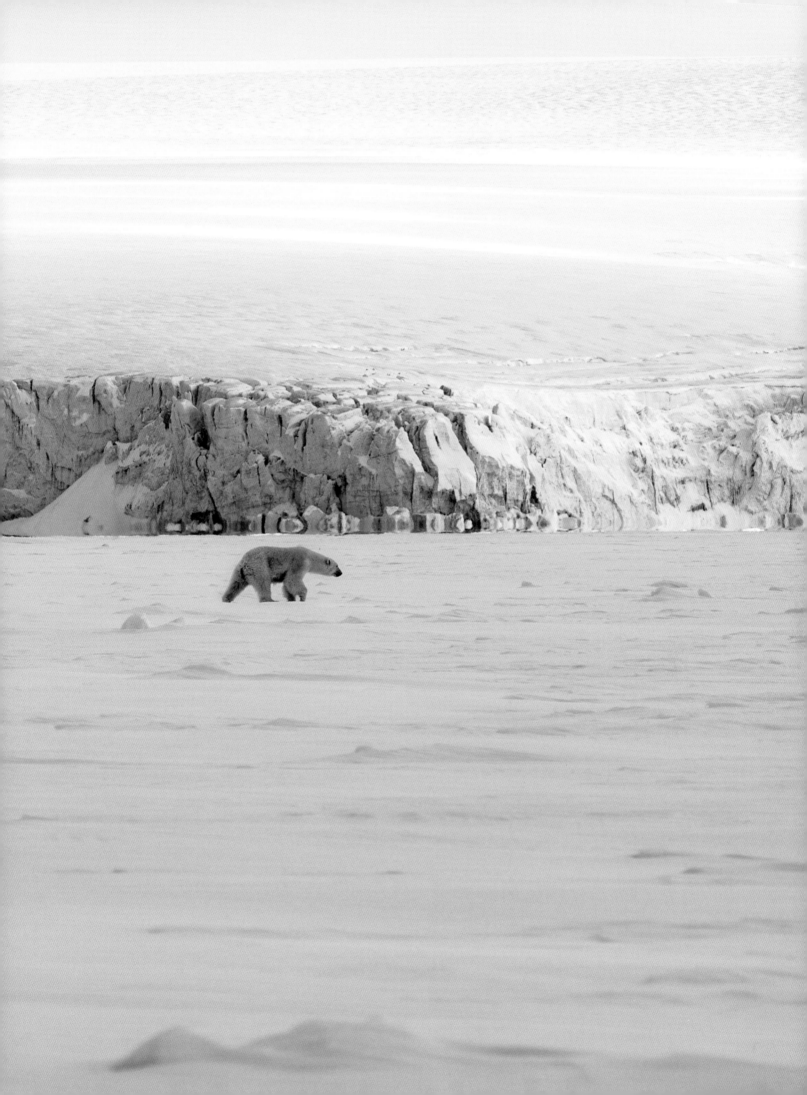

WE GOT TO KNOW THIS LITTLE FAMILY well on the sea ice outside Spitsbergen. We had a magical night, one of the last before the midnight sun, and one of the best we've had with a polar bear.

When a mother and her cubs leave their den, the travel is slow at first, with many stops to rest and feed the little ones. But once the mother starts catching food, the speed and activity increase. Finding food is crucial for a polar bear, even more so for a family like this one, as they just came out of their den and haven't eaten in many months.

The mother was amazing. She was completely focused on hunting, but at the same time she always kept a careful and protective eye on her cubs. Spring and early summer are important times for a mother bear, as there is only another month with good conditions to find seals before the ice melts, breaks up, and drifts away. The solid floor she walks on will disappear and remain open water until the next winter.

The cubs do what small kids usually do: play, wrestle, fight, and have fun. But you can also see how quickly the mother gets them disciplined. They listen to everything she has to say. She allows them to be cubs and fool around, but when she tells them to stop, they do.

Another interesting thing about cub siblings is that one is often adventurous and curious, while the other is more shy and stays close to the mother. The times we believe to have encountered the same cubs a year or two later, their characteristics have remained the same or even been strengthened. Or the weaker cub has been lost.

A polar bear cub weighs 10 pounds at birth and is about 12 inches in length. It is amazing how these cute little cubs will grow and develop if their environment allows it.

On the next spread, the polar bear mother is approaching a seal's breathing hole. A seal can keep dozens of holes open in an area to avoid bears. The bear's four-month-old cubs have already been taught to stay away when she hunts, so they cuddle up by an iceberg a few yards away to wait. They lay close to keep each other warm.

Food is sparse, and patience is a virtue. Silent and still, the mother stands over the hole. Hours pass while she's waiting for the suspicious prey to appear. The patience of a polar bear can seem endless. It is incredible to watch, but for us it can be quite a challenge—sitting still for so long in the cold, not wanting to disturb her.

Following a family like this one—seeing how they play, rest, hunt, interact, and show affection—fills us with so much life. More than anything else, it is perhaps moments like these that give us so much optimism and fighting spirit. Sometimes life is almost too beautiful.

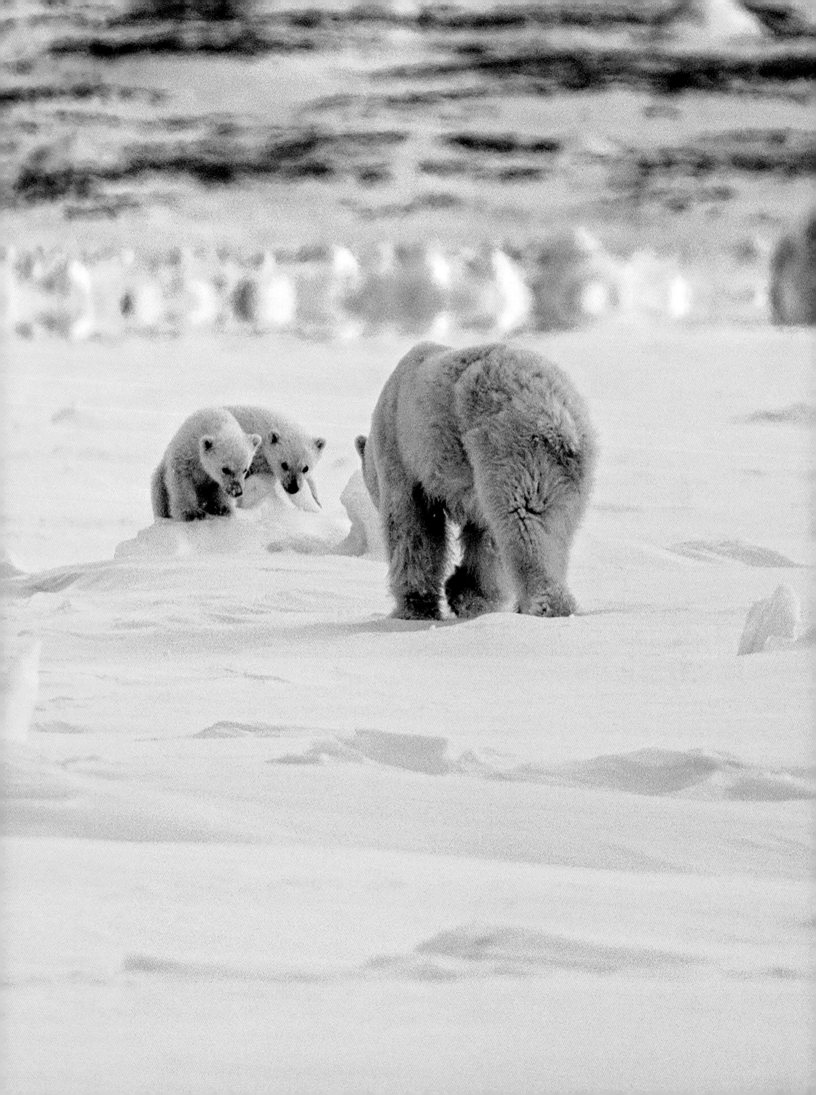

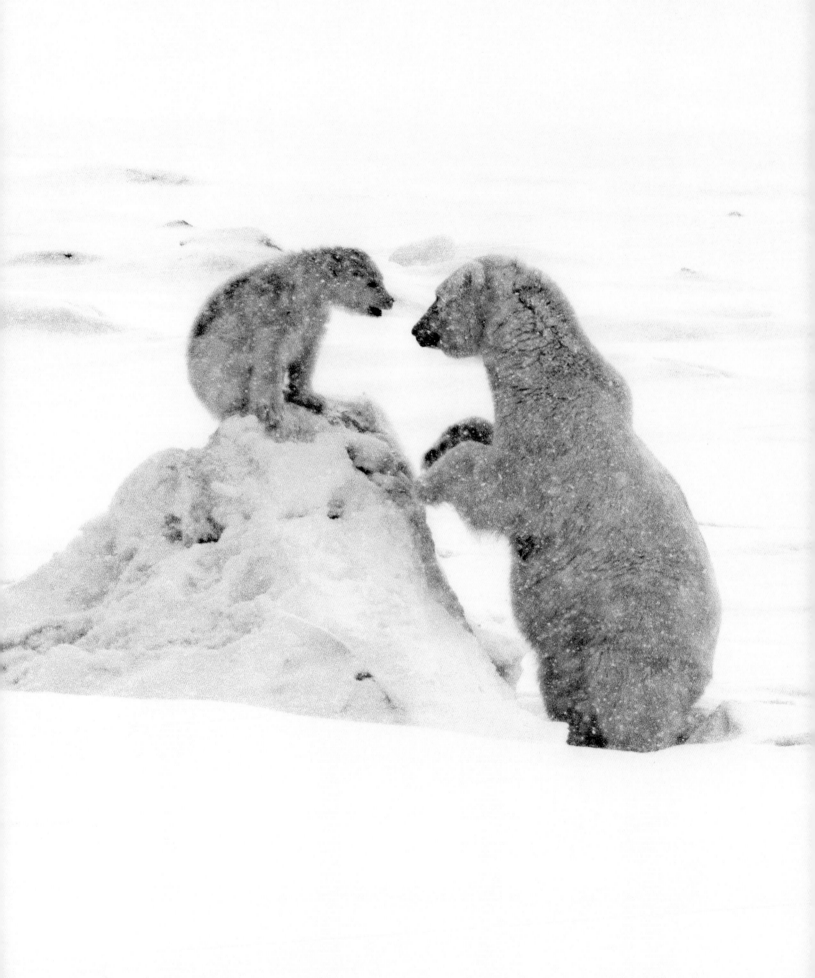

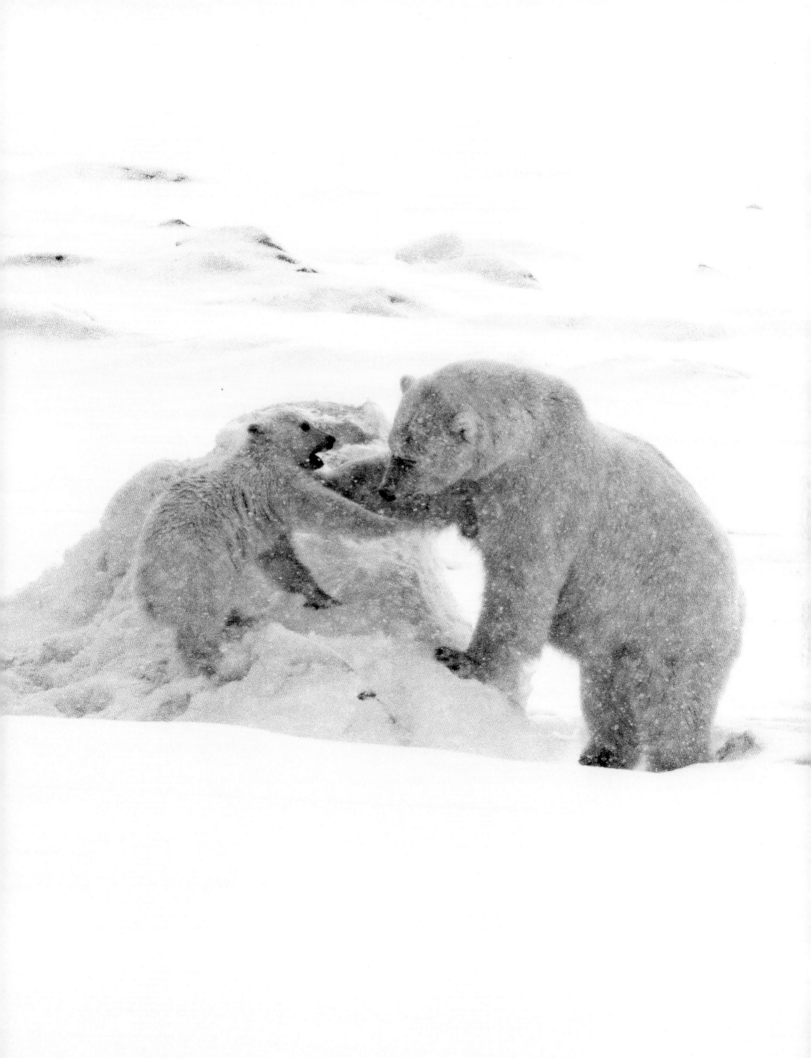

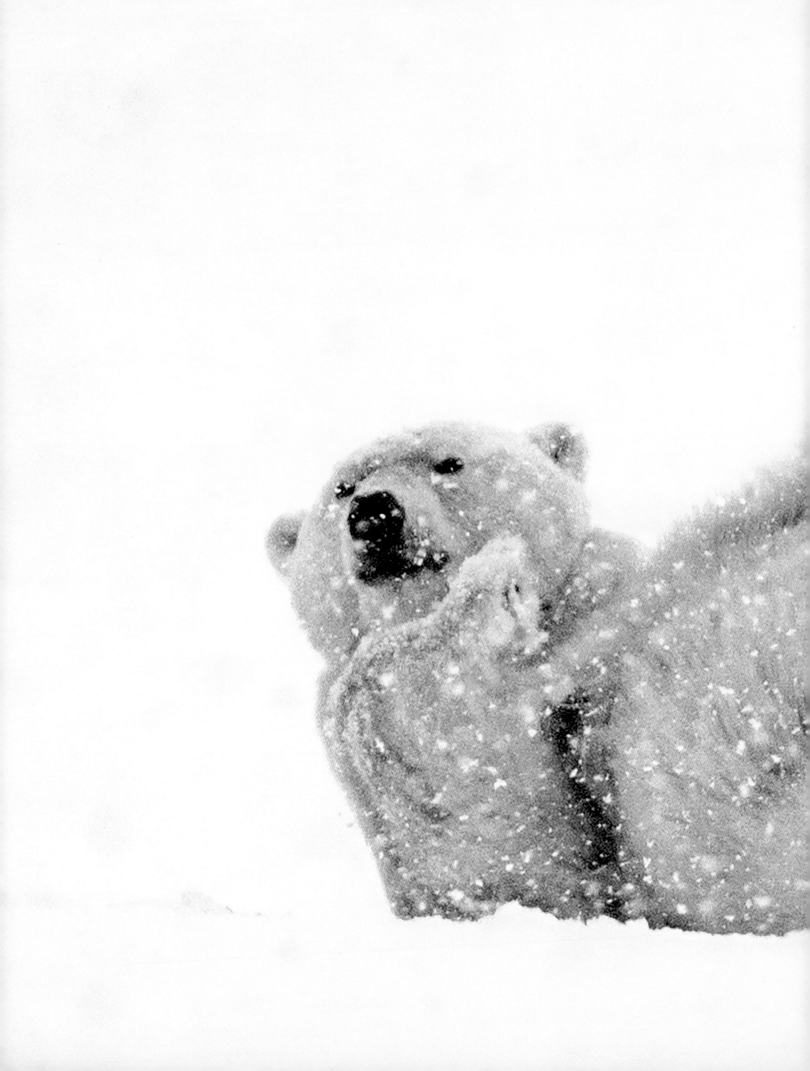

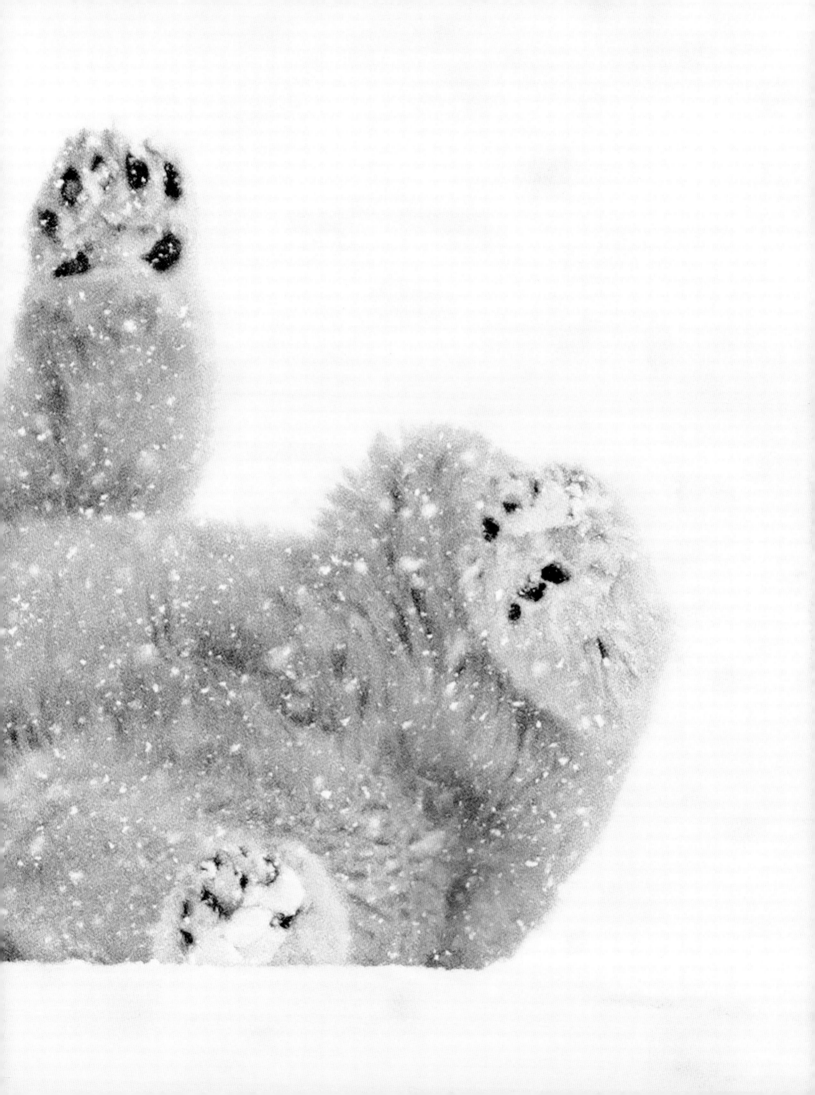

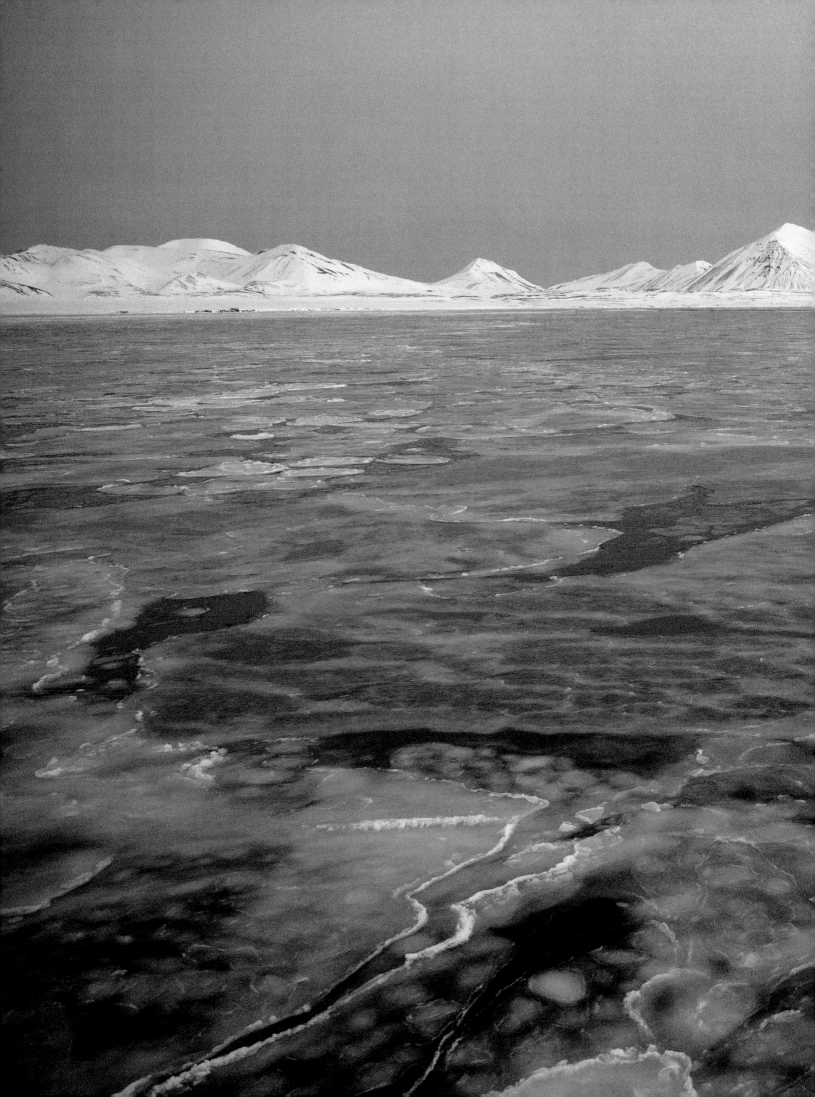

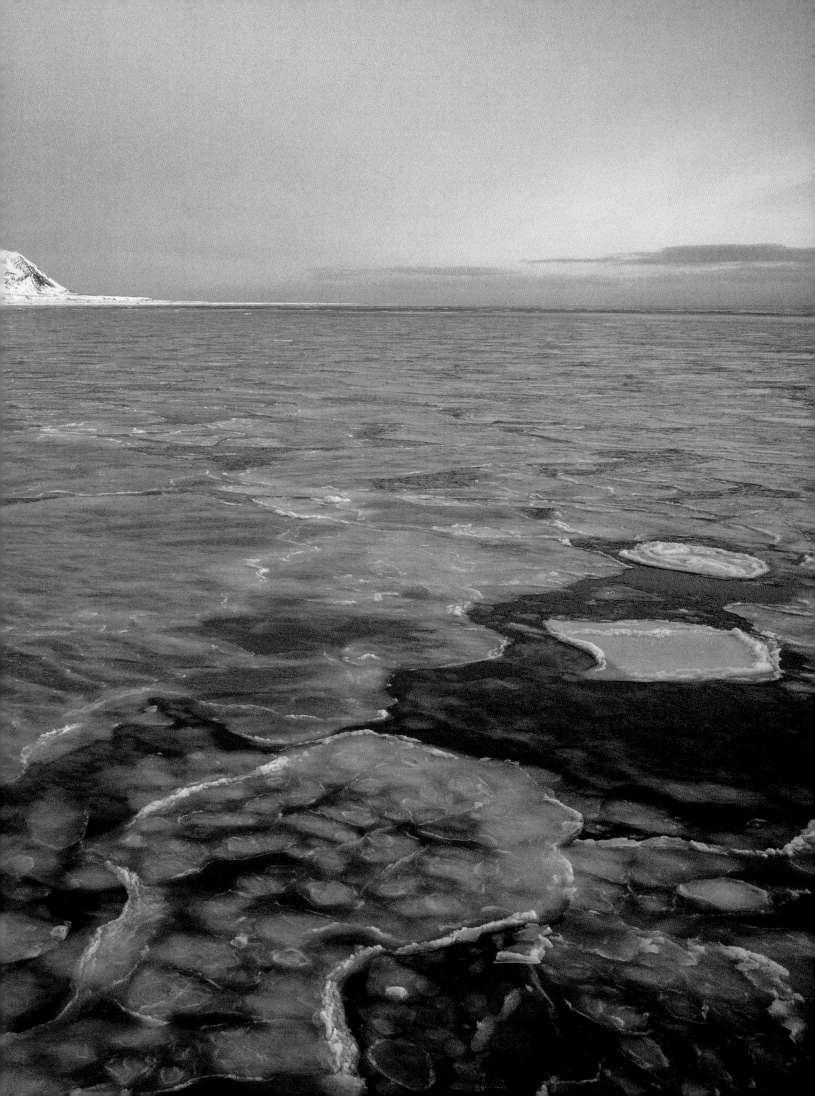

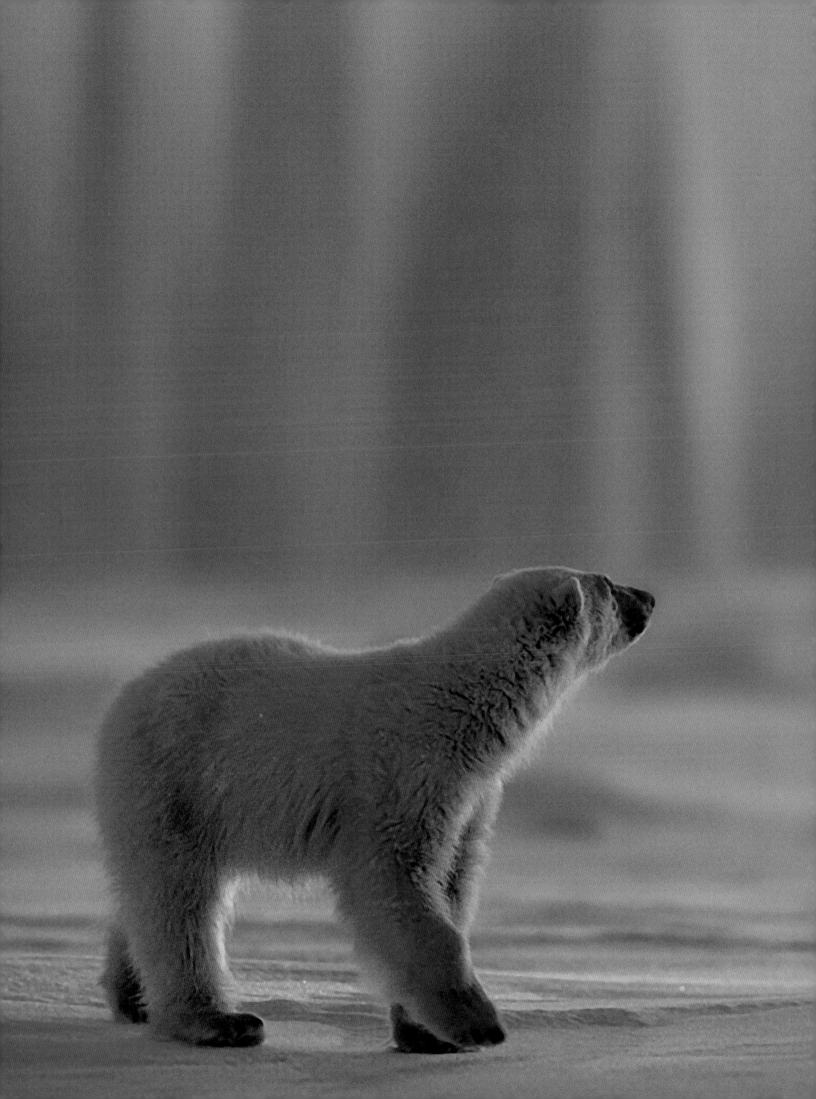

LEARNING ABOUT POLAR BEAR BEHAVIOR and having the privilege to live with the bears over longer periods of time are important parts of what we do. One winter I spent more than a month with a polar bear family—a mother and her two one-year-old cubs, a male and a female. I had a camp on the shore, a cozy little cabin built by polar bear hunters in the 1930s. The bears spent their time on the frozen fjord area surrounding it. The mother didn't take any interest in me. She spent all her waking hours sniffing out seals and hunting—totally ignoring me, as if I wasn't there.

She was an amazing bear. One time she waited over a seal's breathing hole for more than three hours. Then suddenly, with explosive power, she jumped into the hole, and the white scenery of snow and ice transformed into a scene of bloody carnage in a second. Patience is everything. She now had food for her family.

She was the best mother a cub could ask for. One-year-old cubs are growing up quickly—at 150 to 180 pounds, they're already big—and they're beginning to learn how to hunt. But they lack their mother's patience and spend most of their time playing.

The male cub was the strong and dominant one. He would always approach me, very curious and checking me out, not sure if he wanted to play with me or kill me. And even though he was still far from grown up, he'd be able to kill a human if he wanted to. The problem with these youngsters is that they are so unpredictable. They don't read your signals, and it's difficult to read theirs. Trying to make him back off the way I do with adult bears sometimes had the opposite effect—he'd approach more instead of retreating.

His sister was different, not as playful, and she usually stayed as close to the mother as she could, often trying to fend off her stronger and wilder brother. She also kept a good distance away from me. She was curious, but not brave enough to come close. A special and beautiful little lady.

A few months later, after a summer void of sea ice, I came back to this fjord in a boat. On the shore I spotted the mother sleeping. A bit farther out the male cub was playing with a piece of driftwood. His sister was nowhere to be found. One of the many cubs lost.

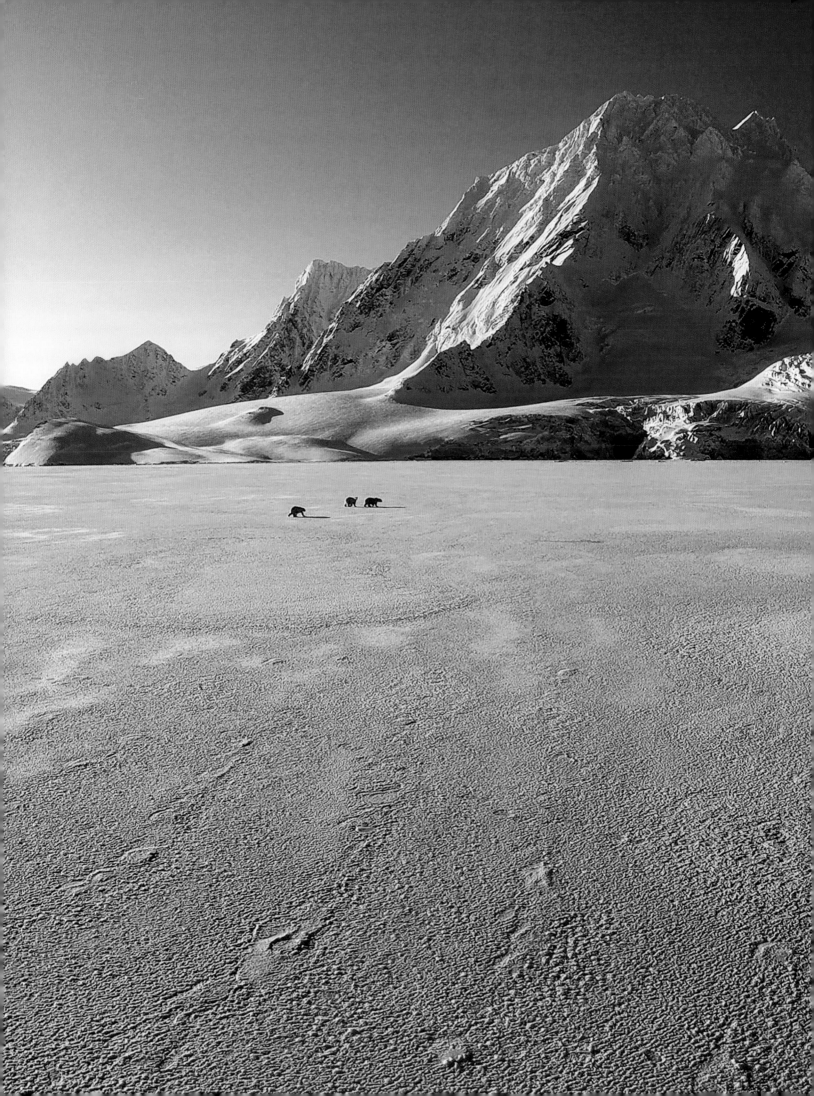

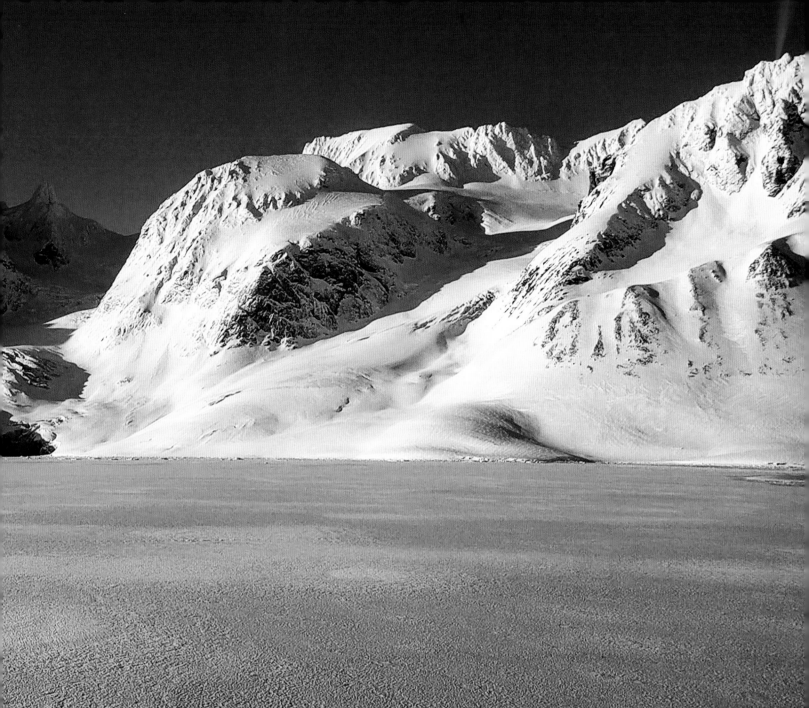

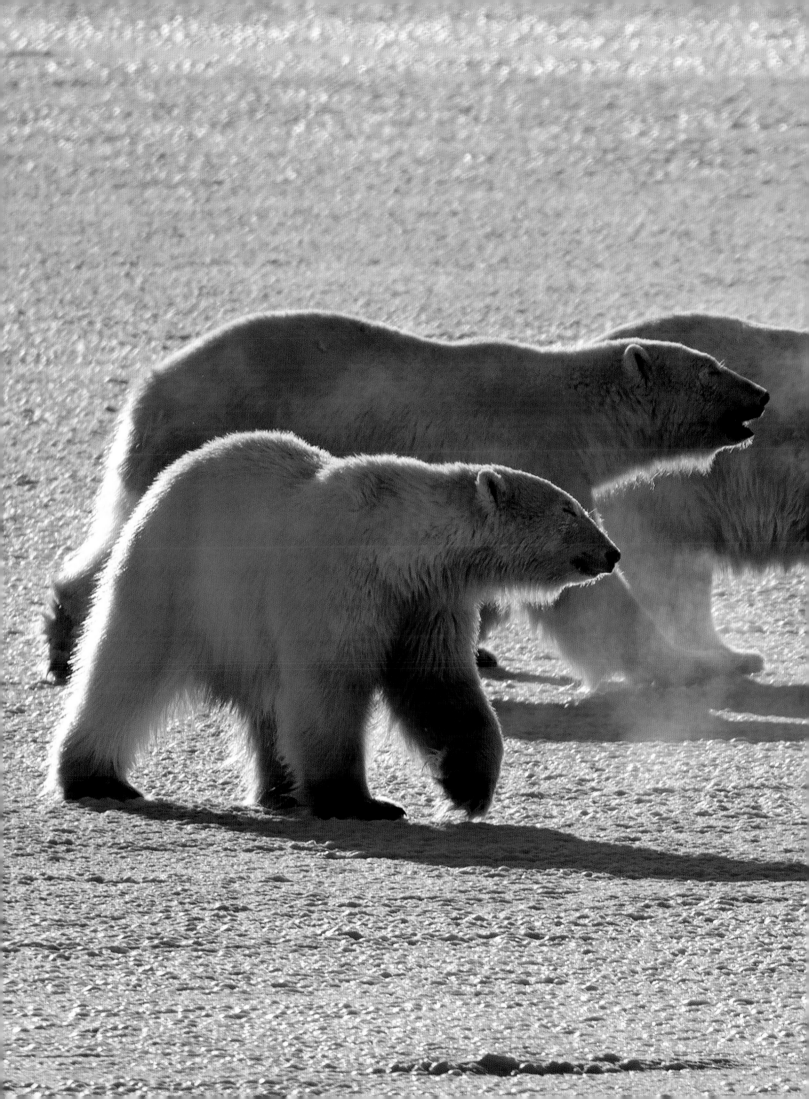

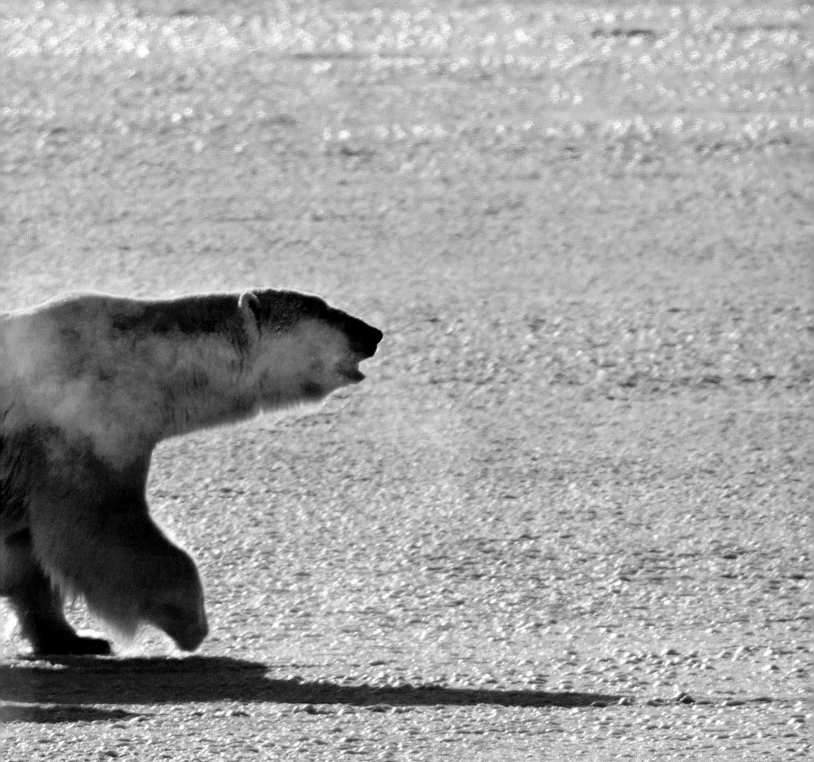

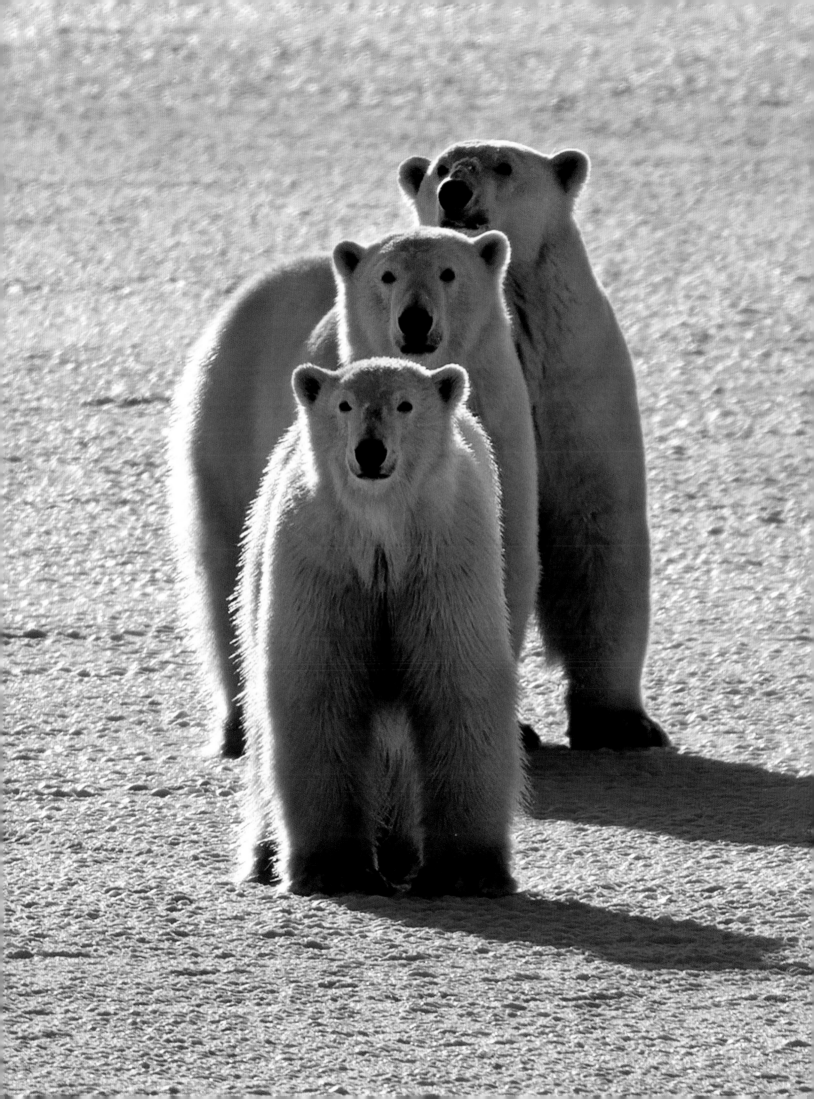

THE BEARS STAY TOGETHER AS A FAMILY for around two-and-a-half years. The cubs follow their mother closely, learning all about life and survival. After two years on the ice caring for her cubs and teaching them everything she knows, the mother is ready to breed again, and the cubs have learned how to make it on their own.

It is usually in spring or early summer when a polar bear cub splits up with its mother. Often it is a process over time—the cub becomes increasingly independent and then eventually leaves—but sometimes it is more dramatic.

A few years ago, I was working with a polar bear mother with a single cub. I had been following them off and on for a few days when a big male bear arrived in the area. Spring is mating season, and this guy saw the bear mother as a potential new partner. He began stalking her, first from a distance, but then closer and closer. When he got too close, the mother firmly pushed him off. Then he would back off, lie down, watch from a distance, and then approach again a few hours later.

This happened several times over a couple of days. The male bear became more anxious, and, I think it was on the third day, he managed to get between the mother and her cub. Only a few yards away, very aggressively, he threatened the cub—lowered his nose, made loud hissing noises, and slammed his paw in the snow. The cub sat down, as if surrendering.

I remember closing my eyes, thinking, "Oh no, I don't want to see this." But just as he was about to attack the defenseless cub, the mother ran in between them, past them, and away. And she kept on running. In the blink of an eye, the big male forgot about the cub and followed the mother. It was the only way she could save her cub. With binoculars, I followed her far away, for miles.

She never came back.

The abandoned cub, looking like the loneliest creature in the world, lay down and didn't move for hours.

Life is tough for a young bear when it splits with its mother. She had taught him a lot, but catching food on your own is difficult. Two weeks later, however, I watched this cub catch what may have been his first seal. He looked strong and confident.

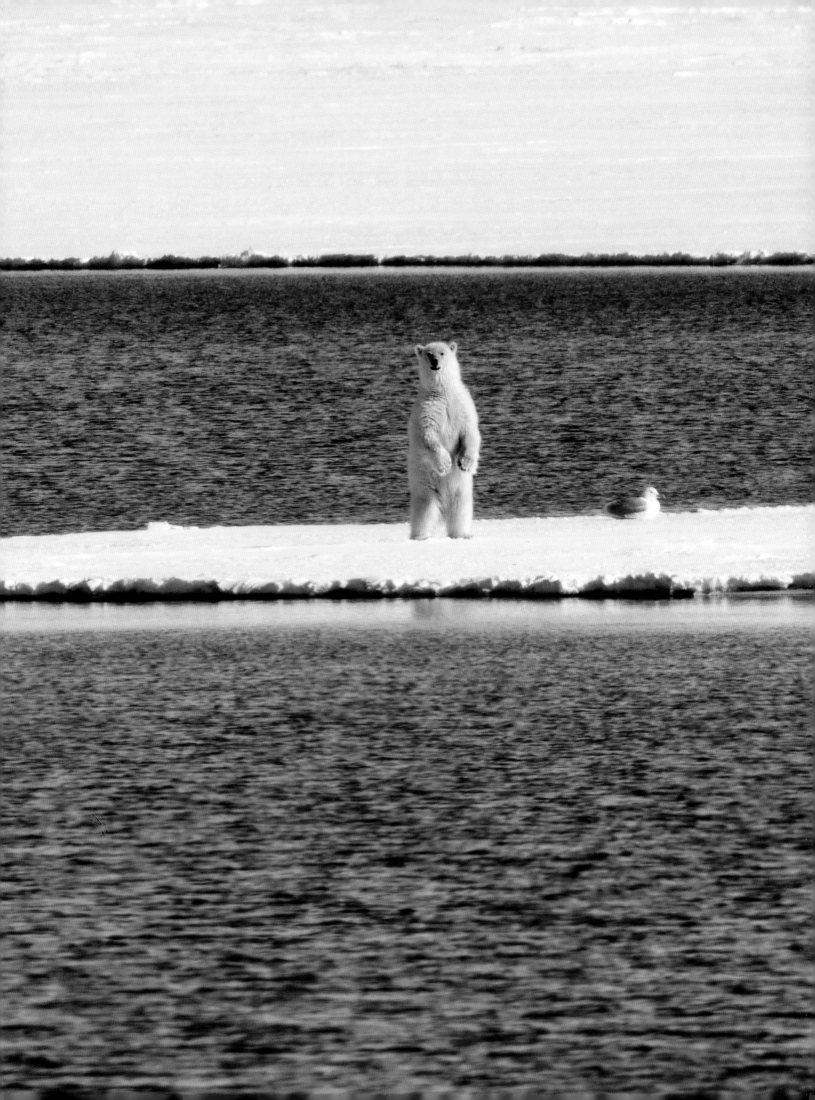

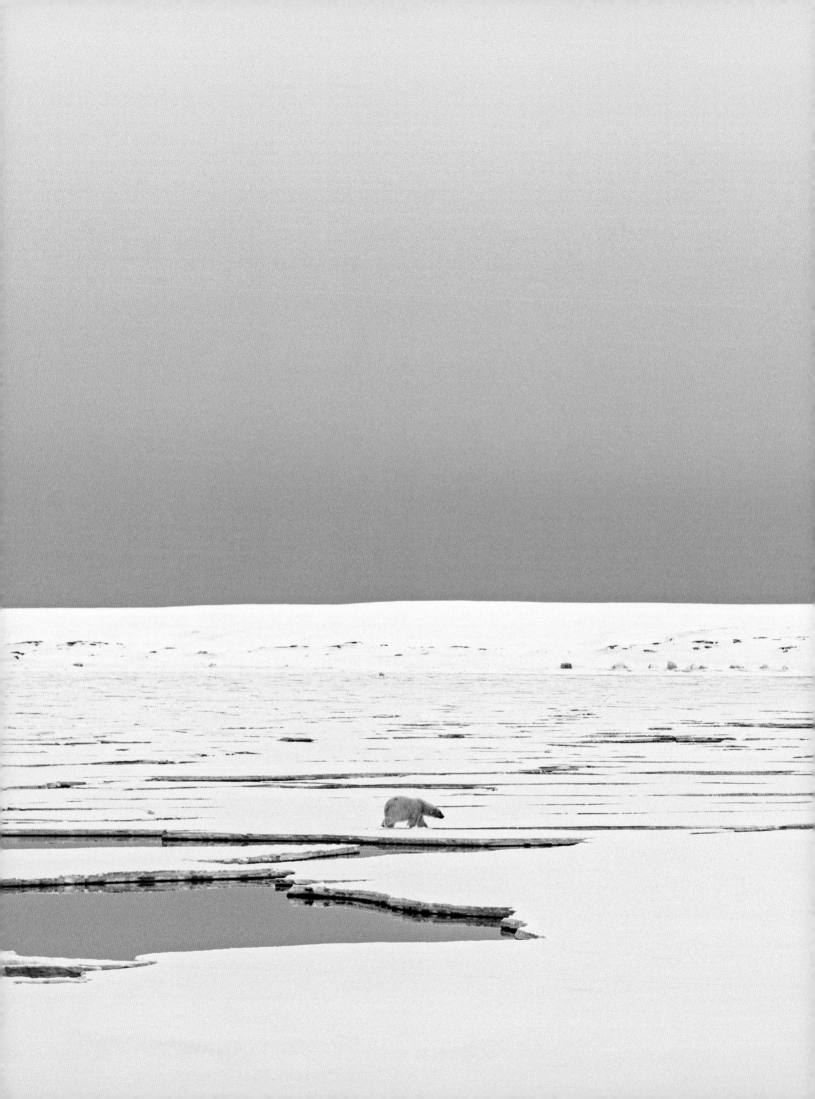

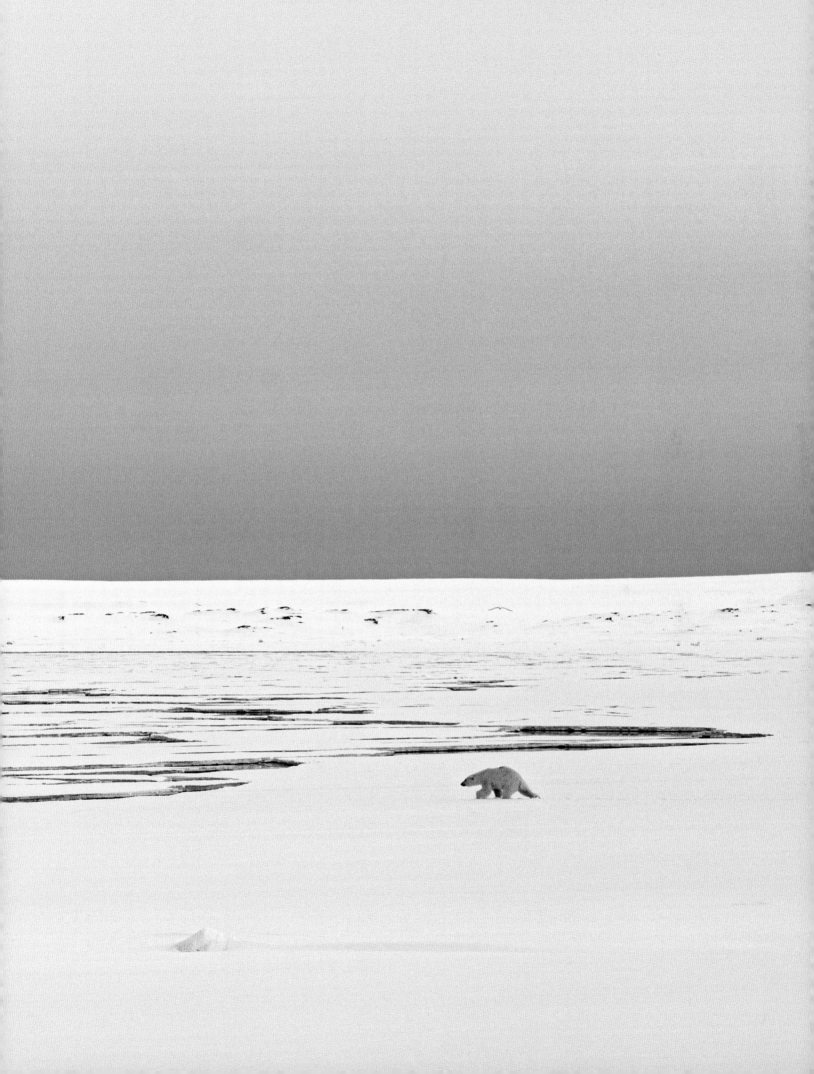

SOMETIMES MIRACLES HAPPEN. One evening we were following another young bear, a three- or four-year-old female. She caught a seal, ate it, and then continued her journey to the next fjord. She walked over the ice, along the shore, and swam when she had to in order to find new areas to hunt in.

But suddenly she stopped and hesitated for a minute before she turned around. Her pace increased, and she walked quickly back to the area where she had come from. Back in the fjord she climbed a small iceberg. It seemed like she was looking for something—or someone. After a little while, she jumped down and ran toward the edge of the fjord to the open water with its drift ice. From far out, we saw another bear coming toward her at the same high speed. The closer they got to each other, the more their speed increased.

For an hour or two they played, wrestled, cuddled, and chased each other across the ice and through the water, showing affection, love, and playfulness.

Both had the same kind of birthmark, like a discolored part of the fur. We are quite sure it was a brother and sister reuniting after what could have been years apart. Life on the ice is lonely. But not on a day like this one.

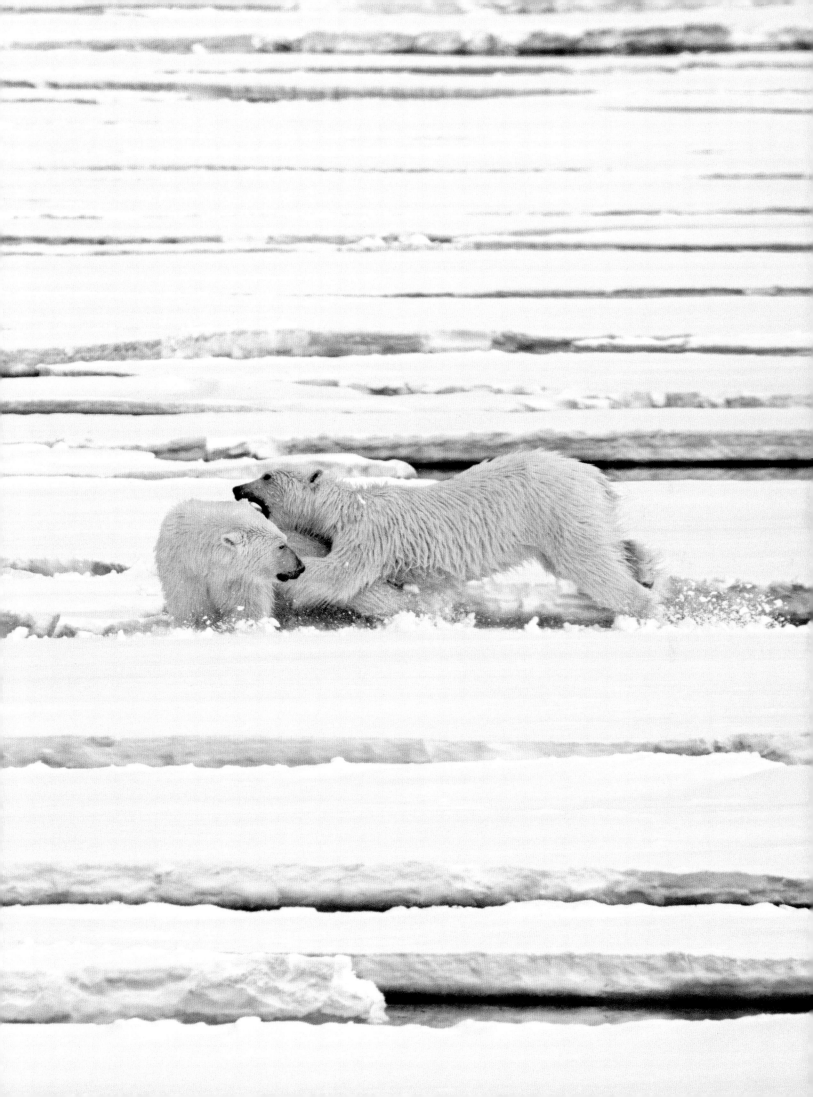

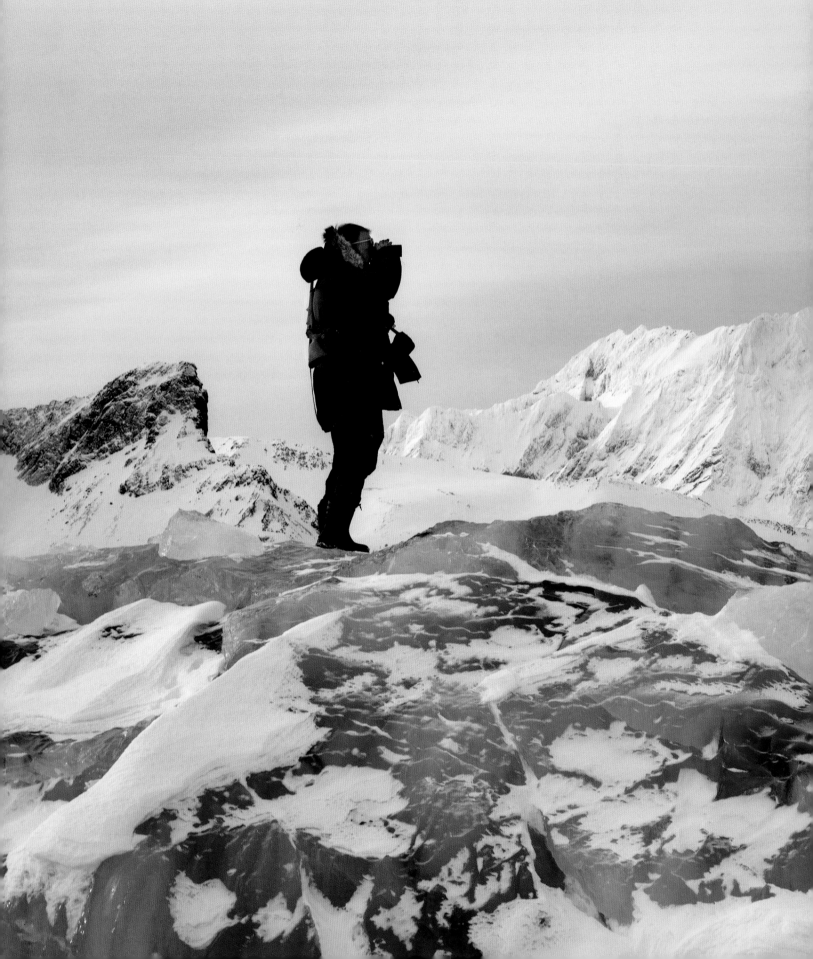

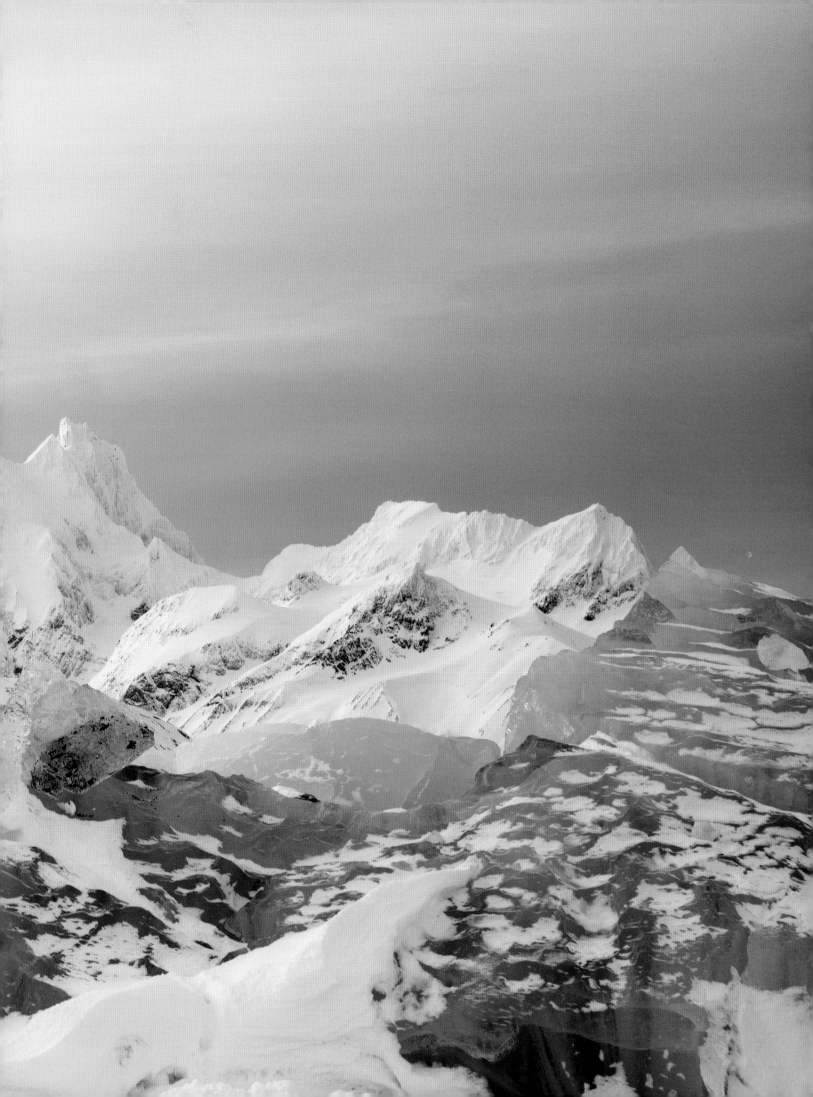

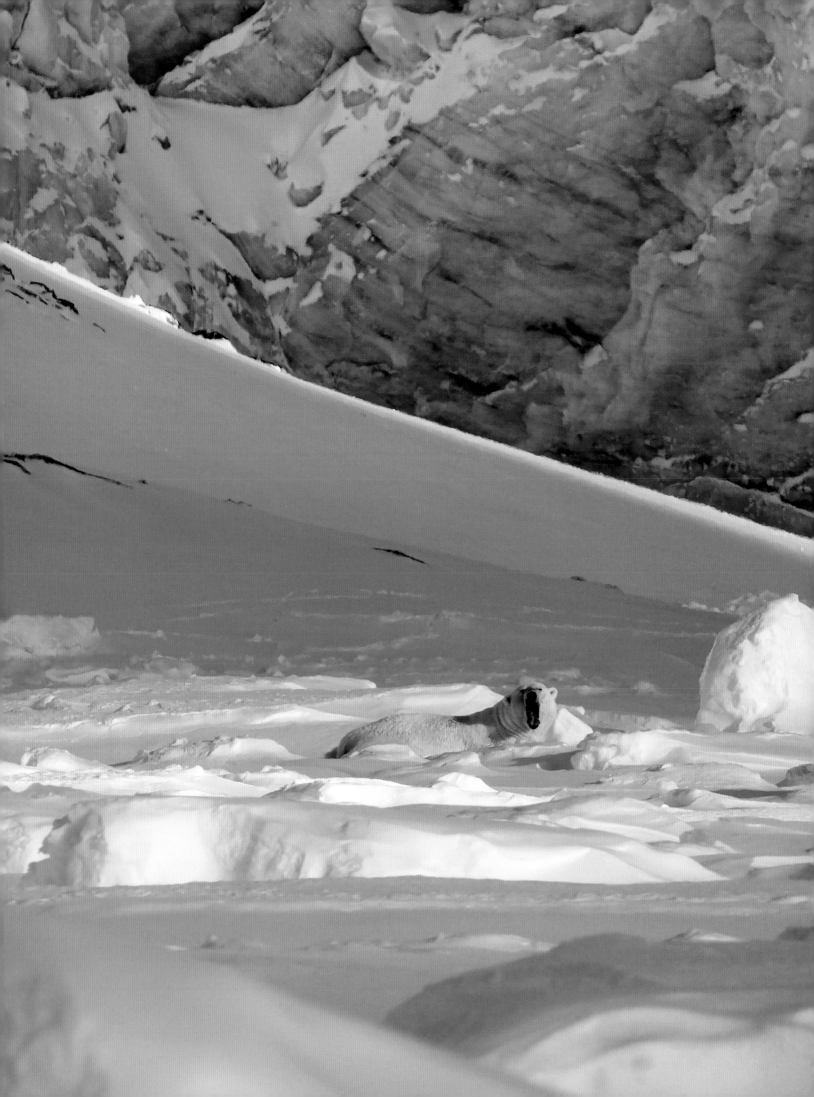

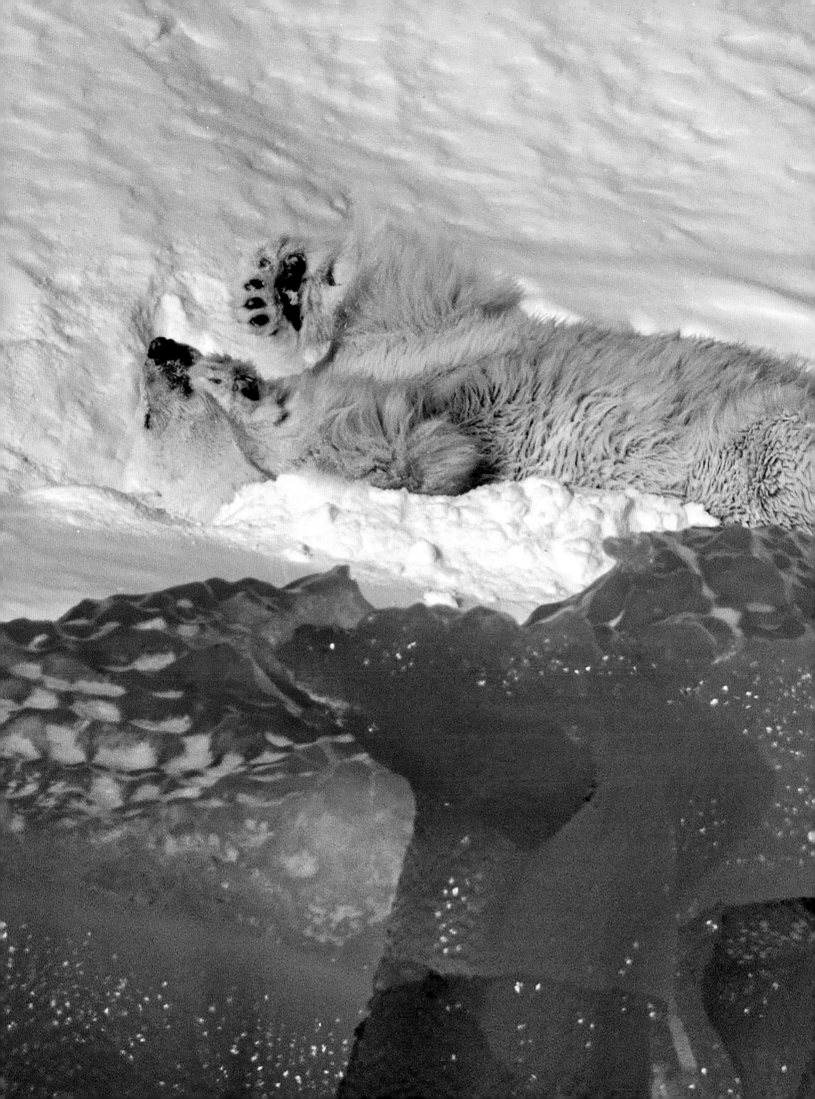

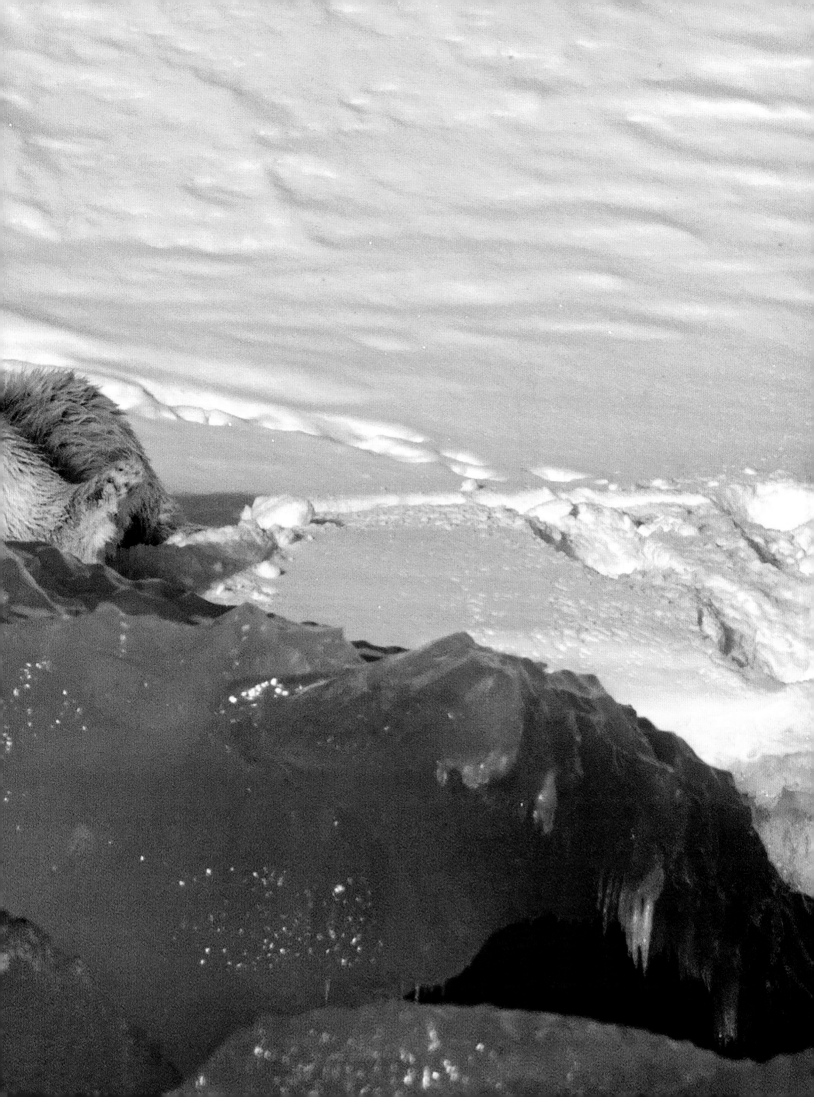

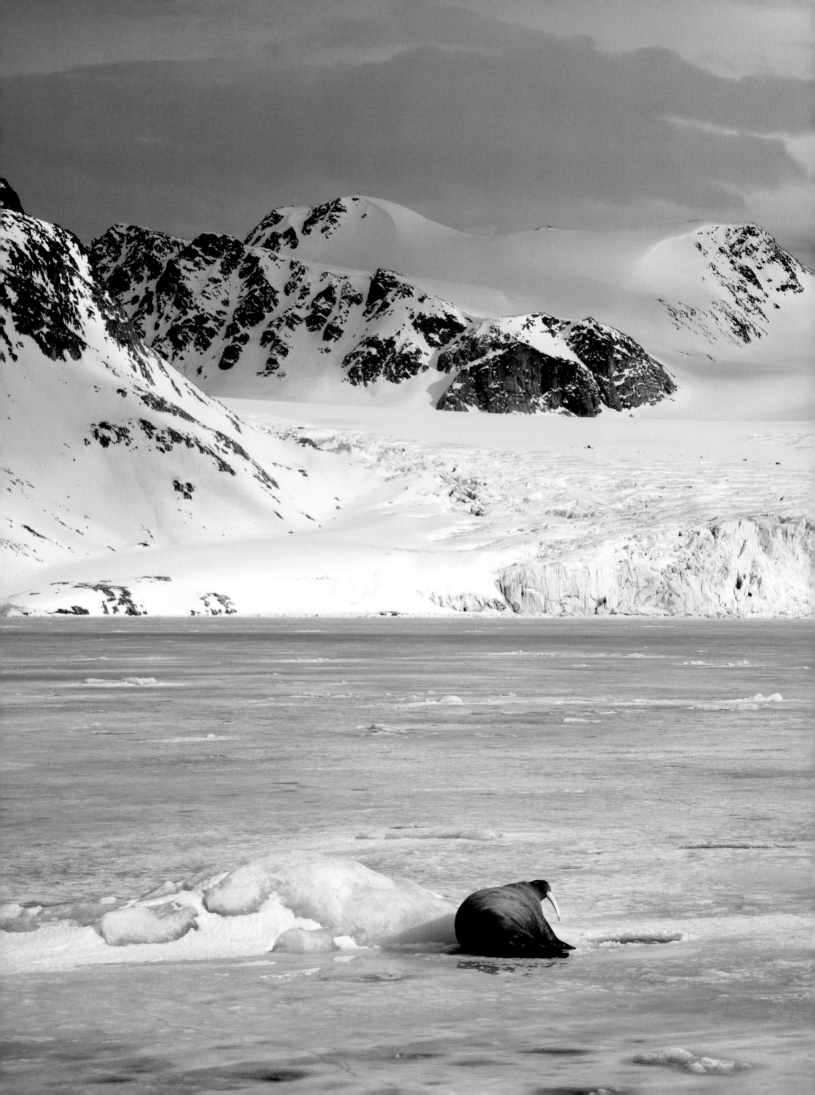

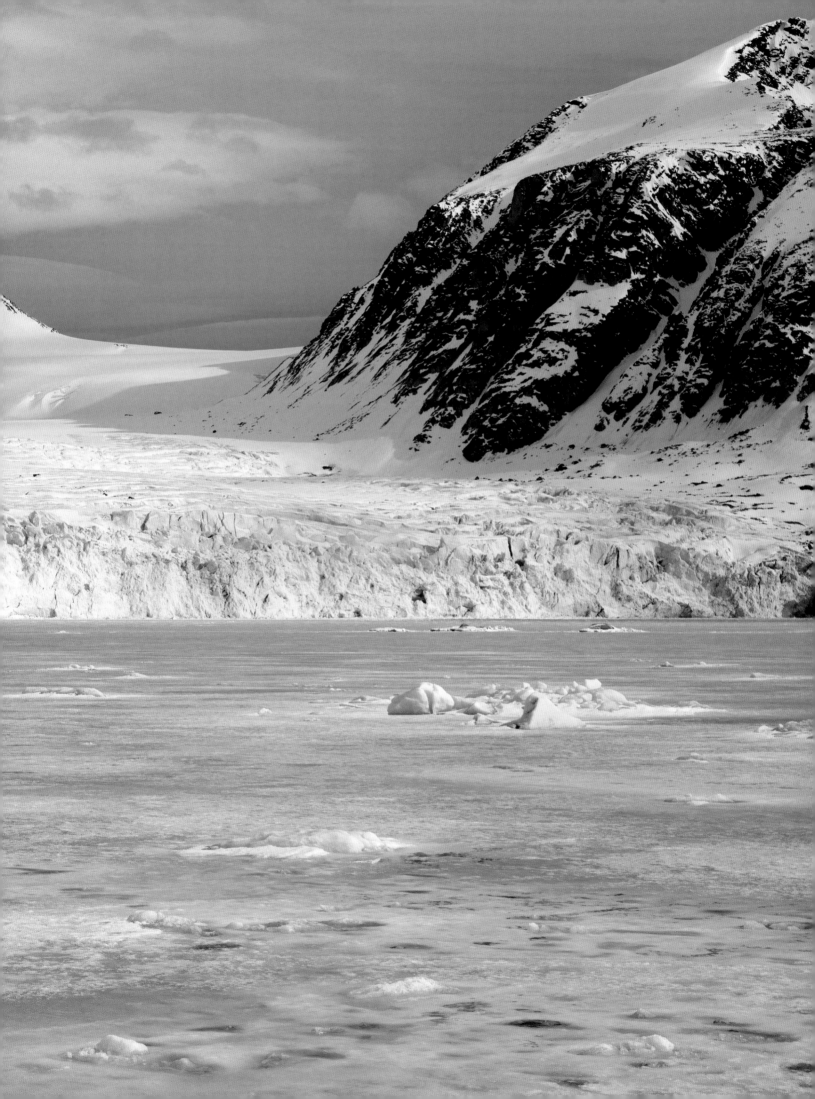

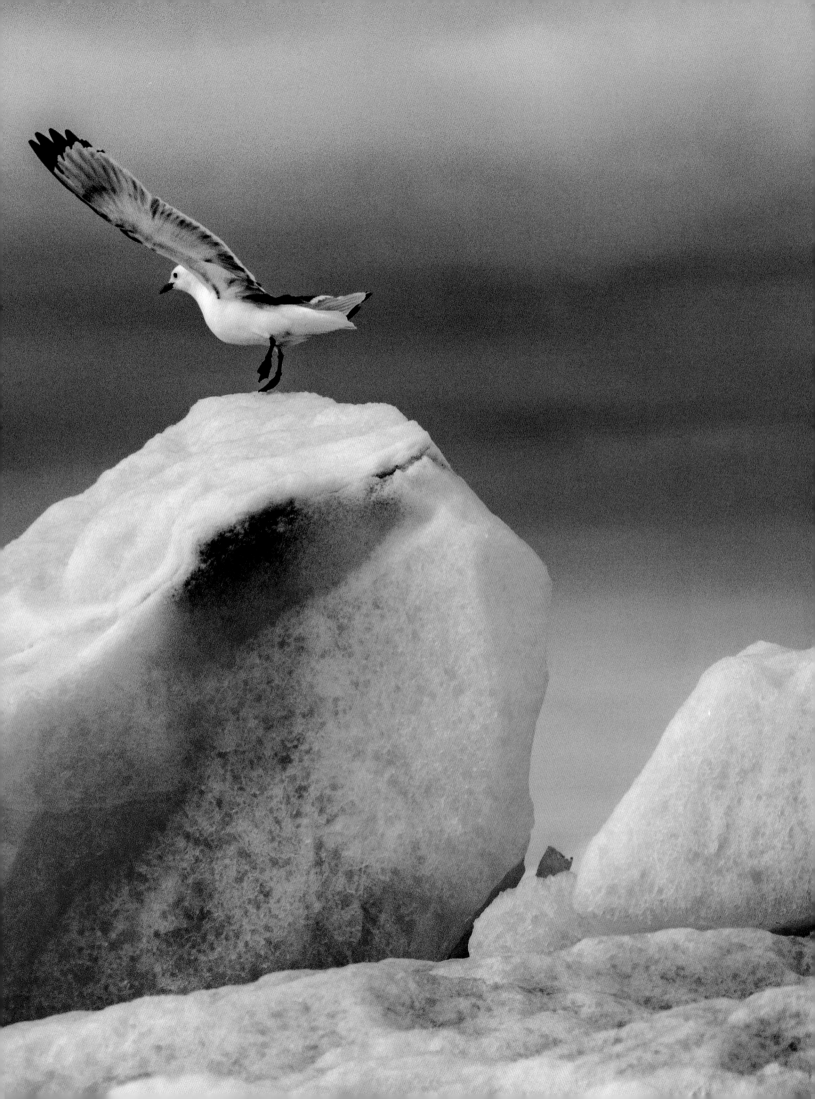

ICE AND THE FUTURE

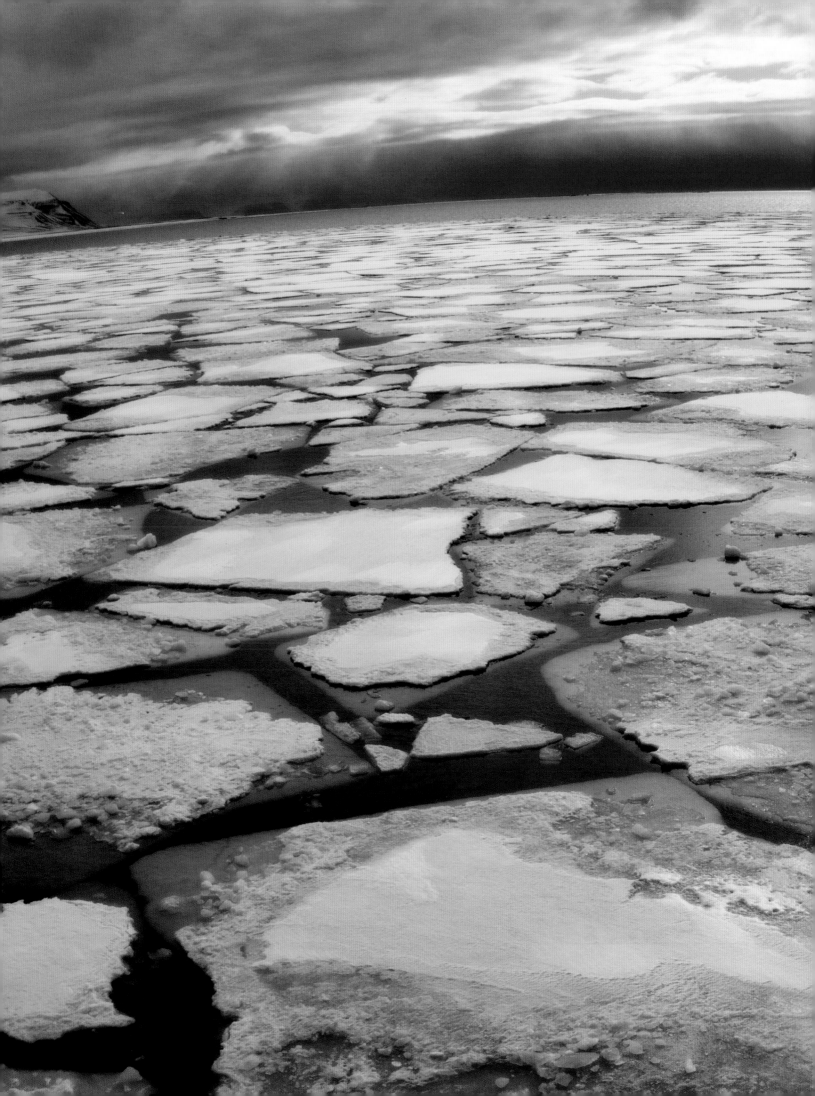

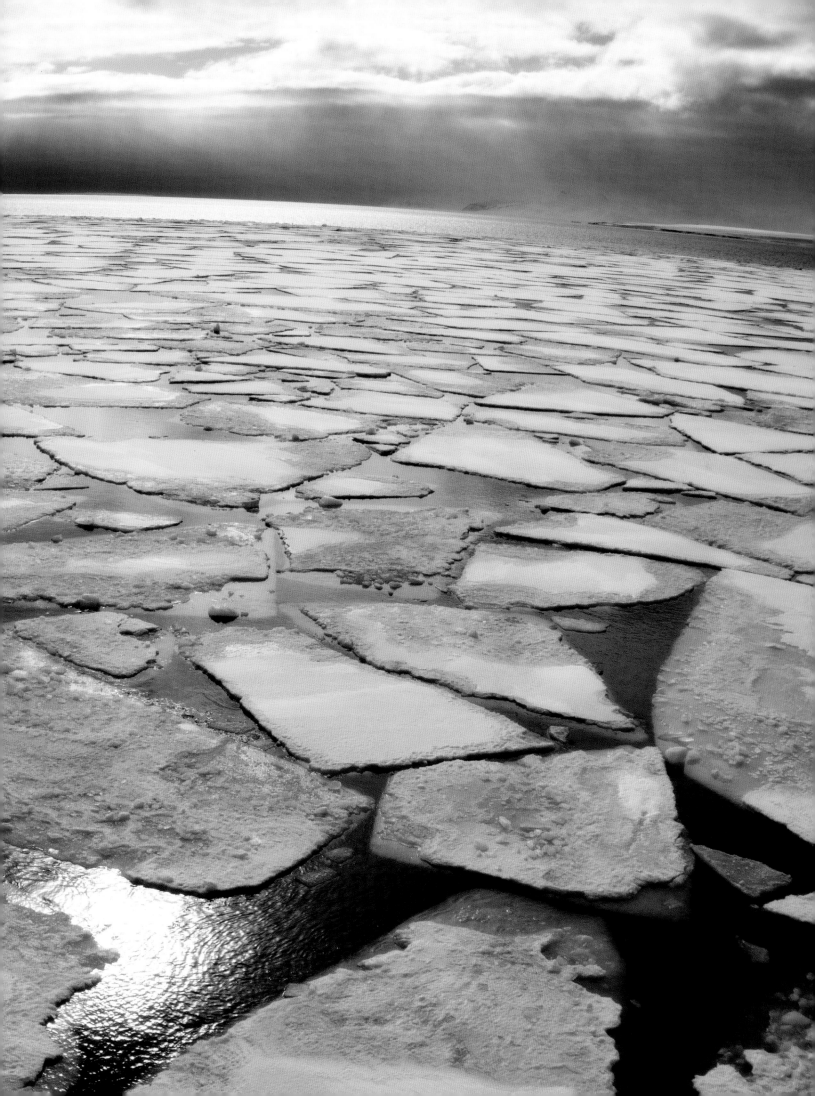

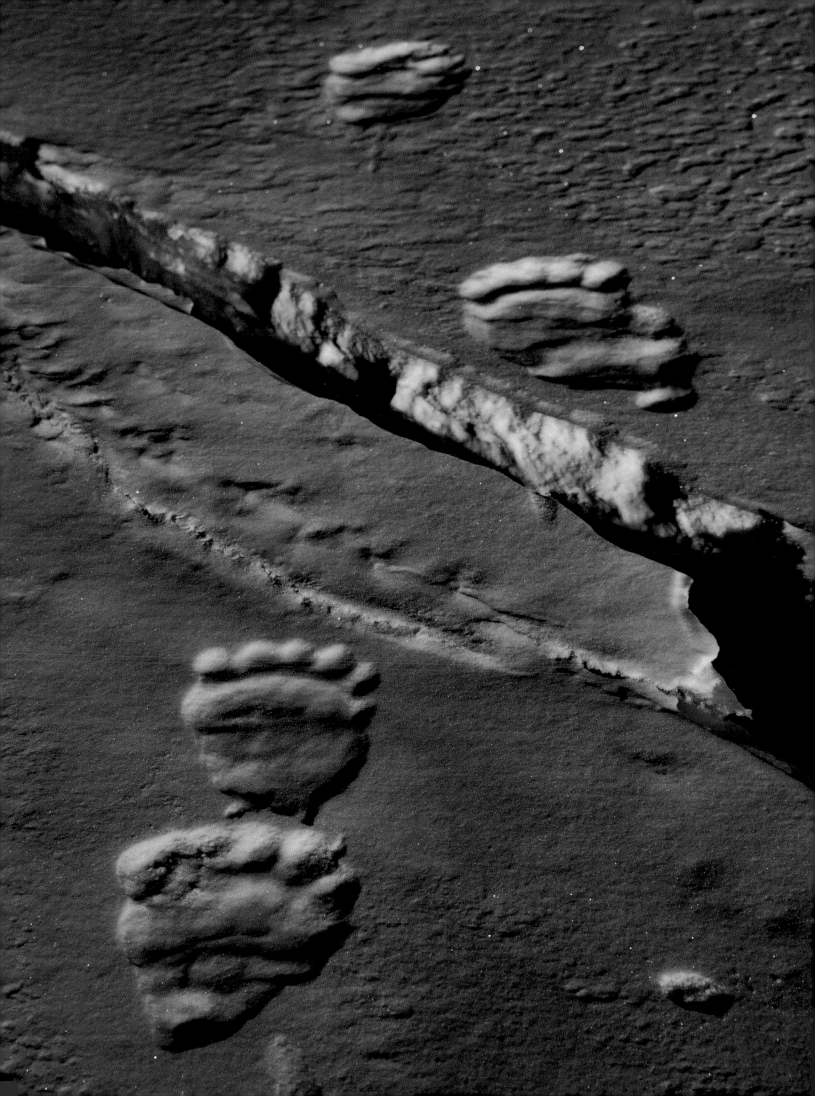

THE POLAR BEAR IS AT THE FRONT LINE of the most important fight of our time. The king of the Arctic can show us, in a very real way, what we are doing with our planet and how we are shaping our future. As the sea ice of the Arctic retreats and the territory of the polar bear becomes open water, the bear's home shrinks and melts away. It is a thermometer for our climate and the state of our planet.

Polar bears are completely dependent on sea ice for life. It is the platform from which they hunt for ringed seals, their primary food. In summer we often find polar bears trapped on land, walking around the beaches, and eating nothing, or very little, while waiting for the next winter and frozen ocean. With a longer summer free of ice, many polar bears are moving to land earlier in the season, with fat reserves that may not be enough to survive until the next winter.

Scientists predict that the Arctic could be completely free of sea ice during the summer in only 15 years. A sign of things to come was when the oldest and thickest sea ice in the Arctic, north of Greenland, started to break up in the summer of 2018. It opened waters that had been frozen year-round for ages, and an ocean free of ice all the way to the North Pole may be a reality sooner than scientists predicted only a few years ago.

It is now clear that the Svalbard ecosystem specifically, with the polar bear at the top of the food chain, is about to collapse. Some bears might find a temporary solution for survival and move with the ice to the northeast, to Franz Josef Land in the Russian Arctic. But the changes we see on Svalbard are likely to happen there as well, only later.

The effects of a warmer climate are many for the polar bear, and follow the same pattern in many areas: sea ice change, habitat loss, body condition loss, and then a drop in reproduction and survival.

Charles Darwin once said, "It is not the strongest of the species that survives, nor the most intelligent that survives. It is the one that is most adaptable to change." Most likely the polar bear was born out of this ability, when its environment changed. The polar bear is a true survivor, with the ability to adapt to almost anything. But while Darwin may have been right, the changes we are now witnessing in the Arctic are happening too fast.

When all the ice is gone, the polar bear will have nowhere to go. Because of how we live, winter is fading from our planet.

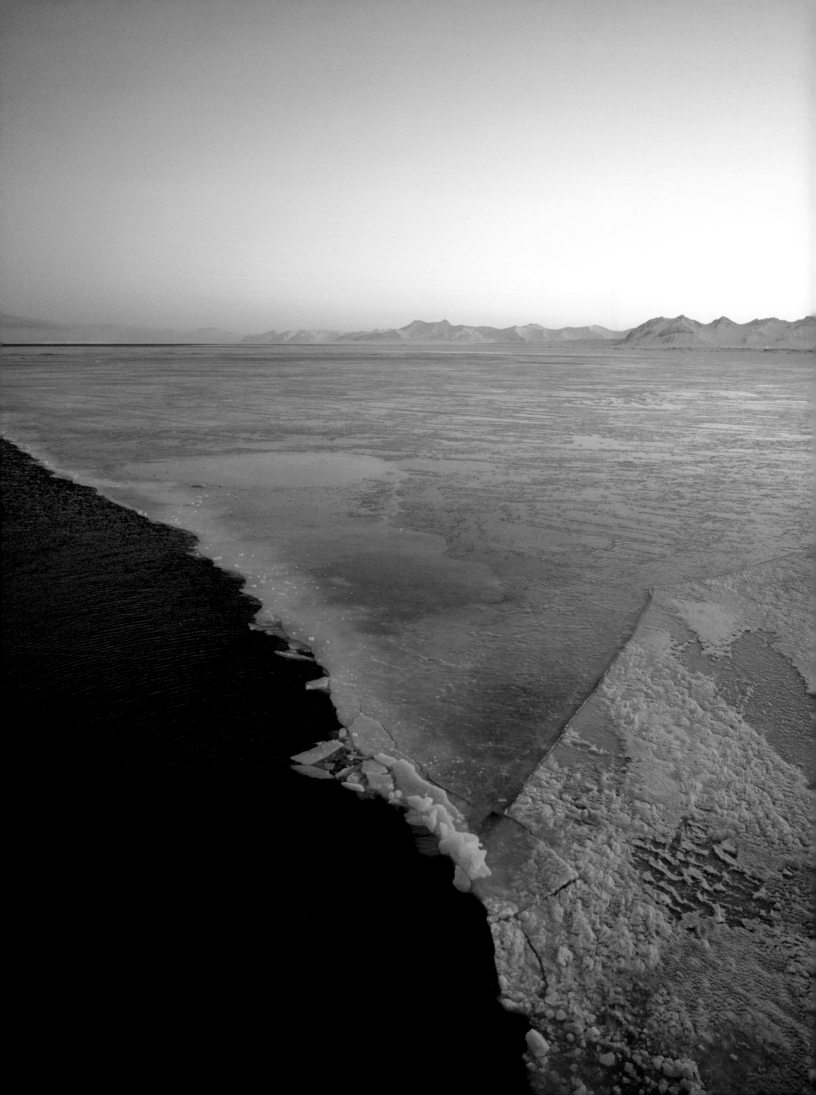

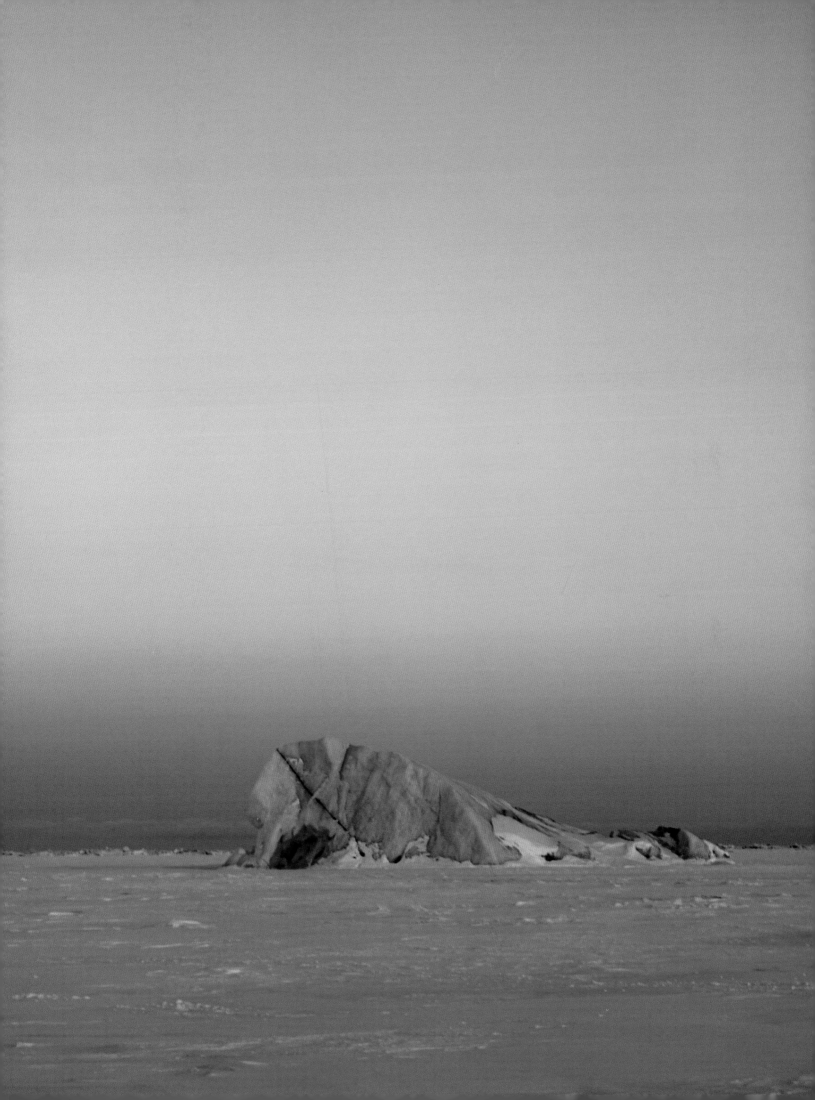

THE ARCTIC IS THE GROUND ZERO of global warming. Climate change caused by human action is the most serious challenge ever faced by humanity and nature, and it is happening right now.

Three-quarters of our planet's fresh water is frozen. Our two poles, glaciers, snow, and sea ice work as Earth's own air conditioner; they reflect the sun's heat back into space. When our climate becomes warmer and the ice melts, more heat is absorbed by open water and dark, bare land areas. This effect further heats the planet and leads to ever more melting. Ice melts exponentially. The less ice there is, the faster it melts.

What happens in the Arctic does not stay in the Arctic. It has profound ripple effects on us all. No one can hide from the warming of our planet. If we are not able to turn the trend, we are facing a worst-case scenario, with a four- to five-degree warming within 200 years. This means that the permanent ice sheets would disappear and sea levels would rise more than 65 feet, completely reshaping huge coastal and land areas around the world.

The melting of the ice caps also affects the planet's weather patterns and the circulation of the oceans. Extreme weather with flooding, fires, droughts, and heat waves would make large parts around the equator uninhabitable. It would also mean enormous difficulties producing food due to unstable and unpredictable growing seasons. What is extreme today could become the new normal.

This is a moral issue. What kind of planet do we want to leave for future generations? Will we look into the eyes of our children and confess that we had the opportunity but lacked the courage? That we had the knowledge and the technology but lacked the vision?

Earth and humankind are standing at a crossroads. The choices and decisions we make now will determine this planet's future—and ours. Recent science reports say we have fewer than 10 years until we reach the tipping point, when we will have lost the chance to keep the warming at a manageable level.

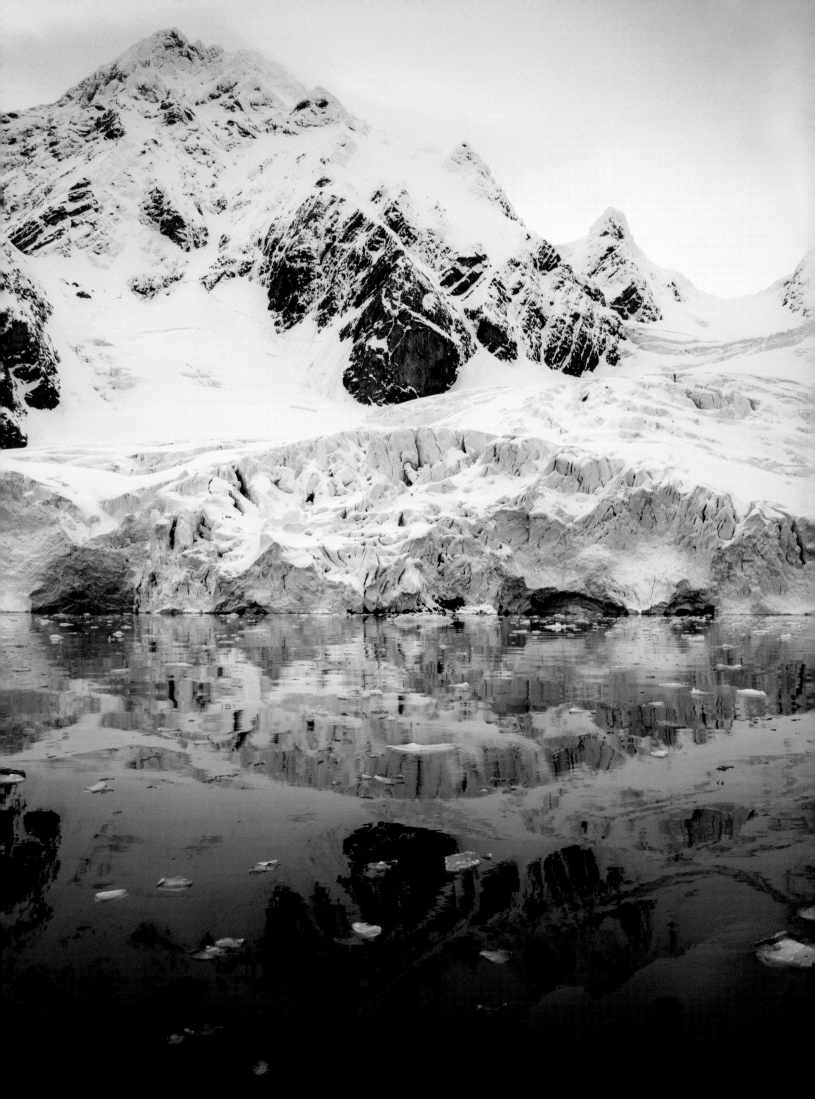

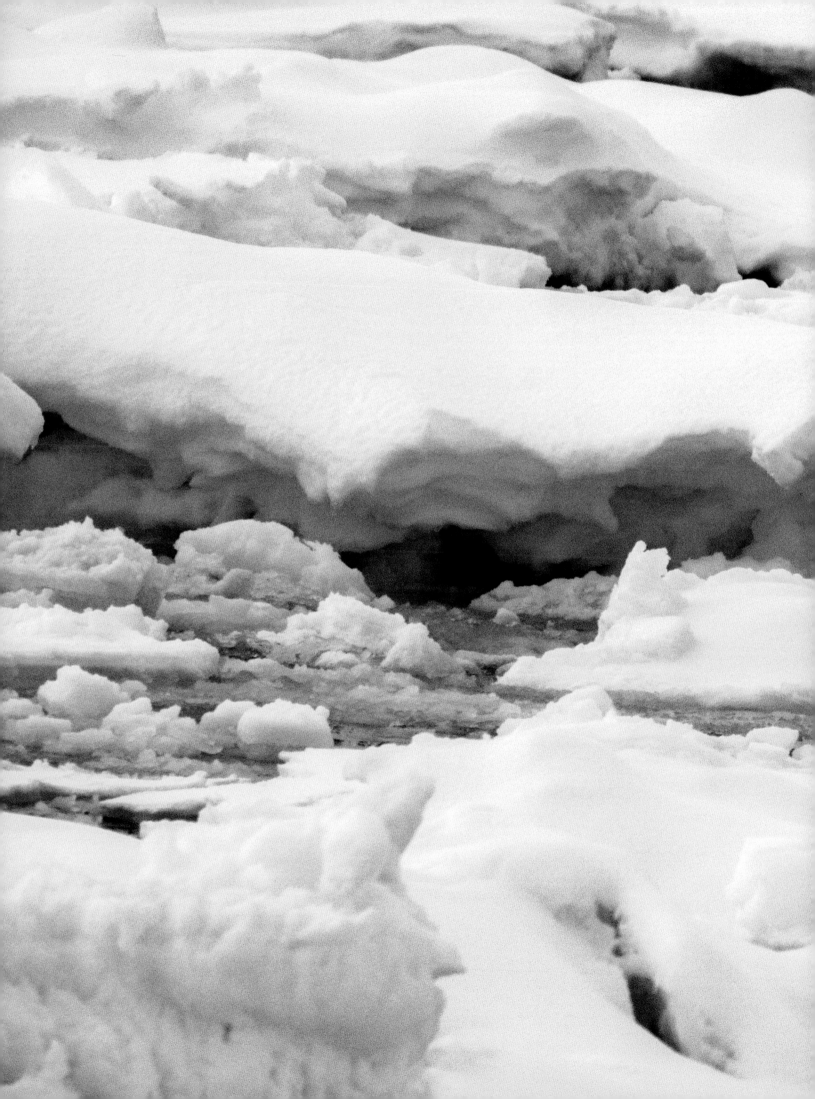

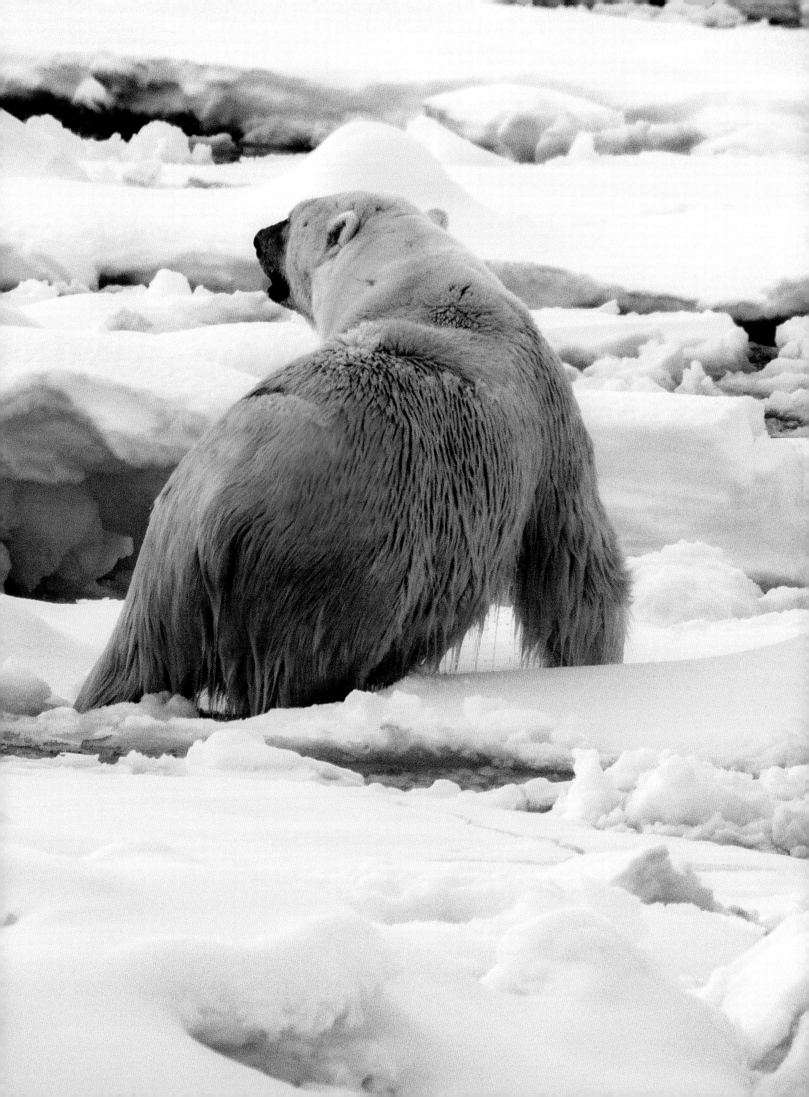

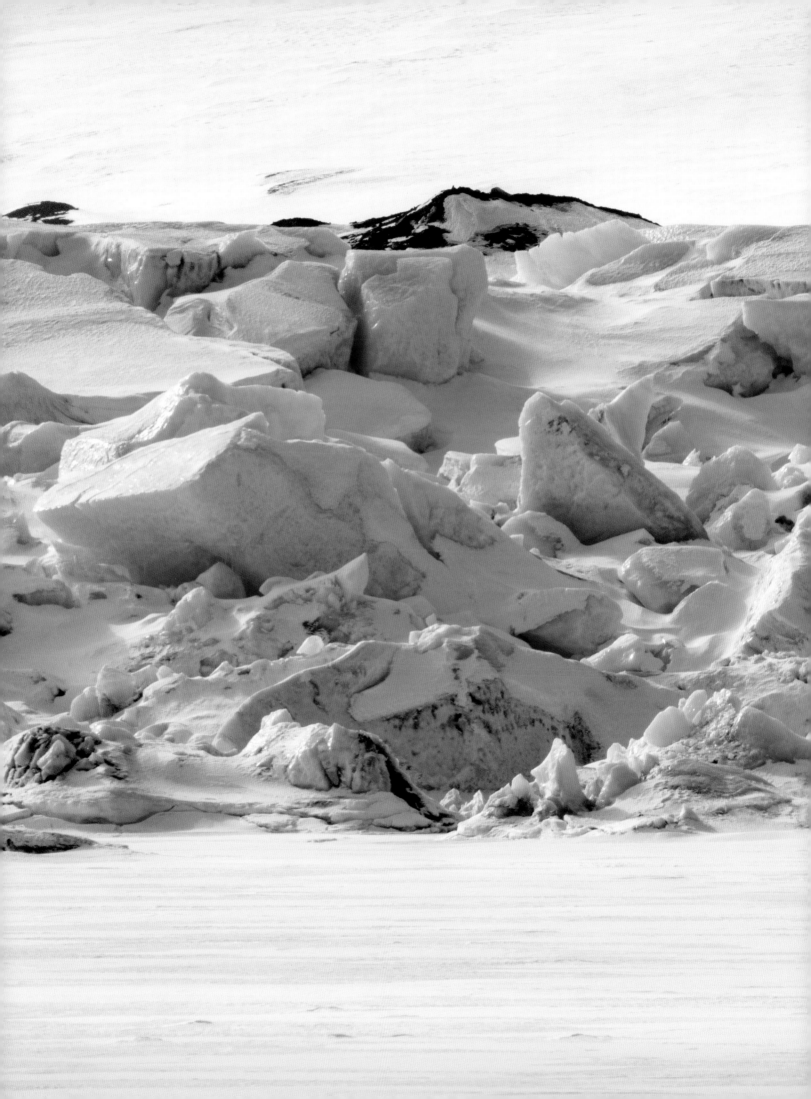

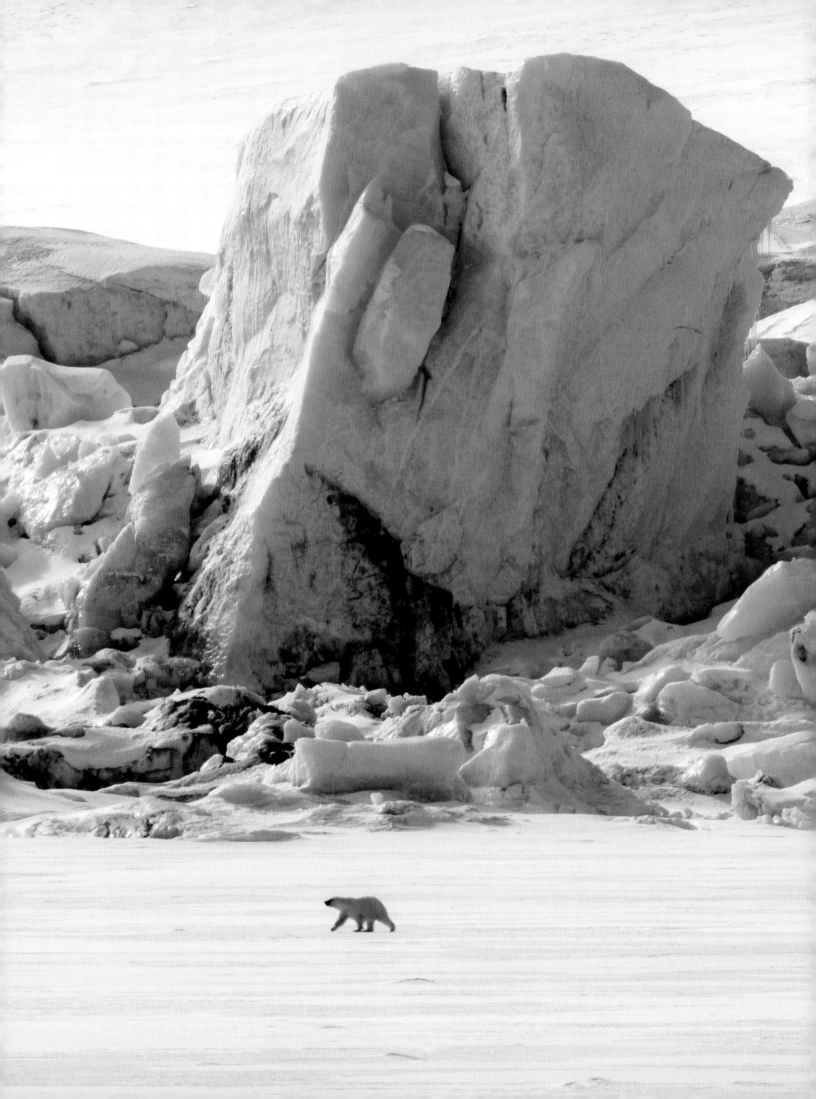

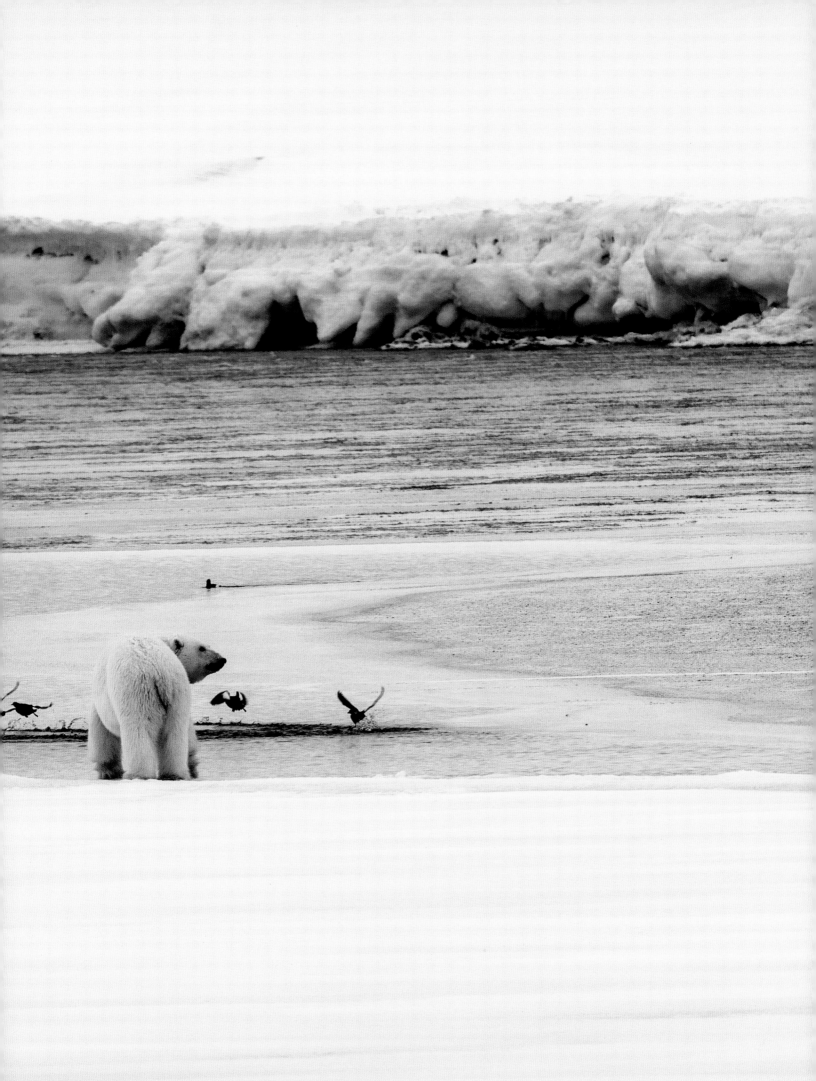

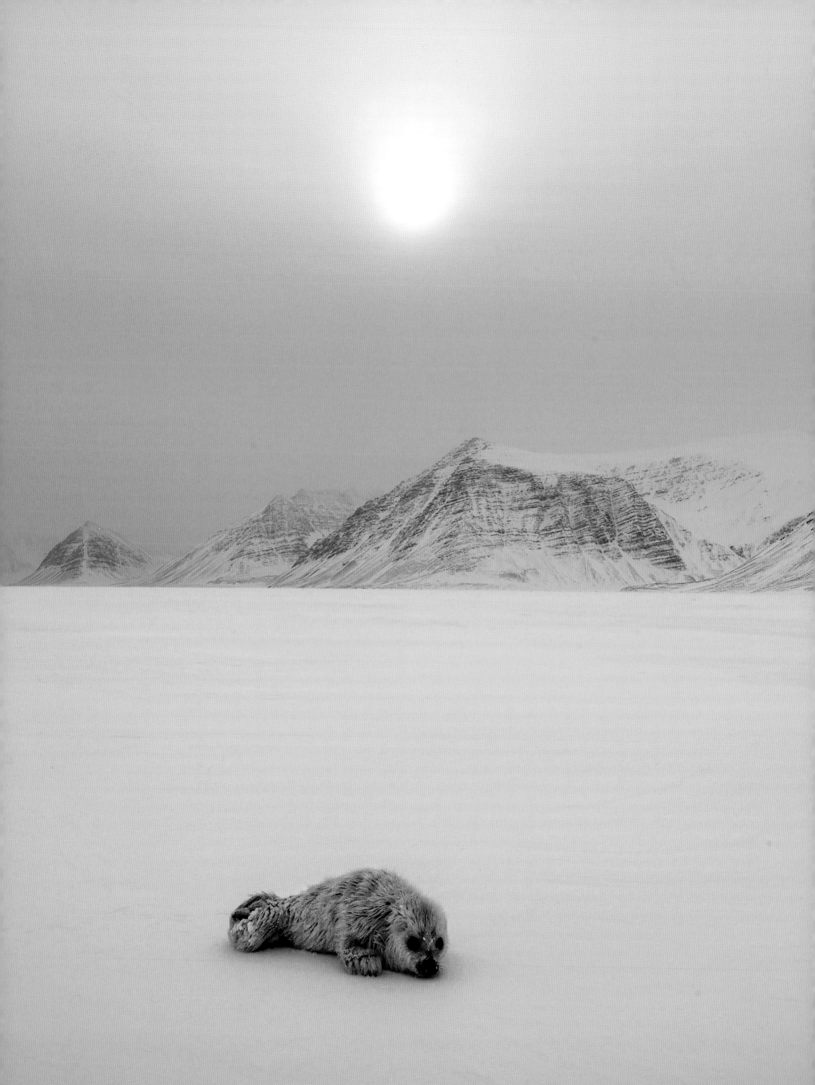

SEA ICE IS THE SOURCE of so much life, and it is the home of many animals, not only the polar bear. In winter the Arctic fox often follows bears on the ice through the coldest months to feed on their leftovers. Some birds do the same. Reindeer and caribou are given bridges to travel between different land areas.

Seals rest and breed on the ice, and find their food under it. One seal can keep dozens of breathing holes open in a big area in order to get away from polar bears.

The same goes for walruses, although they prefer waters with drift ice and ice floes, and can also rest and breed on beaches. We often find them swimming through the drift ice, and sleeping on ice floes. Their latin name, *Odobenus rosmarus*, comes from the Greek for "tooth walker," since the walrus often uses its tusks to pull itself up on the ice.

A changing climate and warmer world mean habitats lost for many and possibly extinction for some.

The little seal pup in this photo was born only hours earlier, but being exposed gave it little chance to make it. Normally, the seal mother tries to give birth in a hole under the snow on the ice to hide the pup not only from polar bears, but also from the birds and Arctic foxes that hunt the pups when they're small. But with flat and hard ice, the seal mother had no option. The pup cannot swim until it's two weeks old, and it has to stay on the ice.

Arctic life is tough. An hour after this photo was taken, a skinny bear in seemingly poor condition killed the pup and ate it. A little seal pup isn't much food, but it can be the difference between surviving or not for a starving polar bear. And that is nature in balance. On this ice, life is given and life is taken.

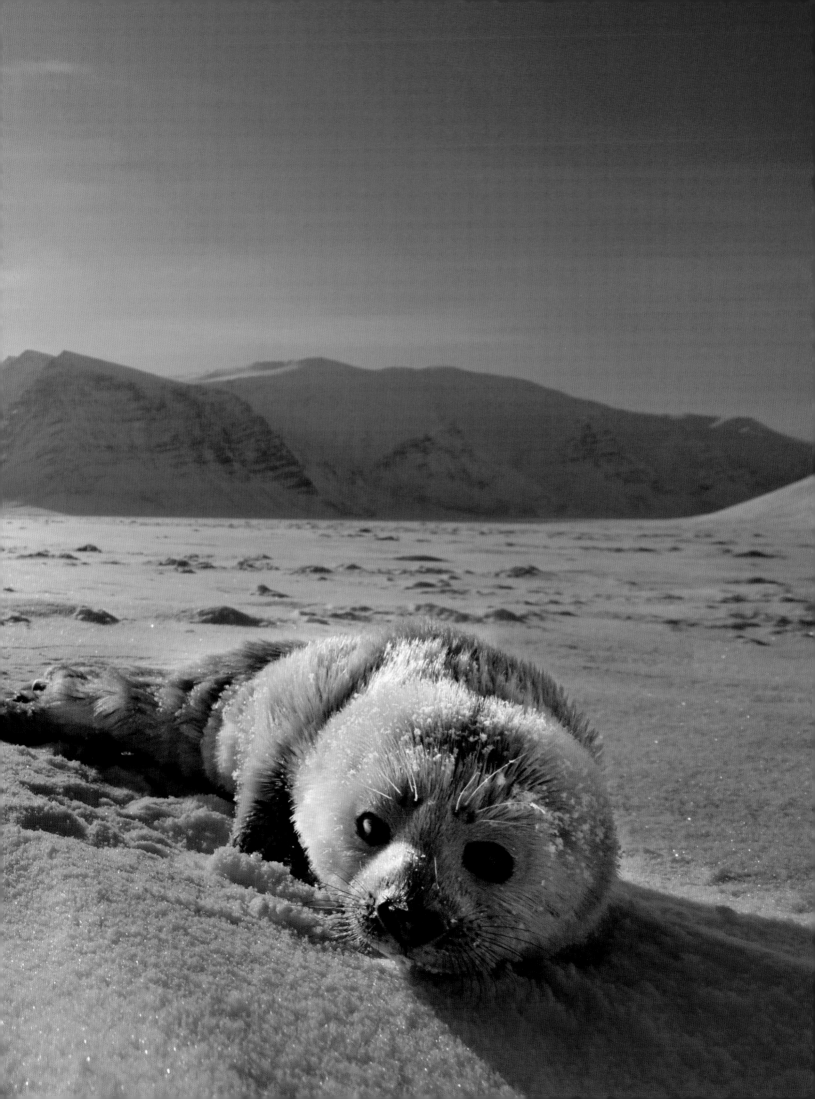

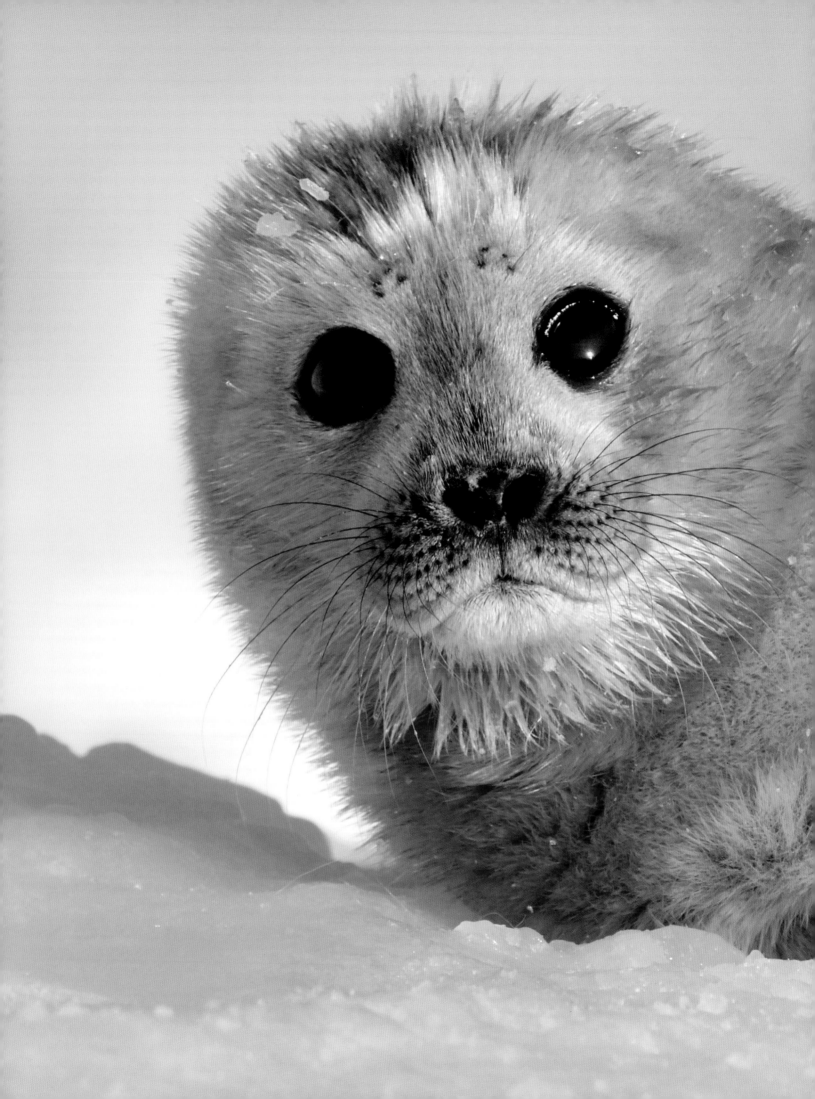

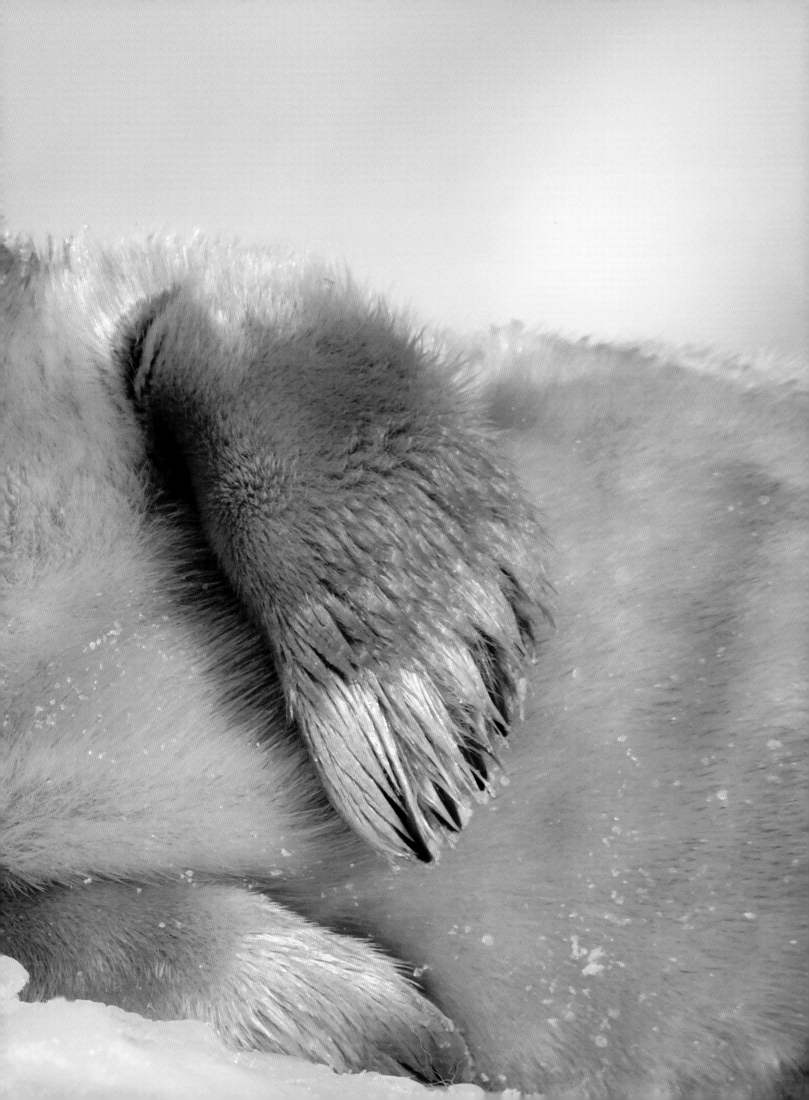

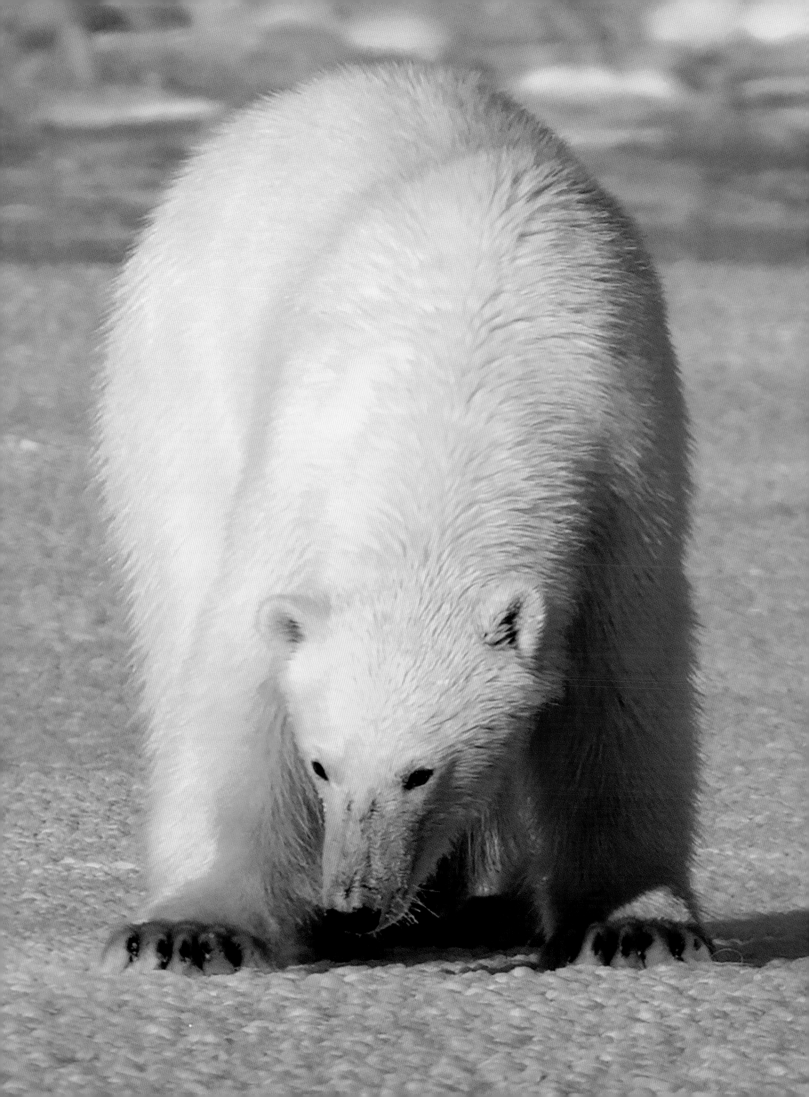

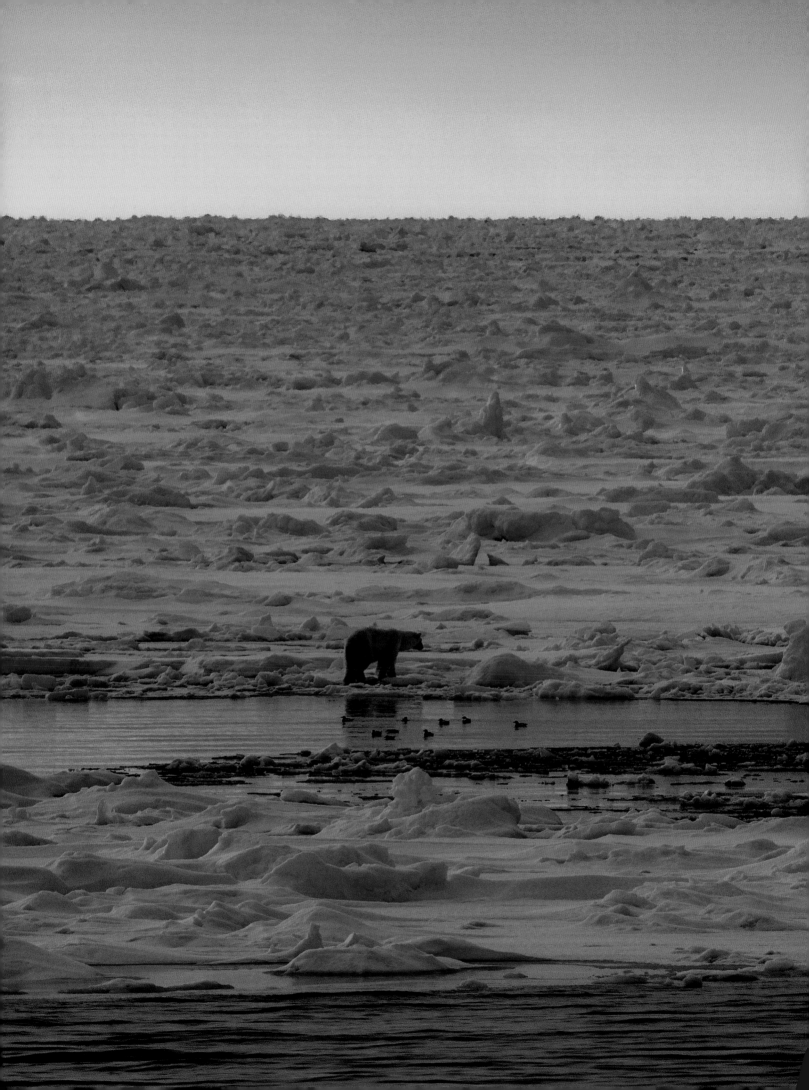

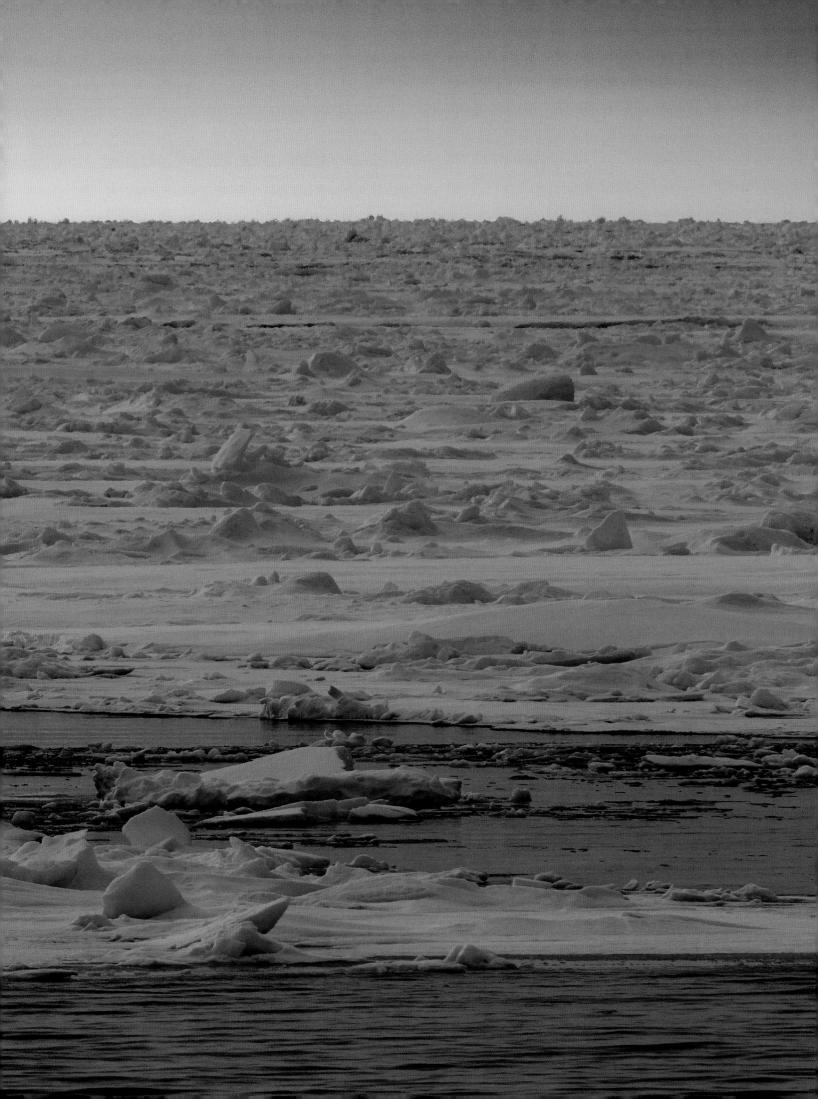

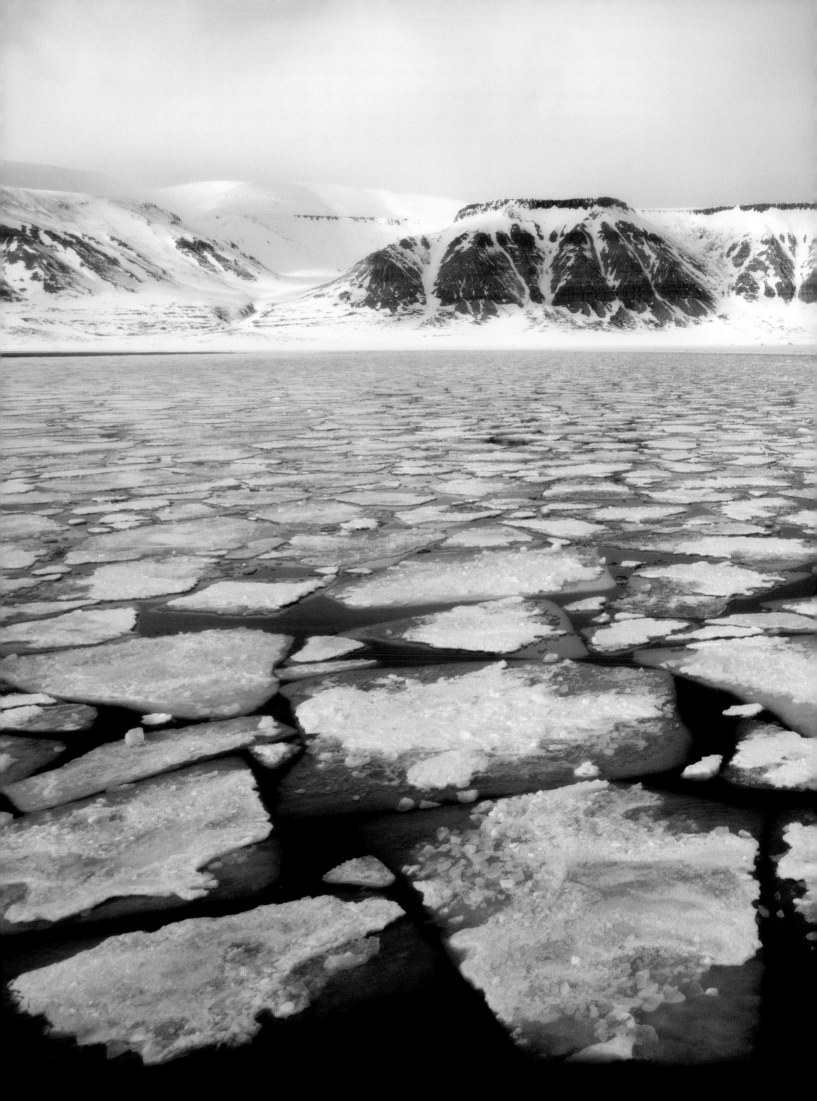

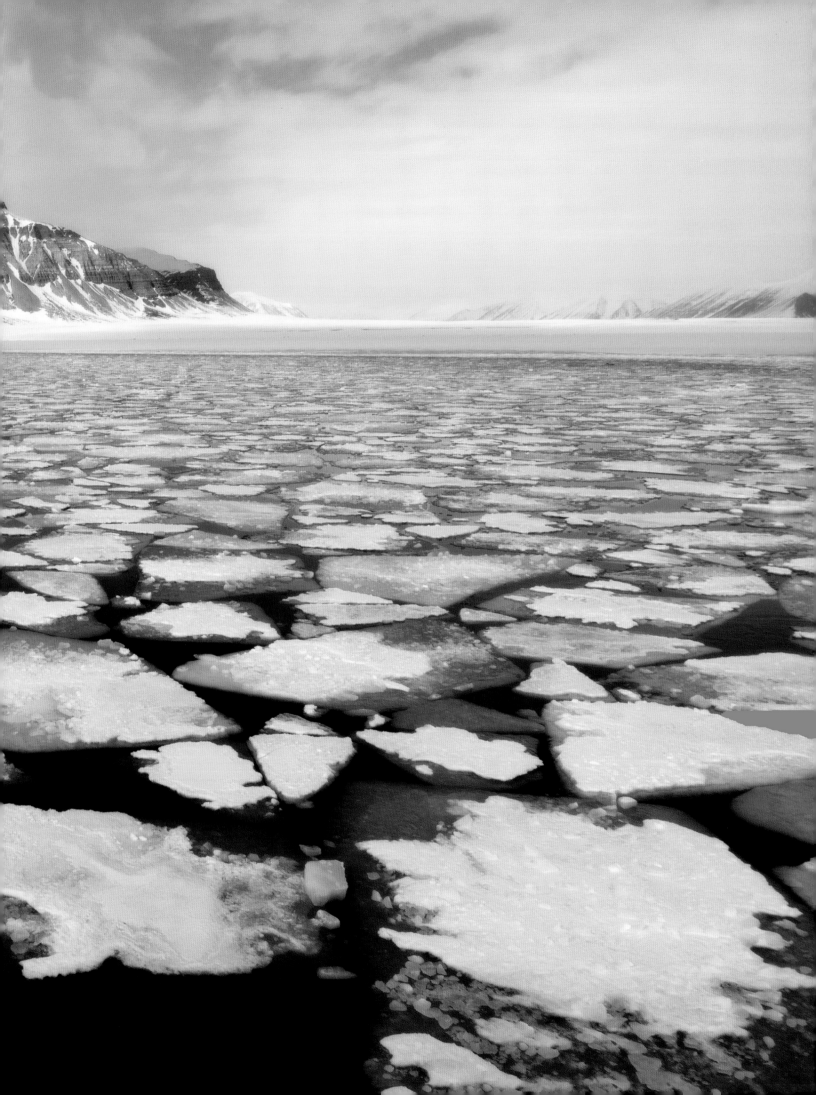

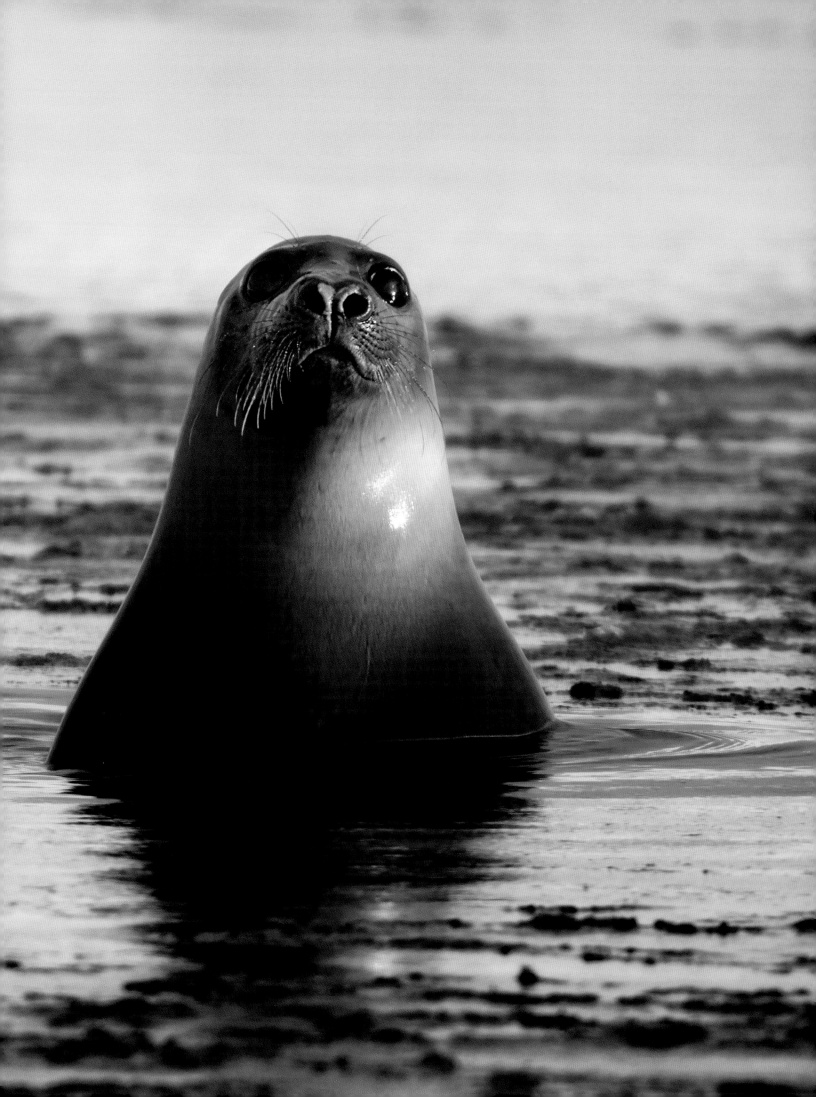

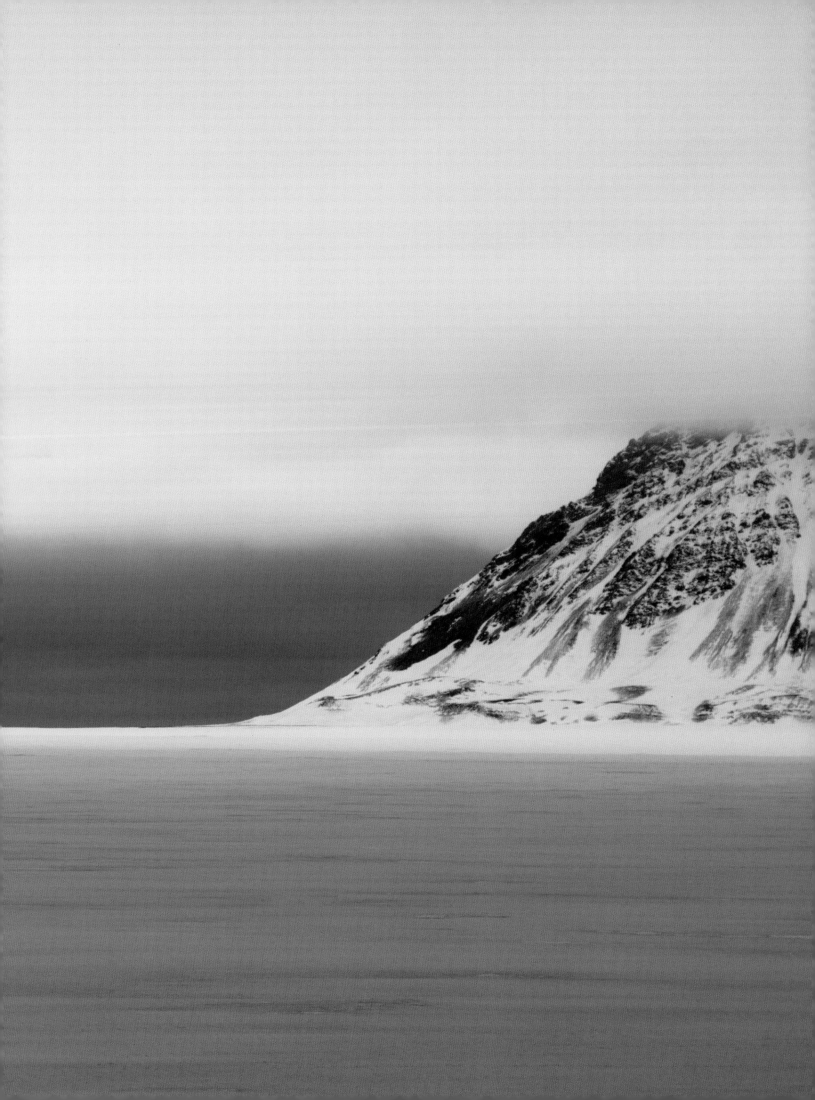

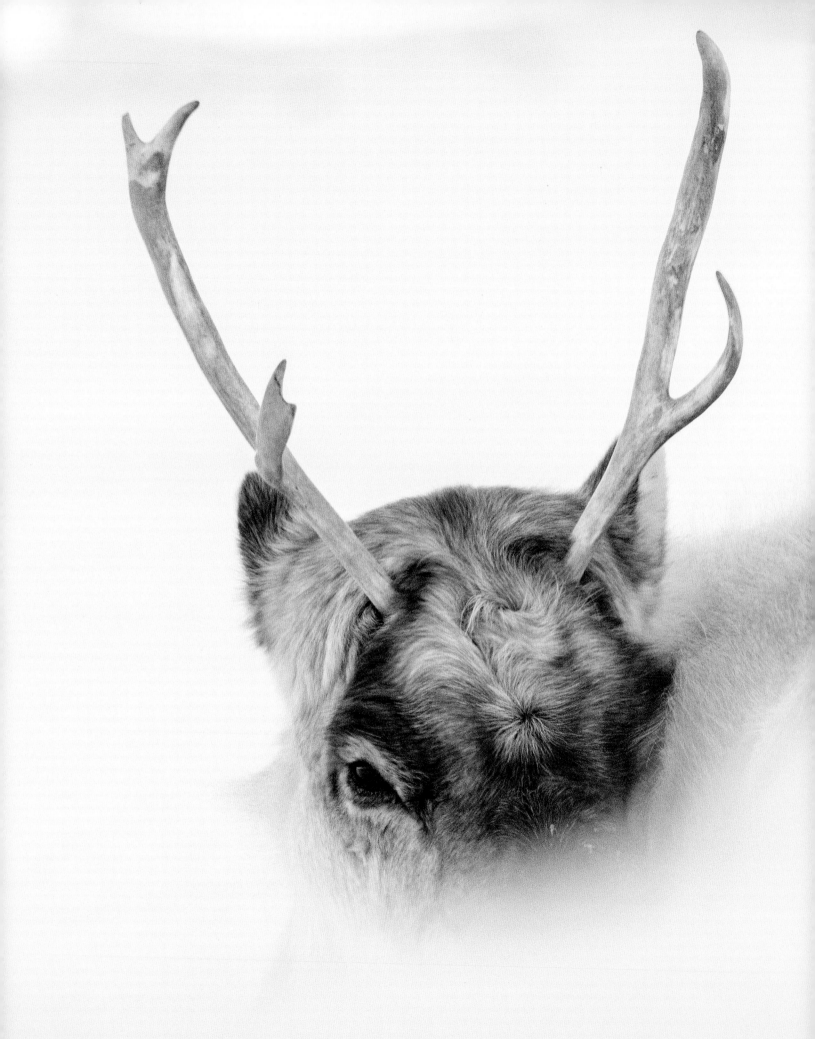

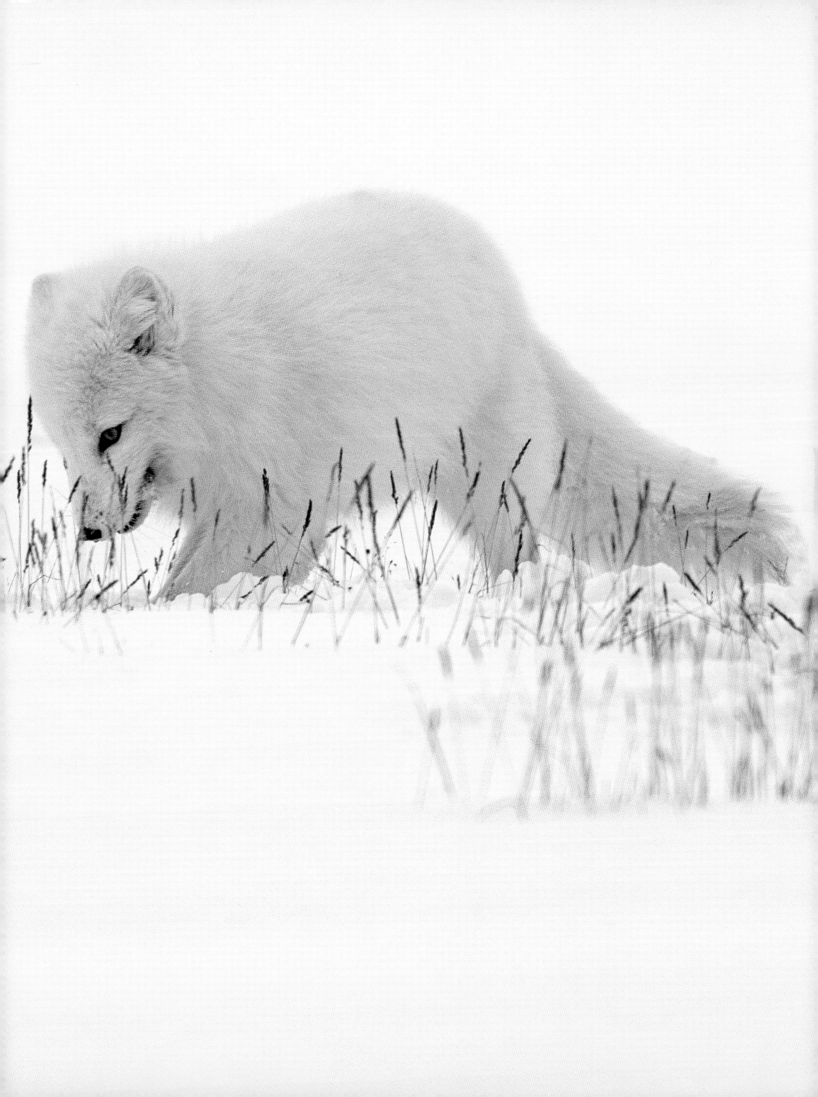

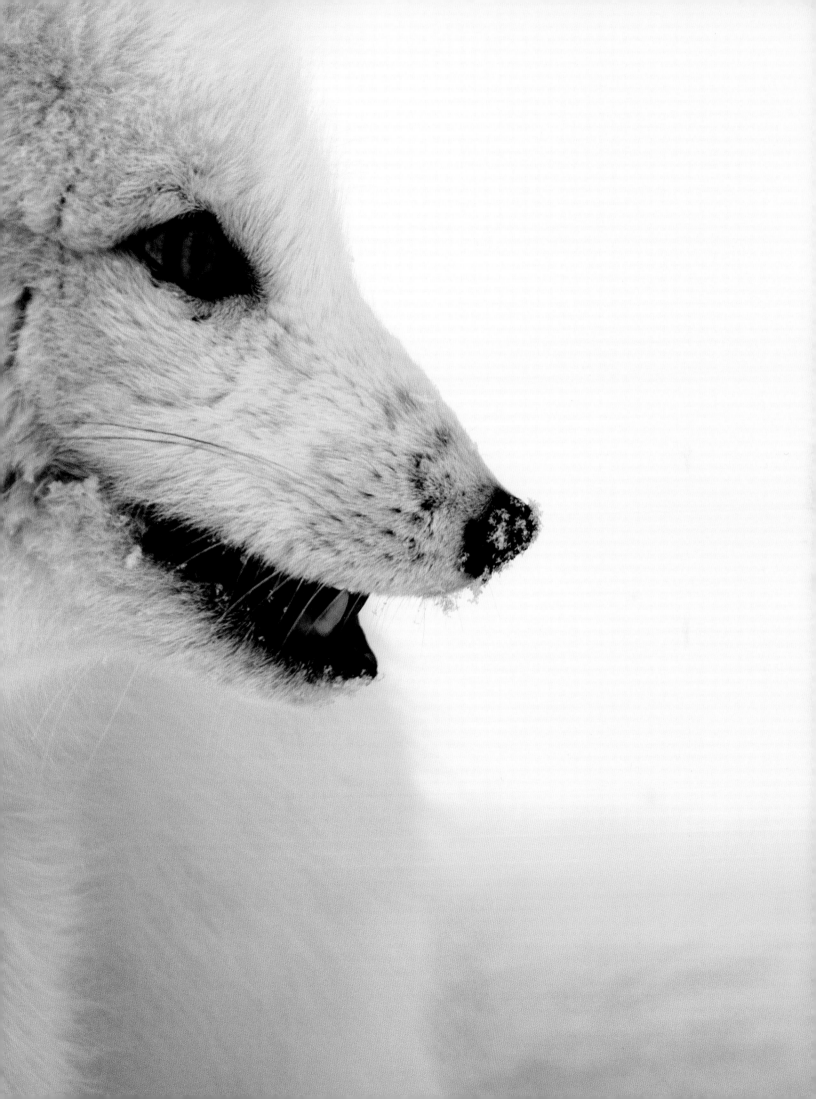

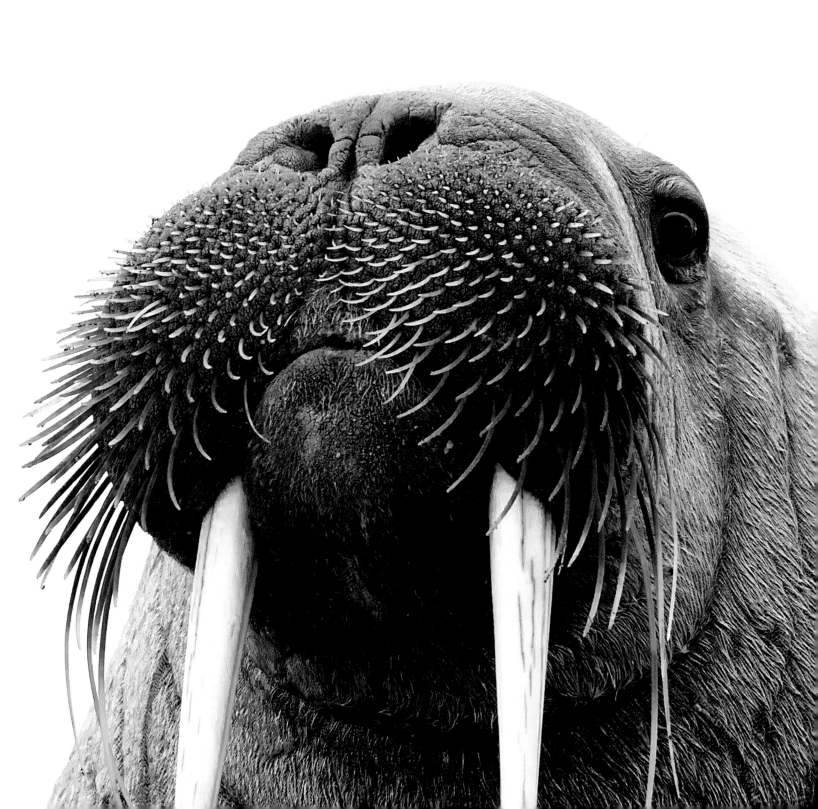

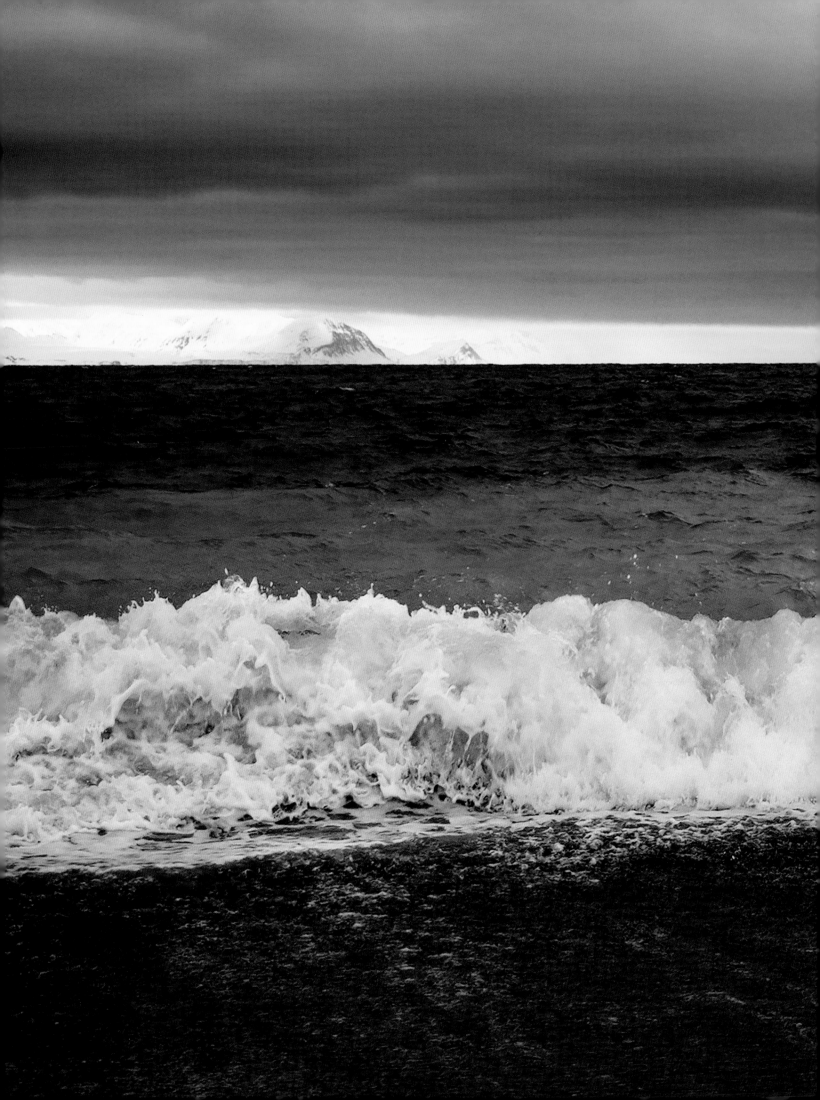

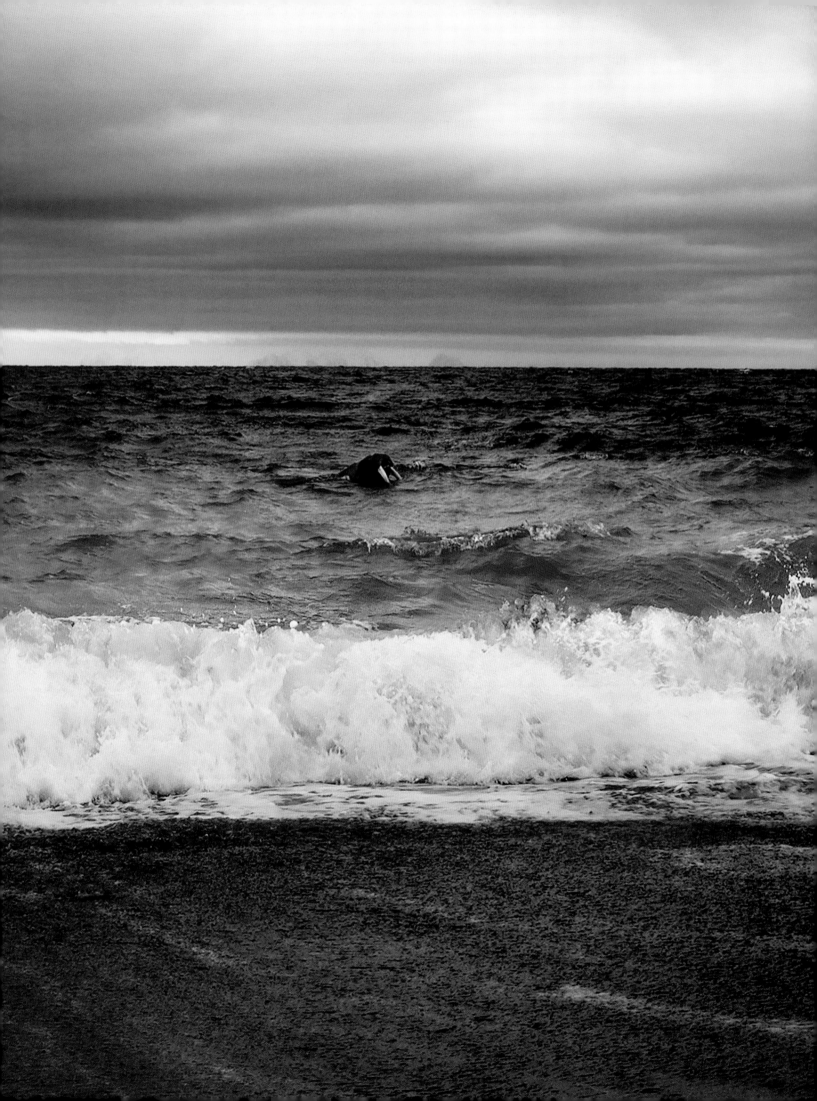

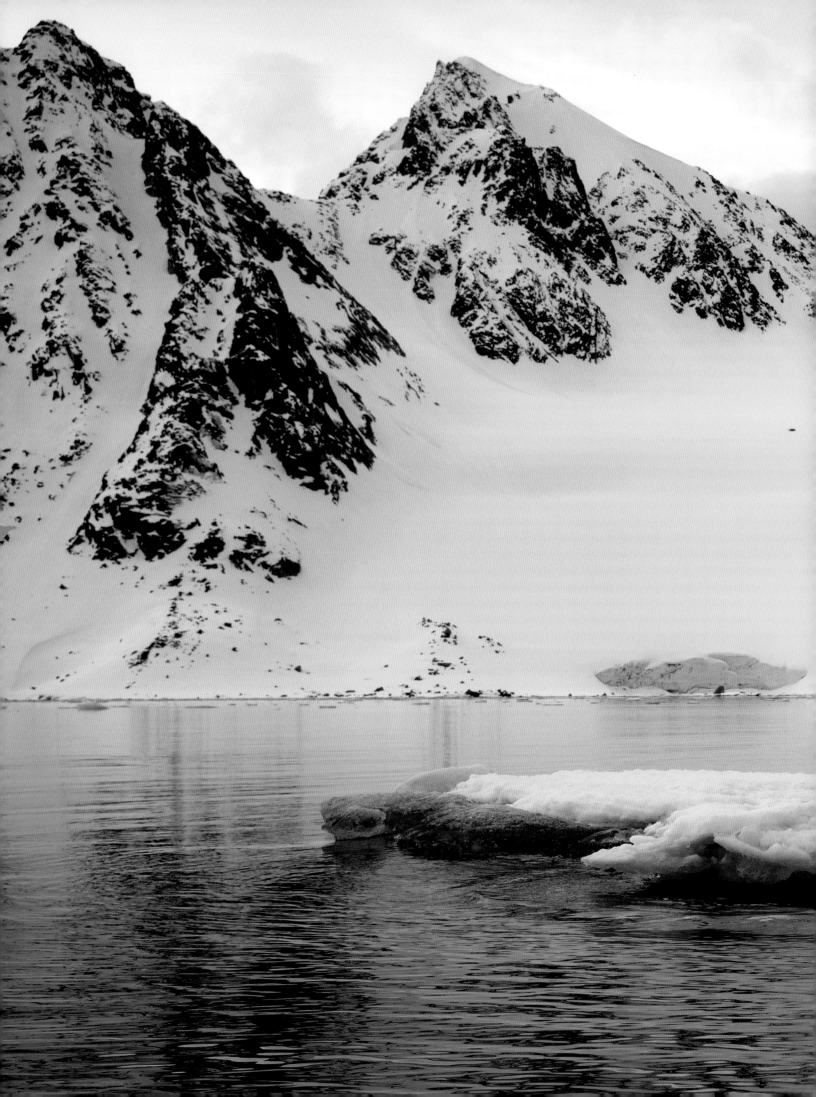

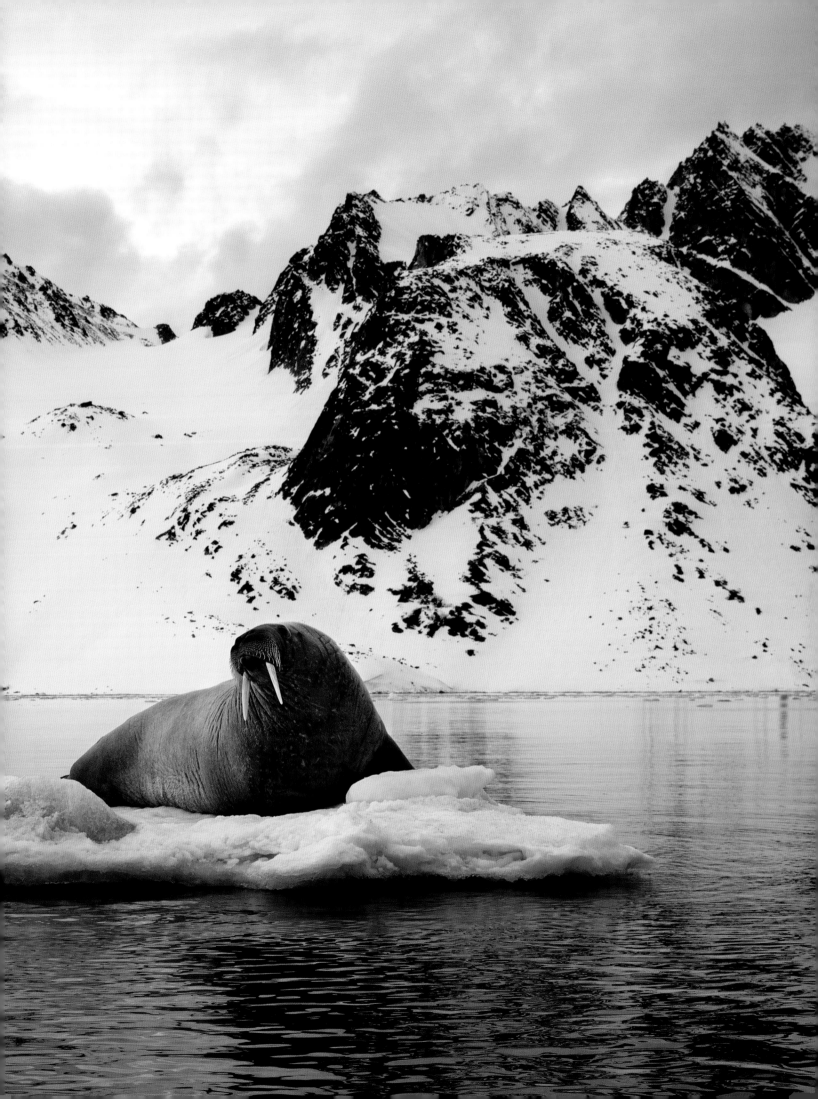

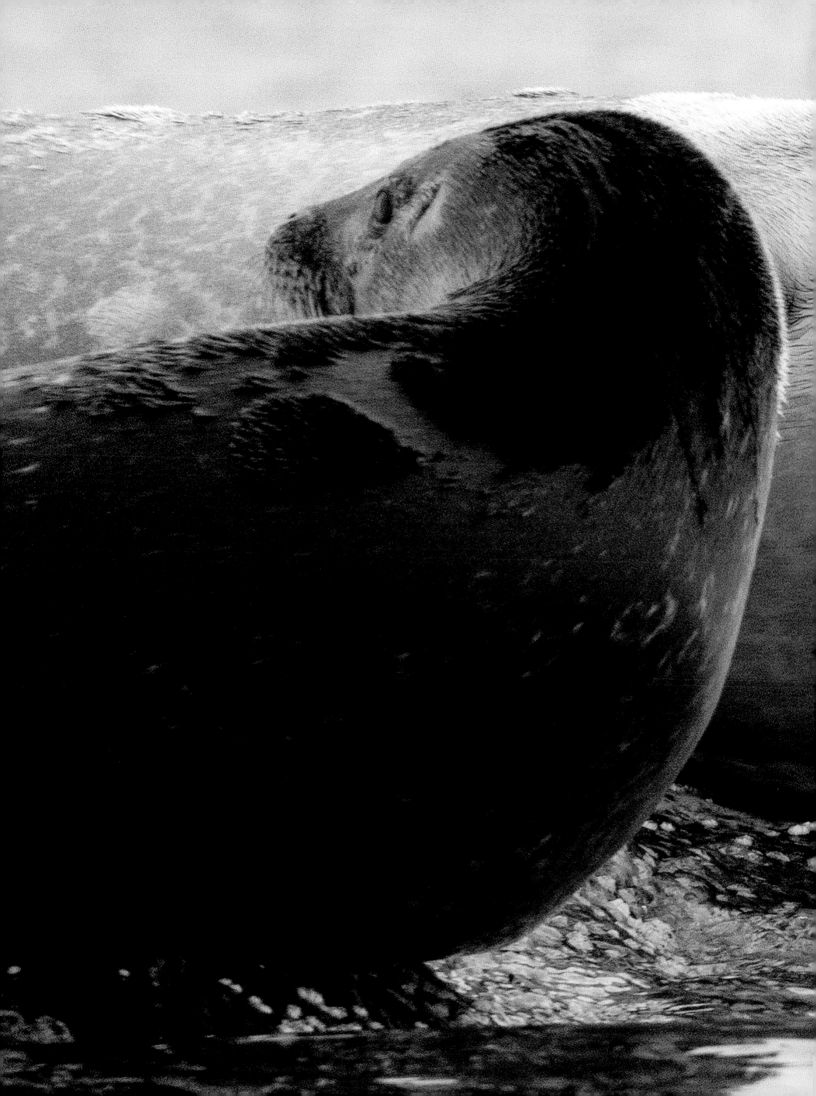

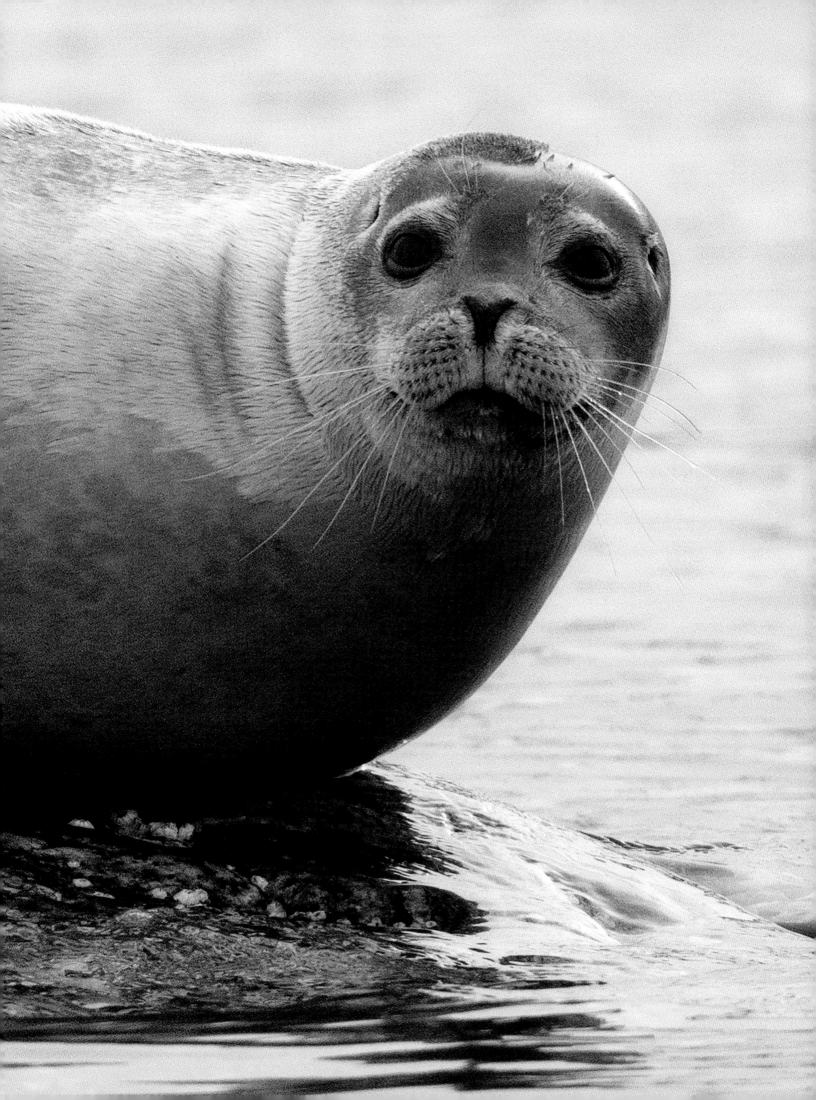

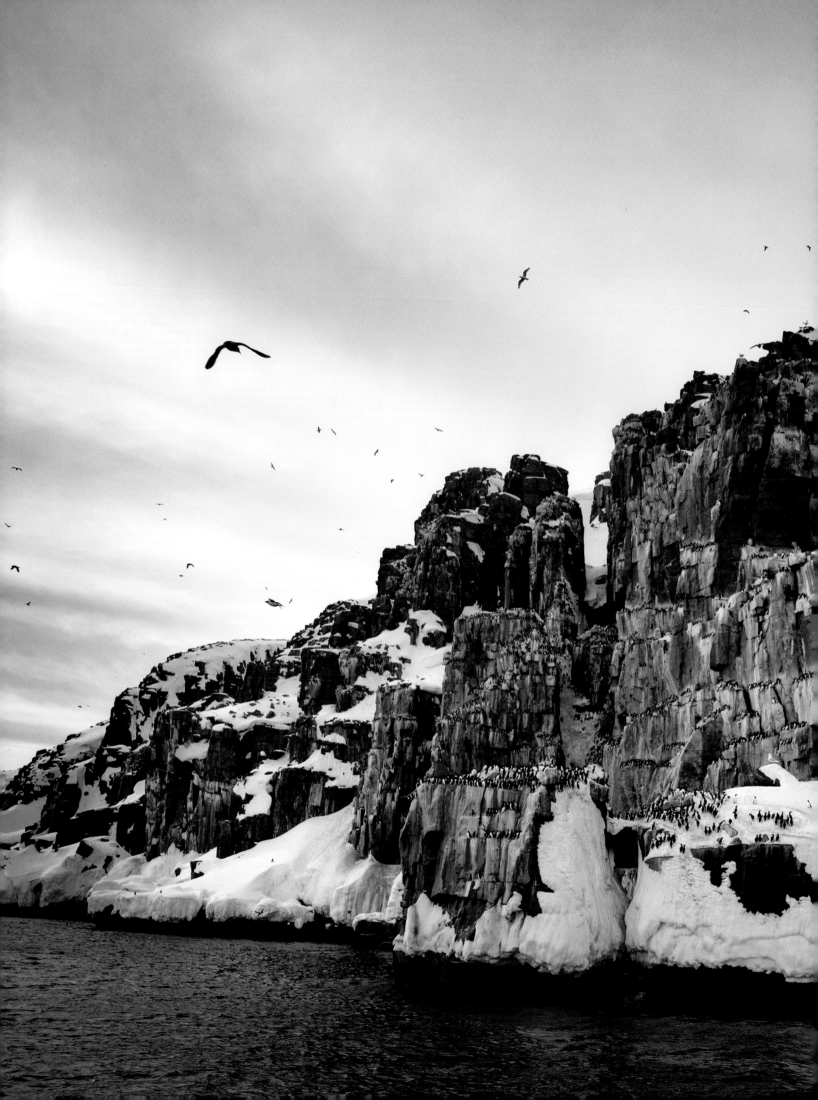

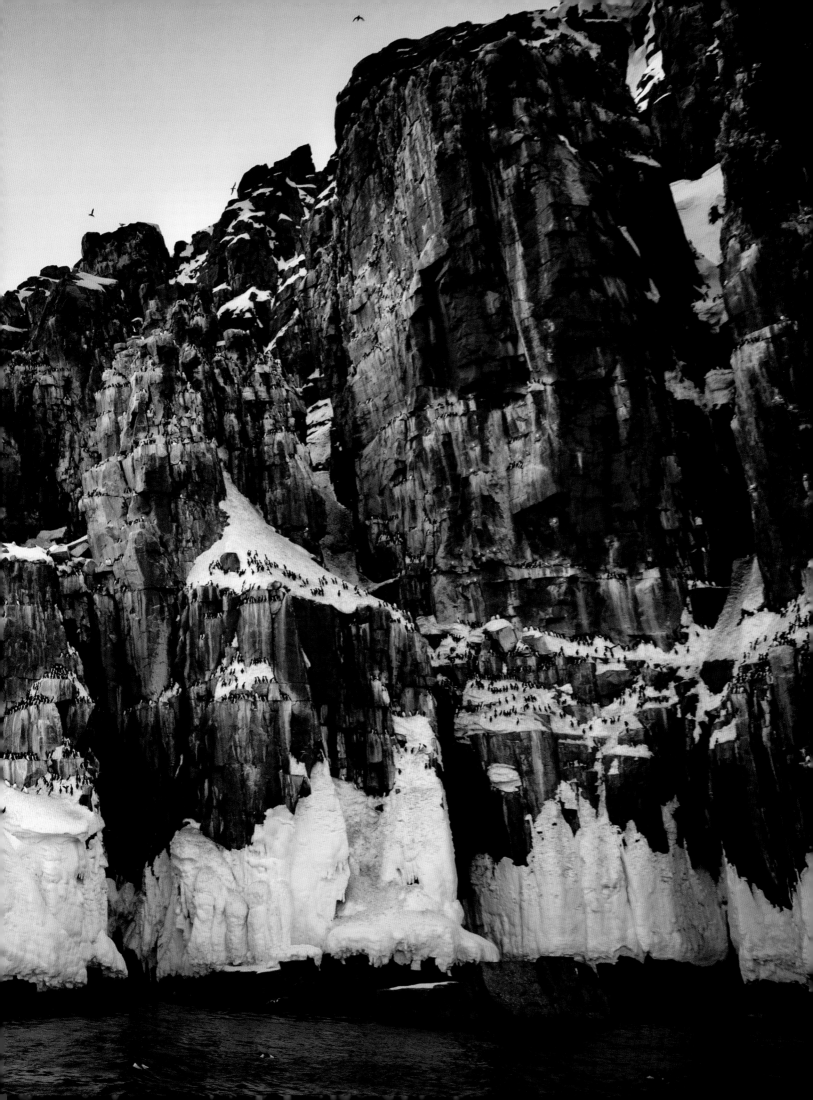

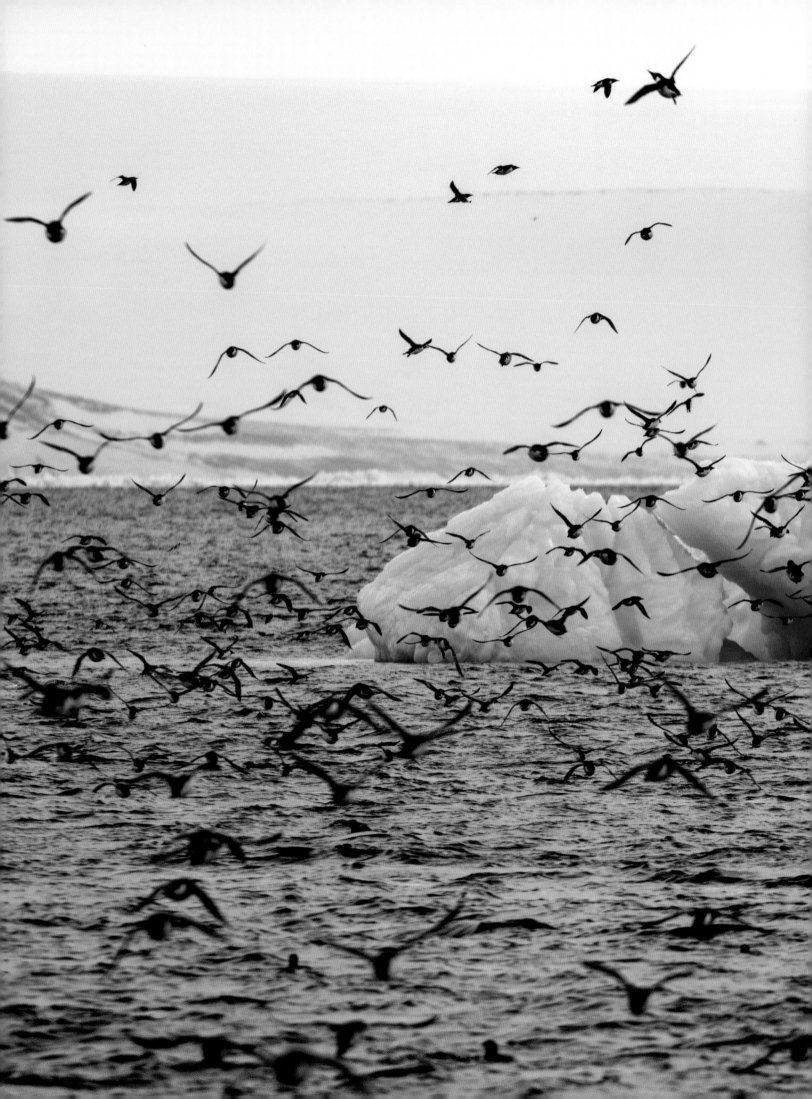

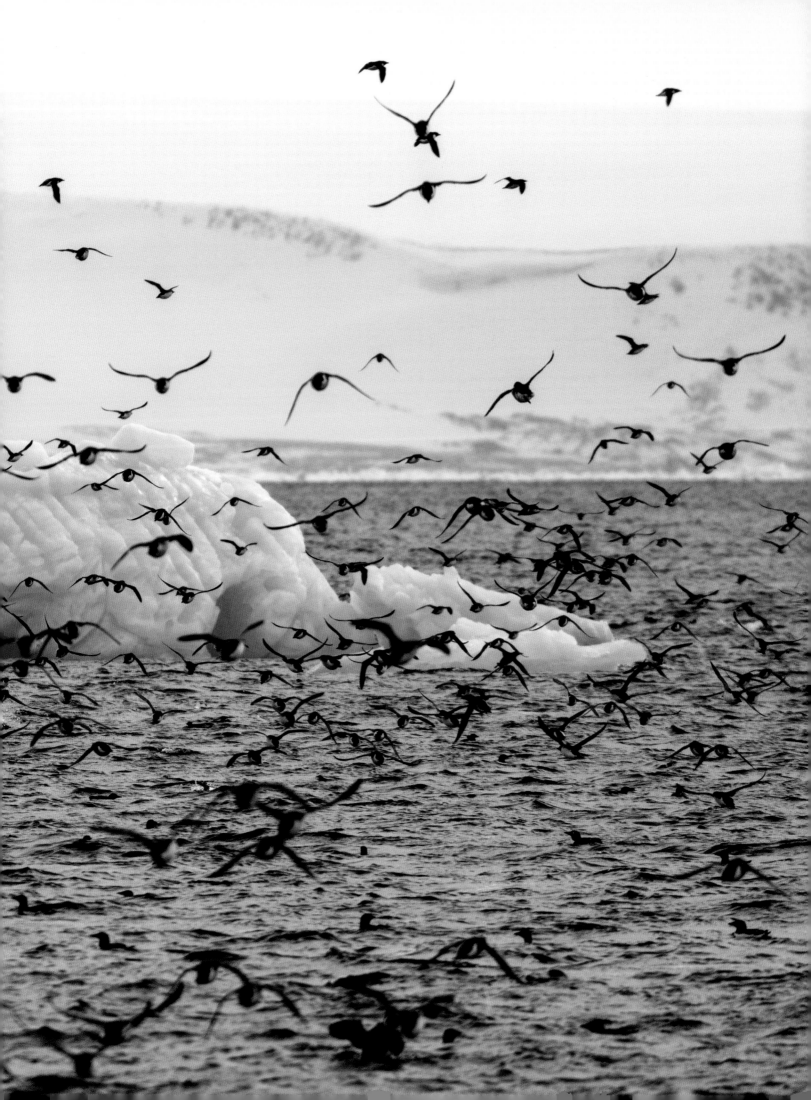

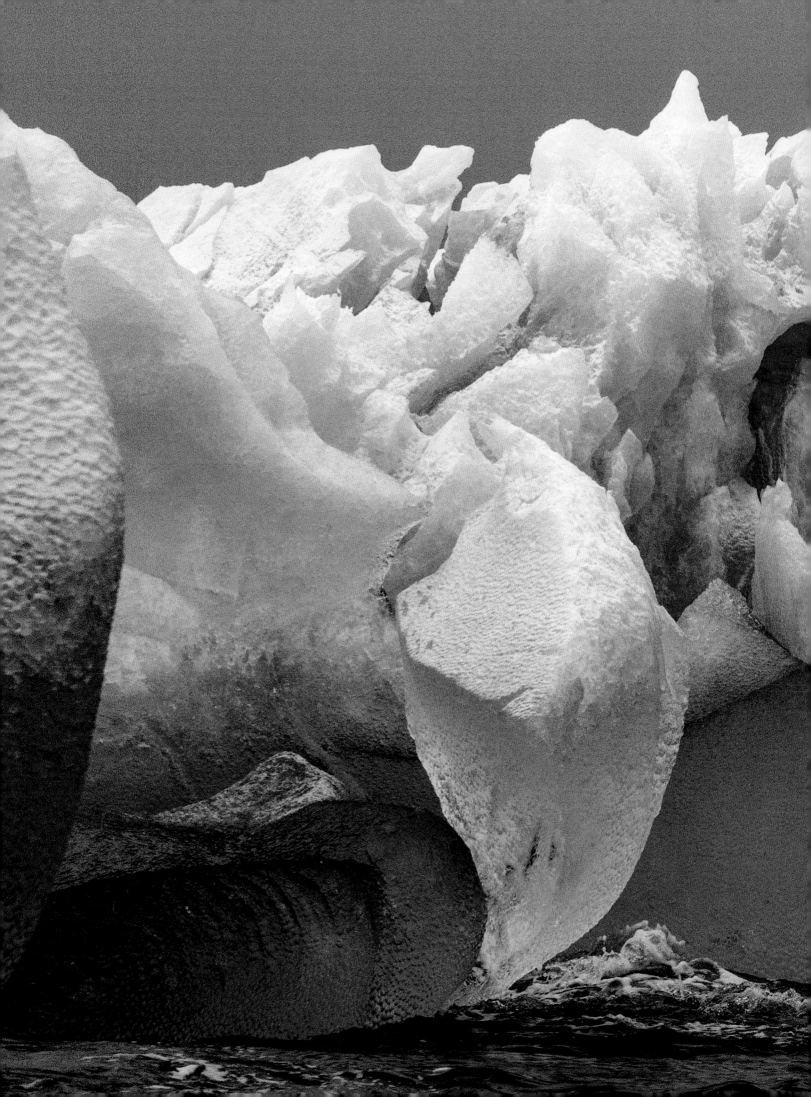

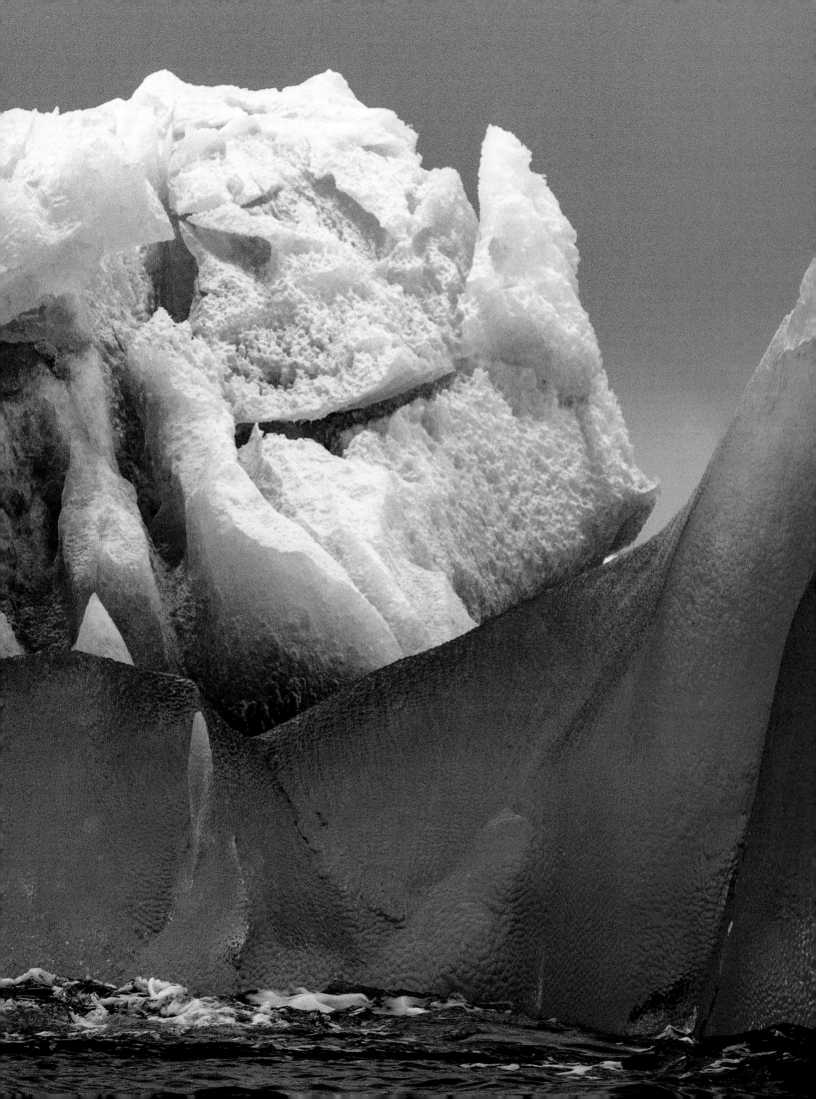

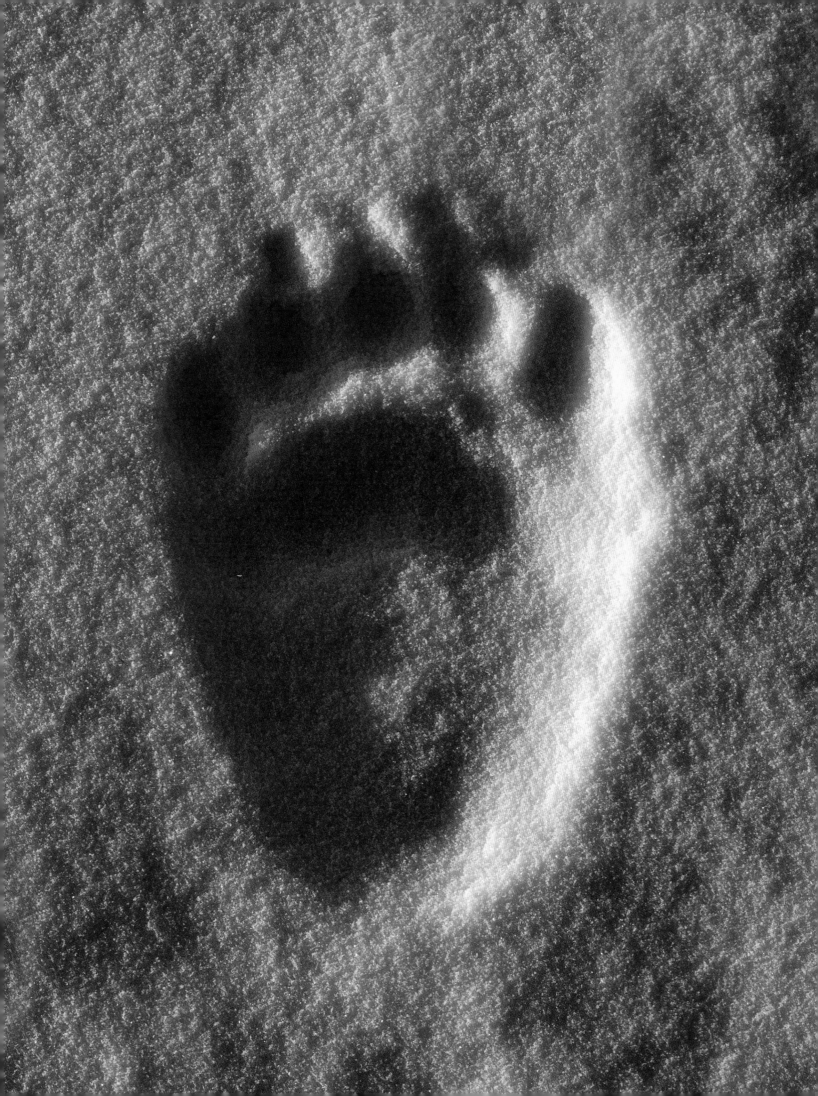

THE LAST STAND

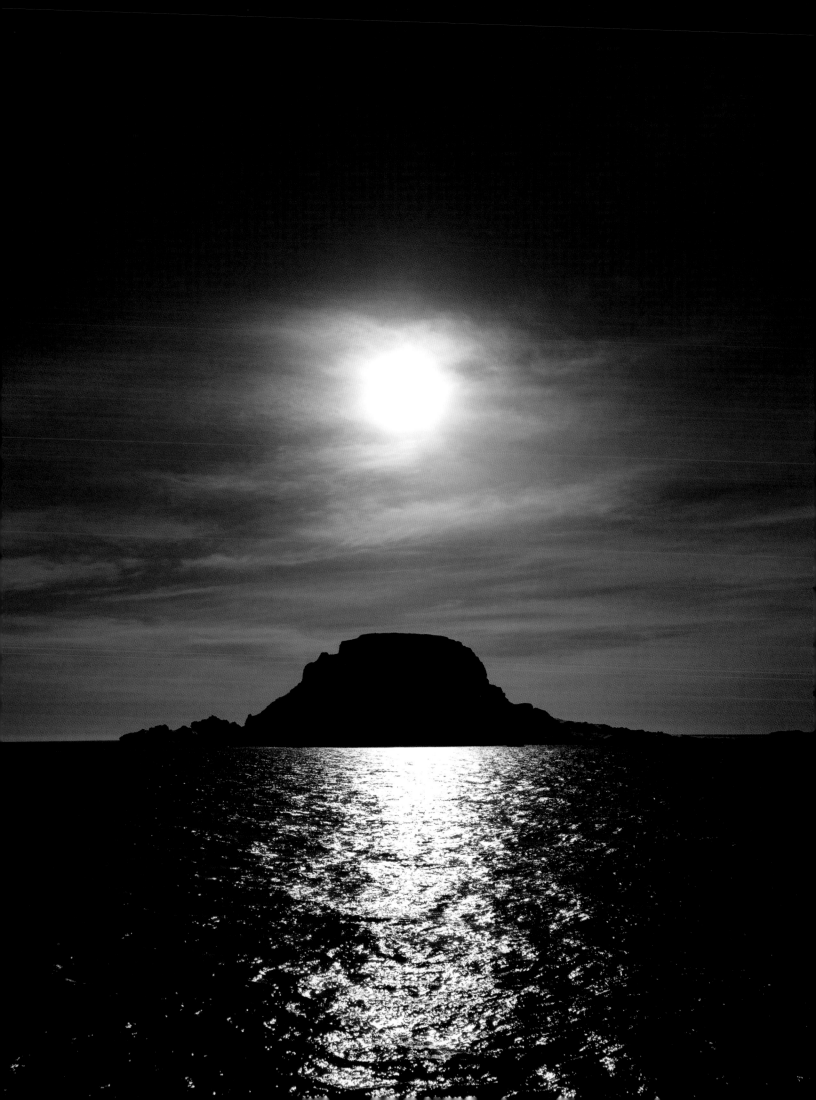

THE DESOLATE ISLAND AT 80° NORTH had been surrounded by the North Pole pack ice only a week earlier. But after a few days with high temperatures, warm ocean currents, and wind, the ice left fast.

When our ship approached the island on a beautiful evening in early May, the ice was already more than 60 miles away, and with summer around the corner, the distance would increase quickly.

We were on Karl XII Island north of Spitsbergen and Svalbard. North of the island, there are only the ocean and the North Pole. I had been there before. Last time, a few years ago, I found a two-year-old polar bear cub dead on the beach. The sight this year was not much brighter.

High up on a hillside, we spotted a young male polar bear, probably three or four years old, trying to catch birds. He was climbing slowly, and he stopped a few times to lay down and rest. He was very skinny. With a long summer and fall void of sea ice ahead, this beautiful bear might not make it.

As he walked out on a ledge and looked at us, the thought of "the last polar bear" struck us. It is something we hope we will never see. But if we do, he will probably look a lot like this one: skinny, climbing a cliff, and fighting for survival.

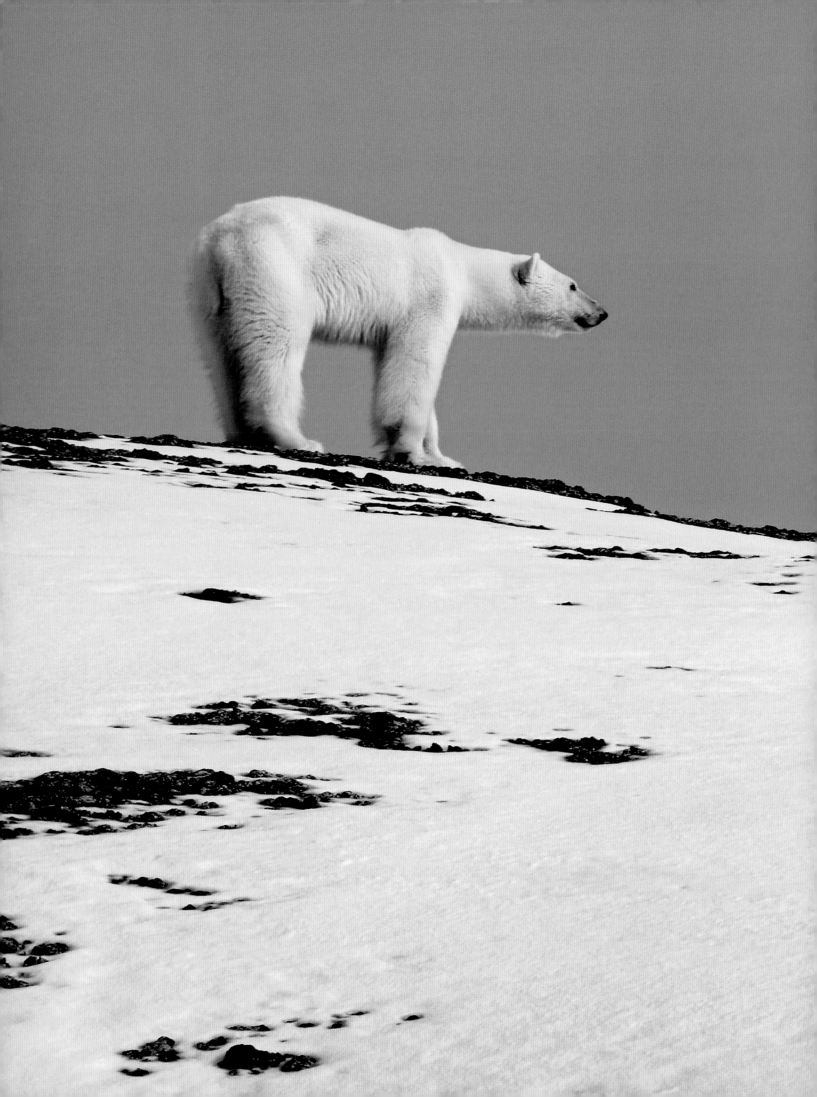

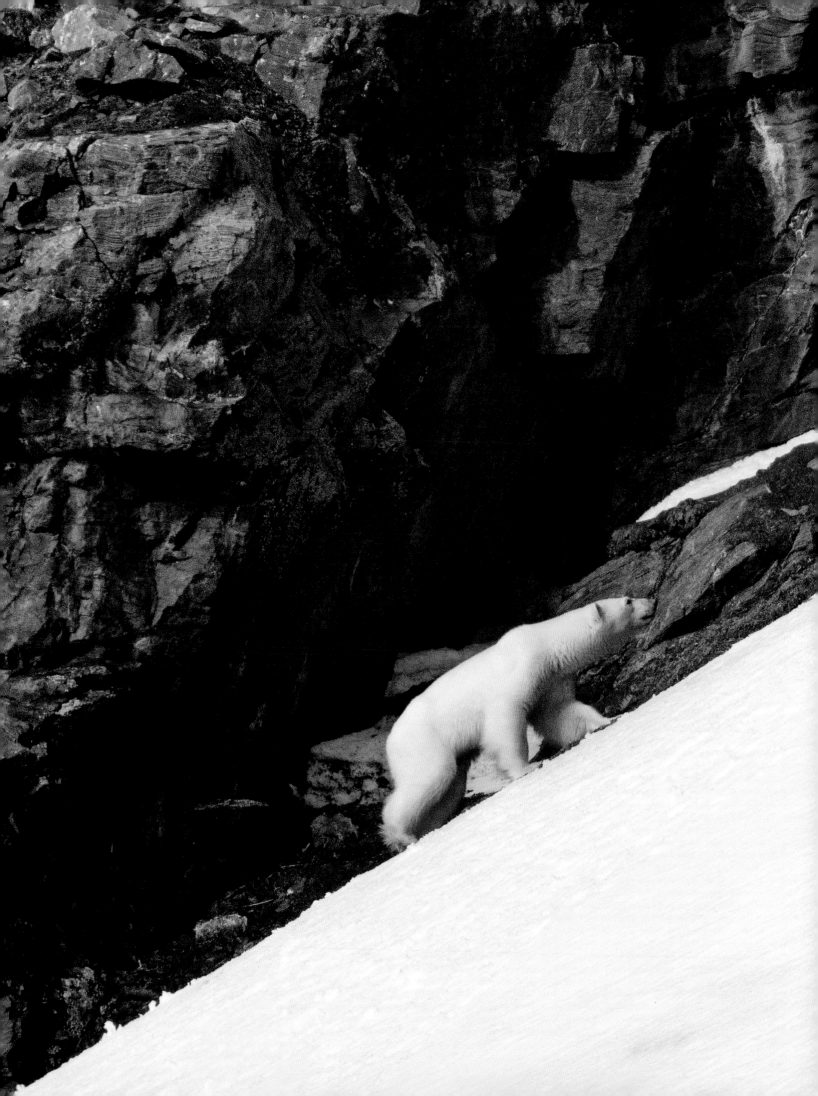

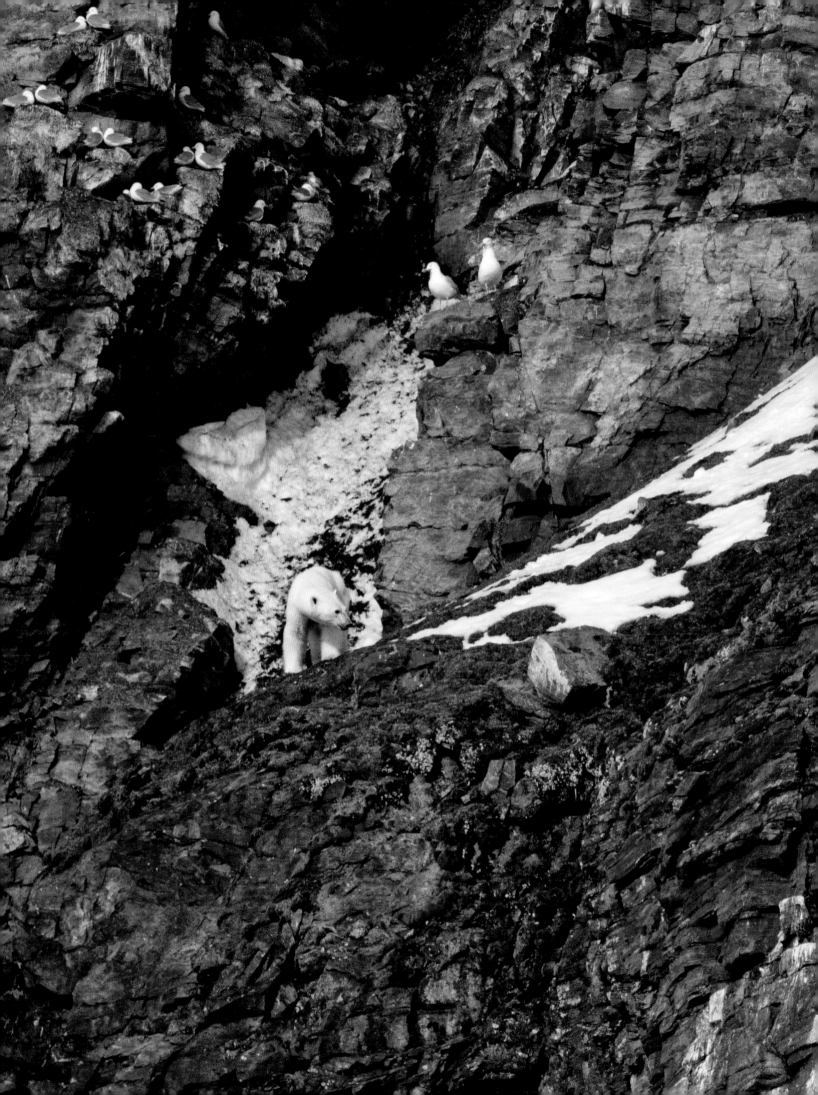

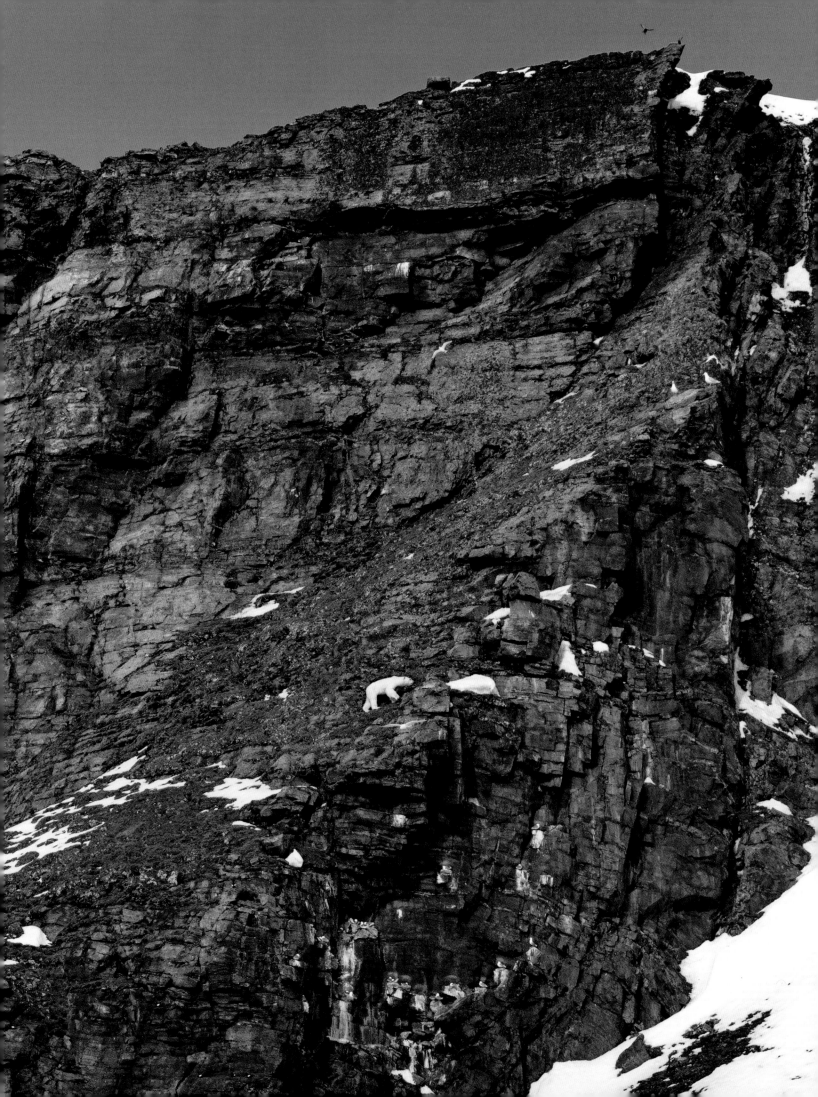

EPILOGUE

LIFE AND LOVE IN THE ARCTIC

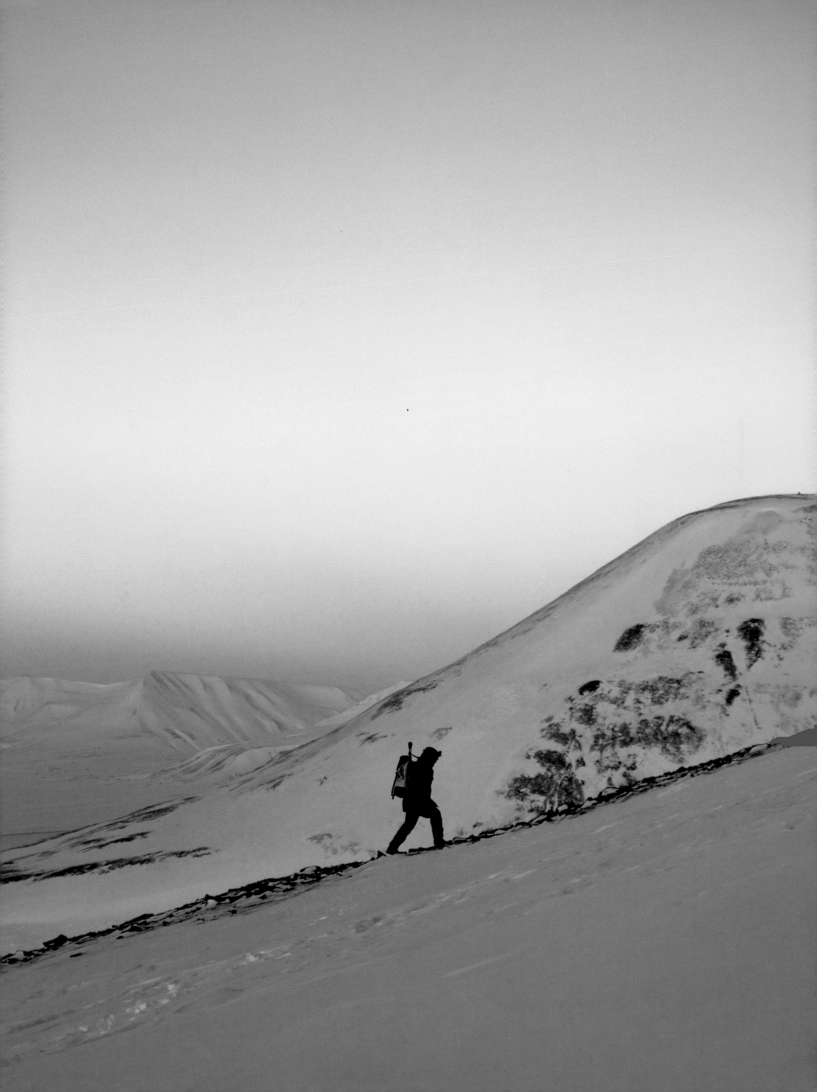

WE DO THIS WORK not only because we feel it is important, but also because we love it. We love life in the field, the long spells in winter out on the pack ice and around the frozen fjords. And, yes, we love the polar bear.

My first encounter with a polar bear was on the very first night of my first winter expedition. The old cabin I had stopped to rest in was almost demolished by a raging polar bear attacking the roof and walls while I sat in the dark inside, not entirely sure how to handle the situation. Thankfully, Melissa's first encounter, with Helen a few years later, was quite the opposite. A lot has happened since then, and we have come to know the great white one quite intimately.

Melissa is the photographer. I am the happiest man in the world to be carrying her gear. I am also what you may call a producer. I take care of things and make sure we have what we need, know where to go, and how to get there. But our roles go along with each other. We do it all together. Everything as one. Including writing this book.

It is work that is as much life as it is work. The best times are when we can spend longer periods—days, or sometimes weeks—in an area or with a special bear. This gives us the chance to get under the skin, to get close. And when we do that, what is behind and between the photos becomes more important than the photos themselves.

In the past, we have often felt that back in civilization we disconnect—from feelings, thoughts, and many other things. With smartphones, social media, funny videos, too many links, 87 channels with nothing on (well, except *Breaking Bad*), and media, media, media, it can happen easily. There is a lot of noise that serves very little purpose other than making time move faster. When life is so short, shouldn't every single second count as something precious? Of course it should.

In the field up in the Arctic, sometimes we miss certain things, mostly our close friends and family. But we are always present. Every single second. Never, ever disconnected.

Something we love about our life in the north is that after a while out there in the field, time kind of stops. There are the sun and the moon to follow, but the hours between the rising and setting sun are more a space than time the way we use and feel it at home. There is weather. There is the silence of the pack ice. There are the moments when that silence is interrupted by the sound of four large paws crushing the snow crust. Time stops being a clock and a calendar and becomes a series of moments.

One thing that happens during a long winter expedition is that you get more receptive. Perhaps it is a cliché, but you become almost one with nature, with the elements. Your senses become more aware, more wild. Your eyesight, your sense of smell, and your hearing get better. You can feel changes coming in the weather. You can smell water. Give nature time, and she will give you something back. Sooner or later, she will present you with a miracle. Her secret is patience.

WORKING IN THE HIGH ARCTIC is demanding. And the preparations for a long winter expedition take months: Logistics, including snowmobiles, boats, air cargo, and sometimes helicopters. Endless lists of gear, clothing, equipment for communication, weapons, camera gear, and countless other things. Checking of local conditions and the development of sea ice. Careful planning of routes to travel, where to go, and when to go there.

But no matter how well you plan an expedition, you never really know what is waiting for you. And that's the adventure. If you take away the uncertainty, you take away some of the motivation.

Sometimes we come home after a long expedition without one single good photograph. Sometimes magic happens almost every day. You never know until you're out there.

Hannah Bloch wrote, "Persistence. Resilience. Adaptability and crisis management. All are key themes in exploration, as in ordinary life. Keeping things in perspective helps too: Explorers tend to take the long view, recognizing the illusory nature of failure and success."

Most of our work is done during midwinter when just the two of us head out, traveling on snowmobiles, with big sleds behind carrying all our equipment and extra gasoline. Once we leave the settlement, we stay out there for days, weeks, or even months.

Around Spitsbergen on Svalbard, there are several small cabins that were built by hunters between 1920 and 1940. They're being kept up by the governor on Svalbard, who often has to renovate them after a polar bear walks through the wall or smashes the roof. They're small and contain not much more than a bunk bed, a table, and a small oven, but they keep us warm.

We also use tents, but since it's usually just the two of us, this involves a lot of work. One has to stay awake all the time, keeping an eye out for bears. So we sleep in shifts, and getting a full night's sleep can take up to 16 hours. We prefer the cabins.

In recent years, we have also started working from a boat. We now charter the Swedish expedition ship *M/S Freya* a few weeks every spring.

Conditions change all the time—from hour to hour, from polar night to midnight sun, and from year to year. Landscapes transform. Glaciers move, and the moraines around them move even more. A route we travel one year is rarely the same the next.

In midwinter, temperatures can be extreme. We cover our bodies and faces completely, but sometimes it's necessary to expose bare skin—our hands, for example, when fixing small details on a camera. It just takes a few seconds to feel the burn of the cold. The windchill effect is painful at low temperatures, and all it takes is a little breeze to make the wind unbearable. At -40°F, a 15 mile-per-hour breeze makes the effective temperature -75°F.

The cold itself isn't the problem, though; we're mostly clothed for it. Layers and layers of wool, and big parkas on top. The dangers are wind and moisture. When you do a lot of walking while carrying or pulling heavy gear, or climb up a hill, it is easy to start sweating, even when it's cold. Just a little moisture can be enough to put you in trouble, and a lot is dangerous in extreme temperatures. The combination of moisture and cold can be lethal.

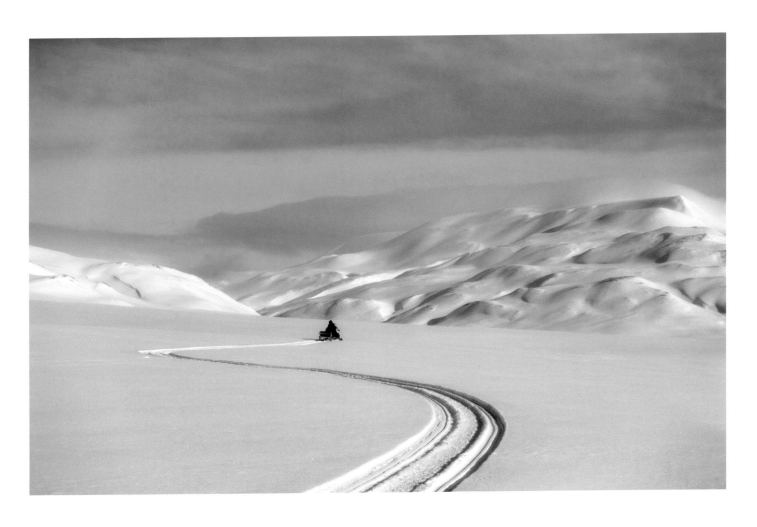

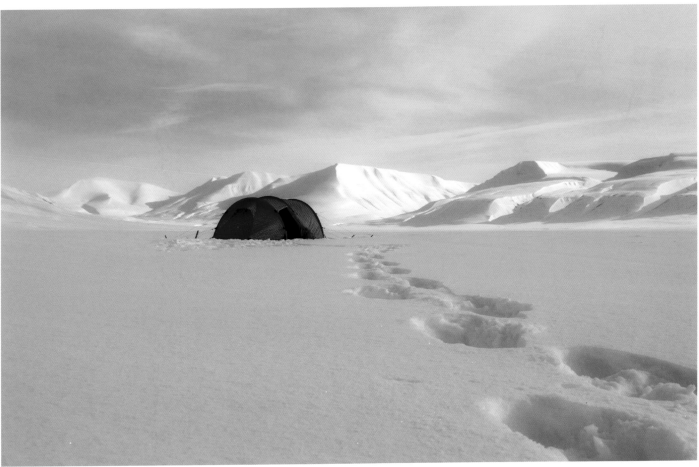

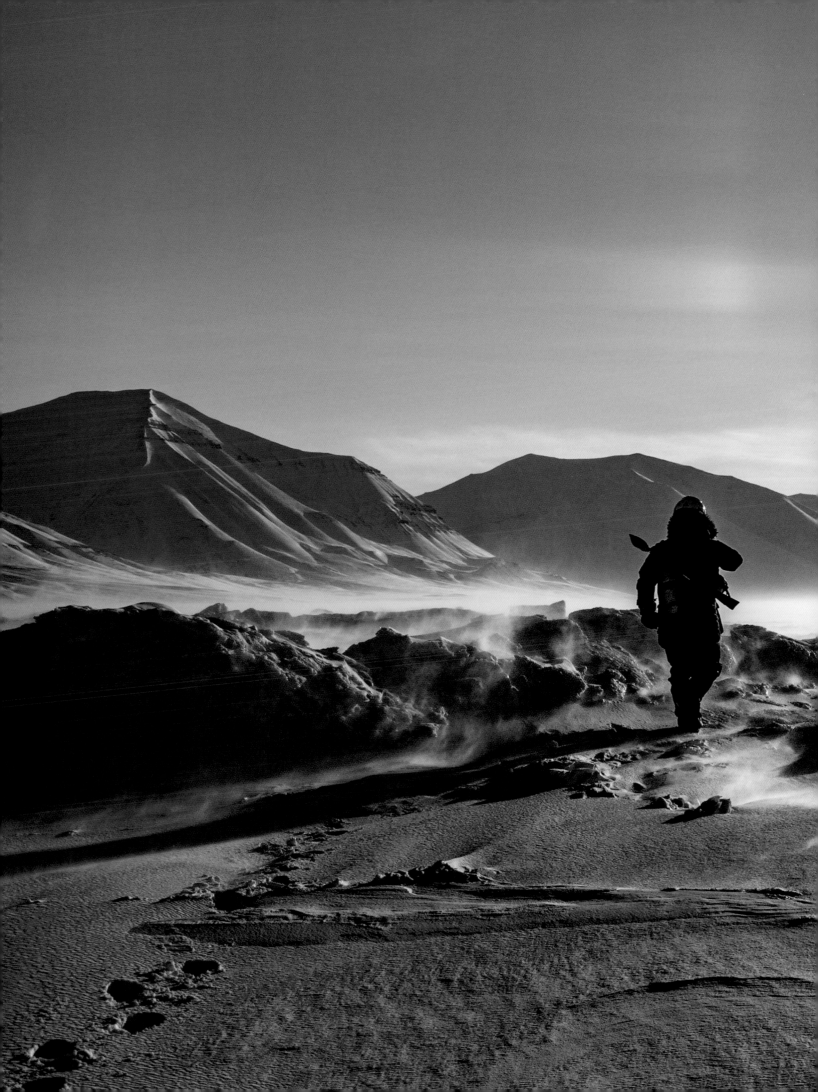

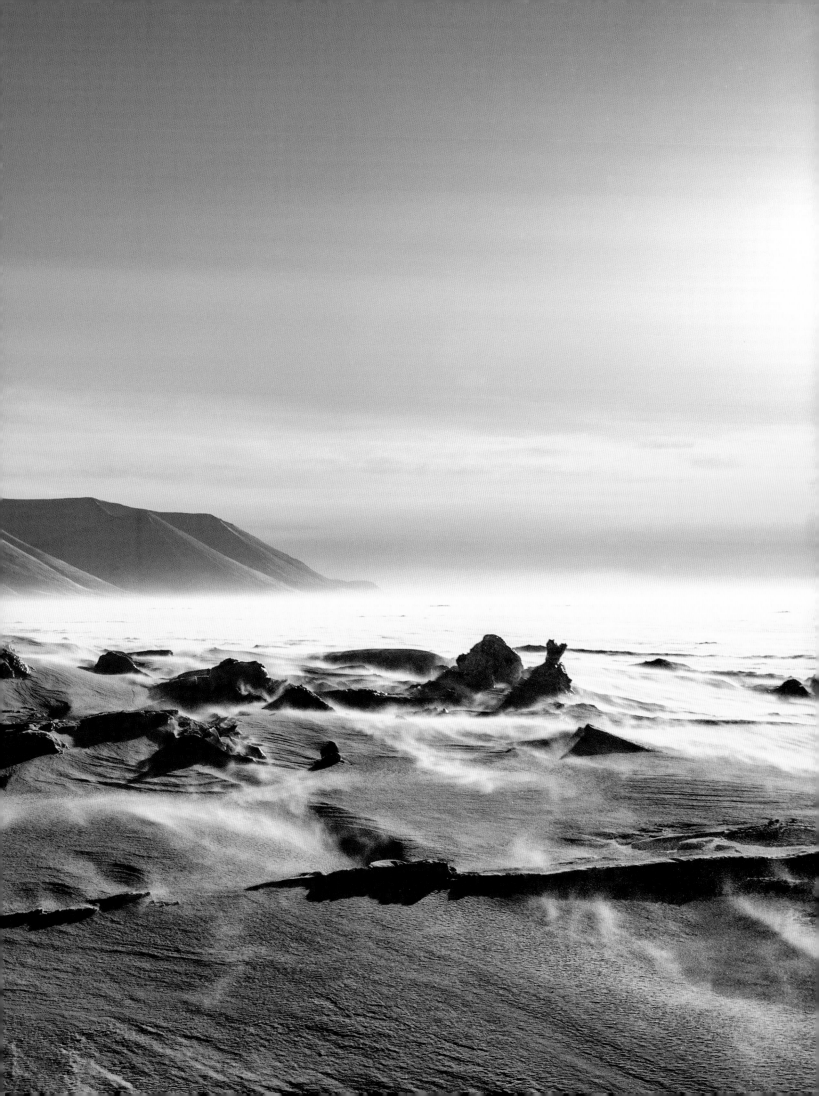

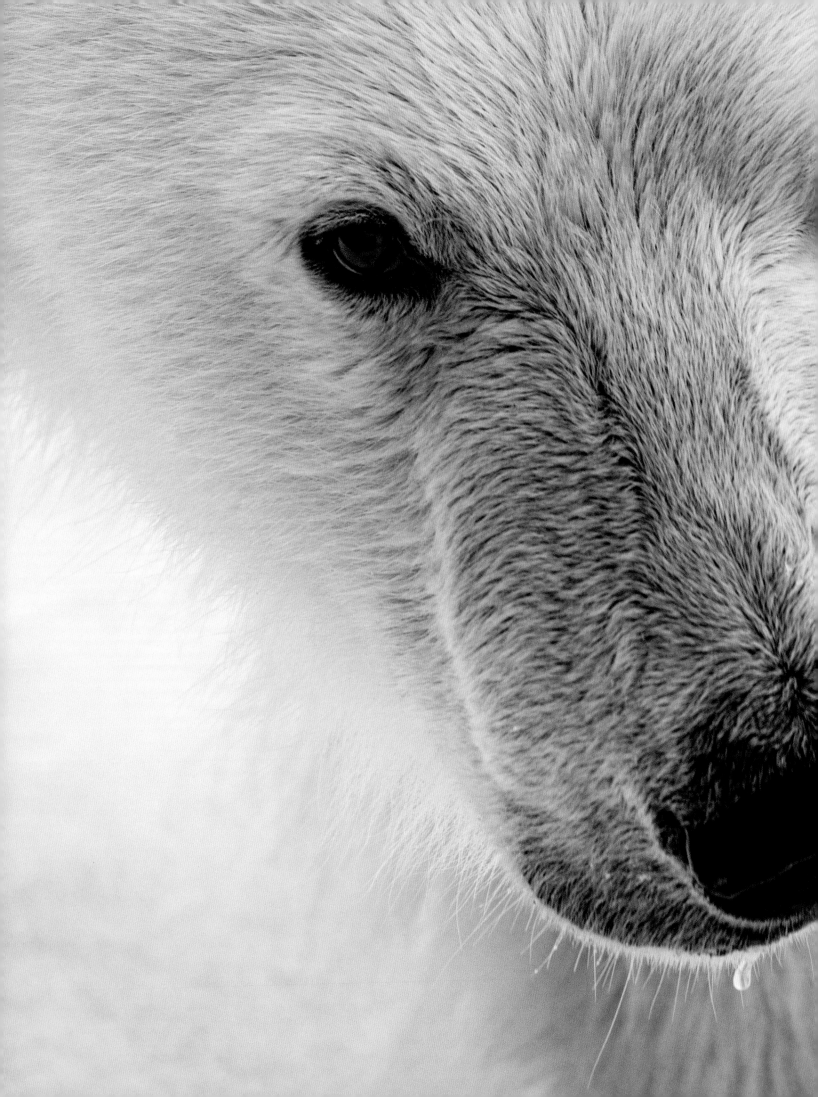

SOMETIMES THE SILENCE ON THE SEA ICE IS DEAFENING. When that silence is interrupted by the sound of four large paws crushing the snow crust, you know you are alive. Those moments make everything worth it.

You can't run from a storm or a polar bear, and you certainly can't win. You have to embrace it, dance with it.

Meeting a new polar bear is always a unique experience. The bear has most likely never seen a human being before, and the first thing it needs to do is decide exactly who or what you are.

I've had close encounters with at least a couple thousand bears on the ice—Melissa and I have met more than a hundred at the time of this writing—and so far haven't had one single dangerous episode when working with them. With experience comes knowledge, and we have learned how to read their signals and behaviors. Remaining calm is important. A polar bear can sense your fear.

If a bear shows any signs of aggression, we simply don't allow it to come close. We back off. The same goes for a bear that shows nervousness or seems scared by our presence, like mothers with small cubs often do. We back off.

We do leave footprints out there, however. It's impossible to take one single step outside civilization without disturbing wildlife. But we do everything we possibly can to minimize it. This is the polar bear's land, after all, and everything has to happen on its terms. No matter how much time we've spent on the ice and how experienced we are, we're just visitors. Respect is key to most things in life.

The few risky encounters we've experienced have all been around the camp or cabin. That's where a bear can surprise you. Like this guy, peeking through the cabin door. It is the closest I have ever been to a polar bear.

People tend to think that the polar bear is the most dangerous element of the Arctic. It is not. The most dangerous element is nature itself, its geography and weather. You need to show it respect and listen to it. If you do, it'll help you when things are the most difficult. Nature's gentle hand will carefully push you over that dangerous mountain pass, take care of you when the sea ice breaks up around you, and, when the time comes and you have to navigate over a glacier and a maze of crevasses despite heavy snowfall and bad visibility, nature will assist you. Its hand will push you forward and help you past the mayhem.

Life in the field is a collaboration with the forces of nature. Everything has to be done on nature's terms. Especially on the frozen seas.

The Arctic sea ice is devious. When you stand on solid, several-feet-thick sea ice, you can sometimes feel the waves under you, careful and slow at first, whispering silently. When they get more intense, you know all hell can break loose. And it can happen quickly—vast areas of solid ice can break up into floes and disappear in a matter of minutes when the wind and ocean currents work against you.

There have been some incidents, but many lessons have been learned, and now we play it safer than ever before. Experience and the ability to read conditions ahead are crucial on a journey through the High Arctic.

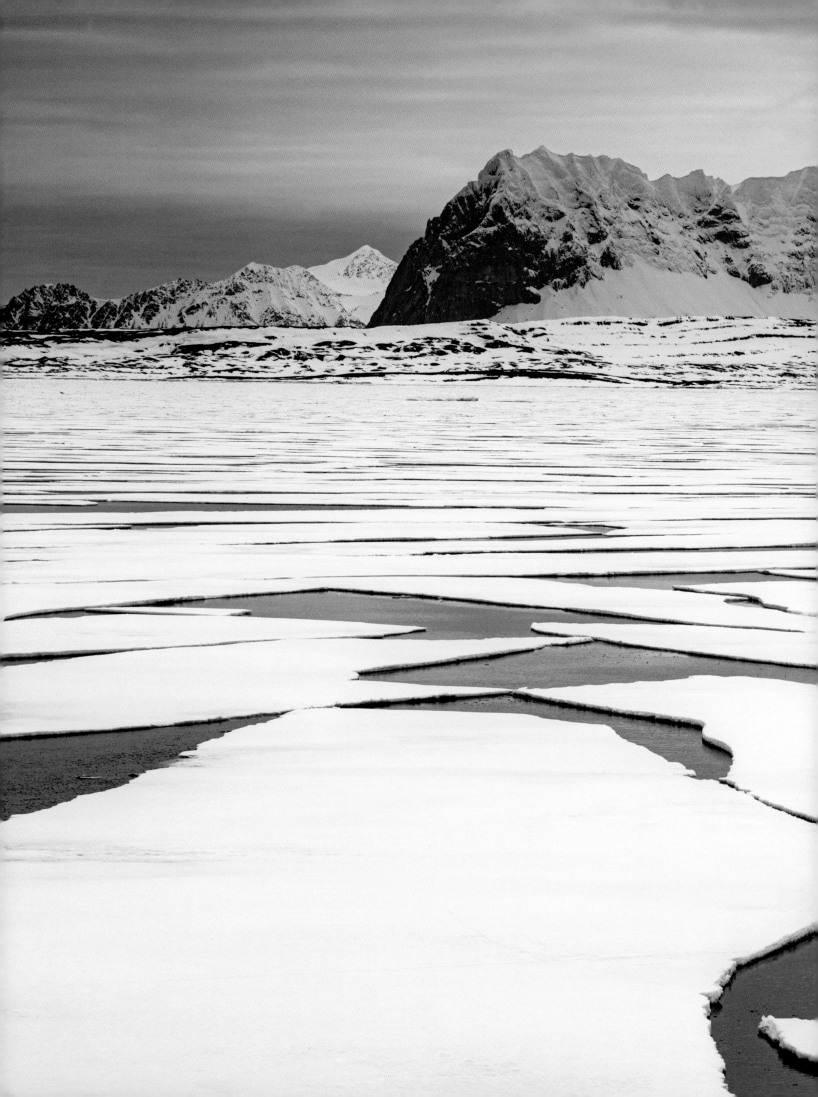

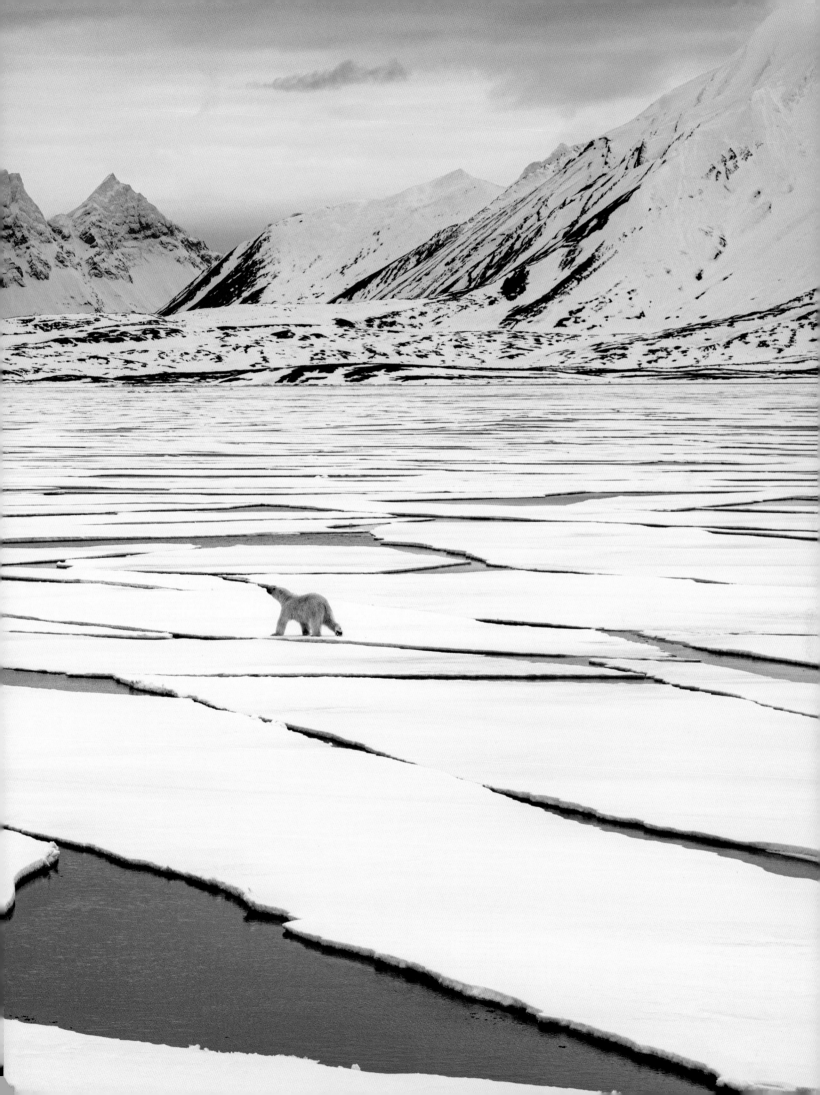

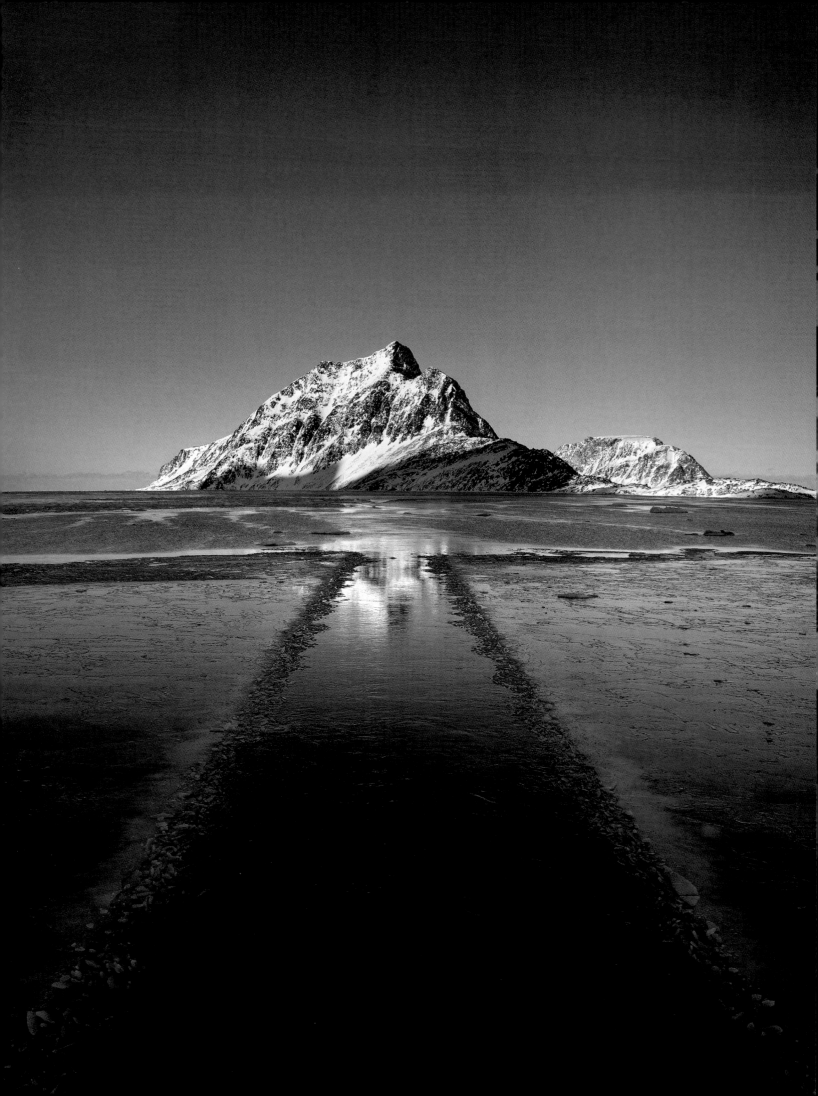

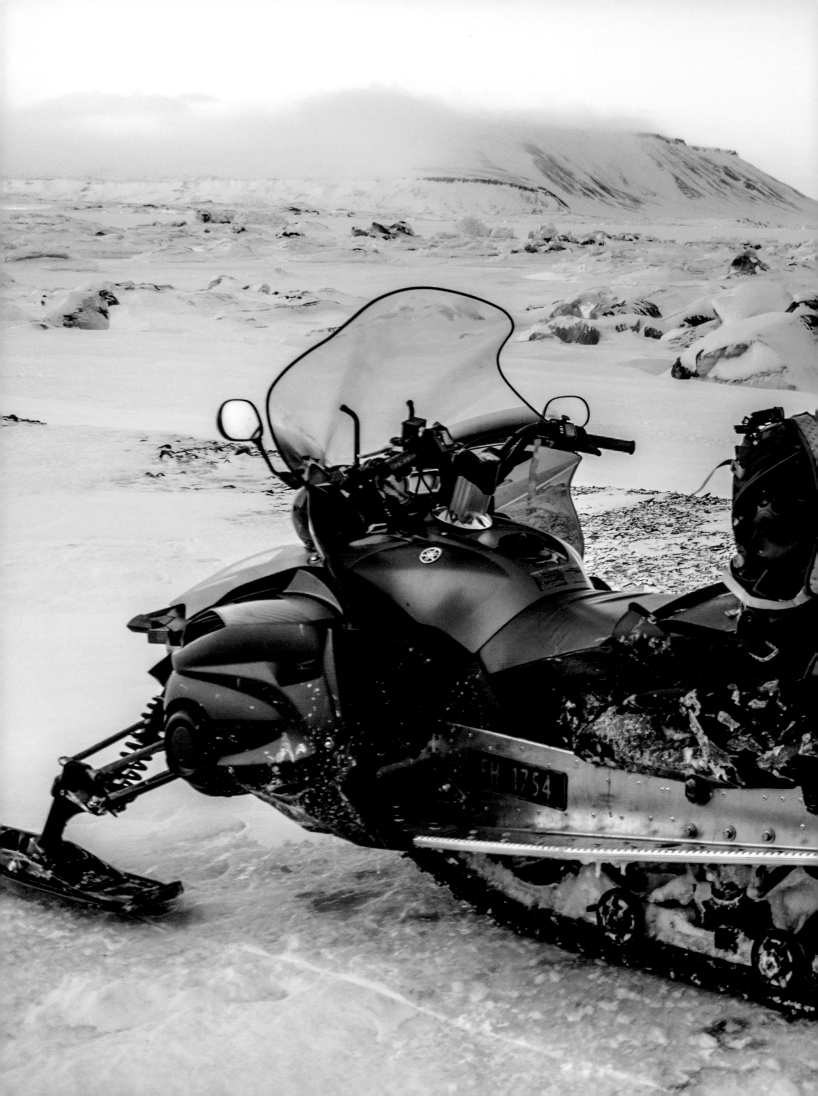

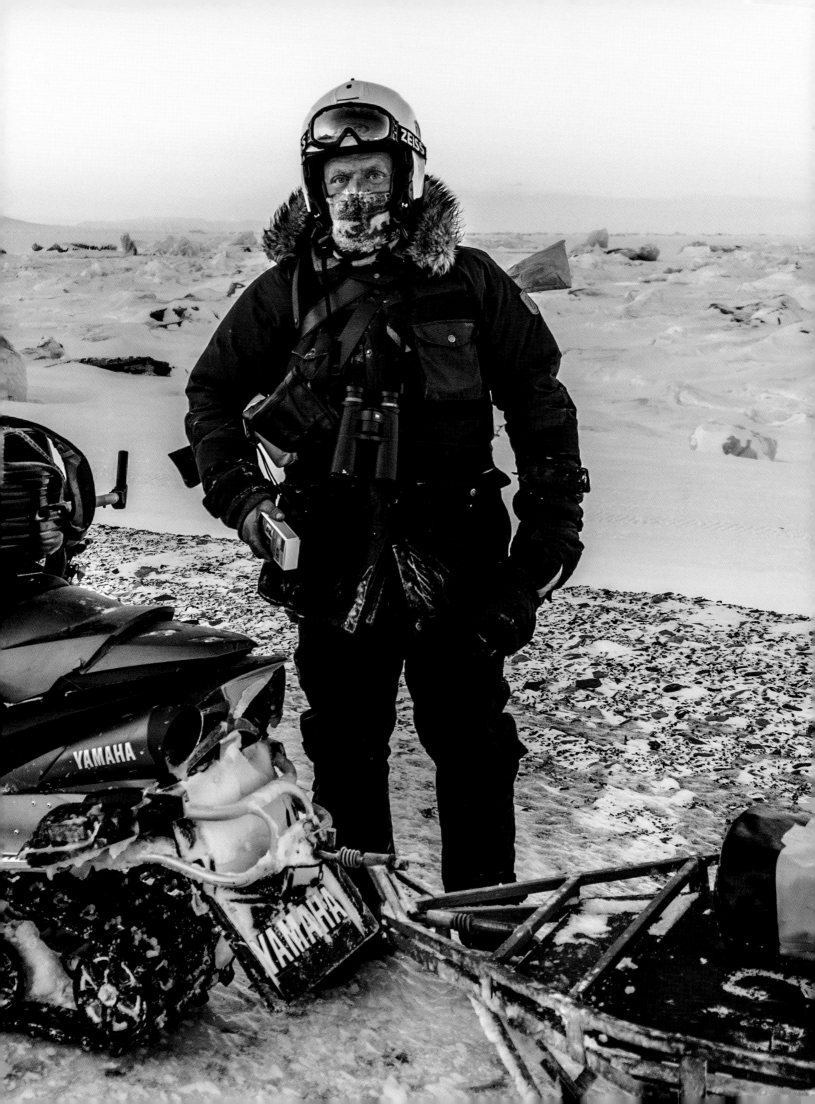

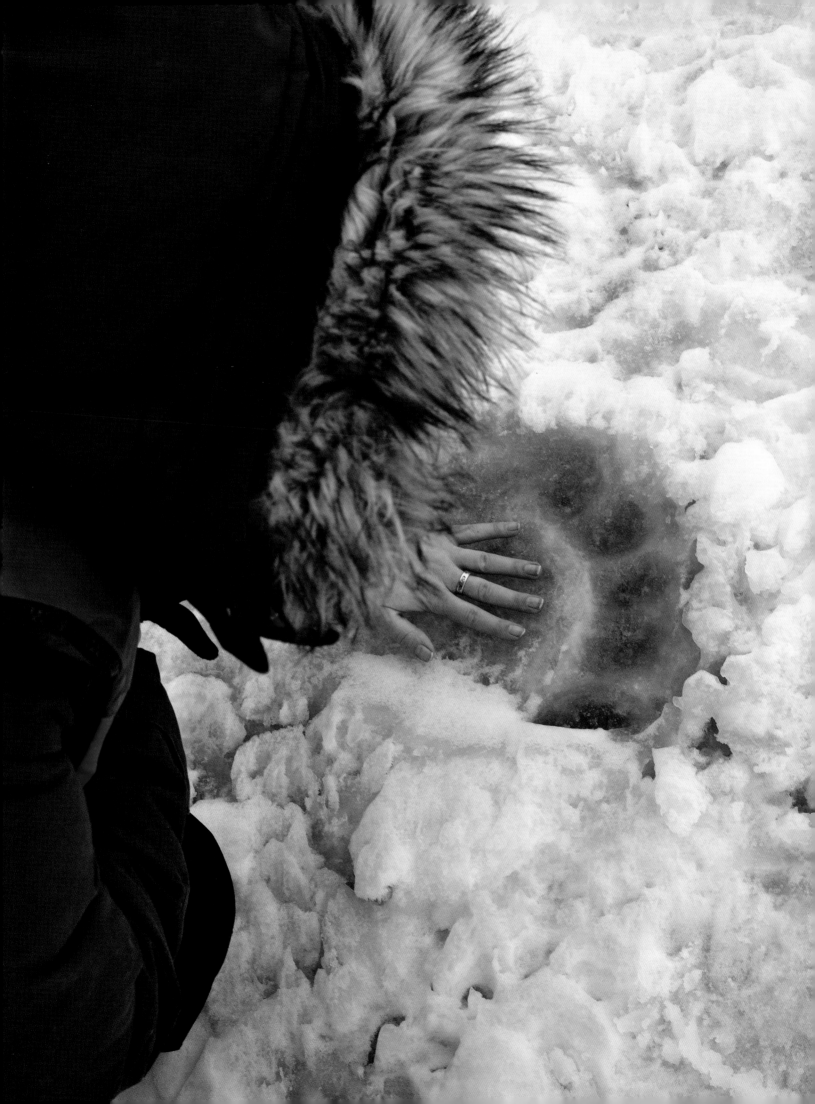

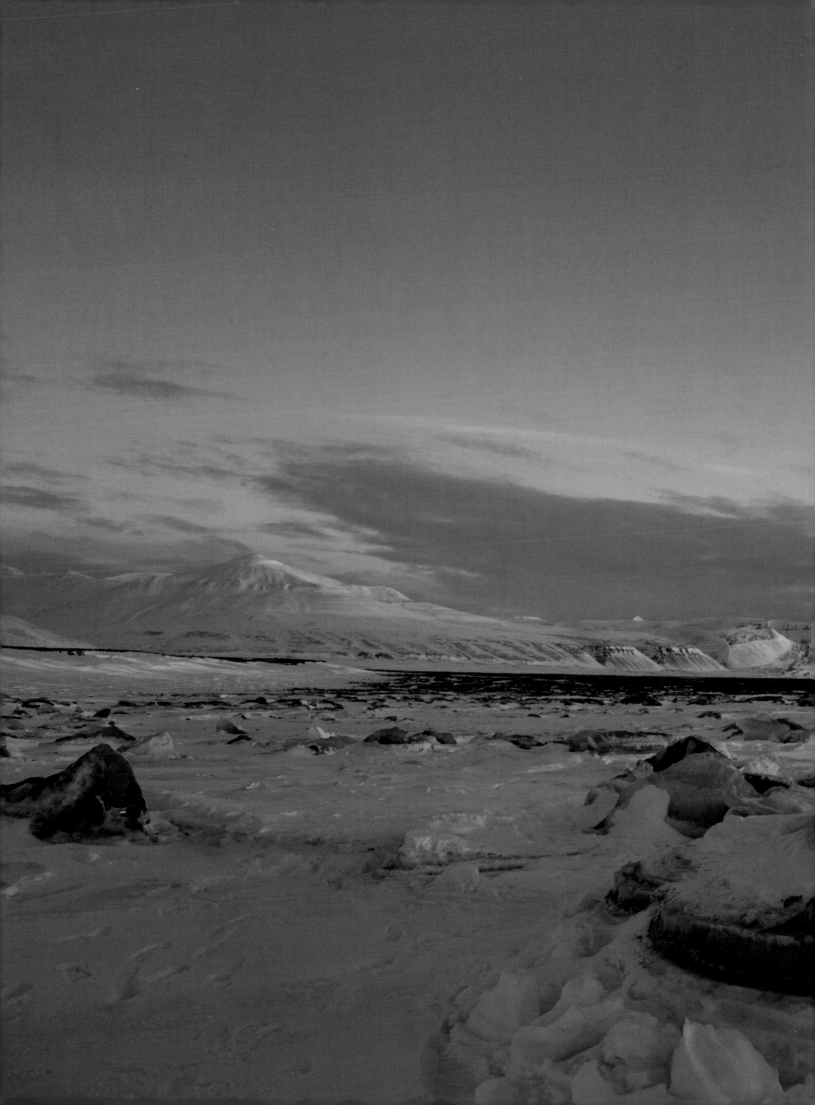

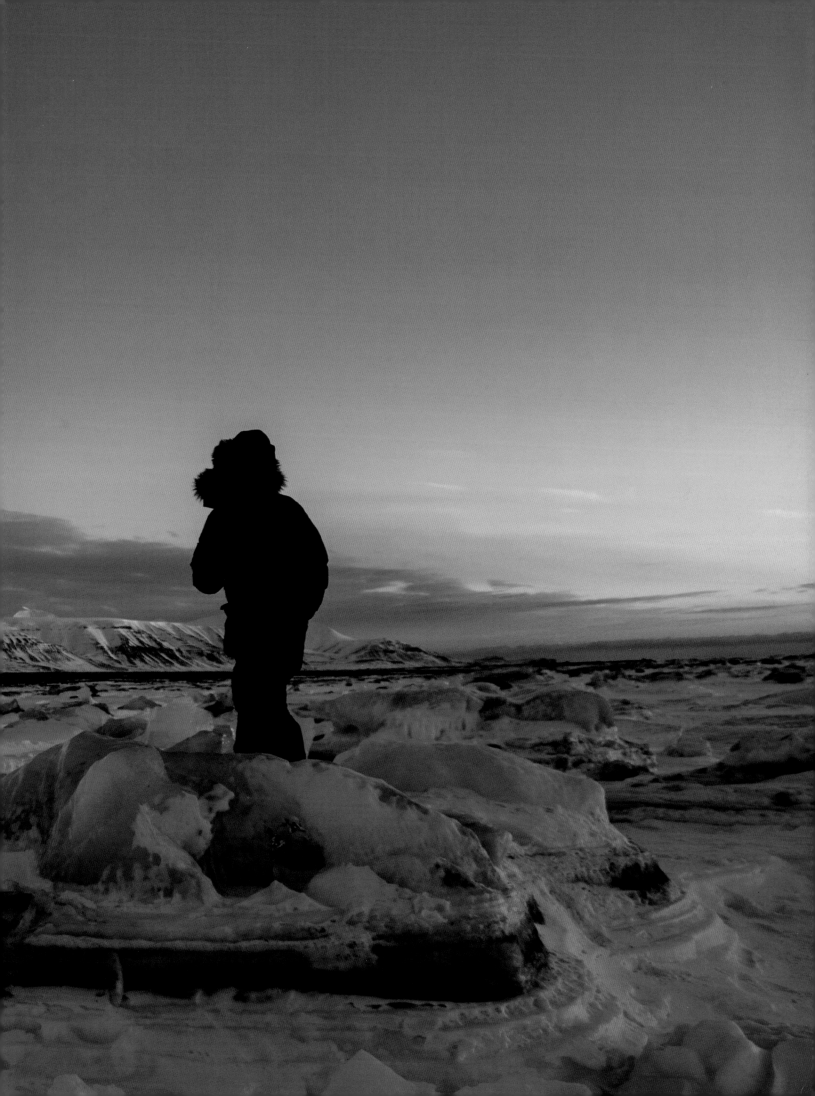

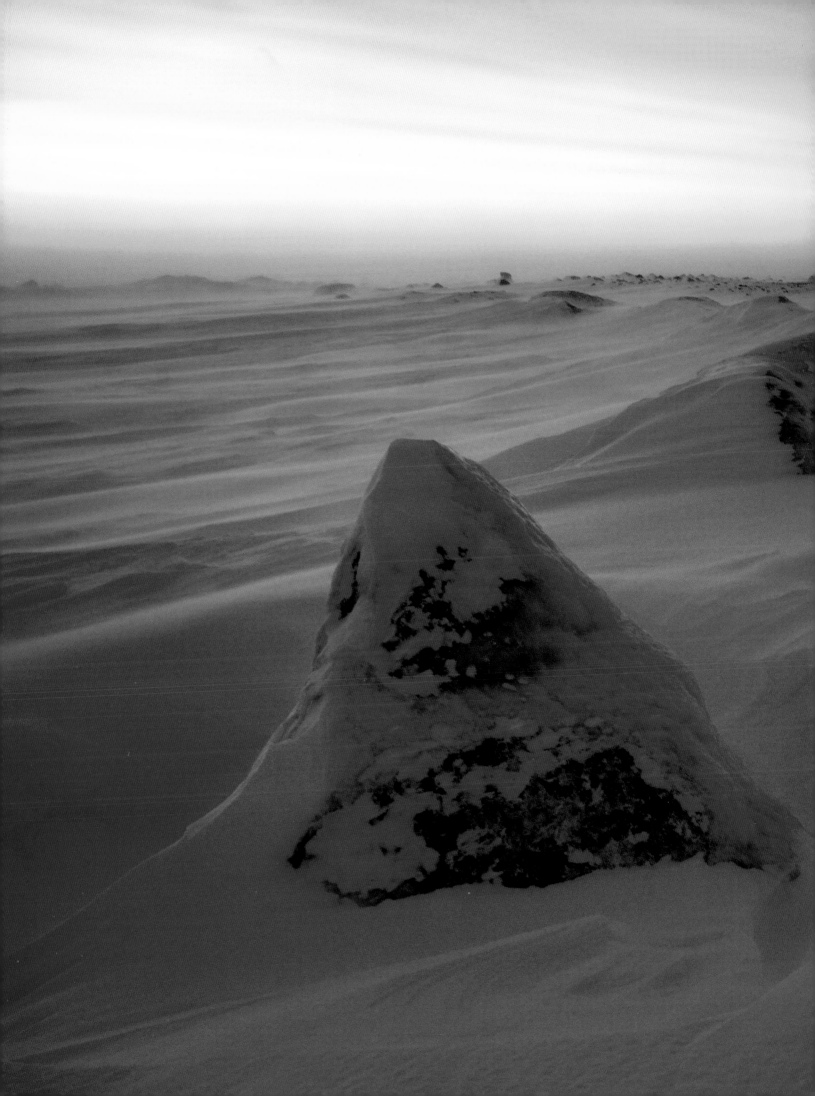

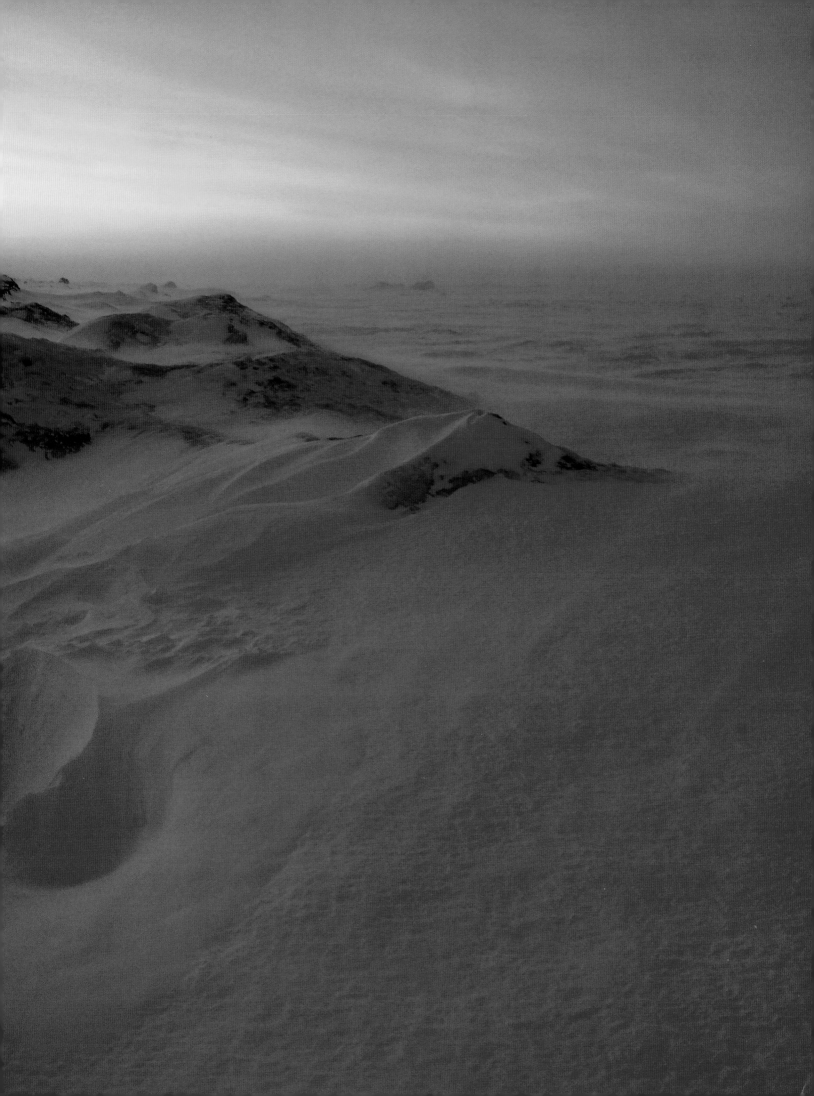

WHEN THE SUN GOES DOWN, we sit on the roof of our little cabin looking for polar bears.

Mohnbukta is a small bay on the east coast of Spitsbergen. It is a place like no other, and it has become our home in the Arctic.

In winter, the water in the bay is frozen and full of beautiful icebergs. Old sea ice and new. Huge blocks of ancient glacier ice in different shapes. When all these elements unite as the waters freeze in the cold of an autumn storm, the most beautiful landscape is created.

A big glacier seeks its way down from the mountains and ends as a huge wall dropping down the fjord. Next to the glacier, a long beach follows the mountain range south.

In the past, I had probably experienced more there than anywhere else in the world. Many months of hard fieldwork, whiteouts, accidents, and near-death experiences, but also amazing and beautiful close encounters with bears, polar night, midnight sun, and more or less everything you'd expect the Arctic to offer.

But when we met, time started over, and coming to Mohnbukta and experiencing a real Arctic winter together has been amazing. Some things can't be described in words or photographs. Mohnbukta is one of those.

On our first winter expedition there we met Helen, Melissa's first polar bear. A year later, we checked into the little cabin on the beach and were able to spend more time in the area and on the ice outside the bay.

The cabin, built by a polar bear hunter in 1928, is the size of a normal-sized bathroom and holds nothing but a small stove, a table, and a bunk bed. It has walls and a roof to keep polar bears out, and, yes, it's cozy. No matter how freezing cold it is outside, you can heat it up to sauna temperatures in a matter of minutes. But when we fall asleep the fire goes out, and it is freezing cold inside again in the morning.

The experiences we've had in Mohnbukta over the last couple of winters are bigger than anything we could have hoped for in our lifetimes. The first winter we met Helen, and a year later the most beautiful polar bear mother with her two small cubs. We'd like to think it was Helen again. Again so generous, sharing herself and her life.

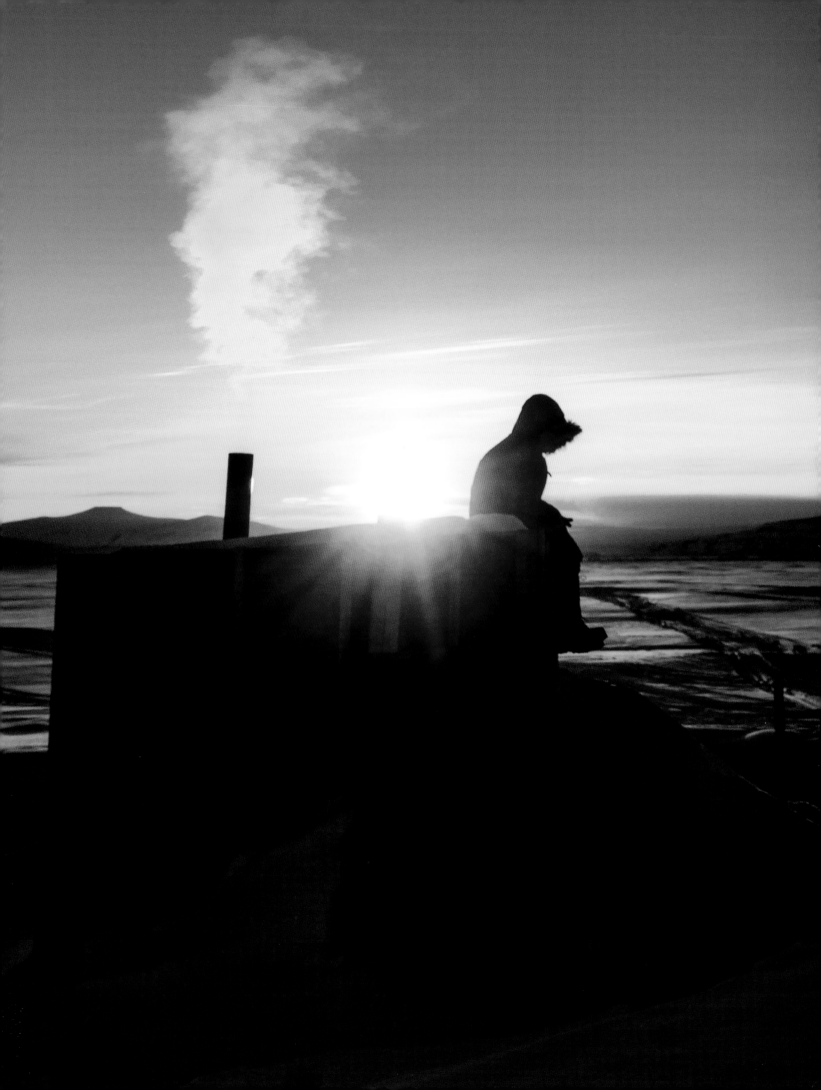

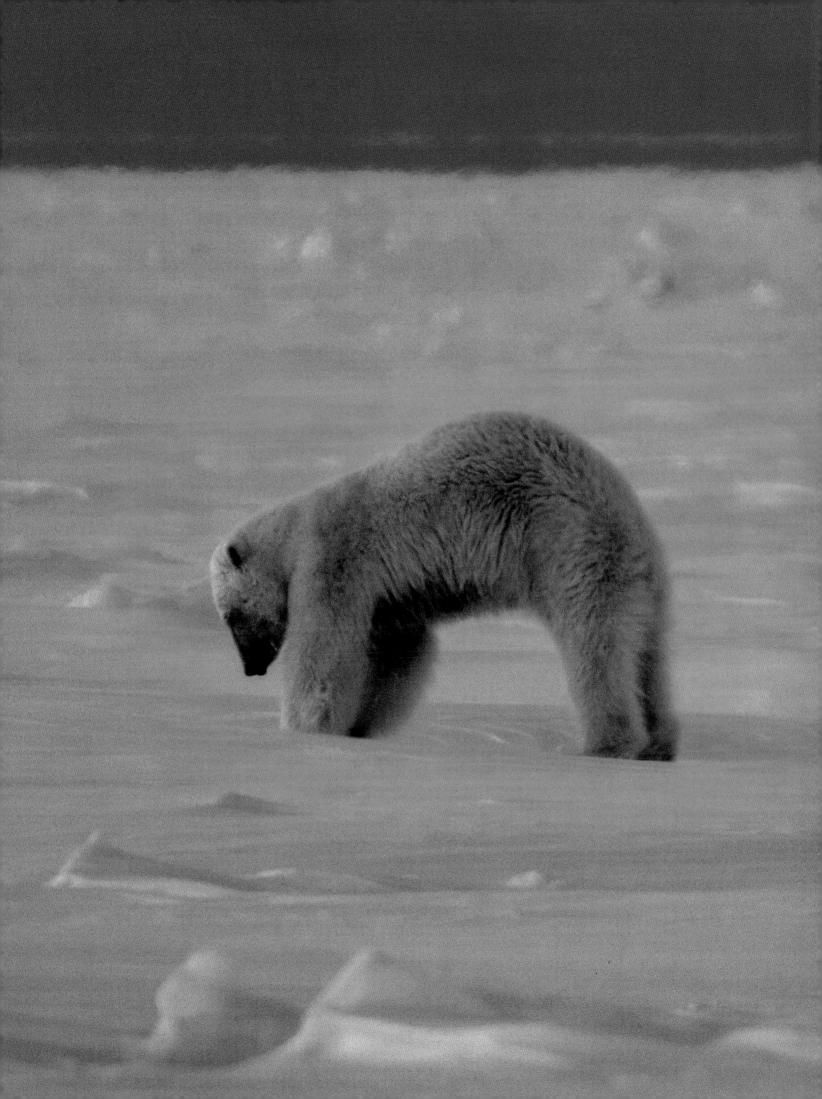

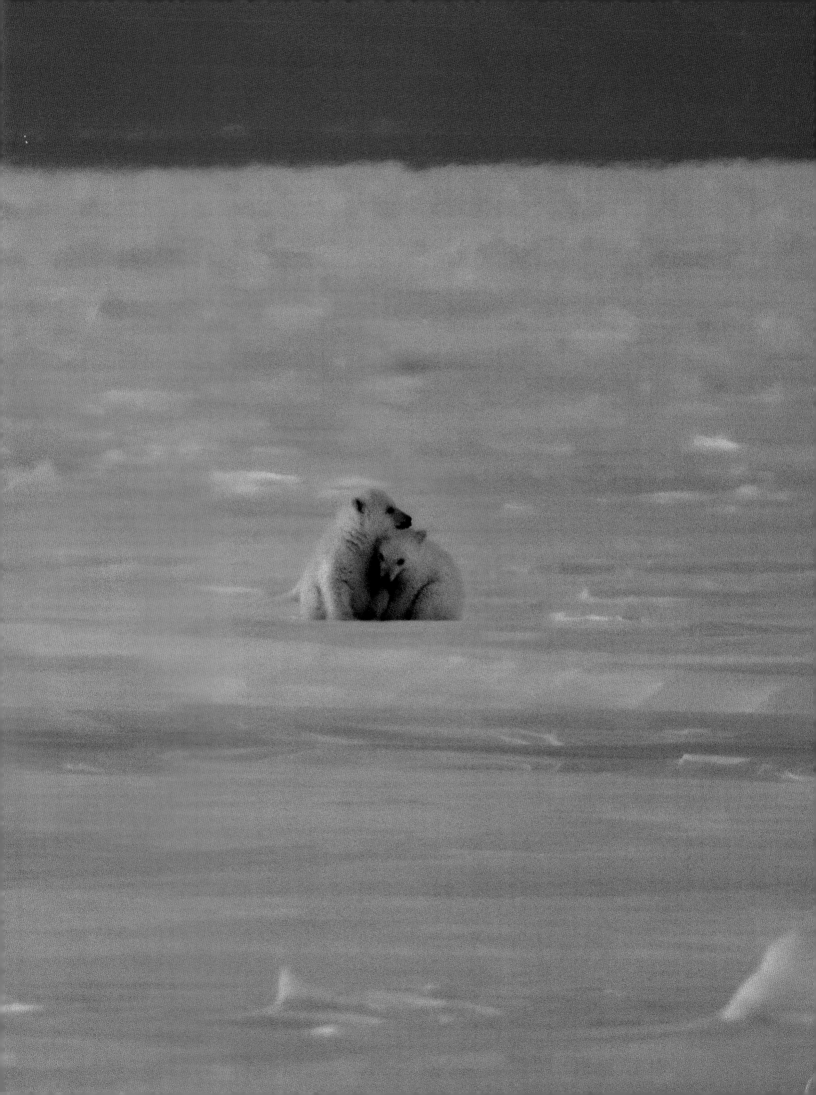

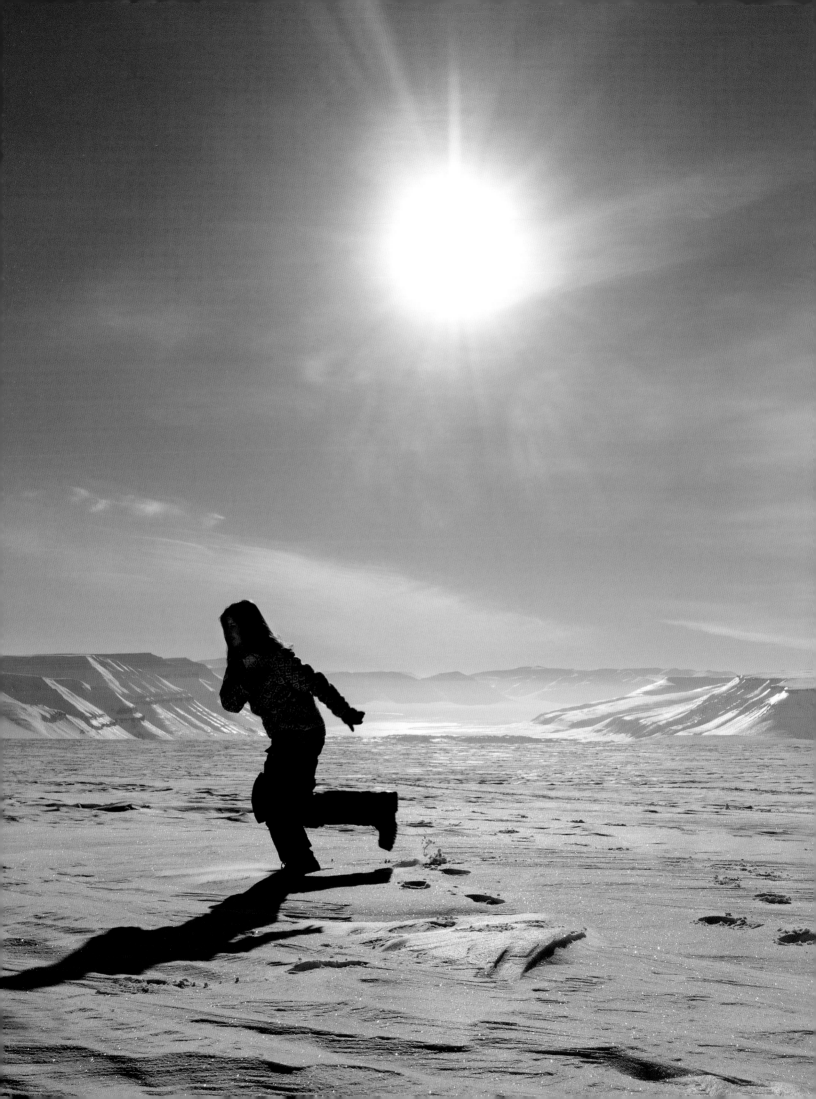

AFTERWORD

PERHAPS THE MAIN OBJECTIVE OF ALL GREAT NATURE and wildlife photography is trying to shorten the distance between people and nature, to make them feel, think, and see what is around and reconnect with what is truly important. Amazing things and incredible beauty are everywhere. In the Arctic, in our backyard, and at the park. We just need to keep our eyes open. A hedgehog or a squirrel in our garden at home in Sweden can fill us with just as much joy and awe as a polar bear on the ice.

The more often we see the things around us, even the beautiful and wonderful things, the more they become invisible to us. We tend to take the beauty of this world for granted: flowers, trees, birds, mountains, light—even those we love. Because we see things so often, we see them less and less.

In recent times, technology has turned the world upside down. We believe it's a good thing in most ways. But it's disastrous in others. Today, many people live their lives through their phones, with reality being filtered and compressed on a little screen.

So what does this have to do with the Arctic? Everything.

The greatest threat to the future of life on our planet is not politicians with short-sighted agendas or money-hungry big corporations. It is indifference. To quote our dear friend Paul Nicklen, "We have to break down the walls of apathy."

It is easy to say that we don't have power, and that what we as individuals do doesn't make much of a difference. Nothing could be further from the truth. We have all the power. We vote not only in elections, but also with our wallets. Every time you buy something, big or small, you approve not only of the product, but also the company that made it and how it was produced. Vote with your wallet. And, of course, we need to stop giving power to people who don't believe in science. Not voting is the same thing as voting for the bad ones.

There are many other small and simple steps to take. For example, remember to turn off the lights when you leave a room. Walk, bike, or take public transport instead of a car. Bring your own bag to the grocery store. Try getting locally produced food. Instead of throwing old things away, give them to a charity. Consume less, reduce your waste, and recycle what you can. And when it comes to food, the most powerful step we can take as individuals to halt climate change is to eat fewer eggs and dairy products and less meat.

Do some reading on climate change. There are many sources online. Learn more about how we cause it and what the effects will be unless we take immediate action. It is easy. Then, talk to friends and family about it.

People often ask what they can do for our environment. We try to take this beautiful planet of ours into consideration in our everyday lives. When you do that, action comes by itself. Think of Earth as your home. Because it is. If you drop something by accident on the floor in your apartment or house, do you clean it up? If your house is on fire, do you try to stop that fire? Of course you do. This planet is our home; we have nowhere else to go. So let's take care of it.

The question is not how we feel about all of this. The question is what we will do. Words, like these, are just words. And don't forget love—love for one another and love for our planet and all the life we share it with.

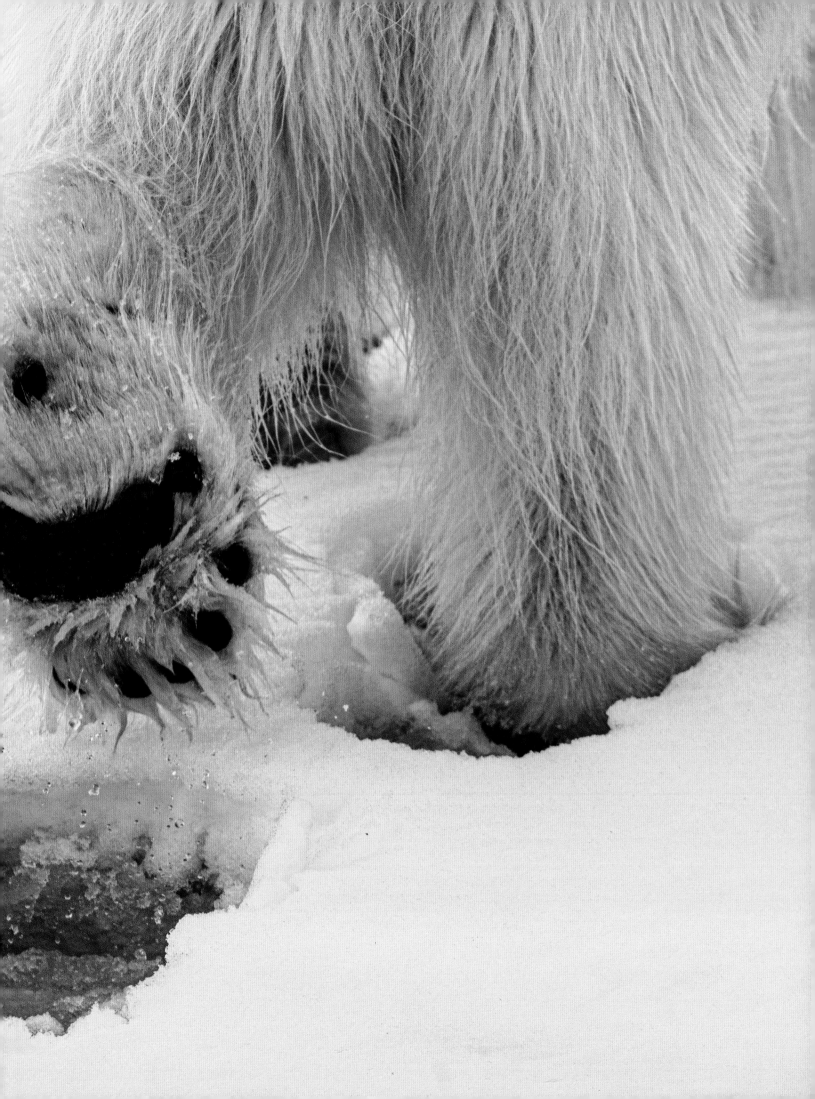

RESOURCES

There are many things we can do as individuals for our environment and future. One is to join others and let our voices be heard together. Part of the proceeds from this book are donated to great organizations like these:

SeaLegacy combines decades of experience in conservation, photography, and communications with the latest digital and social technologies to build a healthy future for our planet and our oceans. SeaLegacy was founded by our friends Paul Nicklen and Cristina Mittermeier. **www.sealegacy.org**

World Wildlife Fund's mission is to conserve nature and reduce the most pressing threats to the diversity of life on Earth. WWF's work combines global reach with a foundation in science and involves action at every level from local to global. **www.worldwildlife.org**

Greenpeace is a global, independent campaigning organization that uses creative communication and peaceful protest to expose global environmental problems and promote solutions that are essential to a green and peaceful future. **www.greenpeace.org**

Sources and References

Our work is mainly about our own experiences. But it is important for us to base everything in the most recent science and research. We have an ongoing dialogue with world-leading scientists in order for the big picture to be as correct as possible. They also helped check all the facts in this book. In some parts of the text we refer to specific articles or science reports:

Page 20 Global temperature records. National Oceanic and Atmospheric Administration, 2019.

Page 50 The polar bear Kara. The Norwegian Polar Institute and WWF polar bear tracker, 2017.

Page 70 Polar bears in water. "Aquatic behaviour of polar bears (*Ursus maritimus*) in an increasingly ice-free Arctic," 2018. By Jon Aars et al.

Page 70 Injury patterns on polar bears. "Fractures of the radius and ulna secondary to possible vitamin 'D' deficiency in captive polar bears (*Ursus maritimus*)," 2010. By Emmanuel Engeli.

Page 112 Long-distance swimming. "Long-distance swimming events by adult female polar bears in the southern Beaufort and Chukchi seas," 2011. By Anthony M. Pagano et al.

Page 117 The polar bear Bouba le Blanc. The Norwegian Polar Institute and WWF polar bear tracker, 2007.

Page 159 Arctic Ocean free of ice in 2040. "Future abrupt reductions in the summer Arctic sea ice," 2006. By M. M. Holland, Bitz et al.

Page 159 The oldest sea ice north of Greenland melts. Article in *The Guardian*, 2018. Norwegian Meteorological Institute, Danish Meteorological Institute.

Page 162 Future temperatures. NASA, "Global Climate Change: Vital Signs of the Planet," 2019.

Field Equipment and Logistics

Cameras and lenses: Canon 5D Mark IV, Canon 7D Mark II, Canon EF 100-400mm f/4,5-5,6L IS II USM, Canon extender 1.4x III, Canon EF 24-70mm f/2,8L II USM, Zeiss Milvus 50mm f/1.4, Sony RX100 IV, iPhone 7, DJI Phantom 4 Pro, GoPro Hero6. **Tripods:** Gitzo Mountaineer GT3542. **Binoculars:** Zeiss Victory RF 10x42, Zeiss Victory Pocket FL 10x25. **Clothing:** Fjällräven jackets Arktis Parka, Expedition Down, and Keb Eco-Shell, Fjällräven trousers, Barents Pro Hydraulic, Ken Eco-Shell, and Polar Bib. Woolpower thermal undergarments, socks, mittens, and balaclavas. Sinisalo Safari Suit overall. Marmot Expedition mittens, Swedish Army snow camouflage jackets and trousers. **Shoes and boots:** Lundhags Polar and Jaure Lite, Sorel Glacier XT, Polyver boots. **Tents:** Fjällräven Polar Endurance 3. **Sleeping bags:** Fjällräven Polar -30. **Mattresses:** Therma-a-Rest BaseCamp and RidgeRest Solar. **Backpacks:** Fjällräven Kajka 100 and Kajka 65, Petzl Transport 45. **Transport cases:** Explorer Cases of many different models and sizes. Zarges K470 and K424. **Dry bags:** Sea to Summit.

Glacier gear: Petzl equipment (helmets, headlamps, harnesses, ascenders, descenders, ropes, carbiners, ice axes, anchors, pulleys, and crampons). **Tools and knives:** Leatherman tools, Fjällkniven S2 knives. **Food and cooking:** Primus Omnifuel kitchen, Primus pots and cookware. Blå Band freeze-dried field food. **Snowmobiles:** Yamaha RS Viking. **Helmets:** HJC with ChatterBox communication. **Watches:** Bruvik Arctic Ocean II. **Various logistics:** Hurtigruten Svalbard, Scandinavian Airlines, Luftransport, SAS Cargo. **Electricity:** Honda EU10i and EU20i generators. **Computers, image editing, and storage in the field:** Apple Macbook Pro, LaCie Rugged hard drives, Adobe Photoshop and Lightroom. **Weapons:** Rifles Sako Black Bear .308, Revolver Smith & Wesson .44 Magnum, and 25.6 mm flare guns. **Safety on sea and ice:** Baltic Legend 275 life jackets, SAR life vests, and Amarok overalls. **Communication:** Iridium Extreme handset, Iridium GO!, McMurdo Personal Locator Beacon MaxG, Garmin Montana 650t GPS, SeaMaster VHF, Pieps avalanche transceivers, various equipment from Cordland Marine.

Our website www.themotherbear.com

ACKNOWLEDGMENTS

Thank you to our families and friends. Vera, Karin, Johannes, Bror, Mark, Tobias, and Angelika. Rosina and Klaus Bertram. Tatjana Bernert. Mathias Wikström.

Longyearbyen is the warmest place on Earth. All the love and support we have been given over the years mean everything. Kine Stiberg, Jørn Kjetil Hansen, Arild Hermansen, Inger Marie Hegvik, Silje Marie Våtvik, Emelie Våtvik, Anna Lena Ekeblad, Johan Berger, Sofia Hansen Berger, Stein Woldengen, Marta Slubowska Woldengen, Tommy Sandal, Mary-Ann Dahle, Anders Magne Lindseth, and Jason Roberts. Egil Brenna and Karl Erik Wilhelmsen, you are always with us.

Our friends, Eric Nixon, Paul Nicklen, Cristina Mittermeier, and SeaLegacy.

Sven-Olof Lindblad. Hero and friend.

Our work in a world of ice makes huge demands on equipment and logistics. Only the best is good enough. We are so thankful for the amazing support we have from our partners. Without you this would not be possible. Thank you Fjällräven, Hurtigruten Svalbard, Yamaha Snowmobiles, SAS Scandinavian Airlines, SAS Cargo, Polyver Boots, Woolpower, Triumf Glass, Carl Zeiss, Lundhags, Petzl, Iridium Communications, Cordland Marine, Honda Sweden, Explorer Cases, Zarges, Blå Band, Continental Foods, Primus, Naturkompaniet, Baltic, Bruvik Time, and Sako Rifles.

Our eternal gratitude to Michael Giese, Ann-Sophie Bach, Paul Dufva, Karin Sundström, Jenny Näslund, Anders Blomster, Magdalena Rohdin-Hurtig, Laurent de la Fouchardiere, Sam Beaugey, Will Kraus, Julie Bastos, Ann Movitz, Carola Larsson, Dario Castiello, Patric Seger, Jens Falkvall, Johan Sollenberg, Henrik Hoffman, Carl Reinestam, Per Frode, Rune Bruvik, and Patric Roman, who all have meant so much.

A special thanks to Ida Dyreng, Angelica Montez de Oca, and Daniel Skjeldam at Hurtigruten Svalbard, Sarah Benton and Leif Öhlund at Fjällräven, Lars Lundmark and Anders Müntzing at Triumf Glass, and, as always, Per Nordgren at Carl Zeiss. Thanks also to Ola Skinnarmo, our wonderful friends at Expeditionsresor, Daniel Börjesson, and Jens Wikström. Split the ice!

We, and the polar bears, would like to thank scientists Jon Aars, Magnus Andersen, and Andrew Derocher. Thanks also to the Norwegian Polar Institute and Sysselmannen for a great collaboration through the years.

Gunnel Cullborg, Edvin Vidarsson, and the amazing crew of *M/S Freya*. You are amazing and make it possible for us to explore the waters of Svalbard with the best expedition ship in the Arctic.

Kenth Grankvist. The closer the drift ice embraces us, the bigger the adventure becomes, and the more we feel your presence when we're out at sea.

Jim Muschett, Charles Miers, Marco Ausenda, Candice Fehrman, and all our wonderful friends at Rizzoli International Publications. Thank you for believing in us.

Nanuk, our little monster. We love you.

This book is dedicated to Tom Winter.

And you.

First published in the United States of America in 2020 by
Rizzoli International Publications, Inc.
300 Park Avenue South
New York, NY 10010
www.rizzoliusa.com

All photographs by Melissa Schäfer, except pages 14–15, 84–85, 88–89, 92–93, 100–101, 108–109, 110, 116, 130, 170, 172–173, 174–175, 232, 236, 237, 238–239, 245, 246–247, and 250 by Fredrik Granath, and pages 226–227 and 234–235 by Eric Nixon. All text by Fredrik Granath and Melissa Schäfer.

Publisher: Charles Miers
Associate Publisher: James Muschett
Managing Editor: Lynn Scrabis
Editor: Candice Fehrman
Production Manager: Colin Hough Trapp

Printed in China

2020 2021 2022 2023 / 10 9 8 7 6 5 4 3 2 1

ISBN: 978-0-8478-6884-1

Library of Congress Control Number: 2020934220

Visit us online:
Facebook.com/RizzoliNewYork
Twitter: @Rizzoli_Books
Instagram.com/RizzoliBooks
Pinterest.com/RizzoliBooks
Youtube.com/user/RizzoliNY
Issuu.com/Rizzoli

FSC
www.fsc.org

MIX
Paper from
responsible sources
FSC® C104723